# DREAMS AND RESPONSIBILITIES

# DREAMS AND RESPONSIBILITIES

The State and The Arts in
Independent Ireland

BRIAN P KENNEDY

ISBN 0 906627 32 X

Design: Bill Murphy
Printed in Ireland by Criterion Press, Dublin
Published by The Arts Council (An Chomhairle Ealaíon)

The Arts Council gratefully acknowledges
the generous financial support of :
The Electricity Supply Board and
Coopers and Lybrand
towards the publication of this book.

CONTENTS

# ACKNOWLEDGEMENTS

This study was commissioned by the Arts Council whose Chairman, Professor Colm O hEocha, members and staff gave me every assistance in bringing it to completion. I owe particular thanks to Mairtín McCullough, former Chairman, for trusting me with the task, for allowing me latitude to interpret the theme of the study and for giving me adequate time to complete it. I asked for and received total independence and, therefore, I accept responsibility for all the contents. The Director of the Arts Council, Adrian Munnelly, showed himself to be a firm believer in open access and could not have been more helpful to me. David McConnell, the Arts Council's Finance Officer, provided useful suggestions by virtue of his admirable knowledge of the contents of old files.

I wish to acknowledge the assistance of University College, Dublin; Trinity College, Dublin; the State Paper Office; the Department of Finance; the National Gallery; and the National Library; in making files available for examination. Ms Catríona MacLeod and Professor Geoffrey Hand also provided important primary material. Special thanks is due to those who agreed to be interviewed. They accepted my detailed questioning patiently and generously. The Arts Council of Great Britain (Rod Fisher), the Welsh Arts Council (Tom Owen), the Scottish Arts Council (Tim Mason), and the Arts Council of Northern Ireland (Kenneth Jamison), provided helpful comparative material about their respective policies.

Professor Donal McCartney deserves my sincere thanks for his advice and support. Mr Seán Cromien, Secretary, Department of Finance, took a keen interest in my work and provided helpful comments. The following provided encouragement and/or assistance: Professor Kevin Cathcart, Dr Raymond Gillespie, Ms Anne Kelly, Mr Patrick Long, Dr Eamonn McKee, Dr Brian Murphy, Mr Seán Oliver, Mr Richard Pine, Mrs Ann Reihill and Professor Alistair Rowan. I am indebted to Professor Ronan Fanning for suggesting that I should undertake this study.

I dedicate this work to my parents, Gerald and Anne, with thanks for their constant support for my academic endeavours and to my wife, Mary, for her generosity in allowing me time to devote myself to what she called 'my second wife'.

# ABBREVIATIONS

| | |
|---|---|
| Bodkin Papers | Thomas Bodkin Papers, Trinity College, Dublin. |
| CAB | Cabinet (Government). |
| C.E. | Comhairle Ealaíon (Arts Council), Merrion Square, Dublin. |
| C.B.L. | Chester Beatty Library, Ballsbridge, Dublin. |
| Dáil Debates | Parliamentary Debates of Dáil Eireann. |
| D/Finance | Department of Finance, Merrion Street, Dublin. |
| Little Papers | Papers of Patrick Little (in possession of Ms Catríona MacLeod). |
| McGreevy Papers | Papers of Thomas McGreevy, Trinity College, Dublin. |
| McGilligan Papers | Papers of Patrick McGilligan, University College, Dublin, Archives Department. |
| M.P. | Member of Parliament, House of Commons, Westminster. |
| N.G.I. | National Gallery of Ireland, Merrion Square, Dublin. |
| S | Provisional Government, Executive Council and Cabinet files. |
| Seanad Debates | Parliamentary Debates of Seanad Eireann. |
| S.P.O. | State Paper Office, Dublin Castle. |
| T.C.D. | Trinity College, Dublin. |
| T.D. | Teachta Dála (member of Dáil Eireann). |
| U.C.D.A. | University College, Dublin, Archives Department. |

# INTRODUCTION

This study seeks to trace the development of official arts policy in independent Ireland and, thereby, demonstrates that this development has been marked more by a tendency to implement grand gestures towards the arts than to realise a comprehensive and cogent arts policy. Despite this, the courage and vision of some politicians, civil and public servants, and a dedicated group of private individuals has helped to establish the arts as an essential part of Irish government policy.

It has not been possible in this study to cover all aspects of the State's involvement with the arts in Ireland. But it is hoped that a reasonable attempt has been made to open up the area of arts policy to close public scrutiny and to encourage further contributions from historians.

# CHAPTER ONE

## THE STATE AND THE ARTS: SOME PRELIMINARY OBSERVATIONS

*Art is, after all, a delicate plant which thrives only in certain soil. It needs culture, attention, enlightenment, and without these things it wilts and dies.*

J.J. ROBINSON

*If the roots of a national culture are in the soil, they flower at the top, in the arts, which in turn shower down seeds a hundredfold.*

CECIL FFRENCH SALKELD

This study presents a history of the development of official arts policy in independent Ireland. Its preparation involved the examination of government files, the archives of the Arts Council - An Chomhairle Ealaíon - and the private correspondence of some of the major contributors to the shaping of Irish arts policy. The material reveals that the arts have most often been an interesting but peripheral part of government policy. But the arts have attracted greater attention from Irish Governments since the second world war. Rapid industrialisation, urbanisation, the arrival of a consumer-orientated society, and increased leisure time have all contributed to a change in attitudes to the arts. Irish arts administrators and former Arts Council officials have not yet followed the example of their counterparts in Great Britain by publishing books about arts policy.[1] It is safe to predict, however, that such a book would be well received by the Irish public. This was not the case during the first decades following independence. The arts were regarded as a luxury, an unnecessary expense.

The title of this study is *The State and the Arts*. By 'The State' is meant the government and all organisations and institutions wholly subsidised from public funds. 'The Arts' is a more difficult term to define. The Arts include all those skilful activities requiring creativity and intelligence which seek to represent and respond to human experience. This open-ended definition clearly makes the arts difficult to pin down from a legislative point of view. There has been a tendency to confine the legal definition of art to the so-called fine arts - painting, sculpture, literature, music and architecture.

It has become accepted that a distinction should be made between the heritage arts (conservation of past creativity and its dissemination) and the living arts (contemporary creative and performance arts). It is obvious that the Irish State[2] is involved in subsidising both the heritage (through support for a broad range of national institutions such as the museum, library and gallery) and the living arts (via the Arts Council, local authorities and other agencies).

The growth of involvement by the State in the subsidy of arts-related activities arose from an acceptance in Ireland of some of the basic tenets of the Welfare State philosophy. Just as health, education and social welfare services were to be open to all irrespective of the ability to pay for them, the arts became an essential service too. Another influence in Ireland was the adoption of what became known in the 1970s as QUANGOS - quasi-autonomous non-governmental organisations. The basic principle underlying the establishment of the Arts Council in 1951 was the need to keep the arts 'at arm's length' from political interference.[3] In recent years this principle has come under sustained attack.[4] With the growth of rigid expenditure control in most advanced economies, it has become necessary to exact a greater degree of public accountability from the administrators of QUANGOS. It has also raised the wider issue of state funding of the arts. Sir Roy Shaw, former Secretary General of the Arts Council of Great Britain, has put it thus:

> Why should public money be spent on subsidising the arts when people are dying for want of kidney machines? This is a question which must be answered and rarely is. Most defenders of the arts simply assume that they are 'a good thing' and cannot understand why this is not obvious to everyone.[5]

It is not the purpose of this study to justify State support for the arts. Nevertheless, the following are among the most oft-cited reasons why the State should subsidise the arts: to safeguard the artistic heritage, to encourage creativity, to ensure equal access for all, and to make available an environment which enhances the quality of life. There are also economic arguments.[6] The

arts are a labour intensive industry. They contribute to making a country attractive as a tourist destination. The arts help to establish a spirit of creativity, inventiveness and exploration. This stimulates imagination in the development, design and marketing of industrial goods.

Whether or not these reasons are accepted, it is evident that a country without artistic activity would be a dull place indeed. While the arts have an important role to play in national economic life, apologists should not stress cost effectiveness but rather the contribution made to the quality of life. This is surely the strongest argument in favour of state support for the arts. The famous economist, John Maynard Keynes, wrote that between about 1700 and 1939 a new view of the functions of state and society had emerged. This view advanced 'the utilitarian and economic - one might almost say financial - ideal, as the sole, respectable purpose of the community as a whole; the most dreadful heresy, perhaps, which has ever gained the ear of a civilised people'.[7] Keynes instead came out in favour of the use of government powers and public expenditure to preserve areas of scenic beauty and national monuments from exploitation and destruction. He was particularly vigorous in his plea for exchequer funds to foster and support the arts.

Pleas for State funding of the arts in Ireland met with little response in the decades which followed independence. There was a standard joke that the new Dáil deputy arrived in Dublin to find the National Library and the College of Art on his left and the National Museum on his right as he entered Leinster House. Therefore when entering politics in Ireland, he turned his back on art and literature. Irish politicians have not yet fully given the lie to this cynical aspersion on their collective sensibility. But progress has been made towards redemption. This study attempts to catalogue the major successes and failures thus far along the way.

*Count Plunkett*

# CHAPTER TWO

## FALSE STARTS: 1922-32

*Art is not and should not be the privilege of a select few - it is part of the social amenity to which everyone has a right.*
FRENCH EXPERTS' REPORT ON THE DUBLIN METROPOLITAN SCHOOL OF ART, 1927

*The chief difficulty in meeting these needs is the financial one.*
JOHN MARCUS O'SULLIVAN, MINISTER OF EDUCATION, 1929

The Second Dáil Eireann (26 August 1921 to 9 January 1922) considered that there should be a Minister of Fine Arts. It was a non-cabinet post. The appointee, George Noble, Count Plunkett (1851-1948), was eminently suited to the position.[1] He was a distinguished author and antiquarian, Director of the National Museum (1907-16), Vice-President of the Royal Irish Academy (1908-9 and 1911-14) and President of the Royal Society of Antiquaries of Ireland.

The Department of Fine Arts had an office at 37 North Great Georges Street, Dublin. The staff comprised of the Secretary, Labhrás Breathnach, and a messenger boy. The Ministry was to be known by its Irish title, Aireacht na n-Ard Ealaíon. In the nineteen weeks of its existence, the Secretary made arrangements for an appropriate stamp, seal and headed notepaper, and organised one public event.[2] This was the rather lofty Dante Sexcentenary Celebration, a dramatic presentation held at the Mansion House to commemorate the death of the famous Italian poet. Its timing was noteworthy

*Dr Thomas Bodkin*

as Eamon de Valera was later to remind the Dáil.[3] During the performance, amid references to Dante's fictional journey from Hell, through Purgatory and in to Paradise, de Valera was informed that the Treaty had been signed in London.

After the Treaty, the Ministry of Fine Arts was abolished but nobody told the Secretary, Labhrás Breathnach. He wrote to Diarmuid O hEigeartaigh, Secretary to Dáil Eireann: 'Would you kindly let me know if anything has been definitely decided about this Dept. I have not received any official instructions yet as to its termination so I am undecided whether to stay or not'.[4] O hEigeartaigh replied that the Department of Fine Arts had been merged with the Department of Education.[5] It did not re-emerge for another sixty years.

It was noteworthy that the Second Dáil Eireann should have considered it important to make provision for a Ministry of Fine Arts. But the idealism which promoted its establishment was tempered quickly in the face of political and economic realities. The essays of the Young Irelander and patriot, Thomas Davis (1814-45), which had been studied carefully by the revolutionaries of 1916, spoke of the need for the Irish language, for publications in Irish, for a school of art in each major city, and for national subject matter in painting and literature.[6] Although these aims were adopted by the first Irish Government, it was not deemed essential to assist their promotion by retaining a Ministry of Fine Arts.

During its short existence, the Ministry encouraged Thomas Bodkin to submit proposals on 'The Functions of a Ministry of Fine Arts'. Bodkin (1887-1961) was a lawyer, art expert, and Secretary to the Committee of Charitable Donations and Bequests. He later became Director of the National Gallery of Ireland (1927-35), Professor of Fine Arts at the Barber Institute, Birmingham (1935-52), and one of the leading figures in the development of Irish arts policy.[7] In October 1921, Fr Timothy Corcoran, S.J., Professor of Education at University College, Dublin, wrote to Bodkin asking him to forward his views regarding art as part of general education.[8] Bodkin replied with a lengthy memorandum on the subject.[9] Corcoran referred the memorandum to the Minister for Education, J.J. O'Kelly. On 16 January 1922, Bodkin submitted another memorandum to O'Kelly's successor, Michael Hayes.[10] He proposed the restoration of the recently extinguished independent Ministry of Fine Arts.

Bodkin pointed out that: 'No modern Government, so far as I am aware, maintains a Ministry of Fine Arts as a separate entity'. He continued:

The ideal Ministry of Fine Art, though affecting every department of the State, should be a small and inexpensive office. The permanent staff need not be numerous nor highly paid. The work of the Ministry would be largely advisory and consultative, and would be best carried on through independent advisers appointed temporarily for specific purposes and acting, as a rule, in an honorary capacity.

Bodkin envisaged that the Ministry would have liaison officers in all the other ministries who 'should have power to investigate and report on such functions of these other ministries as overlap the province of the Ministry of Art'. He offered as examples, the responsibility of the Department of Finance for the design of coinage, of the Post Office for stamps, pillar boxes and postmen's uniforms, of the Department of Defence for military uniforms, of the Office of Public Works for public buildings and national monuments, of the Department of Trade, Commerce and Industry for industrial design and crafts, and of the Department of Education for art in the schools. He also recommended that: 'The Ministry of Art should have power to recognise with suitable honour, in the name of the State, artists who have achieved great reputation'. It could commission portraits of 'distinguished servants of the State' to decorate official buildings. Finally, Bodkin advised that museums and galleries should be 'carefully and liberally maintained' and 'museums of modern art should not be neglected'.

The Minister of Education replied to Bodkin thanking him sincerely for his valuable memorandum:

Your proposals are excellent and will be of immense assistance to us when this Department is being put on a proper footing. You will understand that at this period of transition, we cannot embark on new schemes no matter how highly we approve of them. YOUR ASSISTANCE WILL NOT BE LOST SIGHT OF WHEN THE PROPER TIME COMES.[11]

Bodkin commented in 1949:

Unfortunately for the prospects of Art, the Senator [Michael Hayes] soon became Speaker of the Dáil. The Civil War broke out. I learned that my memorandum had been adversely criticised by some senior civil servants in the Department of Education and, more particularly, in the Department of Finance...Senator Hayes's successors in the Ministry of Education became preoccupied with other duties than those affecting the Arts.[12]

It is an understatement to say that Bodkin was a little ahead of his time. Although his enthusiasm was admired and his expertise valued, he was offering advanced arts policy proposals to politicians who had neither the resources nor the inclination to implement them. Government files for the early decades of independence reveal that Bodkin was a lone voice in submitting arts policy documents to government departments. He was determined to see the re-establishment of a Ministry of Fine Arts. When the legislation constituting and defining the Ministers and Departments of State was being drafted, Bodkin hoped that his proposal would be included. Horace Plunkett wrote to President W. T. Cosgrave recommending Bodkin as 'eminently suited' to the position of Head of the 'rumoured' Department of Fine Arts.[13] The Department of Finance objected to the specific inclusion of such a Department in the new legislation and argued that it would be possible to establish a Sub-Ministry at a later date if it was thought desirable. The Ministers and Secretaries Act, 1924, assigned most of the State's responsibilities in the arts area to the Department of Education.[14]

The power of the Department of Finance in preventing ambitious and even modest arts projects from winning political support was decisive in most cases. Joseph Brennan, Secretary of the Department, wrote in April 1923 that: 'It is

*William T. Cosgrave*

*Sarah Purser*

necessary to insist on the obvious evil of permitting an avoidable deficit on the working of the ordinary services of government'.[15] He was supported in this view by the Minister for Finance, Ernest Blythe, who told the Dáil in October 1923 that the Government was 'quite convinced that the normal public services must be financed out of revenue'.[16]

The only arts issue which attracted the sustained attention of Irish politicians was the Lane Pictures controversy. The reason was because it had a strong political dimension. In 1908, Sir Hugh Lane (1875-1915), art dealer, collector and Director of the National Gallery of Ireland, had offered 39 paintings from his modern collection to the Dublin municipal authorities provided that a modern art gallery was built to house the paintings.[17] There was little support for Lane's plan. In frustration, he withdrew his offer in 1914 and, instead, bequeathed the paintings to the Trustees of the National Gallery, London. In February 1915, he changed his mind again and in a codicil to his will restored the collection to Dublin. No witnesses signed the codicil and a controversy began following the death of Lane in the Lusitania disaster. The case was simple enough. The paintings belonged legally to the Trustees of the National Gallery, London, but there was a strong moral argument that Lane had intended to leave them to Dublin. The Irish Government took up the case as a high profile example of British injustice.

In 1921 Lady Gregory, who was Lane's aunt, published a book which put forward the case for the return of the paintings to Dublin.[18] On 9 May 1923, the Senate of the Irish Free State passed an unanimous resolution asking the Executive Council to press the British Government for the return of the pictures. On 18 May, a similar resolution was passed by Dáil Eireann. On 14 February 1924, the artist Sarah Purser founded the Society of the Friends of the National Collections at a meeting held in the Royal Irish Academy. The Society's main purpose was to campaign for the return of the Lane Pictures. At the behest of the Irish Government, the British Government established a committee to examine the matter. Its report was published in 1926 and caused a furore. It came to the conclusion that although Lane thought he was making a legal disposition in signing the codicil to his will, the British Government would be acting illegally if it attempted to give an unwitnessed codicil legal effect. This reasoning aroused the ire of Lane supporters everywhere. There seemed little the Irish Government could do but wait until the air had cleared to allow a fresh attempt to win back the pictures.

The 1920s saw a limited number of arts initiatives by the Government. There were censorship laws, commissioned reports and some new institutions. The first official recognition of the arts came with the establishment of the

Garda Síochana Military Band in 1922. Its first Director of Music was Superintendent D.J. Delaney. The following year, a German, Fritz Brase, was appointed to the Directorship of the new Irish Army School of Music, with the rank of Colonel. The first recital of the Army No. 1 Band took place in October 1923.[19] The revival of the Tailteann Games gave the military bands an opportunity to join in the grand opening ceremony at Croke Park on 2 August 1924. In 1926 the Executive Council, on the recommendation of President Cosgrave, approved an official national anthem, *Amhrán na bhFiann* ('The Soldiers' Song', written in 1907 by Peadar Kearney with music by Patrick Heeney).

The Government's major arts initiative during the 1920s was the decision to give a grant-in-aid to the Abbey Theatre. It thus became the first state-subsidised theatre in the English speaking world. The Abbey directors were W.B. Yeats, Lady Gregory and Lennox Robinson. They offered the theatre to the Government in June 1924 in the hope that its future would be secured through public subsidy. President Cosgrave claimed that he had never been inside the Abbey[20] and passed the matter to the Minister for Finance, Ernest Blythe 'who had always been a man of the theatre'.[21] Blythe was keen to give official acknowledgement to the achievement of the Irish literary revival movement. He decided that it was easier to offer a grant to the Directors than to compel the Government to run the theatre. In the budget of 1925, a grant of £800 was announced. The Government stipulated one condition - that a Catholic should be invited to join the Abbey Board of Directors. Blythe (the only Protestant member of the Government) chose George O'Brien (Professor of National Economics, and later of Political Economy at University College, Dublin, from 1926 to 1961) who wrote of his appointment: 'I possessed no obvious qualifications, beyond being a Catholic which was apparently considered desirable. I imagine that the Board agreed to my name to avoid having somebody worse imposed on them'.[22] It was not clear if O'Brien was meant to guard against wasteful spending of the grant or to ensure the propriety of the plays selected for performance. Whatever the reason, the Government never introduced a censorship law against offensive theatrical productions. There was no need to do so because the theatre-going public let its verdict be known in demonstrative fashion as in the case of the riotous disturbances provoked by the production of the Seán O'Casey's *The Plough and the Stars* in 1926.

In contrast to the Abbey which presented plays mainly by Irish writers, the Gate Theatre, founded in 1928 by Micheál MacLiammóir and Hilton Edwards, laid its emphasis on the presentation of international drama which

*Hilton Edwards*                    *Micheál MacLiammóir*

was experimental in form. Added to this, the Gate's adventurous lighting, production and stage design techniques, provided a vital antidote to the Abbey's more conservative presentation.[23] The Gate Theatre established a loyal following quickly. In 1930 Edwards and MacLiammóir leased the Concert Rooms at the Rotunda Buildings at the Parnell Square end of O'Connell Street, Dublin. They did not receive assistance from the Government and had to struggle constantly to remain solvent. Edwards and MacLiammóir were remarkable individuals. They confronted the Irish public with the art of the theatre and thereby helped to educate their audiences towards an acceptance of support for the arts generally. They were dedicated, enthusiastic and vigorous in their efforts to, in MacLiammóir's words, 'set a faintly fluttering heart a-beat once more in Ireland's body'.[24] Like many other artists who chose to live out their careers in Ireland, Edwards and MacLiammóir had many disappointments and failures. But they relished the challenge involved in attempting to succeed in a relatively hostile environment. Artistic freedom was not yet a feature of Irish life and there were censorship laws to prove it.

Although there was no censorship law regarding theatre in Ireland, such was not the case in relation to films and literature.[25] In 1923 the Censorship of Films Act established the position of Film Censor to examine the films offered for commercial distribution in Ireland. In 1929 the Censorship of Publications Act empowered the Minister for Justice to prohibit the sale of books judged to be offensive or indecent by the Censorship of Publications Board established for the purpose of vetting them. These laws, though typical of many countries in the 1920s, were implemented with a zeal which gradually alienated many Irish artists and writers and led to them leaving the country or remaining as embittered rebels. The laws were retained in Ireland long after the social climate had become intolerant of them.

Those who supported the censorship laws believed, for the most part, that they were necessary to protect the country from the rising tide of materialism, consumerism and immorality. Catholicism, the declared religion of 93% of the population, was the fundamental credo behind the censorship laws. Fr P.J. Gannon, S.J., praised the censorship laws and found it difficult to understand why writers should protest against them. The laws were but 'a simple measure of moral hygiene, forced upon the Irish public by a veritable spate of filth never surpassed'. Fr Gannon wrote:

> Art and literature are delightful things, treasures beyond price, so far and so long as they fulfil their lofty function of rejoicing, refreshing, elevating the soul of man and affording it noble ground for noble emotion...But they are not treasures - indeed I venture to say they are not art or literature at all - if they fail to do this.[26]

The majority of Irish writers rejected the use of this reasoning to censor literary work. Seán O Faoláin, perhaps the most vociferous critic of the censorship laws, wrote: 'Our Censorship...tries to keep the mind in a state of perpetual adolescence in the midst of all the influences that must, in spite of it, pour in from the adult world'.[27] The censorship laws made Ireland a difficult home for writers. The author Mervyn Wall explained that during the 1930s there was:

> a general intolerant attitude to writing, painting and sculpture. These were thought dangerous, likely to corrupt faith and morals...One encountered frequently among ordinary people bitter hostility to writers...Obscurantism had settled on the country like a fog, so of course anyone who had eyes to see and the heart to feel, was rebellious.[28]

Mervyn Wall considered that the Government was attempting the impossible

in trying to insulate Ireland from 'offensive' literature. But in the 1920s the Government was not daunted by difficult tasks. It had set itself the target of bringing the Irish language into general usage as an everyday medium of speech throughout the country. A phenomenal effort was made to realise the aspiration. Despite this, the language policy was a failure. The 1937 Constitution provided that the first national language was Irish but any honest observer knew that it was in name only. By 1951, it was estimated that 35,000 people used Irish as their ordinary medium of speech.[29] This was probably an under-estimate but equally the 1946 census exaggerated in giving the figure as 589,000 (21% of the population).[30] The economic value of the English language as a passport to other countries and the failure to give Irish language classes to adults as well as children were some of the reasons why the policy failed. It certainly was not for want of financial assistance to Irish language projects. There was considerable state support for the publication of literature and the performance of drama in the Irish language.

In 1928 Ernest Blythe agreed to the payment of a grant by the Department of Education to *An Taibhdhearc,* the Irish language theatre in Galway founded by Micheál MacLiammóir.[31] Blythe was also the main force behind the

*Ernest Blythe*

Government decision to promote the publication of literature in the Irish language. It was obvious to him that the State could not expect private publishers to take on the risk of producing an adequate range and supply of Irish language publications. In 1926 the Government decided that a Publications Branch would be established within the Department of Education. It became known as *An Gúm* (the scheme or plan). At first the Department of Finance confined the publishing programme to the provision of suitable text-books in Irish for Secondary Schools. In July 1928 the scheme was expanded to include the publication of general literature in Irish and of traditional Irish music. The recruitment of full-time staff did not begin until 1930 but by 1934 the staff numbered 34. The Department of Education provided the editorial, proof-reading and translation service and the printing, sale and distribution of the publications were the responsibility of the Stationery Office.

In 1893 Douglas Hyde wrote that there were six Irish language books in print. Between 1926 and 1964, *An Gúm* produced 1,465 publications (1,108 general literary works, 230 pieces of music and 127 text-books). The total cost of *An Gúm* in these years was £1,404,000, an average of £36,947 per year, or £958 per publication.[32] *An Gúm* established high standards of printing, lay-out, illustration and jacket design. The use of the gentle, rounded forms of Gaelic script helped to develop an identifiable native form of typography. But gradually there was a change to Roman lettering and to the standardisation of Irish grammar and spelling. Finally in 1958, an official standard form of Irish, *An Caighdeán Oifigiúil,* was published. A result of this change was that people who learned to read Irish after 1958 had difficulty in reading books in Irish published prior to that date. By the 1960s the publications of *An Gúm,* like the Irish language itself, had become part of the heritage which could not be dispensed with, but about which nobody knew quite what to do.

This was a far cry from the hopes of Douglas Hyde when he launched the Irish broadcasting service, Radio 2RN, on 1 January 1926.[33] He exhorted his listeners:

> The young and old should know that Eire is standing on her own two feet; the Irish language being one and her culture, music and sport being the other...It is a sign to the world that times have changed when we can take our own place amongst the nations and use the wireless in our own language.[34]

Radio was to be an important purveyor of state culture and a key element in developing attitudes to the arts. In its first decades, Irish radio was not

adventurously artistic but offered listeners a staple diet of concerts, lectures, interviews and plays. Its foremost contribution was in the promotion of music. The Radio Orchestra began with four members in 1926 and by 1948 numbered 62.[35]

The visual arts received meagre state support compared to music. One of the few important commissions awarded to a visual artist by a state-sponsored body was that given to Seán Keating to produce a series of works illustrating the progress of the Electricity Supply Board's Shannon Hydro-Electric Scheme. The Shannon Scheme was the brainchild of Dr Thomas McLoughlin and it is likely that he organised the commission.[36] Keating was very much the adopted artist of the Irish Free State. Following the recommendation of Thomas Davis, his work was consciously national in intent and powerful in its images. With painters like Charles Lamb, Patrick Tuohy and Paul Henry, Keating helped to create, in visual terms, 'a corporate identity' for independent Ireland.[37] He was fearless in speaking his mind, a trait which won him deep respect but also some enemies. In 1925 he prepared a memorandum on the Dublin Metropolitan School of Art at the request of the Secretary of the Department of Education, Joseph O'Neill. Keating reported bluntly:

> The Dublin Metropolitan School of Art has been for at least six years in a state of inertia. There are several reasons for its rapid decay, but the root of the trouble is in the system itself and nothing but a complete readjustment will make any permanent improvement. This readjustment need not involve any more expenditure. The money granted is adequate but hopelessly misapplied.[38]

The Department of Education submitted a memorandum to the Government proposing the establishment of a Committee of Experts with the following detailed terms of reference:

> to investigate the working of the Metropolitan School of Art and to report to the Minister of Education and to the Commission on Technical Education whether any, and if so, what reforms are necessary in the organisation and work of the school to enable it to ensure most effectively (a) the improvement of craftsmanship and design as applied to industries, (b) the training of Art Teachers, (c) the giving of a cultural education through the instruction of students in the fine arts, and (d) the giving of a Professional Training in the fine arts.
>
> to examine and report upon the provision for the teaching of Art in the other Art Schools and the Technical Schools and Secondary Schools under the Department of Education, the proper co-ordination of the

*Seán Keating*

teaching in these institutions with the work of the Metropolitan School of Art and its application generally to the work of industrial development.[39]

It was recommended that the enquiry should be conducted by experts from some European country 'which excels in the teaching of Art and the application of Art to Industry'. The Government approved the proposal on 4 October 1926.[40] The following April the appointment of three French experts was approved.[41] Mr Dermod O'Brien, President of the Royal Hibernian Academy, and the ubiquitous Thomas Bodkin were also asked to submit their views.

Before the Committee of Experts had delivered its report, the Department of Education sought Government approval to the establishment of a similar enquiry 'to investigate thoroughly the question of the purposes to which the National Museum can be put, the needs of the Museum if it fulfils these purposes, and the re-organisation, if any, which may be necessary in order to enable it to do so'.[42] For this enquiry, it was suggested that five experts should be appointed, four Irish (including Bodkin) and one Swede, Professor Nils Lithberg, Director of the Northern Museum in Stockholm, which had recently carried out a re-organisation of its activities. The Government agreed to the proposal on 31 March 1927.[43]

The report on the School of Art was submitted by the three French experts in June 1927.[44] As might have been expected, given their comprehensive terms of reference, the report was an important statement of general principles on the State's role in promoting the arts. The experts declared that: 'It is an all-important duty for a people to create a tradition of Art and of Crafts; the reason for reviving it is all the stronger when, in the case of Ireland, it existed in the past'. Art was a democratic right:

> Art is not and should not be the privilege of a select few - it is part of the social amenity to which everyone has a right. The awakening of the artistic conscience of a nation and the nourishing of that sacred fire strengthen her solidarity in a common ideal and in the defence of an intellectual patrimony. Industries may be provided with an arm in the commercial struggle by bestowing on their products a special stamp which makes them more sought after owing to technical perfection or originality.

The experts stressed the need for the arts as an integral part of the school child's experience. One of the first policy decisions of the Department of Education in 1922 had been the removal of drawing from the obligatory to

the optional list of subjects in the primary curriculum. The subject was also awarded only half the marks given for compulsory subjects like mathematics and languages. The experts proposed numerous measures to remedy this situation and also regarding the system of education in the Dublin Metropolitan School of Art.[45] Dermod O'Brien and Thomas Bodkin endorsed the assessment of the French experts.[46]

The Department of Education received the report and, as Seán Keating later put it: 'The whole matter was then dropped'.[47] He remained a part-time teacher at the School of Art on a salary of £100 per year and continued to press for reform 'to revitalise the obsolete, non-national, non-Gaelic and non-productive machine'.[48]

The Department of Education also found the report received in December 1927 from the Committee of Enquiry on the National Museum uncomfortably forthright. A small number of its recommendations were approved by the Government and then it was 'quietly shelved'.[49]

The only foreign expert on the Committee, Professor Lithberg, had been recruited to offer his advice on museum reorganisation. His report suggested a staff restructuring process at the National Museum and many changes in the presentation of exhibits. He proposed that the Museum should be based on two principles: 'the knowledge of Ireland's earlier culture and of the present day life of the people'. He advanced three main divisions for the Museum - the Antiquities Section, the Section for Folk Culture and the Applied Art Section. There would be three Keepers and twelve Assistants, all working to a Senior Keeper and he under an independent Board. Each division would have its own archive and library. He thought that registers should be better organised and photographic services should be provided. The Museum should have a lecture hall, an educational service, illustrated publications, and a central library of relevant periodical literature.[50]

The Irish experts considered that 'the policy of the Museum should be to illustrate the growth of civilisation in Ireland and from Ireland outwards'. Given the overcrowded presentation of exhibits, they recommended 'to the immediate consideration of the Government the necessity for more extensive alterations and additions'. Other proposals were for legislation to prevent the destruction or removal of national monuments, the provision of electric lighting in the Museum, the establishment of local museums, the extension of opening times to the evening hours, and the formation of an Advisory Board 'constituted much as is the existing Board of Visitors but with definite status, functions and powers'.[51]

Thomas Bodkin, in a note appended to the report, objected to the establishment of local museums. His reasoning was simple. If a local authority found itself unable to fund its museum 'any Government which refused to relieve such a situation would either incur serious odium or be driven to deplete the resources which should be available for the purpose of the National Museum'. Equally, when local people found objects of national importance, they would most likely bring them to their local museum. It might prove 'most difficult to persuade or to coerce local authorities to surrender such objects even if the true interests of scholarship called for their inclusion in the National Collection'.[52]

The Minister for Education, John Marcus O'Sullivan, responded to the Report on the National Museum by submitting a memorandum to the Government in July 1928.[53] The Department of Finance objected vigorously to the expenditure implications of the Report and, as a result, the three recommendations put forward to government for approval involved no cost to the Exchequer.[54] First, the Government was asked to agree:

> that the main purposes of the National Museum of Ireland should be to accumulate, preserve, study and display such objects as may serve to increase and diffuse the knowledge of Irish civilisation, of the Natural History of Ireland and of the relations of Ireland in these respects with other countries.

Second, it was proposed that plaster casts, copies and replicas of which the original was not in Ireland 'should be removed from the Museum and transferred on loan to Educational Institutions in the Saorstát'. Third, the Museum collection of engravings and water colour drawings should be transferred to the National Gallery and, in exchange, the Gallery should transfer its collection of topographical prints and maps to the Museum.

This was a weak-kneed response to the Committee of Enquiry's Report but at least it was more attention than was given to the Report of the Committee on the School of Art. Although the Government approved the Minister for Education's recommendations, there was widespread disenchantment among those interested in the arts at the casual treatment which the Reports had received. It had been hoped that President Cosgrave would authorise the publication of the Reports, thus provoking some public debate. A number of opposition deputies tried to harass the Minister for Education on the matter.[55] Finally in November 1929, the Minister declared his opinion that the needs of the National Museum could not be accommodated: 'The chief difficulty in satisfying these needs is the financial one, and all proposals or applications for

increases in expenditure of this nature must be considered in the light of the State's financial position'.[56] This reply put a stop to any further questions: there was no point in asking them.

It was of course true that the arts were the least of the Government's concerns. They seemed a luxury which the country could not afford. The first census of population following independence revealed that the average size of dwelling had three rooms. Although overcrowding (that is more than two persons to a room) was severe in certain rural areas, it was not giving rise to high death rates. In the towns however, overcrowding and high death rates were typical. In Dublin City, 28.7% of the population lived in one room dwellings and a further 22.3% in two room dwellings.[57] Given these statistics, the arts were justifiably low on the priority list and the reluctance to spend limited finances on institutions like the National Museum becomes more understandable.

One positive result of the Report on the National Museum was that it prompted the drafting of the National Monuments Bill which was passed by the Oireachtas in 1930. The Act established the protection of national monuments under law and introduced fines against those who damaged or interfered with them. A National Monuments Advisory Council was empowered to advise and assist the Commissioners of Public Works on matters affecting national monuments. Bodkin's view on the primacy of the National Museum was accommodated by a provision which obliged anyone discovering a potential national monument to report it to a member of the Garda Síochana or to the Keeper of Irish Antiquities at the National Museum.

Thomas Bodkin was aware that the arts were not a priority for the Government. Yet despite his lack of success in promoting the establishment of a Ministry of Fine Arts, he never gave up trying to achieve it. He was friendly with President Cosgrave and was a supporter of the Cumann na nGaedheal party.[58] Bodkin drafted Cosgrave's speeches for the opening of exhibitions of recent acquisitions by the National Gallery and also speeches about the Lane Pictures. But he found it impossible to persuade Cosgrave to establish a Ministry of Fine Arts. In 1929 he tried to influence the President circuitously by fostering the interest of other members of the Government. He sent an up-dated version of his memorandum written in 1922 about 'The Functions of a Ministry of Fine Arts' to Patrick McGilligan (Minister for External Affairs and Industry and Commerce), Patrick Hogan (Minister for Agriculture) and Ernest Blythe (Minister for Finance).[59]

McGilligan was impressed by Bodkin's ideas and wrote to Cosgrave:

I was very much struck, both by what he says as to the present disorganisation and also by his proposals to co-ordinate the existing institutions under an existing Department. I had intended, once or twice, to raise the matter at Executive Council meetings, but hesitated to do so as it was hardly for me to bring forward an item which, when discussed, might seem to reflect in some way on the administration by another Minister of certain parts of his Departmental work. However, I did not like to let the memorandum simply remain where it is and I suggest to you that you might, as controlling the whole Ministry, get some enquiry into the matters dealt with by Mr Bodkin and see if it would not be wise to seize the opportunity, which now presents itself, for a thorough overhauling of all the matters to which the memo refers.[60]

Cosgrave organised a preliminary meeting to discuss the matter on 15 December 1929, which he attended with McGilligan, Blythe and John Marcus O'Sullivan (Minister for Education). The outcome was a request to the Department of Education to provide observations on Bodkin's proposals. The Department's response paid little attention to the recommendations affecting its own remit - the arts in education - and concluded: 'Of the many issues raised the most important is probably that of improving the position of certain industries by establishing a closer relationship between them and up-to-date instruction in design'.[61]

Bodkin was delighted that his ideas were at last receiving some attention. It would appear that he allowed his enthusiasm to get the better of him. On 18 December 1929, he delivered a lecture at Rathmines about 'The Importance of Art to Ireland'. In his lecture script, Bodkin was careful not to criticise the Government. He was mindful of the constraints imposed on him by his position as Director of the National Gallery. During an informal question and answer session following the lecture, Bodkin said that all was not well at the National Museum and at the National College of Art. He hinted his dissatisfaction with the Government's reaction to the commissioned reports on the two institutions. When the national newspapers reported Bodkin's lecture the following day, they concentrated on his informal remarks.[62] The Minister for Education was furious. Bodkin apologised but pleaded that the newspapers had exaggerated.[63] Although he was correct, the damage had been done. President Cosgrave called no more meetings to discuss Bodkin's memorandum about 'The Functions of a Ministry of Fine Arts'. In a vain attempt to restore confidence, Bodkin submitted a supplementary memorandum in February 1930 and asked Cosgrave how the deliberations on his ideas were progressing.[64] Cosgrave apologised for the delay and offered the excuse that 'pressure of work on other matters' had precluded a further meeting with his

Government colleagues.[65]

A year passed before Bodkin raised the subject again with Cosgrave.[66] He wrote with thinly-veiled impatience:

> I presume it has not been found possible, owing to the exigencies of public business, to take any steps towards implementing that memorandum; yet every day seems to me to show the desirability of setting up some organisation, in the interests not only of the cultural but of the industrial activities of the State. The situation of all the artistic institutions of the country remains practically as it was when I first approached Mr Hayes, as Minister for Education in 1922. They are all stagnant and out-of-date. There is no co-relation between them. There is no sound plan for the training or recruitment of the necessary staffs. All our national industries from boot-making to bottle-making, stand in urgent need of good designers.

Bodkin thought that his proposals had been resisted on the basis that the electorate had not raised them with their politicians:

> I know that the Minister for Education [O'Sullivan] is not very sympathetic to my views, and holds that there is little need or demand for most of the reforms which I advocate. I admit that there does not seem to be much demand for them at present among the general public, but at the same time I feel very strongly that it would be possible to awake easily a real and deep interest throughout the country in such matters.

Cosgrave's reaction was to commission Bodkin to write a history of the only arts issue which had a public profile - the Lane Pictures controversy. Bodkin's work, *Hugh Lane and his pictures,* was published in Paris in de-luxe volume format by the Pegasus Press.[67] It was presented to Heads of State, diplomats and dignatories, to win support for Ireland's claim to the Lane Pictures. In the preface to the volume, Cosgrave wrote: 'The Executive Council issue this book as an outline of Ireland's case, in the confident hope that it will be found irresistible on equitable grounds'.

Bodkin tried to use his influence with President Cosgrave to gain support for the National Gallery of Ireland. He encouraged the Board of Governors and Guardians of the Gallery to point out their needs to the Government. The Board duly submitted a report to President Cosgrave.[68] The report was forwarded to the Department of Finance for its informal views. In a preliminary examination of the report, H.P. Boland, Assistant Secretary in the Department, concluded that there was no real ground for any changes at the Gallery. He wrote:

Even however, if there were a change which seemed to show grounds for the proposals, the grounds would need to be very strong in face of the pressure being placed on all Departments to effect economies on existing expenditure - even by the suspension of existing services. The proposal here is largely to create new services and fresh expenditure.[69]

Boland was dismissive of the suggestion that Bodkin's salary as Director should be increased. He considered that perhaps Bodkin was being over-paid already: 'The fact that Dr Bodkin is so well-fitted to be Director makes his work all the more an entertainment'. There was no reason to consider the need for 'An Assistant with Technical Knowledge' because 'this would be a new post'. There would be no extra money for the provision of lectures because 'Such lectures if given must take place during normal hours...Lectures by the Director requiring no time in preparation should, one would think, be a part of his ordinary duty'.

President Cosgrave met a deputation from the Gallery Board in December 1931 and advised them to consider: 'whether it would not be wiser to withdraw the present request rather than that it should be forwarded formally to the Ministry of Finance, where it would most certainly "get the knock"'.[70] The Gallery Board took the President's advice and withdrew their proposals.

In 1932 ten years of government by Cumann na nGaedheal came to an end with the election to office of the Fianna Fáil party led by Eamon de Valera. For the next sixteen years, Fianna Fáil won successive general elections. Before the change-over, the *Saorstát Eireann Official Handbook* was published as a record of Cumann na nGaedheal's years in government. It was an honest enough account of the Government's successes and failures. De Valera called it: 'a valuable book in many respects. It was very well produced. It was, in fact, a splendid specimen of Irish printing and Irish production'.[71] The *Official Handbook* was the work of a committee appointed by the Minister for Industry and Commerce, Patrick McGilligan. Its editor was Bulmer Hobson who wrote that much had been achieved in the first decade of native government:

> This work so recently begun will require many years of effort before the effects of past repression and neglect are eradicated. But the progress during the first ten years has been constant, and already the results are evident in improving conditions and accelerating development'.[72]

The Celtic style cover of the *Official Handbook* was designed by Art O'Murnaghan and the illustrations included works by Seán Keating, Paul

Henry, Harry Kernoff, Seán O'Sullivan, Maurice MacGonigal and Estella Solomons. Many of the chapters concerned the cultural life of Ireland. There were articles on Cultural Agencies, Education, Libraries, Archaeology, Early Christian Art in Ireland, Modern Irish Art, Irish Architecture, the Irish Language and the Linguistic Struggle, Folklore, Irish Literature, Anglo-Irish Literature, and Irish Folk Music.

Inevitably, the article about Modern Irish Art was written by Thomas Bodkin. He emphasised the need for the application of art to industry. This subject had, he knew, attracted official interest but no action. Bodkin complained that modern Irish manufactures 'though excellent from a technical standpoint are for the most part, mediocre in design'.[73] There were a few honourable exceptions, Cuala Industries, The Three Candles Press (managed by Colm O Lochlainn), The Dún Emer Guild (carpet manufacturers) and Sarah Purser's *An Túr Gloine* (stained glass studio).

Bodkin used the opportunity afforded him to stress his belief that the only way to improve matters was to encourage the teaching of art in the schools and universities. He considered that the Schools of Art in Dublin, Cork and Galway, were 'well-equipped' but they suffered 'from a lack of public encouragement'. Students entering the Schools of Art lacked preliminary training because drawing was 'not yet systematically taught in many Irish schools'. Similarly, he continued: 'Neither of the two Universities in the Irish Free State [The National University of Ireland and Dublin University (Trinity College)] has fully awakened to the necessity of devoting serious attention to the study of art or aesthetics'. Adopting the official excuse which had so often been used to put down his own ideas, Bodkin pleaded:

> We have had so many vital problems to deal with in the last few years that we may well be excused for having allowed the problem of art to bide awhile; and the government can claim that public opinion has hitherto been turned towards what are too often supposed to be more urgent realities.[74]

He concluded optimistically however:

> We are now, at last, ready to deal with the situation; and it is not an idle dream to hope...that this nation, once so distinguished in the practice of the arts, will recreate a national art of its own, not based on out-worn styles and lost endeavours, but reflecting the energetic aspirations and enthusiasms of a reborn race.[75]

In February 1933 Bodkin sent his proposals for a Ministry of Fine Arts to the new President of the Executive Council, Eamon de Valera. The President's Secretary, Seán Moynihan, replied that the matter had been passed to the Minister for Education as it was proper to him in the first instance. Although this was a standard official procedure, it convinced Bodkin that de Valera had no time for the arts. Their correspondence always remained official, formal but courteous.[76] A new era had begun and Bodkin was out of sympathy with it.

*Eamon de Valera*

# CHAPTER THREE

## PRIVATE INITIATIVES AND OFFICIAL PIPEDREAMS: 1932-9

*Sooner or later the Irish Government will be faced by a dead wall. They will discover they are building a house without windows.*

<div align="right">JAMES DEVANE</div>

De Valera's long tenure as an Irish political leader makes it imperative that his attitude to the arts be considered closely. Edward MacLysaght thought that de Valera 'almost alone of leading public men in Ireland at the time, was not only sympathetic but positively helpful in promoting cultural endeavours'.[1] In contrast, Mervyn Wall, while acknowledging that de Valera had 'many virtues', has said:

> The regrettable thing was that he hadn't the slightest understanding of, or interest in, the arts. He didn't think them important. I remember a public statement of his in which he said that he couldn't see any reason for playing the work of foreign composers in Ireland, as we already had our own beautiful Irish music. When he was in his fifties, he visited the Abbey theatre to see a play about Saint Francis of Assisi, remarking rather innocently that he had never been in the Abbey Theatre before, a truly remarkable admission.[2]

De Valera's admission was not so remarkable - Cosgrave had admitted in 1924

that he had never been to the Abbey. But how can these two opposing views of de Valera be reconciled?

De Valera certainly viewed the fine arts as a luxury which the country could not afford. In 1928 he said that the country:

> had to make the sort of choice that might be open, for instance, to a servant in a big mansion. If the servant was displeased with the kicks of the young master and wanted to have his freedom, he had to make up his mind whether or not he was going to have that freedom and give up the luxuries of a certain kind which were not available to him by being in that mansion...If he goes into the cottage, he has to make up his mind to put up with the frugal fare of that cottage. As far as I am concerned, if I had that choice to make, I would make it willingly. I would say, 'We are prepared to get out of the mansion, to live our lives in our own way, and to live in that frugal manner'.[3]

De Valera did not envisage that Irish families should forever be confined to frugal lives in little cottages. In 1932, he told the Dáil: 'If there are hair-shirts at all, it will be hair-shirts all round. Ultimately I hope the day will come when the hair-shirt will give way to the silk shirt all round'.[4]

It is obvious that de Valera would have included the fine arts among 'the luxuries of a certain kind' which had been part of life in the mansion of Anglo-Ireland. The fine arts had been the preserve of the landed gentry for centuries. Orchestral concerts, dance galas and opera were the fashionable recreations of the wealthy ruling class. Fine paintings were seen only on the walls of rooms in the 'big houses'. Therefore it was believed that the fine arts were not part of native Irish tradition. De Valera knew that it was politically viable to support what were perceived to be native art forms, political dynamite to fund 'non-national' art. The government had to proceed cautiously. It would be some time before the Irish people would regard the fine arts as legitimate recipients of government funds.

De Valera believed in an Irish culture comprised of native sports, music, dancing, story-telling, folklore and literature. He would take time to assist cultural endeavour if it was in spirit with his religious and nationalist beliefs. In the task of nation-building, de Valera saw it as essential to promote activities which were rooted in the traditions of the majority of the Irish people. This attitude led to praise from those, like MacLysaght, who emphasised the need for an Irish culture. For others, like Wall, such an introverted attitude was equated with philistinism.

De Valera put political before artistic considerations as Dr George Furlong (Director of the National Gallery of Ireland, 1935-50) found out to his dismay:

De Valera never came to visit the National Gallery. The only time he requested advice from me was in connection with his Christmas card which was sent to foreign Heads of State. In 1936 I proposed that a new design should be used instead of the stock designs like the Rock of Cashel. I suggested a 'Greetings from Ireland' card with the heraldic shields of the four provinces. Dev's initial reaction was favourable. He thought it looked well but after some discussion he asked me what was the origin of the heraldic designs. I told him they were probably of Norman origin. He immediately cooled on the idea and a stock design was used again that year. I was surprised when the next year, he called me to see him. He asked me did I remember the design I had proposed with the heraldic shields. He thought it would be very appropriate for 1937. The new Constitution had laid claim to the four green fields.[5]

In a speech to open Radio Eireann's Athlone station in 1933, de Valera offered a precis of the achievements of Irish culture.[6] The speech was no doubt prepared for de Valera but it offered a public declaration of what was considered by officialdom to be significant in Irish cultural history. De Valera praised, first and foremost, the Irish language which was 'one of the oldest and, from the point of view of the philologist, one of the most interesting in Europe'. Next, he referred to 'the tradition of Irish learning' which had been preserved by the monastic and bardic schools; the contributions of Irish ecclesiastics in Louvain, Rome, Salamanca, Paris and elsewhere, the schools of poetry and the hedge schools in the eighteenth century. Despite the Penal Laws, Irish poetry, language and song had flourished. They had provided the roots of modern Irish culture.

De Valera paid a half-tribute to Anglo-Irish literature which 'though far less characteristic of the nation than that produced in the Irish language includes much that is of lasting worth'. He singled out Dean Swift, 'perhaps the greatest satirist in the English language', 'Edmund Burke probably the greatest writer on politics', William Carleton 'a novelist of the first rank', Oliver Goldsmith 'a poet of rare merit', Henry Grattan 'one of the most eloquent orators of his time', and Theobald Wolfe Tone who 'left us one of the most delightful autobiographies in literature'. He added: 'Several recent or still living Irish novelists and poets have produced work which is likely to stand the test of time'. It is significant that de Valera did not venture to name any of these writers.

Turning to drama, de Valera said: 'The Irish theatre movement has given us the finest school of acting of the present day and some plays of high quality'. 'Ireland's music', he continued, 'is of singular beauty...It is characterised by perfection of form and variety of melodic content...Equal in rhythmic variety

are our dance tunes - spirited and energetic, in keeping with the temperament of our people'.

The speech then progressed to even more sweeping generalities about Ireland's mission in the world:

> The Irish genius has always stressed spiritual and intellectual rather than material values. That is the characteristic that fits the Irish people in a special manner for the task, now a vital one, of helping to save Western civilisation. The great material progress of recent times, coming in a world where false philosophies already reigned, has distorted men's sense of proportion; the material has usurped the sovereignty that is the right of the spiritual.

De Valera concluded with an oblique reference to the censorship laws:

> You sometimes hear Ireland charged with a narrow and intolerant nationalism, but Ireland today has no dearer hope than this: that, true to her own holiest traditions, she may humbly serve the truth and help by truth to save the world.

Such was de Valera's remarkable idealism. Translated into practical politics, it meant that the arts were to be encouraged when they observed the 'holiest traditions'. It was quite proper that they should be censored when they failed to live up to this ideal. As for state involvement in the arts, de Valera believed that: 'It is much better to proceed quietly and to try to get results by stimulating the endeavour of private individuals and organisations'.[7] He was anxious to encourage the cultural life of the nation but reluctant to involve or add to the machinery of the state. He generally supported the arts initiatives of his colleagues in government but he preferred when their suggestions made no call on public funds. It is fair to say that de Valera considered the arts to be desirable but he had little personal interest in them.

Much of the work of promoting the arts in Ireland during the 1930s was done by the Catholic Church. Although Catholic pronouncements warned against ignoble art, they supported those who promoted art which was judged to be spiritually enriching. Pope Pius XI advised in *Vigilanti Cura:*

> Recreation, in its manifold varieties, has become a necessity for people who work under the fatiguing conditions of modern industry, but it must be worthy of the rational nature of man and, therefore, must be morally healthy. It must be elevated to the rank of a positive factor for good and must seek to arouse noble sentiments. A people who, in time of repose, give themselves to recreations which violate decency, honour,

or morality, to recreations which, especially to the young, constitute occasions of sin, are in grave danger of losing their greatness and even their national power.[8]

The major celebrations of the Irish Free State centred around religious events. To mark the centenary of Catholic Emancipation, 1929 was declared a Year of National Celebration in Ireland. A 129-member committee organised a week-long programme culminating in Pontifical High Mass and a Solemn Eucharistic Procession at the Phoenix Park, Dublin, on Sunday 23 June.[9] The experience of 1929 was invaluable when in 1932, the 31st International Eucharistic Congress was held in Dublin during the week 22-26 June. On the last day of the Congress, an estimated one million people attended Pontifical High Mass at the Phoenix Park.[10]

These events provided a focus around which various artistic activities were organised by the clergy, religious orders, lay organisations and individuals. Fr E.J. Cullen, Principal of St Patrick's Training College, Drumcondra, told a meeting of the Academy of Christian Art:

> It is the Church that offers opportunities for architectural genius to display itself, it is also the Church that offers the greatest sphere for just and proper decoration. And as the Church is the object that most people see, and see often, where the Fine Arts are called in, as they have always been, to good advantage in the building and embellishment of a church, the edifice, besides discharging its sacred and proper mission, becomes unconsciously a source of education and art culture for the people that frequent it'.[11]

The activities of groups like the Academy of Christian Art led to a steady improvement in the quality of Irish stained glass and church fittings.[12] Indeed Irish stained glass artists were commissioned to provide works for churches in all Continents.

One Catholic priest merits particular mention for his encouragement of the arts - Fr Senan Moynihan, O.F.M. Cap., the founder editor of *The Capuchin Annual*, the first edition of which was published in 1930.[13] It was a remarkable publication which reached a circulation of 25,000 per volume including a wide readership in the United States of America and Canada. Fr Senan crafted *The Capuchin Annual* into a finely tuned expression of Irish nationalism. His editorial office was situated above Lemass Drapers in Capel Street and became a regular meeting place for artists and writers. Fr Senan and Seán Lemass were good friends. De Valera also supported *The Capuchin Annual* and appreciated Fr Senan's clear allegiance to Fianna Fáil.

*Fr Senan Moynihan, O. F. M., Cap.*

*The Capuchin Annual* helped to develop its readers' sense of art appreciation. Fr Senan was naturally gifted as a page-setter so the publication looked well. Its content spread knowledge of and heightened awareness of Irish painting, sculpture, music, poetry and literature. Its success demonstrated that high standards were appreciated. To be the subject of a series of tributes in *The Capuchin Annual* was to enter the pantheon of acclaimed Irish artists.[14] Fr Senan provided direct assistance to artists by purchasing the works of Irish painters and sculptors for a special *Capuchin Annual* collection which was exhibited from time to time. With Thomas McGreevy, he championed the work of Jack B. Yeats and helped to promote it in Ireland and abroad. The abstract paintings of Yeats's later career were important in winning acceptance by the Irish public of the need to look beyond subject matter to the appreciation of colour, style and technique.

Art appreciation was also stimulated by the private initiatives behind the so-called Haverty Trust Exhibitions and the Purser-Griffith Lectures in the History of Art. Thomas Haverty was a Dublin artist, son of the portrait painter, Joseph P. Haverty, R.H.A.. During his life, Thomas Haverty saved whatever money he could in order to establish a trust fund on his death which would be used to purchase paintings by living Irish artists for exhibition in public places. The Haverty Trust was founded in 1930 and every five years thereafter, an exhibition of the paintings acquired was held at the Municipal Gallery, Dublin, and then went on tour to regional centres.[15] In 1934 Miss Sarah Purser and Sir John Purser Griffith established two funds of equal amount, £1,000 each, one to be administered by Trinity College, Dublin, the other by University College, Dublin, the purpose being the encouragement of the study of the History of Art and to assist those wishing to pursue careers in the subject. The annual course of Purser-Griffith lectures in the history of art provided a useful service in a city deprived of such activities.

The artistic interest in most people's lives was not painting but the cinema. The power of film as a cultural influence was recognised and feared. In 1935 Ireland imported 5,500,000 linear feet of film, 80% of which was American, the rest British. The estimated number of admissions to cinemas in the same year was 18,250,000.[16] Douglas Hyde's celebrated call for the de-anglicisation of Ireland was lost in the face of what James Montgomery (Film Censor, 1923-40) called 'the menace of Los-Angelesicisation'[sic].[17]

The Irish Government never officially accepted film as an art form in the early decades of the Irish Free State. But the propaganda and commercial potential of the cinema were accepted. In 1926, the Government gave approval in principle to the making of a propaganda film about Ireland. Irish

*Liam O' Leary*

diplomatic missions had been clamouring for a promotional film. The film, titled *Ireland,* was produced by the advertising agency, McConnell Hartley, and received its first public showing at the opening of the Savoy Cinema, Dublin, in November 1929.[18] The Government's only other financial involvement with the cinema in the 1930s was prompted by the success of Robert Flaherty's expensive privately funded documentary film, *Man of Aran* (1934). De Valera and members of the Government attended its premiere on 6 May 1934. The Dáil decided to vote a grant of £200 to a Flaherty produced short film with an Irish language script prepared by the Department of Education. Titled *Oidhche Sheanchais,* it told of the heritage of Irish story-telling and folklore. It was shown for the first time in Dublin in March 1935.

A small number of devotees of the cinema - James O'Donovan, Edward Toner, Patrick Fitzsimons, Liam O' Leary and Seán O Meadhra - tried to stimulate an appreciation of foreign language and silent films. They founded the Irish Film Society on 15 November 1936.[19] The same close group launched the progressive but short-lived periodical *Ireland To-Day* (22 issues, June 1936 to March 1938).[20] Its editor, James O'Donovan, provided a brave outlet for young art critics to air their views. Aloys Fleischmann lamented the low status of classical music, John Dowling and Mervyn Wall attacked the Abbey Theatre, Seán O Faoláin railed against the censorship laws, E. A. McGuire called for the application of art to industry, and James Devane pointed to the need for an Irish cultural policy. Devane wrote:

> Sooner or later the Irish government will be faced by a dead wall. They will discover they are building a house without windows...You  cannot have national ideals and political forms rotating in one plane, and the culture of the people, music, literature, art, architecture, non-existent, or rotating on a different plane.[21]

Liam O'Leary who contributed articles on the cinema to *Ireland To-Day* wrote in June 1937:

> The subject of Irish film production should claim the interest of all public spirited people, being as it is a vital influence nowadays in the life of a nation. Patrons of art and leaders of culture should feel it their duty to encourage efforts along the right lines, and, quite apart from the philanthropic aspect, Irish film production is a  definite commercial proposition.[22]

The Government was slow to accept that it had a duty to encourage the Irish cinema. It was left to Hollywood producers to implant their fantasies about

stage Irishmen and sentimental scenes in the minds of cinema-goers everywhere.

While de Valera favoured the encouragement of private initiatives rather than direct state support for the arts, government files reveal that considerable time was devoted by his government to a number of cultural projects. Fianna Fáil's methods were discreet and therefore, from the historical point of view, their failed initiatives have not been noted. This has caused the widespread belief that they cared nothing for the arts. In fact, de Valera's Government discussed the provision in Dublin of a new national theatre, a national concert hall and a national cultural centre. Schemes for village halls and libraries throughout the country, efforts to create a national film studio, a new National Library, a cultural relations committee to promote Irish culture abroad, and attempts to improve industrial design were also pursued. The mere record of these proposals does not alter the fact that the arts languished with minimal funding. Nevertheless, the documents facilitate the belated acknowledgement of those who at least made an effort to improve the situation.

The first arts issue to occupy the new Government's attention was the same one which had attracted Cumann na nGaedheal. The indomitable Sarah Purser had continued to campaign for the return of the Lane Pictures to Dublin. In 1924 and 1927, the Friends of the National Collections made representations to the Irish Government for the opening of a modern art gallery in line with Lane's wishes. Miss Purser suggested that the Government should rent Charlemont House to Dublin Corporation for a small sum on a 99 year lease provided that the Corporation would spend not less than £20,000 on the conversion and extension of the building for use as a Municipal Gallery of Modern Art.[23] The deal was accepted by President Cosgrave but it fell to his successor, Eamon de Valera, to open the completed Gallery to the public on 19 June 1933. A special room was set aside and kept empty for the display of the 39 Lane Pictures when these would eventually be returned.

Political expediency also underlay a major proposal by the Minister for Finance, Seán MacEntee, which was submitted to the Executive Council in December 1933. He proposed that an architectural scheme be devised for the erection of purpose-built government offices in Dublin.[24] At this stage no particular site had been identified. The matter was referred to a committee for examination.[25] The committee met on 17 January 1934 and decided to recommend that while 'there was no case for building immediately a large scale central block of Government buildings', plans should be made for the

building of such offices in the future. 'Leinster House and surroundings', the committee advised, 'should be reserved for extensions to Museums and Art Galleries etc. with due regard to the amenities of Leinster House'. Government offices should be sited in a designated area bounded by Merrion Street, Lower Baggot Street, the Canal and Fenian Street. The possibility of acquiring Merrion Square from the Archbishop of Dublin was to be investigated.

The Government approved the committee's recommendations and the Office of Public Works was asked to prepare the necessary plans.[26] All documents relating to the scheme were stamped 'Strictly Confidential' because the Government feared an information leak which would prompt property speculators to move in on the designated area. The dream project involved the demolition of large numbers of Georgian buildings including those on Merrion Square between the National Gallery and Clare Street. The Government saw nothing wrong with demolishing these buildings because they were associated with the ascendancy. Although the plans were brought to an advanced stage, it was clear from the outset that the project would be enormously expensive. In 1937 the Government adjudged arterial drainage to be a greater priority and the centralised government office plans were shelved.[27]

The knowledge that the Government had considered the demolition of some of the best examples of Georgian architecture in Dublin would have horrified, though perhaps not surprised, Thomas Bodkin. De Valera had no need of Bodkin who was regarded as Cosgrave's art adviser. In 1935 Bodkin resigned from his post as Director of the National Gallery and moved to England where he became Professor of Fine Arts at the Barber Institute of the University of Birmingham. He wrote to Cosgrave:

> I still think of you as the leader to whom I owe allegiance...the University authorities and people in general have been extraordinarily kind and friendly to me...In fact I am occasionally disconcerted by hearing them speak in terms of sympathetic admiration of Mr de Valera. Of course I, as I think you would wish, feel that I must be guarded against disparaging the present Government of my country; so all I can do when I hear him praised is to emit vague, non-committal disparaging noises.[28]

Bodkin confided: 'I shall come back in the long run to Dublin, to find peace and sense pervading Ireland under your wise, enlightened government'.

De Valera had his own art adviser whom he liked and trusted. Patrick Little (1884-1963) was not an art expert like Bodkin. He was a Fianna Fáil T.D. for

*Patrick J. Little*

Waterford County (1927-54) who had a keen interest in the arts. University educated and widely travelled, Little was de Valera's Parliamentary Secretary from 1933 to 1939. He loved music and often entertained visiting artists at his home in Sandyford, County Dublin.[29] He admired de Valera and always referred to him as 'The Chief'. His closest political ally was the Minister for Finance, Seán MacEntee. They had both written poetry and shared strong cultural interests.[30] Together they conspired to further a number of major arts initiatives despite the implications for government expenditure. Incongruously, the first of these initiatives was supported by a senior official of the Department of Finance. In 1931 the same official, H.P. Boland, had spurned the proposals of the Board of Governors and Guardians of the National Gallery of Ireland. But in 1936 he co-operated with Seán MacEntee in proposing the establishment of a National Symphony Orchestra and the provision of a concert hall. De Valera had been encouraged by Paddy Little to ask the Minister for Finance to put forward some proposals. MacEntee then spoke privately to H.P. Boland and asked him to draft an appropriate memorandum for government.

In a letter to de Valera, MacEntee praised Boland 'who for a great number of years past has taken a very active share in the musical life of Dublin and who has done as much as any one individual in his position could do to foster an interest in music'.[31] Boland suggested that a Symphony Orchestra could be established inexpensively by combining the talents of the Radio Eireann Orchestra and the No. 1 Army Band. As to the concert hall, the lease on the Rotunda building at the end of O'Connell Street on Parnell Square, Dublin, was due to expire and the premises could be refurbished and extended quite readily. These ideas were not new but it was the first time they had been presented to the Government.

De Valera discussed the proposals with Sir Hamilton Harty, the Irish-born musician who had won fame as a conductor with the Halle Orchestra, Manchester.[32] Harty was interested when de Valera asked him to consider coming to Dublin to conduct the new orchestra on important occasions. Boland's memorandum was submitted to de Valera in October 1936.[33] MacEntee was encouraging and told Boland that it was 'excellently suited to its purpose'.[34]

The Secretary of the Department of Posts and Telegraphs, P.S. O'Hegarty, did not agree. He had been tipped off about the proposals and wrote a private note to Boland advising him that: 'The general principle of subsidising places of amusement, whether theatres or concert halls or stadia, no matter how highbrow or desirable in themselves, seems to me to be entirely bad'.[35]

O'Hegarty felt that while, in this case, there seemed good reason to provide some sort of hall for the orchestra of the Broadcasting Service, there was an even more urgent need for increased office space for his Department.

O'Hegarty's warning put MacEntee on his guard. He wrote to de Valera to stress that Boland's memorandum was 'prepared *quite unofficially*'. He added: 'It would be, from a departmental point of view, unseemly that proposals for expenditure of this character should originate with the Minister for Finance'. He suggested that perhaps it was time to 'enlist the sympathy of the Minister for Posts and Telegraphs and the Minister for Education'. A good way to do this would be to establish an inter-departmental committee.[36]

De Valera took the matter in hand. The arrangements were made to form an inter-departmental committee 'to make proposals for the establishment of a Symphony Orchestra and Concert Hall in Dublin'. The Department of Posts and Telegraphs was advised that: 'The question is one in which the President is very interested and he is anxious that full consideration should be given to the practicality of assisting the project without undue expenditure out of State funds'.[37]

A committee was duly appointed on 30 January 1937 under the chairmanship of H.P. Boland.[38] Its report was submitted to the Minister for Finance within four weeks. It was essentially a dressed up version of the memorandum which Boland had prepared at MacEntee's request. The report proposed that a Company should be formed to manage the Rotunda and to raise revenue by holding concerts, congresses, lectures and similar functions. The broadcasting service could be used to popularise concerts for school children. The Rotunda Round Room was suitable for drama in the Irish language and would provide a centre 'for exhibitions or displays of physical exercises, Irish dances, Irish traditional singing, traditional singing and traditional instrumental music'.[39]

The Minister for Education, Tomás O Deirg, approved the report's recommendations[40] but the Minister for Posts and Telegraphs, Oscar Traynor poured cold water on them.[41] P.S. O'Hegarty wrote that his Minister felt the matter was 'perhaps properly one for Municipal rather than Governmental action'. He suggested that the Inter-Departmental committee was outside its brief in asserting that the broadcasting service should be interested in the permanent acquisition of a hall. Furthermore, at no stage did the report discuss 'any figures, approximate or otherwise' of the probable costs of the Rotunda scheme.[42]

O'Hegarty's objections seemed mild in comparison to those of the Department of Finance. Boland's colleagues were defiant:

Thirty years ago or more a case might possibly have been made for State subsidisation of public musical performances. At that time a piano in a drawing room or a squeaky phonograph in the parlour supplied the only satisfaction for the musical yearning of the common man, unless he got a chance to attend an occasional concert. Nowadays musical talking films can be attended every night in the week in all parts of the country; Wireless sets and gramophones are widely distributed; even as he drives abroad a motorist can listen to the best music on his radio set. Accordingly although interest in music must have increased enormously, public attendances at Symphony Concerts, and consequently the necessity for such public concerts, has become smaller and will continue to decline. Is it any part of the State's duty to resuscitate a Victorian form of educational recreation.[43]

León O Broin has written about this type of Finance comment:

I had often heard Finance, my old department, slated. It was said to be mean and miserable; so hard to get money, even small amounts, out of; it was antidiluvian, and so forth. That was not my general experience, but occasionally I was tempted to regard 'the Boss Department' as it was called with dismay.[44]

MacEntee found it difficult to get the project back on the rails after such a righteous condemnation by his own department. When it was suggested to him that the Rotunda proposal might succeed if the Round Room could be adapted to provide for a Concert Hall and for a new National Theatre, he insisted that the two schemes should proceed independently.[45]

Boland retired from the Department of Finance in 1937 and immediately led a deputation to see President de Valera who agreed to ask the Minister for Finance to consider the need for a concert hall 'from a sympathetic standpoint'.[46] MacEntee seized his chance and told his officials that the Rotunda premises 'should be acquired for an experimental period of some years'.[47] The Department of Posts and Telegraphs was advised of the Minister for Finance's instruction but they opposed it successfully by doing nothing. Without the backing of a spending department, the plans for a concert hall came to a full stop for the time being.

Throughout 1937 the attention of politicians was directed towards the enactment of a new constitution. It is worth noting that Article 1 of the Constitution - Bunreacht na hEireann - implied the development of a cultural policy. It stated: 'The Irish nation hereby affirms its inalienable, indefeasible, and sovereign right to choose its own form of Government, to determine its relations with other nations, and *to develop its life, political, economic and*

*cultural*, in accordance with its own genius and traditions'. The ordering of the nation's priorities was in line with government practice. The development of national cultural life was considered after politics and economics.

When a cultural project could be shown to provide an economic return, it was more likely to win political and bureaucratic acceptance. Such was the case in 1937 when the Minister for Industry and Commerce, Seán Lemass, agreed to appoint a Committee on Design in Industry 'to advise on matters affecting the design and decoration of articles manufactured in Saorstát Eireann'.[48] The Committee met on 42 occasions before its work was suspended during the so-called emergency (1939-45) 'as it was felt that supply difficulties during the war period would make matters relating to design in industry of subsidiary importance'.[49] Investigations were conducted by the Committee into design matters in a number of selected industries: aluminium hollow-ware, carpets, furniture, pottery, silver and electro-plated ware, and wallpapers. Unfortunately, because the Committee had advisory powers only, its reports quickly gathered dust in the Department of Industry and Commerce.

It would be easy to continue painting a depressing picture of the position of the arts in independent Ireland as the isolationist years of the emergency drew near. Micheál MacLiammóir wrote eloquently: 'What was to come to Ireland now...striving to visualise the future of the arts in this rain-sodden country, turning restlessly from side to side in her long, dream-haunted sleep?'[50] The period of the emergency was indeed restless for the cultural development of the country. During these years, private initiatives blossomed forth and the Government began to give more serious consideration to what it might do for the arts. The emergency was a watershed in modern Irish history. Terence Brown has argued correctly that:

> There were various signs that a new Ireland, an Ireland less concerned with its own national identity, less antagonistic to outside influence, less obsessively absorbed by its own problems to the exclusion of wider issues, was, however embryonically, in the making.[51]

Many Irish people began to question the fundamental assumptions on which their country had been built. Did the future lie in manufacturing industry rather than in agriculture? Why was the language revival programme faltering? Were the censorship laws a good idea? Should Ireland not be looking to the culture of Europe instead of to that of Great Britain and the United States of America? In Seán O Faoláin's phrase: why had the dream of those who fought for independence gone bust?

CHAPTER FOUR

CAUTIOUS BEGINNINGS - THE SEEDS OF PROGRESS:1940-8

*Culture is always something that was,*
*Something pedants can measure,*
*Skull of bard, thigh of chief,*
*Depth of dried-up river.*
*Shall we be thus forever?*
*Shall we be thus forever?*

PATRICK KAVANAGH

On 19 January 1940 the Committee for the Encouragement of Music and the Arts (which quickly became known by its initials C.E.M.A.) was formally established in Great Britain to promote the following objectives during wartime: to preserve the highest standards in the arts of music, drama and painting; to ensure widespread provision of opportunities for attending arts events and the general enjoyment of the arts; to encourage music-making and the performance of drama by the people themselves; and to render indirect assistance to professional singers and players who were out of work because of wartime.[1]

C.E.M.A. was a huge success and contributed to maintaining British morale despite the trials of the war. In Ireland, the Government made no such official moves to keep the population entertained during the emergency. But Paddy Little took note of the developments in Great Britain and began to plan a way of applying them to Ireland. He was tireless in his efforts to win support for his ideas. He, more than any other politician, encouraged the development of an official arts policy.

De Valera valued the promotion of learning more than the encouragement of art. He was proud of the work of the Irish Manuscripts Commission and the Irish Folklore Commission which had been established in 1928 and 1935 respectively. His attempt to establish an Institute of Irish Historical Studies failed in 1938.[2] Two years later however, he guided the legislation to establish the Dublin Institute for Advanced Studies safely through the Oireachtas.[3] The Institute had two constituent Schools - the School of Celtic Studies and the School of Theoretical Physics (the School of Cosmic Physics was added later), and received an annual State grant-in-aid. In 1946 de Valera helped to launch the Irish Placenames Commission. These initiatives promoted the type of Irish culture of which de Valera had often spoken. They reflected his cultural concerns and he applied himself to realising them. He did not have the same commitment to the realisation of Paddy Little's ideas for the arts.

In 1939 Seán MacEntee was replaced as Minister for Finance by Seán T. O'Kelly. MacEntee became Minister for Industry and Commerce for two years and was then appointed Minister for Local Government and Public Health. In the Cabinet shuffle of 1939, de Valera appointed Paddy Little as Minister for Posts and Telegraphs. Little had not much interest in the work of the Post Office but he was delighted to have responsibility for the broadcasting service. He hoped to use his ministerial influence to advance the cause of the arts in general and of music in particular.

Little quickly reactivated the plans laid by MacEntee and Boland in 1936 for a national concert hall. He was fortunate to have the support of a sympathetic civil servant, León O Broin, who backed all his Minister's efforts to promote music in Irish life. In 1940 Little requested the Department of Finance to allow him to see their file on the aborted scheme to purchase the Rotunda buildings. This was considered to be an unusual request and Seán Moynihan, an Assistant Secretary in the Department, viewed it with suspicion. He advised the Departmental Secretary, J.J. McElligott:

> The presumption is that Mr Little is thinking of reviving the scheme for the leasing of the Rotunda which was under consideration a few years ago. No doubt, the request for the loan of the file must be granted, but you may wish, before lending the file, to discuss with our own Minister the propriety of reviving in present circumstances a scheme which could involve considerable expenditure, both capital and recurrent, and produce very little in the way of financial return.[4]

McElligott spoke to his Minister, Seán T. O'Kelly, who wrote a letter to the Minister for Posts and Telegraphs with the caution:

It would, as you will I am sure readily admit, be out of the question to enter into a commitment of this kind at a time when financing of vital services is straining our resources to the limit...I trust, accordingly, that I may assume you have no intention of reviving this proposal which is one that I would feel bound to oppose.[5]

The message was loud and clear: Little would have to fight against the full weight of the Department of Finance.

The Department of Education had tried to stimulate interest in music but had met with limited success. It was difficult to overcome the inherent problem that most teachers had no musical training. In 1932, the Department appointed an Organising Inspector of Music, Donnchadh O Braoin, and for the next twenty years he worked unceasingly to promote music in the education system.[6] He introduced annual music courses for primary school teachers and, between 1939 and 1951, over 4,000 teachers attended them.[7] In the secondary school system the situation was pitiful and remained so. In 1938, 0.02% of the total number of boys and 2.4% of girls enrolled in Intermediate Certificate classes were studying music. In the Leaving Certificate classes, 0.05% of pupils were studying music (208 girls and 8 boys).[8]

Faced with this situation, officialdom hardly knew where to begin to improve matters. The Dublin Vocational Education Committee decided to promote the establishment of industrial choirs at various factories in the city. Jacob's Biscuit factory and Varian's Brush factory were among the first to have such choirs. Soon the trades unions followed the lead by forming their own choirs. Without official help, Colonel William 'Bill' O'Kelly founded the Dublin Grand Opera Society in 1941. In the autumn of the same year, Radio Eireann inaugurated a season of public symphony concerts. At first the concerts were held in the Round Room of the Mansion House, Dublin. After two years the venue was transferred to the Capitol Theatre which had twice the seating capacity of the Mansion House.

In August 1942 Paddy Little, undaunted by his previous experience, submitted a memorandum to the Minister for Finance proposing that the Government should purchase the Capitol Theatre. The observations on the memorandum by the Department of Finance opposed the proposal on the basis that there was insufficient demand for such a venue and that:

cultural development cannot be hastened by schemes on such a grandiose scale as to invite failure. Of its nature, cultural development is a slow process, and State efforts to promote it may be regarded as very

successful indeed if a generation from now they have produced such a widespread appreciation of music as would be necessary to give the Capitol Theatre project even a moderate chance of success.[9]

The Department argued that the Government had committed itself in May 1938 to providing a national theatre building and this would consume any available resources for cultural purposes. The proposed scheme for a national theatre envisaged a building with three auditoria of 1,000, 600 and 300 seats for the Abbey Theatre, the Gate Theatre and An Comhar Drámaíochta respectively; at an estimated cost of £170,000 exclusive of compensation to adjoining property owners. The Minister for Finance had met a deputation of the Abbey Theatre directors in February 1940 and agreed in principle to the project but said that it would have to be postponed until after the emergency. If, on top of this commitment, the Government was to finance a national concert hall, the Department of Finance considered that it 'would be nothing short of an outrage on the public's sense of financial prudence'. The Minister for Finance expressed his concern to the Government:

> at the effect which a decision to spend a large amount of public money on a scheme for the provision of entertainment would have on public morale and on the prestige of the Government. The national economy is passing through a grave and dangerous crisis; supplies of various essential commodities are scarce; the standard of living of the poorer classes of the community has suffered a serious reduction. The position in these respects will certainly not improve during the emergency. In these circumstances the acquisition of the Capitol Theatre, which even in normal times would have little to commend it, would the Minister for Finance is convinced, be in the highest degree unwise and indefensible. Accordingly, he recommends that the proposal be rejected.[10]

Despite this gloomy prognosis, the Government decided to instruct the Minister for Posts and Telegraphs to purchase the Capitol Theatre through the aegis of the Office of Public Works. De Valera supported Little and rejected the Minister for Finance's advice. But the deal fell through because the purchase price of £65,000 was considered too expensive. The negotiations were not re-opened.

In 1943 the Minister for Finance, in a further act of retrenchment, withdrew his support for the Abbey Theatre project. He recommended to the Cabinet Committee on Economic Planning that:

> In view of the vast amounts which will be required for purposes such as housing (in both town and country), family allowances and other social

services - not to mention arterial drainage, the scientific development of agriculture - it seems likely that an artistic luxury such as a national theatre will have to take a low place in financial priorities.[11]

It is important to emphasise that a national theatre was considered to be a luxury. While this was indeed the case on one level, the judgment indicated that the Minister for Finance and his Department did not consider that the State had an obligation to fund the arts. The Cabinet Committee considered the Minister for Finance's recommendation and opted for a political solution. It was decided that 'the project should be given active attention up to the point of completing detailed plans' for the erection of a theatre on a site at the junction of Abbey Street and Marlborough Street.[12] The effect of this decision was the postponement of the project indefinitely. A new national theatre building would have to be delayed until it was no longer considered to be a luxury item.

The former Minister for Finance, Seán MacEntee, was preoccupied with a proposal that the Government should give grants to local authorities for the purpose of building village halls as venues for cultural and social activities. He was impressed by the successful establishment of the public library system. By 1944 all but two (Longford and Westmeath) of the twenty-six counties in the Irish Free State had a public library. MacEntee thought that the next step was to establish village halls as part of his scheme to give statutory powers to local parish councils. He was invited to submit a practical scheme to the Government.[13] His memorandum was idealistic and the Government rejected it.[14] The Department of Finance advised that if every parish council pleaded for its own village hall, the financial implications for the Government might be 'horrendous'.

The minor ideological battles being fought within the Government bureaucracy were symptomatic of shifts in attitudes and growing popular frustration regarding important cultural issues. In November 1942, the Senate was the scene of a crucial debate on the censorship system. The major debating adversaries were Sir John Keane and Professor William Magennis. Three publications which had been banned were debated, Keane against the censorship, Magennis in favour.[15] Passages from one of the publications, *The Tailor and Ansty* by Eric Cross, were read in to the official record by Senator Keane. On the instructions of the Chairman of the Senate, they were deleted from the published report of the debate. Censorship had now won out against the free speech of a member of the Oireachtas. This was the high water mark of the censorship saga although it was far from over. The Censorship of Publications Act, 1946, established an Appeals Board in a supposed

improvement of the legislation. The Bill was introduced in the Dáil by the Minister for Justice, Gerry Boland and in the Senate by the Minister for Posts and Telegraphs, Paddy Little. But the next five years saw the banning of many important works of literature like John Steinbeck's *East of Eden* (1947), Graham Greene's *The Heart of the Matter* (1948), and C.S. Forester's *The African Queen* (1951).

The position of the Irish language revival movement was highlighted in 1943 when the Minister for Education, Tomás O Deirg, told the Dáil that Irish would not be saved 'without waging a most intense war against English, and against human nature itself for the life of the language'.[16] The first step in the 'war against English' had been the training of Irish speaking teachers. In 1922, 1,107 primary school teachers were qualified to teach through Irish. In 1943 some 9,000 could do so, that is two thirds of all primary teachers. In 1931 there were 228 primary schools in which all subjects were taught through Irish. In 1939 the number of these all-Irish schools had increased to 704. This was the peak figure and by 1951 the number had declined to 523 all-Irish schools.[17] The Irish National Teachers' Organisation was not enthusiastic about all-Irish policies. The aim had been to make Irish the spoken language of the people but the education system was so dominated by written examinations that it militated against the success of the policy. The Irish Government retained the British system of education while adopting the views of Patrick Pearse on the importance of the Irish language. Kenneth Reddin wrote in 1945 that the Government had failed:

> to uproot the deeper tendrils of Victorianism in Irish Education. They survived Pearse. They still survive. And so Irish Education is narrow, stereotyped, uninspired, unenthusiastic, without fervour or imagination. It is Victorian. And we have the bad legacy of Inspectors, Bonuses, Competitive Examinations, and Grants-per-Capita.[18]

Pearse's belief in the importance of art in schools was paid lip service by the Department of Education. The history and practice of painting were still not on the curriculum. Instead drawing was an optional subject which included pictorial design (Roman and Celtic lettering), object drawing, woodwork design, and natural forms (still life drawing). The percentage of pupils who studied drawing was much greater than that for music. The position was poor nevertheless. In 1938, 60% of Intermediate Certificate pupils (33% boys) and 7.8% of Leaving Certificate pupils (4% boys) studied drawing.[19]

The emphasis on rigid academic training in draughtsmanship extended to the Dublin Metropolitan School of Art. In some respects this was beneficial

but gradually artists like Paul Henry and Jack Yeats began to break down the academic style of painting. They gained popular attention too. In 1945, 1,500 people daily visited the Jack Yeats Loan Exhibition in Dublin.[20] Three women led the progressive movement in Irish art - Sarah Purser, Evie Hone and Mainie Jellett. The latter pair studied cubism in Paris and following their return to Dublin, Jellett especially, in print and on radio, proclaimed the virtues of abstract art. Artists began to enter the social scene and became involved in theatre design (Micheál MacLiammóir as set designer at the Gate Theatre, Anne Yeats at the Abbey, and Louis Le Brocquy at the Gaiety and the Olympia Theatres). The influence of a group of immigrant English painters who exhibited under the title 'The White Stag' was considerable. Terence de Vere White described them as 'a corduroy panzer division' whose 'commissariat' was the Country Shop in St Stephen's Green. 'Their visit did us good. Official art in Dublin was very stuffy indeed'.[21]

The major artistic event was the establishment of the Irish Exhibition of Living Art in 1943. Mainie Jellett was elected chairman and the first committee members were: Evie Hone, Fr Jack Hanlon, Norah McGuinness, Louis Le Brocquy, Margaret Clarke, Elizabeth Curran, Ralph Cusack and Laurence Campbell.[22] Sybil Le Brocquy conceived the idea of an annual exhibition for the new generation of artists and she organised the initial meetings. The first exhibition was held at the Dublin Metropolitan School of Art from 16 September to 9 October 1943. Three years later, the School of Art was extended and established as the National College of Art with separate Schools of Design, Painting and Sculpture. In 1947/8 the College had 510 students enrolled.

Efforts were also made to encourage the public to visit the National Museum. In 1937/8 a campaign to bring groups of school children to the Museum led to a creditworthy total of 26,400 visitors per month.[23] For the next decade the visitor numbers averaged 250,000 per year.[24] These figures were insignificant compared to those for the cinema. In 1943, 22 million cinema tickets were purchased in the 26 counties. Many people were worried about the effect of the cinema on Irish life. For example, B.G. MacCarthy, Lecturer in Education at University College, Cork, wrote:

> The cinema nowadays occupies man's leisure to the exclusion of former interests and pursuits. It has brought him some knowledge; it has deprived him of some hitherto unquestioned convictions. It has affected his standards of aesthetic taste. Despite censorship, it has loosened his moral fibres. It has confirmed the unthinking in their lack of thought, and has filled their lives with a colourful and varied vacuity.[25]

MacCarthy continued with the interesting observation: 'Ireland is a strange country. It revolts only against symbols - not against the ideas behind those symbols.'[26] The cinema became a vital stimulant of social change. In 1945 Seán O Faoláin explained why the periodical, *The Bell*, was introducing film reviews: 'any periodical with a social conscience has to acknowledge that after the Churchman, the Politician, the Industrialist, and the Farmer, the next greatest influence in Eire is Mr Sam Goldwyn and all his beautified sistern and brethern'.[27]

The Government's involvement with the cinema was half-hearted. In 1938, Fr Richard Devane, S.J., persuaded de Valera to establish an enquiry into the cinema in Ireland. Fr Devane had been an outspoken proponent of the efforts to create a national film industry. De Valera agreed to set up an inter-departmental committee under the auspices of the Department of Industry and Commerce. The committee's report was submitted to the Government in 1943 but was never published. The report, titled 'The Film in National Life', recommended that the Government should set up and finance a small national film studio.[28] This was also the main proposal of the *Irish Cinema Handbook*, published in 1943 and edited by Fr Devane. Although the cost implications frightened the Department of Finance, the Minister for Industry and Commerce, Seán Lemass, was enthusiastic about the idea. He was interested in the economic rather than the artistic potential of a national film studio. He had been frustrated by the failure of a number of private efforts to establish film studios in the 1930s and early 1940s. He decided that the Government would have to become involved if a national film studio was ever to become a reality. He submitted two memoranda to the Government, one in December 1946, the second in September 1947.[29] In the second memorandum, he suggested that the Government should build and equip film studios and offices at a cost of £500,000. There would be capital incentives for foreign companies which made films in Ireland.

The Minister for Finance, Frank Aiken (who had replaced Seán T. O'Kelly in 1945), rejected Lemass's proposal. He said that if money was to be spent 'on the film business, it should be spent on the production of Irish films by Irish organisations'.[30] Aiken supported the more modest proposal of the 1943 report of the inter-departmental committee to establish a small film studio. Lemass was forced to drop the proposal temporarily. In the 1950s he realised his ambition with the establishment of the Ardmore Studios.

Despite Frank Aiken's efforts to thwart Lemass's proposal, he was not against film-making. He positively encouraged it during the emergency when an American company called March of Time was commissioned to make a

*Thomas Davis*

number of documentary films for the Government. These films included 'The Irish Question' and 'Neutral Ireland'. The Government also granted £3,000 for the making of a film to mark the centenary of the death of Thomas Davis (16 September 1945). The film, 'A Nation Once Again', was propagandist in tone and the epitome of Irish Irelandism. The film critic in the *Irish Independent* gave it a laudatory review: 'In the cinema, as elsewhere, it is possible to be effective without being spectacular and I venture to say that this is our most effective and most competent essay in film-making to date'.[31]

The Davis Centenary served to focus attention on the Young Irelander's writings. Paddy Little regarded Davis as a prophet, a source of inspiration. Davis had emphasised the duty of a native Irish Government to support the arts. Little began to consider the best way of doing this and decided that the Government should establish a Council of National Culture or a Cultural Institute 'which could broadly and regularly review the whole field of culture and entertainment and endeavour systematically to fill the gaps they find in it'.[32] He was impressed by developments in Great Britain, especially by the work of the Committee for the Encouragement of Music and the Arts. He sought the assistance of his distant relative and close friend, Fr Arthur Little,

S.J., to formulate a scheme which would be appropriate to the Irish situation. Fr Little told him:

> One suggestion I can make without diffidence and with all the urgency I can: that you should be very definite about the purpose of your institute, that you should be able to state in a few lines on paper the precise effect it is intended to have on the people and even be able to give an official definition of every word used in the statement. Many good schemes fizzle out because they are launched while the purpose aimed at is vague in the hope that they will "take shape" in the course of development.[33]

While this advice was sound, Fr Little's attempts to describe the purpose of a Cultural Institute were extremely vague. He thought that 'such an Institute should have for its purpose to save the mind of the country'. He continued:

> I believe that our greatest and gravest defect as a nation is our lack of a simple code of reasoned convictions that is universally or at least generally accepted. Now I should say that the best purpose of your Institute would be to work out such a code and propagate it.[34]

Paddy Little asked his Departmental Secretary, León O Broin, 'to draw up a sketch of what an Arts Department might encompass'.[35] Little then set himself the task of writing a suitable memorandum for the Government. He mentioned his idea to de Valera who told him 'to put forward a definite set of proposals which could be carried into practical effect'.[36]

During the summer of 1945, while Little was preparing his memorandum, the British Government announced that it had decided to establish the Arts Council of Great Britain (A.C.G.B.) to continue the work of C.E.M.A. John Maynard Keynes, who was appointed first Chairman of the A.C.G.B., wrote about the decision:

> I do not believe it is yet realised what an important thing has happened. State patronage of the arts has crept in. It has happened in a very English, informal, unostentatious way - half-baked if you like. A semi-independent body is provided with modest funds to stimulate, comfort and support any societies or bodies brought together on private or local initiative which are striving with serious purpose and a reasonable prospect of success to present for public enjoyment the arts of drama, music and painting.[37]

Keynes exaggerated somewhat - there had been state patronage of the arts in Great Britain since the eighteenth century at least - but he highlighted

correctly the significance of the decision. The Council, Keynes explained, would be a permanent body, free from red-tape, financed by the Treasury and ultimately responsible to Parliament. He praised the British Government for recognising so clearly the State's duty to support and encourage the civilising arts.

Little's memorandum was ready in November 1945 but before submitting it formally to the Government, he sought the personal support of de Valera and MacEntee. He told de Valera (whom he addressed as 'My dear Chief') that the proposed Cultural Institute or Council of National Culture could be known by an Irish title, either 'An Chomhairle le Saíocht Náisiúnta' (The Council of National Learning) or 'Comhairle an Dáibhísigh' (The Davis Council').[38]

Little's letter to MacEntee explained why he thought the proposed Council was necessary:

> My connection with Broadcasting and the efforts that are being made through Radio Eireann to raise cultural standards has brought to my notice the existence of many problems of a cultural or recreational character that cannot readily be solved through the agency of any existing organisation or that can only be solved by helping existing organisations to expand their sphere of action. The range and interaction of the problems have convinced me that some central directive body, such as the memorandum outlines, is a real national need; otherwise the problems will be left unsolved to the detriment of the country or they will be dealt with only in part or disjointedly or haphazardly and always in an unsatisfactory fashion...the best and most inexpensive procedure is to stimulate local interest and to get people as far as possible to do things for themselves.[39]

Activities which the Council might undertake in its first year could include: extending the concert tour system in collaboration with local societies; sending lecturers to local areas; encouraging local folk museums, picture galleries or recreational centres; attempting to organise existing amateur dramatic societies into a unified organsiation to assist their aims; helping to form a National Orchestra; and arranging symphony concerts in Dublin and in the major provincial centres.

Little was worried about national morale following the emergency period:

> There is a danger that with the defence situation no longer intense, politics will run to seed and that even the language movement will suffer unless a widespread cultural renaissance is achieved, something that will stimulate and fill people's minds with interest in the treasures and

possibilities of their own land. Such a revival might easily prove to be one of our best safeguards in time of national emergency, a way to future national unity and a very desirable and valuable invisible export.[40]

MacEntee replied with qualified support:

> Naturally I am most sympathetic to the idea. However, I would not like you to regard me as being committed to your support of it until I have had the opportunity to look into the proposal in detail...At the moment I am just a bit dubious about the effect of imposing any kind of bureaucratic control over the arts.[41]

MacEntee retreated from the issue by asking his Parliamentary Secretary, Erskine Childers, to provide observations on Little's proposal.

In January 1946 Little wrote to de Valera again about the proposed Council:

> I would ask you as a special favour to give it your personal interest. I feel it is extremely important if Ireland is to survive culturally. If you could decide that it is important, maybe you would press the importance on Frank A.[iken]. I have grave misgivings that it will receive rough handling and niggardly treatment - from Finance - and so the scheme will only limp and fail.[42]

As Little suspected, the Minister for Finance was not keen on the establishment of a Council of Culture. Little decided that he would have to change his tactics. He attempted to fuse his proposal with renewed efforts to purchase the lease on the Rotunda buildings. He reckoned that if he was involved in cabinet discussions about the proposed national concert hall, he could then inform the Government of the general need for a Council of Culture. Whereas in 1936 de Valera had directed that an inter-departmental committee of civil servants should be established to put forward plans for a national concert hall, the Government decided in January 1946 to appoint a committee of ministers 'to examine the position in regard to the provision of a public Concert Hall in Dublin and to report to the Government'.[43] Those appointed to the committee were the Ministers for Local Government and Public Health (MacEntee), Posts and Telegraphs (Little), and Lands (Seán Moylan).

Matters began to move quickly following the appointment of the cabinet committee. Little was impatient to air his proposal for a Council of Culture before the Government. On 5 February he raised the question informally at a

government meeting. He told his colleagues that he did not want a decision: 'He merely wished to ascertain whether there was any likelihood that the Government would approve of his proposal if it were formally submitted. If there appeared no such likelihood, he would not proceed with his proposal'.[44] Following some discussion, the Taoiseach (the title given to the leader of the Irish Government under the 1937 Constitution) suggested to Little 'that in the first instance the objects he had in view might best be approached by the setting up of some voluntary organisation'. Little complied and said that he would take steps to assemble 'a voluntary group of persons interested in cultural development'.[45]

Meanwhile the Cabinet Committee, of which Little was a member, had won approval from the Government to open negotiations with the Rotunda authorities to acquire the lease on the premises for £2,000 per annum (plus refurbishment costs of £150,000). MacEntee advised Aiken that it would be 'unfortunate' if the Government should fail to acquire the lease as had happened in 1937.[46] Aiken instructed his Department 'that sanction should issue as a matter of urgency'.[47] The Government decided that the Minister for Posts and Telegraphs should be responsible for the negotiations on the lease.[48]

Erskine Childers provided MacEntee with detailed comments about the proposed Council of Culture.[49] In a twenty-page memorandum, Childers gave evidence of having reflected carefully on the subject. He believed that Irish culture was in danger 'because of a certain apathy which shows itself in a destructive rather than a constructive form of nationalism'. In relation to the Irish language, reality would have to be faced:

> There is no hope of restoring the Irish language or of maintaining Irish civilisation as a distinct force unless the general culture of the people is enhanced. In fact one of the principal reasons why the language societies progress so slowly is that they consist of people who I know well in my own constituency have an extremely narrow isolationist tradition of thought.

Childers felt that Little's memorandum was 'really an admission that a fundamental gap exists in our educational system'. The Council of Culture's activities would have to correct this fault by stimulating culture and not by directing culture. It should co-ordinate activities, offer advice and limited sponsorship, but should not direct activities itself. The Council would 'find considerable difficulty in operating on less than twenty or thirty thousand pounds per annum' and would need full-time officials.

Little was pleased with these comments and asked his Cabinet Committee

colleagues, MacEntee and Moylan, to consider them. He decided to exploit the authority which the Government had bestowed on him by making him responsible for the negotiations on the Rotunda buildings lease. He persuaded MacEntee and Moylan to go beyond the public concert hall issue and propose that the Rotunda premises should serve as a National Arts Centre to be managed by a board corresponding in function to the Arts Council of Great Britain. In a report to the Government, the Cabinet Committee proposed that the Arts Council should be under the aegis of the Minister for Posts and Telegraphs.[50] The Minister, Paddy Little, 'would stress the note of local contribution in effort and money'. The Arts Council would have the following terms of reference:

(a) to increase and develop popular interest and participation in all forms of cultural activity; to supply people with wider opportunities of hearing and seeing the best works of art through whatsoever media; to provide people where organised into cultural groups (e.g. music groups, dramatic societies, etc.) with expert direction and training; to encourage the creative efforts of Irish artists; and to stimulate local action designed to improve the appearance and amenities of the countryside

(b) to advise the Minister for Posts and Telegraphs regarding the use of a National Arts Centre in order that in association with Radio Eireann it may be utilised to the best advantage for the purposes described in the previous paragraph (a) and

(c) to establish a body of patrons who would consider it a privilege to share the cost of these activities with the State.[51]

The Committee recommended that: 'The members of the Board should be individuals of wide contacts with persons and organisations known to be interested in the terms covered by the foregoing terms of reference as well as persons of distinction in Music and Art circles'.[52] The Board would probably have to form sub-committees, so 'the membership should be on the large side, possibly 20 or even more. Representation could be given to say the Universities of Cork, Galway and Belfast'.[53]

All these recommendations hinged on the acceptance of the plan to purchase the lease and then refurbish the Rotunda buildings. The Chief Architect of the Office of Public Works, J.M. Fairweather, supplied the Government with an estimate of the cost of providing a concert hall by adapting and extending the Rotunda site.[54] The estimated cost was £350,000, more than double the figure on which the Government had given the Cabinet Committee permission to negotiate with the Rotunda authorities. Fairweather

argued that the site was too long and too narrow (from an acoustic point of view) to seat 2,000 people.

The Government stalled by requesting the Minister for Posts and Telegraphs to prepare a detailed memorandum on the proposal for a National Arts Centre. Little obliged quickly and presented a memorandum for government within two weeks.[55] This was too fast for the civil servants of the Department of Finance who felt that the Government was being steam-rolled into an expensive commitment. Maurice Moynihan, Secretary to the Government, in a note of a conversation with J.E. Hanna, Assistant Secretary, Department of Finance, wrote that Hanna:

> agreed that the proposal to place the Minister for Posts and Telegraphs at the head of the board of management of the proposed Arts Centre springs from personal considerations, and that it would be premature to assume that the Department of Posts and Telegraphs will have any responsibility for the enterprise.[56]

It would appear that the Government also found Little's vigour too strong because his wings were clipped by a decision that the Minister for Finance would take over responsibility for the negotiations on the Rotunda lease. This slowed the process and it was November 1946 before the formal lease negotiations were opened with the Rotunda authorities based on the revised costings. The negotiations became protracted when legal difficulties emerged and one of the sub-lessees, the owner of the Rotunda cinema, became reluctant to sell his lease which was not due to expire for six years. The problems were exaggerated when the State's involvement was leaked to the newspapers.[57] Lord Longford, whose theatre company Longford Productions performed in the Gate Theatre (part of the Rotunda complex), told the newspapers that he had heard nothing about the proposed acquisition by the State. He wrote to the Minister for Finance in protest.[58] The Minister of State at the Department of Finance with responsibility for the Office of Public Works replied to say that the announcement 'was unauthorised and premature'.[59]

It now became necessary to pacify the theatre interests which were based in the Gate Theatre, Longford Productions and the Edwards/MacLiammóir partnership, by guaranteeing them that they would be accommodated in the proposed National Arts Centre and State Concert Hall development. The Minister for Finance, Frank Aiken, accompanied by J.J. McElligott and Owen Redmond of his Department, met the theatre interests twice to attempt a resolution of the difficulties.[60] Aiken assured them that 'if a reasonable scheme

was presented to him, he would be prepared to ask the Government to come to the aid of the theatres' as regards temporary accommodation pending the completion of refurbishment works at the Rotunda.[61] By the end of 1947 the negotiations with the Rotunda authorities were deadlocked and the difficulties seemed insurmountable. Raymond McGrath, Assistant Principal Architect of the Office of Public Works, was asked to design an alternative proposal for the Rotunda site. He completed his report and plans in April 1948 and they were forwarded to the Department of Finance.[62] The estimated cost of McGrath's scheme was £537,000. Fianna Fáil never had a chance to consider the scheme. On previous experience, the cost would have precluded any hope of progress. The cost was certainly too much for the Inter-Party Government led by Fine Gael (formerly Cumann na nGaedheal) which won the general election of February 1948 and thereby ended an era of Fianna Fáil governments.

Before moving on to developments under the Inter-Party Government, two other important policy initiatives by Fianna Fáil should be recalled. These were the plans laid to establish a Cultural Relations Committee of the Department of External Affairs and to build a new National Library.

The plan for a Cultural Relations Committee was prompted by a letter to the Taoiseach from Basil Clancy, editor of *Hibernia* magazine. Clancy suggested a number of ways in which the Government might stimulate cultural activity. He thought, like Paddy Little, that some form of government-nominated Council could contribute by organising various activities. This Council would be national in focus but attention would also be paid to Ireland's image abroad. Clancy proposed:

> The establishment of a Council which would engage in national propaganda at home and abroad on a high level and promote lecture tours with art and trade exhibits etc. in other countries and ensure suitable representations for Ireland at Congresses, Conferences, Exhibitions and other similar functions abroad. The Council could also be a help to Irish organisations and societies abroad, influence them along the right lines, and provide them with useful work to do in cultural, political, trade and propaganda matters.[63]

Maurice Moynihan replied to Clancy to say that while the Taoiseach was 'naturally interested in a number of the proposals outlined', he felt 'that at the moment action for their implementation by the State would not be warranted'.[64] The proposal to stimulate the appreciation of Irish culture abroad was attractive to de Valera however. The Department of External Affairs had been working on a similar proposal and the Taoiseach put Clancy in touch

with the Departmental Secretary, Frederick Boland (son of H.P. Boland). A memorandum was presented to the Government in June 1946 proposing 'a small committee of say, twelve persons of well-recognised cultural qualifications' whose function would be 'to examine, and make recommendations to the Minister for External Affairs...in connection with cultural activities abroad'.[65]

The memorandum mentioned £5,000 per annum as an appropriate grant-in-aid for the new Committee. It was argued that cultural propaganda was 'not "suspect" as obviously political propaganda tends to be'. Nor was it subject 'to the conventional limitations which diplomatic representatives are bound to observe'. Experience had shown 'that foreigners who develop an interest in a particular aspect of a country's culture are apt quickly to become generally friendly and sympathetic'. Another advantage of cultural propaganda was 'that its primary impact is on the intelligentsia - the very people who, in most countries, are in the best position to influence Press, radio and public opinion'.[66]

These arguments must have impressed the Government because the proposed scheme was accepted and the financial provision increased from £5,000 to £10,000 per annum.[67] Thus it was that while rejecting the establishment of a Council of Culture or Arts Council to promote the arts within Ireland, the Government agreed to set up an Advisory Committee on Cultural Relations to promote Irish culture abroad. The incongruity was not lost on *The Bell* which published a satirical attack on 'offeechal' culture under the title 'A Pathetic Ballad of a Big Dinner':

> Sure, we must have some culture, yet safe we must be,
> So we'll back up the fiddlers and actors, says he,
> And if the flag of poetry must be unfurled,
> Father Senan is there to introduce it to the world,
> And Patrick J. Little from Waterford fair,
> Sends out gilded culture each night on the air,
> And the rich men are backing with money and kind
> All culture that hasn't to do with the mind.
> So we drank to 'Our Guests' and we emptied our glasses
> And praised the safe slopes of our phoney Parnassus.[68]

In contrast to this withering verse, Fianna Fáil was anxious to publicise the initiative and a lengthy editorial appeared in the *Irish Press* titled 'Cultural Contacts'.[69] The leader writer remarked that Ireland now had the means of redressing 'the astonishing ignorance abroad' about the huge changes which had occurred in 25 years of native rule.

Fine Gael doubted the motives of the Government in introducing such a committee. They feared that it would act as a propaganda agency for Fianna Fáil to continue its domination of Irish party politics. When de Valera introduced a supplementary estimate in the Dáil giving £10,000 to the Department of External Affairs for a grant-in-aid to the Cultural Relations Committee, Fine Gael refused to support the grant 'in the absence of fuller information'.[70] Although the money was voted, it was not expended because the members of the Committee were not appointed by Fianna Fáil before the change of government in February 1948. It fell to the new Minister for External Affairs, Seán MacBride, to nominate the first Committee.

The plan for a new National Library emerged from the deliberations of an inter-departmental committee established by the Government in August 1946 'to advise the Minister for Finance in regard to the building of accommodation for the Houses of the Oireachtas and for the Departments of State (including cultural institutions).[71] Office accommodation problems had increased significantly since the rejection of the proposal to designate the whole area around Merrion Square as a site for government offices. Whereas the 1934 committee on government accommodation had recommended that 'Leinster House and surroundings' should be reserved for extensions to the cultural institutions (National Library, Museum and Gallery), the main aim in 1946 was to move the cultural institutions out of the area to free space for Oireachtas offices.

It was decided that the National Library should be relocated in a purpose-built premises at a cost of £650,000 excluding site and purchase costs.[72] It was the choice of site which ultimately led to the abandonment of the scheme. The inter-departmental committee recommended and the Government accepted that negotiations should be opened with Fitzwilliam Lawn Tennis Club to acquire their tennis grounds at Wilton Place in Dublin and, if necessary, legislation would be enacted to acquire the site compulsorily.[73] The problem with this decision was that Fitzwilliam Lawn Tennis Club knew nothing about it. Matters were made worse by a rather blunt letter from the Office of Public Works to the Club's Secretary:

> We desire to state for your confidential information that it has become necessary to erect a new National Library building, and that the site selected for the purposes includes the property occupied by the Fitzwilliam Lawn Tennis Club at Wilton Place. We accordingly regret to have to inform you that the acquisition of these premises by the State is unavoidable.[74]

The Tennis Club was understandably upset and reacted by asking under what statute the State claimed its authority to force the Club to move from the site which it had occupied since 1879.[75] The Department of Finance advised the Office of Public Works that the Government decision would have to be implemented but suggested that 'they might try to soften the blow by couching their letter to the Fitzwilliam Club in more courteous terms than their first intimation'.[76]

The Taoiseach met a deputation from the Fitzwilliam Club on 10 January 1948 to discuss the matter.[77] De Valera said that he did not feel the Club would suffer by removal to another site. He added that 'in certain respects, he had always thought it strange that a tennis club should be located on such a site as Wilton Place'.[78] The Club would be given time to find an alternative site and would be paid to allow them to acquire new grounds. But time ran out for Fianna Fáil a few weeks after this meeting. The Fitzwilliam Club's worries were ended when the new Inter-Party Government immediately scrapped the plans for a new National Library.

Just before the general election, Paddy Little tried to persuade de Valera to commit the Government to his proposal for an Arts Council. It had been pushed aside by the attention paid to the national concert hall scheme and by de Valera's reluctance to give Little sufficient support to carry the Arts Council plan into existence. In January 1945, Little presented de Valera with a revised version of his Arts Council memorandum.[79] He proposed a 12-member Arts Council with appropriate sub-committees chosen on a regional basis and representative of the various artistic disciplines. Little advised that the Chairman of the Council should preferably be a government minister. The Council would receive an annual grant-in-aid, initially perhaps £10,000. The annual accounts would be audited by the Comptroller and Auditor General.

Little was disappointed when de Valera once again refused to back his proposal. But following the general election, the new Taoiseach, John A. Costello, adopted the blueprint enthusiastically. He did not appoint a Minister as Chairman of the Council but all of Little's other recommendations were implemented. Costello's government gave Little no credit for his role as architect of the Arts Council. All the credit was given publicly to Thomas Bodkin. With a fateful sense of justice, however, the Inter-Party Government fell from office allowing de Valera, returning as Taoiseach in 1951, to appoint Little as first Director of the Arts Council which was to be known as 'An Chomhairle Ealaíon'.

*John A. Costello*

# CHAPTER FIVE

## THE BODKIN REPORT AND THE FORMATION OF 'AN CHOMHAIRLE EALAION':1948-51

*No civilised nation of modern times has neglected art to the extent that we have during the past fifty years.*

THOMAS BODKIN

The change of government in 1948 was symptomatic of the many changes which took place in Irish society in the years following the watershed of the emergency. The liveliness of a new political party, Clann na Poblachta, stimulated the Irish political scene which had been static and dull. The country, it seemed, had been gazing at its own reflection since independence and many were becoming weary of the image. There was a new-found idealism which declared that the country would have to take her place among the nations, to face outside influences rather than seek to exclude them.

John A. Costello was keen to establish his government on an optimistic note. In 1949 he told listeners to Radio Eireann: 'Ireland is now entering the most prosperous period in her history'.[1] A massive building programme of houses and hospitals costing £120,000,000 was undertaken and emigrants were beseeched that 'strong material reasons' should encourage them to return to tackle 'the grand adventure of building up a State'.[2] The Department of Finance was forced to loosen the purse strings and to stop submitting

memoranda which, Costello told the Minister for Finance, Patrick McGilligan, created 'an atmosphere of gloom...scarcely justified by the facts'. Costello continued:

> It is my desire that when information is placed before the Government...the facts should be submitted against a broad perspective and that the approach should be as constructive as possible. A negative or unduly pessimistic presentation of the facts will not provide the kind of atmosphere in which I propose to have...cabinet deliberations take place.[3]

Economic historians are agreed that between 1946 and 1951 the Irish economy experienced 'remarkably rapid growth'[4] and made 'very considerable progress in the face of substantial external difficulties'.[5] In 1950 McGilligan introduced 'the first explicit expression of Keynes in an Irish budget'.[6] He declared that the Government would, for the first time, deliberately fail to balance the budget and would resort to borrowing £6,000,000 in order to fund the major capital works being undertaken. Economic growth was thereby encouraged 'but it was unbalanced growth in the context of inflation. In the 1950s correction of these inflationary tendencies was to cause stagnation'.[7]

Costello's liberal financial attitude brought, in 1951, one of the largest ever deficits on the current account of the balance of payments relative to Gross National Product (14.6%).[8] This precipitated the 1952 balance of payments crisis. But the new attitude also encouraged the country to take a more vigorous role in international affairs. Although excluded from joining the United Nations Organisation by a Russian veto, and from participating in the North Atlantic Treaty Organisation by her neutral status, Ireland joined the Food and Agriculture Organisation (1946), the World Health Organisation (1948), the Organisation for European Economic Co-Operation (1948) and the Council of Europe (1949). In 1948 the link with the British Commonwealth was finally broken by the declaration of the Irish Republic.

These developments were indicative of the growing influence of the Department of External Affairs which was expanded and gained significant control over the distribution of Marshall Aid. The Minister for External Affairs, Seán MacBride, appointed the Cultural Relations Committee planned by the previous administration. The Committee soon began to develop its role and took a special interest in film-making. Clann na Poblachta, led by MacBride, had promised in its election manifesto to establish a national film industry. Much of the party's success with the electorate was due to the effect

*Seán MacBride*

of a powerful short film, *Our Country,* made by Liam O'Leary. The speakers on the film were Seán MacBride, Noel Browne and Noel Hartnett. Inspired by Clann na Poblachta, the Inter-Party Government decided that the question of a national film industry should be dealt with by the Industrial Development Authority (established in 1949).[9] Meanwhile Liam O'Leary was asked to provide the Cultural Relations Committee with suggestions for the making of films about aspects of Irish culture. The first film produced was *W.B. Yeats - a Tribute* (1950) and the second was a record of President Seán T. O'Kelly's pilgrimage to the Vatican, *Ireland - Rome* (1950). The next film was Liam O'Leary's *Portrait of Dublin* (1952), an affectionate but realistic documentary about the capital city. The film was suppressed by Frank Aiken, Minister for External Affairs, after Fianna Fáil returned to office in 1951.[10] Ridiculous reasons were put forward to justify the censorship but, in truth, the motive was revenge for the making of *Our Country.* Liam O'Leary never made another film.

The emphasis on international affairs also led to the launch of the Irish News Agency and of the *Bulletin of the Department of External Affairs* in 1949. The following year, the Dollar Exports Advisory Committee was established to promote international trade between Ireland and the United States. In 1952 Fianna Fáil expanded the committee to form An Córas Tráchtála, the Export Advisory Board, which was charged with the promotion of trade with all countries.

There was a marginal increase in the population of the twenty-six counties from 1946 to 1951, the first increase since 1841.[11] It would be wrong to assume that this signified the end of emigration. While the Taoiseach was declaring a period of prosperity, Irish citizens were emigrating at the rate of 24,000 per annum.[12] This is the peculiarity and the difficulty of assessing these years. Signs of progress must be situated against a background of under-development, high emigration (8 per 1,000), unemployment (7.3%)[13] and poor housing and sanitary conditions (61% of private dwellings had no piped water supply,[14] 62% had no fixed bath, 62% had no flush lavatory and nearly one half had no special sanitary facilities[15]). The number of persons living in overcrowded conditions (more than two persons to a room) was high despite a decrease from 27.2% of the population in 1926, to 22.5% in 1936, to 16.8% in 1946.[16]

Similar contradictions and difficulties are encountered in attempting to assess the cultural state of the nation in this period. T.J. Barrington has written of Ireland as 'a vast intellectual scrubland in which, for a whole generation, virtually no cultivation had taken place'.[17] Seán O Faoláin argued in 1951 that

'we are snoring gently behind the Green Curtain that we have been rigging up for the last thirty years'.[18] In the same year, John Ryan wrote of 'the ghastly intellectual climate'.[19] Writing in 1975, with hindsight, Ryan took a different view:

> The period 1945-55, for the arts in Ireland, was a particularly rich one...many factors conspired to make the new decade the prolific one that it turned out to be, and not the least of these was a universal reaction following the insularity of the wartime years of neutrality. The windows had been flung open and intellectually speaking, people were breathing again.[20]

Harold Pinter who toured Ireland with the actor-manager, Anew McMaster, has also recalled the period in affectionate terms: 'Ireland wasn't golden always, but it was golden sometimes and in 1950, it was, all in all, a golden age for me and for others'.[21] There is indeed ample evidence to suggest that the post-war period in Ireland was, if not quite a golden age, a time of increased cultural activity.

The international atmosphere in the post-war period was marked by discontent, fear of communism and of another war. The mood of these years is captured by the major works of drama and literature which it produced - Albert Camus's *La Peste* (1947), Arthur Miller's *Death of a Salesman* (1948), Samuel Beckett's *En Attendant Godot* (1949) and George Orwell's *Nineteen Eighty-Four* (1949). Ireland remained sheltered from these international trends but, from the roots of her own introspection, a vibrancy was beginning to emerge. The critic, Edward Sheehy, observed in 1950:

> that our very isolation created here a feeling of individuality and self-confidence; or alternatively and perhaps simultaneously the very precariousness of our chosen isolation demonstrated even more strongly than involvement that we were part of modern Europe and not, as some would pretend, an exotic and miraculous survival from a Celtic Middle Ages.[22]

Open discussion was stimulated by established literary periodicals like *The Bell, The Irish Monthly* and *The Dublin Magazine* and by the emergence of *Irish Writing, Poetry Ireland* and *Envoy*.[23] The burden which *Studies* had long carried as Ireland's foremost religious and intellectual periodical[24] was lightened by the arrival of *Christus Rex* (1947), *The Furrow* (1950) and *Doctrine and Life* (1951).

Among the important literary works written in Ireland during these years were Patrick Kavanagh's *Tarry Flynn*, Denis Devlin's long poem *Lough Derg* Mervyn Wall's satirical novel *The Unfortunate Fursey* and Walter Macken' romantic novel *Rain on the Wind*. The censorship laws, which Robert Graves described as 'the fiercest literary censorship this side of the Iron Curtain',[25] ensured that the works of many Irish writers were banned in their native country.

The state of Irish publishing was poor and output minimal. In the period 1938 to 1948, Irish publishers produced 555 books, of which 31 were in Irish - an average of 55 books published per year.[26] Some of these books were of high quality and a small dedicated group of publishers was attempting to increase standards and output. In 1951 Liam Miller founded a progressive little company, Dolmen Press, which began to produce books which quickly became collector's items.

Irish language writing was also being revitalised. New periodicals appeared - *Comhar* (1942), *Inniu* (1943) and *Feasta* (1948) - which were as open to European intellectual currents as any of their English language counterparts. The publications of *An Gúm* continued but the real impetus came from Seán O hEigeartaigh's publishing house, *Sairseal agus Dill*, which was established in 1945. *An Club Leabhar* was formed in 1948 and it provided a guaranteed circulation for books in Irish. These initiatives bore fruit in the writings of Seán O Riordáin, Máirtín O Direáin and Máirtín O Cadhain whose novel *Cré na Cille* (1949) was acclaimed widely. In 1955 David Marcus felt sufficiently confident to declare that:

> During the last ten years or so Gaelic writing in Ireland has moved into a new era...and among the new writers which this activity has produced are many whose freshness and modernity might be said to have given Irish literature in Gaelic something it never had at any previous stage of its long development - an *avant garde* movement.[27]

While drama at the Abbey Theatre had reached its nadir in 1947 when two young writers, Roger McHugh and Valentin Iremonger, interrupted the interval of an O'Casey production to protest at the quality and policy of the theatre, it showed signs of hope the following year with the performance of M.J. Molloy's *The King of Friday's Men*. The Abbey players were reorganised in an attempt to match the cast in the Longford Productions at the Gate Theatre. The formation of the Radio Eireann Players in 1947 by Roibeárd O Farachái assured the place of drama in Irish broadcasting.[28]

There were optimistic signs in the visual arts too. The presence of the Irish Exhibition of Living Art was a vital factor for change.[29] Irish artists gained

*Jack B. Yeats* *Evie Hone*

international recognition, especially Jack B. Yeats who was proclaimed a painter of international stature following a retrospective exhibition at the Tate Gallery, London, in 1948. Evie Hone's magnificent Eton College Chapel Window (1948) was considered to be a masterpiece of stained glass work.

A concern for the environment was apparent in the establishment of *An Taisce*, the National Trust for Ireland, in 1948. Architecture was jolted from a state of apathy by Desmond Fitzgerald's Collinstown Airport Terminal Building (completed 1943, now Dublin Airport) and particularly by Michael Scott's design for Busárus, the Central Bus Station in Dublin (completed 1953).[30] The Bus Station was the biggest single building project started in Europe after the end of the war. It attracted international attention among architects and brought Michael Scott fame and recognition. The building cost one million pounds to build and was detailed meticulously with portland stone, mosaic columns and handmade bricks. The willingness of the Government to allow funds to be used on radical designs like the Airport Building and Busárus constituted a public statement that a new era was emerging.

The level of activity in the field of music led one critic to write that it was 'in the healthiest state of any of the arts'.[31] Another critic took a disturbing view: 'the unpleasant fact is plainly emerging that music in Ireland, in spite of superficial appearances, is in a shocking state'.[32] Although Radio Eireann had established separate Symphony and Light Orchestras in 1948, on the initiative of the Minister for Posts and Telegraphs, Paddy Little, there was widespread dissatisfaction at the Government's failure to provide a national concert hall.[33] There was, however, a new concern to improve the situation rather than talk about it. In 1947 the Music Association of Ireland was formed with the principal aim of securing a state subsidised concert hall. It was also encouraging when a full-time chair of music was founded at University College, Cork, in 1948. Amateur involvement in choral societies, orchestras and music teaching demonstrated the popularity of musical activity. Traditional Irish music showed the beginnings of organised revival with the founding of Comhaltas Ceolteóirí Eireann in 1951.

The success of the post-war British 'festivals' culminating in the Festival of Britain,[34] encouraged the launch of the first Wexford Opera Festival in 1951. Sir Compton MacKenzie claimed credit for inspiring the Wexford Festival, of which he was made President,[35] but it was really the work of an enthusiastic group of Wexford people led by the dynamic, Dr T.J. Walsh.[36] The festival was modelled on the Aldeburgh Festival[37] and it soon became an important national and international event. The Festival was glamorous, had an excellent

*Dr T. J. Walsh*

programme, was well-publicised and much-reviewed. An editorial in the *Irish Independent* stated that: 'Wexford has just given a lead which could with great cultural benefit be followed by other towns throughout the country'.[38] The Festival was described by the *Sunday Times* as 'the most ambitious venture of its kind in years'.[39] The *Boston Globe* regarded the event as a milestone: 'its promise for the future is so encouraging that Irish art circles hold it to have been the most constructive cultural step taken by the nation since the founding of the Abbey Theatre 50 years ago'.[40]

Wexford was the first of many towns to establish a cultural festival during the 1950s. There was a corresponding decline in the growth of 'feiseanna' - music festivals which promoted Irish music, language, drama and dance. Eamonn O Gallchobhair, Director of Music at the Abbey Theatre, composer and adjudicator, described the 'Feis' as:

> a "political" gesture, an assertion of the distinctiveness of Irish separatism, originally motivated by the idea of the rehabilitation of old-time Gaelic culture. Some ill-defined idea lay embodied in the Feis of the pure, noble, upright, hard-working and Irish-speaking peasant as the chosen custodian of this old and better way of life, and early Feiseanna were displays of peasant culture, in the same way as the old "Pattern" was a display.[41]

Post-war Ireland saw 'the battle joined between Festival and Feis: it is the old political battle fought ideologically'.[42] This is perhaps an over-statement but it illustrates the underlying move away from the concerns of an Irish Ireland. There was a growing acceptance of the so-called 'high art' forms - opera, classical music and ballet.

In July 1951, a group of teachers attending a summer course in music organised by the Department of Education and held at University College, Dublin, founded what became known initially as the 'School Concerts Association'. The aim of the association, which was renamed 'Ceol Chumann na nOg', was to give school children an opportunity they might not otherwise have had of hearing classical music. A brief explanatory introduction to the music and instruments of the orchestra was a special feature of the concerts.[43]

A concern to interest Irish school children in the art of dance was a feature of the Cork Ballet Company, founded by Joan Denise Moriarty. The first performance of the new Company took place on 1 June 1947 with music provided by the Cork Symphony Orchestra conducted by Professor Aloys Fleischmann. This performance launched Miss Moriarty's lifelong struggle to maintain a ballet company which would develop dance in the schools, use

*Joan Denise Moriarty*                    *Muriel Gahan*

Irish dancing as material for choreographers, and tour its productions throughout the country.[44]

With all the privately sponsored efforts to advance the arts in Ireland, it might be suggested that a cultural revolution was in progress. This was partly a product of rapid urbanisation and partly recognition by the public that, compared to other countries, Ireland's record of official arts policy initiatives was poor. Fianna Fáil failed to realise any of its ambitious schemes although much time and effort was spent on them. It is difficult to say whether de Valera's government would have implemented them if it had been re-elected in 1951. Without doubt, a Cultural Relations Committee would have been appointed and perhaps the plan for a new National Library would have proceeded. What is clear is that Fianna Fáil left its successors with much to be done.

Although it was not acknowledged publicly, the Inter-Party Government had no intention of embarking on expensive cultural initiatives. It was decided that while launching the programme to improve standards of housing and

hospitals, the Government would have to cancel many of the capital projects which had been under consideration by Fianna Fáil. Included on a list of 'Projects to be dropped' were the plans for a national concert hall and cultural centre (at the Rotunda premises), a national library (at the Wilton Place site) and a Broadcasting House (at Stillorgan).[45] Having thus rid the Government of inherited proposals, Costello was saved from charges of total philistinism by the ideas of Thomas Bodkin. It had been a long time since Bodkin had acted as arts adviser to an Irish government. With the return of Fine Gael to power, he had his chance again and he seized it with vigour. He and Costello had been friends for twenty years so he had guaranteed access to the Taoiseach.[46]

Bodkin wrote to Costello enclosing a pamphlet titled 'The Importance of Art to Ireland'.[47] This was the published version of the lecture which Bodkin had delivered in 1929 at Rathmines which had led to a row with the Minister for Education. Despite its tainted history, Bodkin wrote: 'Its main ideas are still, I think, valid...I wish, vainly, that I had a dozen for circulation among your cabinet'. He informed Costello that he was going to write:

> a short memorandum on what I think I might be able to do in the cause of art in Ireland, if you thought fit to call me back to that service. Apart altogether from my desire to be useful in my own country, I hanker to serve under your banner; but will need a little time to weigh the pros and cons before I can submit anything definite for your consideration.

If Bodkin was anxious to create a job for himself, Costello had every intention of assisting him. Costello was familiar with Paddy Little's proposals and thought that Bodkin could help to implement them. Costello told him: 'the primary object to be looked to is your own personal desire'. He continued:

> I mentioned the matter to my colleagues who are very anxious to avail of your services. I think they would prefer to get you altogether if you are agreeable and perhaps you would consider whether it would be possible to bring this about and, if so, what sort of post should be created. I do not think there would be any necessity to do it by statute.[48]

Bodkin replied suggesting that the Taoiseach should appoint him as a Commissioner for Arts: 'What I look for is enough to live on in decent comfort in Dublin with a guarantee of continuous congenial employment'.[49] He noted that his salary for the previous few years had been about £3,000. He failed to see this as a tall order. The salary which Costello received as Taoiseach was £3,000.[50]

Bodkin felt encouraged by the involvement of the Department of External Affairs in promoting Irish culture abroad: 'The way in which the modern state is fostering the arts for the sake of prestige and international relations is very striking'.[51] Something needed to be done however to develop the arts in Ireland. Costello obviously agreed because he set about trying to persuade the Minister for Finance to allocate some money to the arts. The Minister, Patrick McGilligan, was not pleased at the idea of further expenditure at a time when he was appealing to government departments to cut their estimates. Costello told Bodkin that 'the atmosphere was not favourable' but he added: 'I still have great hopes and undiminished enthusiasm'.[52] Costello decided that before any initiative could be launched, it was necessary to have a criticial assessment of the state of the arts in Ireland. In July 1949, the Taoiseach, on behalf of the Government, requested Bodkin to write a document to be titled 'A Report on the Arts in Ireland'.[53]

Costello announced the decision when presenting the Estimates for the Department of the Taoiseach in the Dáil on 20 July 1949. Having dealt with agriculture, industry and unemployment, he announced:

> While we are concentrating on our material advancement, we should not, I think, neglect matters of the spirit. We should not neglect the effort to foster, and if necessary to create or recreate, a proper national tradition in art, and the necessity that there really is and the scope there is, for the application of art to industry, the revival of handcrafts and the old arts and crafts for which the Irish were so famous in years gone by.[54]

Although there was no money specifically in the Estimate, the Taoiseach asserted that it was government policy to advance the arts. It was noteworthy that Costello chose an economic argument as his primary motive. The promotion of the arts had to be justified as a cost effective exercise by referring to the advantages of the application of art to industry. It would 'bring spiritual good and material advancement to this country'.[55] The Taoiseach described Bodkin as 'an Irishman who has won fame and distinction for himself and brought credit to his country'. It was appropriate, he said, that the Government should have asked such a distinguished expert to write a report on the arts. Not everybody shared Costello's enthusiasm about Bodkin. It was known that Bodkin disliked de Valera and Fianna Fáil feared that he would have a jaundiced view based on his previous bad experience in Ireland before he moved to Birmingham.

Bodkin was aware of the difficulties of his task but he set to work without delay. He spent six weeks in Dublin, from 16 July to 31 August, making his

enquiries and another month writing his report. It was submitted to the Government on 4 October 1949. In a private letter to Costello, Bodkin wrote:

> I'm afraid it will provoke adverse comment on its author: but I'm prepared for that, as I'm conscious of having no axe to grind and no old score to settle, while believing that no good way can be cleared for the proper functioning of the Arts in Ireland without a preliminary survey of the existing situation.[56]

Beginning with the National Museum which received the most severe criticism, Bodkin reviewed the state of the National Gallery, the National College of Art and provincial art schools, the Royal Hibernian Academy, school and university arts education, design in industry, the promotion of Irish culture abroad, the preservation of monuments and sites, the Irish Tourist Board, and photography in the Public Service.

Bodkin was not in conciliatory mood. He described the historical collection in the National Museum as:

> an unscholarly and tendentious collection, likely to do more harm than good to the taste of our people and to excite the ridicule of intelligent foreigners. A major proportion of the objects exhibited are trivial or ridiculous and owe their inclusion to misconceived sentimentality.[57]

The Museum shop had three pictorial postcards on sale only. The Museum, in general, presented 'an uncomfortably overcrowded appearance', was 'cluttered with surplus exhibits' with 'articles piled carelessly into show-cases and unlabelled' and was 'housed in a building quite unsuitable for its purpose according to present-day ideas'.[58]

The National Gallery was 'notoriously badly housed' and appeared 'to be in a stagnant, if not moribund, condition'. Lectures about the contents were not given either in the Gallery or elsewhere. There were six pictorial postcards on sale and applications for a grant towards the publication of additional postcards had been consistently refused by the Department of Finance.[59]

There was a neglect 'amounting almost to contempt' for art in the educational system: 'The present apathy, amounting almost to antagonism, towards Art in Ireland is largely attributable to that lack of opportunity for study of the Arts at a high level from which our best minds have suffered for so long'.[60] Bodkin argued that: 'no civilised nation of modern times has neglected art to the extent that we have done during the past fifty years'.[61]

The Irish Tourist Association was criticised for the general standards of its publications. They were 'lamentably inartistic', 'unpleasant', 'clumsy' and

'generally crude in the extreme'. These adjectives were 'also applicable to many of the publications of the Stationery Office', which were 'singularly indifferent to appearances'.[62]

Having thus stated the depressing condition of the arts in Ireland, Bodkin concluded with a major proposal: 'I think it desirable that a Department or sub-department of Fine Arts should be established as a branch of some Ministry or, preferably, directly under the control of the Taoiseach'.[63] This sub-department would correlate and supervise the administration of existing art institutions. It would also act in an advisory and consultative capacity to Ministries requiring its services. Bodkin proposed a wide brief in charging the sub-department with 'direct responsibility' for the administration of the National Gallery, the National Museum and other institutions; the planning of arts education; the provision of designs for coins, medals, seals, stamps and uniforms; the supervision of official publications; the organisation of State ceremonies; the organisation of exhibitions and of a photographic archive; a limited amount of patronage of living artists; the campaign for the return of the Lane Pictures; the promotion of industrial design; the supervision of national monuments; the organisation and control of archaeological excavations; responsibility for State buildings; and the supervision of town planning.[64]

It would be difficult, Bodkin thought, to find executive officers trained to promote cultural activities and this led him to suggest that as well as a sub-department, the Government might consider the establishment of another 'less formal body' which might be titled the Arts Commission, the Board of Arts, the Institute of Arts or the Arts Council of Ireland.[65] It would be 'a quasi-official body' empowered 'to plan and execute schemes for the promotion and application of the arts'. Members would be appointed by the appropriate Minister of State, with a Director or Chairman appointed by the Government. The members would hold office for a fixed renewable period, and would have an annual grant-in-aid to spend subject to the presentation of an annual report to the Dáil. This had been the scheme used by the Arts Council of Great Britain and it had worked well.

There is no evidence that Bodkin had seen Paddy Little's revised memorandum of January 1945 which proposed a Council of Culture. Bodkin did not need to see it. His proposals were based on his own memorandum of 1922 and on the recent developments in Great Britain which he had witnessed at first hand. But the Department of the Taoiseach made use of Little's more specific plan when the heads of an Arts Bill were being drawn up to establish the Arts Council. Little and Bodkin shared a strong desire to become Director

of the new institution. Bodkin mentioned that the Director of the Arts Council of Great Britain was 71 years of age in order to offset any objection that he himself was too old for a similar Irish job at the age of 63.[66]

Costello welcomed Bodkin's honest appraisal and thanked him for the work he had put into its preparation. The Taoiseach suggested a few minor changes to the report. Bodkin agreed to the changes signing his letter 'yours obediently and sincerely'.[67] The amendments included the removal of certain phrases which could have been interpreted as criticism of the civil service, of Fianna Fáil, or as anti-nationalist comments.[68] Other provocative comments were not deleted, for example, Bodkin wrote that: 'A reprehensible amount of iconoclasm has been prevalent in Dublin of recent years under the excuse of patriotism'.[69] He was against the removal of Nelson's column from O'Connell Street but felt that: 'No one could dispute the propriety of removing Queen Victoria's monument from the front of Leinster House'.[70]

The members of the Government who read Bodkin's report must have recognised that, if accepted, its proposals would involve a revolution in arts policy. They implied a progressive leap towards the concept of an integrated cultural policy. No revolution occurred but instead, a modest initiative, the weak and under-financed Arts Council, was launched. In advancing his radical proposals, Bodkin realised that: 'It is not until Art has won an honourable place in public estimation that the emergence of individuals who are not merely aware of art but inspired to action by it can be expected'.[71] Bodkin hoped that Costello would be his revolutionary. He wrote: 'I have excellent reason to think that Mr Costello is deeply interested in the cause of Art in Ireland, more so than any Irish statesman for the last fifty years'.[72]

The Taoiseach knew that he had to act quickly because his multi-party government might fall from office at any time. The Parliamentary Draftsman was requested to draw up a Bill and within a year (a relatively short time for the preparation of legislation), Costello was in a position to try to persuade the Dáil of the worthiness of his proposals for an Arts Council. The scheme was essentially that proposed by Paddy Little. This was a very limited and meek response to Bodkin's challenge. Costello admitted that the Bill represented 'a less ambitious approach' and said that it departed 'slightly' from Bodkin's recommendation.[73] Bruce Arnold has censured the Dáil harshly for agreeing to a Bill which 'watered down the objective' and for failing to recognise its 'hopeless inadequacy...and even its potentially damaging effects on the very areas they wished to put right'.[74]

It is easy to criticise the mean aspects of the Arts Bill but it is important to note that many thought, at the time, that the proposed measure was far too generous. Costello told the Dáil: 'I must admit that it was with a certain

amount of trepidation that I brought forward this Bill'.[75] Although his fears were understandable because the Bill was the first of its kind, the Dáil and Seanad gave it an unperturbed and speedy passage.

The major casualty as a result of the diluted nature of the Arts Bill was the ill-fated Professor Bodkin. Throughout the year 1950, he did his best to ensure that his report would avoid the fate of the previous reports which he had helped to prepare about the Dublin Metropolitan School of Art and the National Museum. He wrote to Costello expressing his worry: 'I sometimes feel that some of the departments to whom it has been sent for comment will, not liking its strictures, do their best to suppress it'.[76] The *Irish Times* told its readers that the Bodkin Report had been doing the rounds of government departments for months, 'in which event we expect - if ever - to see it in a couple of years hence'.[77]

It was true that the Report was being circulated to the relevant government departments and cultural institutions.[78] The most supportive response was submitted by the Minister of Agriculture, James Dillon, who showed an enlightened attitude to the promotion of good design in industry and advertising. He named those he wished to see as members of the new Arts Council and, as a first step towards cultural progress, suggested that there should be full-time directors of the National Gallery, National Museum and National Monuments Service. He agreed that Bodkin would be the best person to head the Arts Council and proposed that £25,000 would be a good starting figure as a grant-in-aid.[79]

The most irate response was written by Liam Gogan, Keeper of the Art and Industrial Division of the National Museum. He took Bodkin's criticism personally and wrote angrily to the Department of the Taoiseach: 'The Reporter has clearly no criteria at his disposal, or at any rate does not reveal them'. He accused Bodkin of 'inexperience', 'carelessness' and 'iresponsibilty'.[80] Curators like Gogan were undoubtedly doing their best with limited resources and they received little support from the Government. Bodkin was convinced that the situation would change if the Arts Council was given adequate powers. He told Costello: 'The Chairman should have the title Director of Art and exercise a somewhat similar relation to the Government in connection with matters concerning the Arts as that exercised by the Attorney General in legal matters'.[81] This comment showed that Bodkin had no idea of political realities. He was also, like Dillon, ambitious about the funds for the proposed Council: 'To make a start to rehabilitate the arts in Ireland an annual grant of £25,000 would be exceedingly moderate. But would there be a chance of getting that much from an Irish Minister of Finance?'[82]

Bodkin flooded Costello with obsequious and suppliant letters with comments like: 'I want to convince you, and I'm sure I can do so, that I would dearly like to be working in and for my own country, if I were sure of being able to do so under conditions that make me of real use'.[83] Another letter was more explicit:

> If you think fit to offer me the post of Chairman as I propose I shall accept it promptly and look forward eagerly to serving the cause of Art in Ireland to the very best of my ability under your direction.[84]

Costello did not need to be pushed so hard. He was anxious that the public should know about his commitment to the arts.

The presentation of an important collection of paintings to the National Gallery, the gift of Alfred Chester Beatty, gave Costello the opportunity to deliver the first important speech by an Irish government leader on the duty of the State to support the arts.[85] He told the 220 invited guests at the lavish presentation ceremony on 6 September 1950:

> We have still to establish our own national tradition in art. Such a tradition, the growth of which has been stunted by centuries of oppression and neglect, cannot be created by tariffs or quotas, still less by prohibitions on the import of artistic ideas. To the extent to which conditions wherein such growth may blossom and thrive can be fostered or created, it is the duty of the State and of statesmen to lend their aid.

It is tempting to call this 'a polite example of political breast-beating',[86] especially when Costello went on to say: 'These new and splendid possessions which we take over today should inspire us, accordingly, to continue unfalteringly, the long campaign for the restoration of the Lane Pictures to the city of Dublin, for which Sir Hugh Lane destined them and where there is now better reason than ever for their presence'.

The continuing sore point about the Lane Pictures was alleviated to some extent by the Chester Beatty gift. The American-born copper-mining magnate was, during the next eighteen years, to present further gifts to the Irish nation, culminating in the bequest of his world-renowned library of manuscripts and printed books. The manner in which the Irish Government dealt with Beatty was singularly enlightened but it had more to do with politics than culture.[87] His presence in Ireland encouraged the Government, however, to take an overt interest in cultural matters. It was hoped that other patrons would soon emerge to continue Beatty's generous example.

A month after Costello's eloquent speech declaring that the State should

*Sir Alfred Chester Beatty*

foster the arts, Maurice Moynihan, Secretary to the Government, sent the Taoiseach some observations on the Arts Bill.[88] He noted that the Bill proposed to allocate £20,000 to the Arts Council although Bodkin had suggested £25,000. If the Director's salary was £2,000 (plus £1,000 earned as Professor of Fine Arts at University College, Dublin, which had agreed to establish a post for Bodkin), and office and travel expenses were £2,500, this left £15,500 only for the promotion of the arts. Moynihan also suggested that: 'Failure to adopt an Irish title for the Arts Council would provoke adverse comment'. He approved of the title 'An Chomhairle Ealaíon'.

Whereas Moynihan had intimated that the amount proposed for the Arts Council was too small, J.J. McElligott, Secretary, Department of Finance, was concerned that it was too much. The battle to prevent deficit budgeting had been lost but now the Government was attempting to use State funds to subsidise what the Department of Finance viewed as a luxury. McElligott told Moynihan that 'the Minister cannot accept any proposals of a non-essential character'.[89] As C.S. Andrews noted, Adam Smith's philosophy was still governing the thinking of Finance officials:

They took the view that the function of the Government was to maintain law and order, collect the revenues and prevent money being disbursed from the Exchequer for any avoidable reason...they felt no obligation to improve living standards.[90]

The arrival of Keynesian economics was a painful process and it was with bureaucratic reluctance that the State moved towards comprehensive economic planning.[91] Seán Lemass had warned the Inter-Party Government: 'Beware of the Department of Finance. It has always been restrictive of development'.[92] Costello was determined to use his political power to over-rule Finance although he stressed that he had 'the greatest admiration' for the Department's officials.[93]

On 15 November 1950, the Government considered a memorandum, 'Proposed Establishment of the Arts Council', prepared by the Department of Finance.[94] It began:

> The Minister is facing a most critical budgetary situation. While it might be contended that £20,000 a year is not a very considerable sum, the Minister for Finance has reason to apprehend that the expenditure resulting from the activities of the Arts Council could not in practice be limited to £20,000 a year.

The memorandum stated that government expenditure on culture in 1950-51 was £228,628. Of this sum, £105,816 was already devoted to grants to independent cultural institutions. Most of the other grants helped to fund projects to advance the cause of the Irish language. The Department of Finance considered that the new Council should not subvent drama and literature in English because to do so represented 'a reversal of the policy adhered to by successive governments since 1922'. This was untrue because the State had since 1925 given a grant-in-aid to the Abbey Theatre. The memorandum continued: 'It would be desirable that the Director and members of any body charged with functions in relation to drama and literature should have a sound knowledge of Irish'. Given that Bodkin could not speak Irish, he was ruled out as a possible Director. To emphasise the point, it was stressed that the public might not like Bodkin's criticisms and therefore the Department of Finance considered the whole concept of an Arts Council to be ill-advised. The memorandum concluded: 'The Minister for Finance would not welcome any addition at the present juncture to the number of semi-state organisations already in existence at the expense of the exchequer'.

The Government decided to ignore the Department of Finance's views.

Costello wanted Bodkin as Director whether he spoke Irish or not. A memorandum for government was prepared by the Department of the Taoiseach presenting the positive case for an Arts Council.[95] It would undertake the kind of work discharged by the Arts Council of Great Britain. The Taoiseach proposed that it should receive a grant-in-aid not exceeding £20,000 per annum but normally the grant should not be substantially lower than the maximum figure in any year. Four main points were advanced in support of the proposal. The Taoiseach wished that the country should no longer suffer from Bodkin's reproach that no civilised nation of modern times had neglected art to the extent Ireland had in the previous fifty years. The proposed Council could be justified 'on strictly utilitarian grounds'. There were also strong cultural reasons 'demonstrating the national advantage from the encouragement of the arts, crafts and artistic technique and design in industry'. Finally the Taoiseach 'urged that apathy or preoccupation in urgent governmental executive or administrative matters should not be allowed to delay action on Dr Bodkin's Report'.

Every government department except Local Government provided observations on the memorandum.[96] In general the standard of the observations was poor. The Government approved the Taoiseach's proposal on 28 November 1950 and decided that the draft Arts Bill should proceed subject to certain alterations: that provision be made for the name of the Council to be 'An Chomhairle Ealaíon or (in the English language) The Arts Council'; and that the words 'and with due regard to fostering the development of Irish music and of original literature and drama in the Irish language' be added to the Bill at the suggestion of the Minister for Education, General Richard Mulcahy.[97]

The following day, the Taoiseach introduced the Arts Bill in Dáil Eireann and declared that the Second Stage debate would take place a week later on 6 December. The rush had become unseemly and the Taoiseach's own Department advised him that it would be best to first test public reaction and, in particular, find out what Bodkin thought of the Bill. Bodkin had not yet seen it but wrote to Costello of his hope 'to get a formal invitation from you to come back and work in Ireland. If so, I shall certainly accept it and come as soon as I could'.[98]

Newspaper reaction to the Arts Bill was entirely negative. Paddy Little must have winced at an editorial which appeared in the Fianna Fáil controlled *Irish Press* titled 'Advisers on Art'.[99] The editorial bemoaned 'still another advisory body' and considered that: 'A lot could be done by spending £20,000 annually in the cultural sphere, but it would be of more help if it went towards

encouraging art rather than in paying officials to tell the Government how best the arts should be encouraged'. It appeared that the Government could do nothing but create advisory bodies. An Emigration Commission, an Industrial Authority, a Council of Education, a Prices Advisory Body - all these had been established since 1948. Continuing the Fianna Fáil party political broadcast, the editorial sneered: 'Now comes the proposal for a Council of the Fine Arts, which appears to be another example of "passing the buck", a practice which the coalition is developing into one of the fine arts'.

An article in *The Leader* suggested that it might be better to give more money to established cultural institutions than to set up another one: 'We are not so sure that the proposal represents a good investment from either an intellectual or from a budgetary standpoint'. It was doubted that any Director, no matter how distinguished, was 'worth £20,000 in the circumstances'.[100] This was not the view of the Government. At a Cabinet meeting on 19 December, the Taoiseach was authorised to convey an offer of appointment as Director of the Arts Council to Professor Thomas Bodkin.[101] Costello enclosed a copy of the Fine Arts Bill, 1950, with his letter to Bodkin and said that he hoped to be in a position to appoint him by 1 April 1951.[102]

In reply to Costello, Bodkin said that he would study the Bill and added: 'I am greatly obliged to you'.[103] A few days later, he wrote to the Taoiseach expressing the reservation: 'Unfortunately I know no Irish which, in view of the terms of the Bill for the establishment of the Arts Council, would seem to put me in a difficult position'.[104] Costello reassured him: 'As regards the Bill and the provisions as to Irish literature, drama etc, you need not worry about your supposed lack of knowledge of those matters. They were put in to forestall criticism if they had been omitted'.[105]

On 11 January 1951, Bodkin's *Report on the Arts,* published by the Stationery Office, was released to the public. The newspapers gave it little attention beyond some articles summarising its contents.[106] The response was disappointing for Bodkin and it convinced him that the Irish public still had little care for the arts. Bodkin wrote his formal reply to the Government on 29 January. He thought the offer of the Council directorship a 'great and much appreciated honour' but he deeply regretted that 'having regard to the terms of the Fine Arts Bill, 1950, I find I cannot accept it'.[107] He set forth three reasons why he felt that he had to decline the offer. Firstly, he had assumed that the Arts Council would be answerable to the Taoiseach and, under the proposed Act, it was controlled by the Minister for Education. Secondly, there was to be special regard to the desirability of developing Irish music and original drama and literature in the Irish language. This was a change from Bodkin's emphasis

on the visual arts and it involved an area in which he was not competent. Thirdly, he objected to the clause which referred to the annual grant of the Arts Council as 'not exceeding £20,000'. He concluded with the bitter reflection that the conditions of service of the Director had not been specified except with regard to salary ('which is far less than I have earned for many years past') and:

> My previous experience as Director of the National Gallery (at a salary of £200 a year without pension or retiring allowance) has shown me that no one should take up office as a servant of State without prior consideration and settlement of all the terms of his employment.

Costello replied wearily:

> I was not wholly disappointed by your attitude. It added rather a further weight of discouragement. As you know, the whole purpose of my efforts was to secure your services but I felt that I could not, in conscience, press you unduly.[108]

The reception given to the Arts Bill had been dismissive, so much so that Costello wrote:

> For some time I felt greatly inclined to drop the whole business but within the last few days, having a breathing space, I examined the Bill criticially and have come to the conclusions (1) to have the Bill re-drafted and (2) to proceed in face of discouragement and even if it involves doing without your help on which the whole scheme of things originally rested.

The Taoiseach considered that he had not examined the Bill closely enough himself: 'I allowed myself to be unduly influenced by the advice from the Secretary and the Assistant Secretary of my own Department to the effect that responsibility should be placed on the Minister for Education'. As for the grant to the Arts Council, he wrote:

> I also myself reduced the sum from £25,000 to £20,000 to ease Finance approval...Finance did not object on the ground of amount but on the ground that whatever sum was put in (and they admitted the amount was not unreasonable) it was only a beginning to what, of course, they were, I hope, correct.

Costello admitted that he had given the Bill the appearance of placing 'undue emphasis on Irish literature, drama and music'.

On receipt of this honest statement, Bodkin's indignation dissolved. He wrote to Costello: 'I felt, in fact, a bit ashamed at writing you a letter that might have added something to your burdens. But I didn't write it without long thought and consultation'.[109] He repeated, in gentler terms, his objections to the Bill but he wished the Taoiseach every success in his efforts to promote the arts.

Costello had the Bill redrafted to take account of Bodkin's three objections. The Arts Council would be the responsibility of the Taoiseach and not of the Minister for Education. It would have no specific responsibility for Irish drama, literature or music, and there would be no upper limit on the grant-in-aid to the Council.

The only organisation to lobby the Taoiseach on the Arts Bill was the Gaelic League. Its members expressed concern that those appointed to the Arts Council would be people 'actively interested in the revival of Irish, though not necessarily all Irish speakers, and that State funds would not be used to foster drama and literature in the language of another country'.[110] On 2 April 1951, a deputation from the Gaelic League, led by its President, Annraoí O Líatháin, met the Taoiseach and the Minister for Education, General Mulcahy.[111] It was pointed out to the deputation that State funds already supported the Abbey Theatre and that it would be better to allow the Arts Council to support drama and literature in both Irish and English. Costello suggested withdrawing drama and literature altogether but this was unacceptable. The Gaelic League insisted on the inclusion of Irish language drama and literature. Faced with intransigence, the Taoiseach directed that the Bill should provide for drama and literature without reference to the language in which it was written.

The Second Stage debate on the Arts Bill took place on 24 April 1951.[112] The debate was not well attended judging by the comment of one Dáil deputy that: 'Art appreciation in this House is depicted very well by the number of people here to discuss the question of art. The Dáil at present reminds me of a room in the National Gallery any day of the week'.[113] Nevertheless, the nine speakers who contributed to the debate displayed an air of enthusiasm which surprised the Taoiseach. This was the first occasion since independence on which the Dáil had conducted a debate about the arts in Ireland and government policy towards them. Some of the contributions revealed underlying reasons why the arts had been neglected. It was beneficial to have them stated publicly.

The debate began with the Taoiseach's acceptance of the criticisms of the Bodkin Report. He declared:

> It is difficult to avoid coming to the conclusion that there was something in the nature of a deliberate policy to obstruct anybody who evinced any desire or inclination to do anything for the furtherance of art in Ireland or for the furtherance of the application of art to industry in Ireland.[114]

He accepted the criticisms of the Arts Bill: 'I am keenly aware, [it] does not go as far as I would like it to go, but nevertheless it is a beginning. I think it is a good beginning'.[115] Continuing in this vein, he noted that £20,000 spent on the arts represented 1½d. per head of population of the country.[116] 'That we should spend the small amount of money proposed in this Bill is, I hope, merely a beginning. That probably will be a great shock to the officials of the Department of Finance'.[117]

In reply to Costello, Thomas Derrig (Fianna Fáil) suggested that it 'was, perhaps, not fair to any particular government' to infer that there had been a deliberate anti-art policy. The reason for lack of progress was historical, Derrig said: 'we have had gaps of centuries in our history, when there had been very little effort, not alone intellectual or artistic, but when the people were hard put to it even to find an existence'. He expressed the familiar grievance:

> Those of us who have been associated with the movement that has brought about Irish independence have a right to be annoyed when we frequently see denigrations of Irish culture and a pretence that there was, in fact, no culture ever there; that there was no background to which we could look back; that we had no traditions of our own and that we were entirely thrown upon the resources of this Anglo-Irish school.[118]

Ireland had set the headline for Christian art in Europe back in the eighth century and even though there was an ascendancy class in eighteenth century Dublin which exercised patronage, they did 'not represent the ordinary Irish people'. Derrig associated 'real Irish art' with the glorious period before the Normans arrived to begin centuries of conquest. Ireland, independent once again, should strive to emulate the efforts of that great period.

Con Lehane (Clann na Poblachta) echoed Derrig's nationalist views and asked the Taoiseach to ensure that members of the Arts Council should be aware of the national aim to restore the Irish language. It was important to remember that Ireland was attempting to undo a three-fold conquest - cultural, political and economic.[119]

A humorous note was introduced by Seán Moylan (Fianna Fáil) who, in his characteristic no-nonsense style, said that 'art appreciation in this country is in a great measure associated with social snobbishness and anything that is based on pretence will have very little success in this country'. He elaborated:

A rough-neck like me, representing the general view throughout the countryside, is prone to picture in his mind, in approaching this question of art appreciation, a bare-headed young man with a beard and a young lady in slacks breathless in their appreciation of Picasso, particularly if the picture is hung upside down.[120]

Moylan offered his own proposal:

All our literary men, in order to live, have to become muck-rakers attacking their own country in foreign journals. Since they have to live, would it not be a good idea if, instead of spending money on an arts council, we provided something in the way of a Nobel Prize of literature in this country for the encouragement of those people so that they would not be obliged to be, like Joxer, derogatory of their own country.[121]

Maurice Dockrell (Fine Gael) thought that the sum of £20,000 mentioned as the appropriate grant for the Arts Council was too small. Paddy Little (Fianna Fáil) emphasised the importance of encouraging and stimulating voluntary activity and, therefore, 'the sum which is being allocated is a small one, wisely so'. He felt that literature should not be included in the Bill as it led to divisive arguments with the Gaelic movement. He also made the important point that: 'We can easily regard the development of our cultural activity as possibly the biggest dollar earning asset we have'.[122] Ireland could benefit greatly from cultural tourism. Little was modest in not alluding to his own role in the genesis of the Arts Bill. But by not doing so, the public was led to believe that the idea had started with Bodkin's Report.

Seán Collins (Fine Gael) supported Costello's encouragement of the application of art to industry. He hoped to see the revival of glasswork in Cork and Waterford, of weaving, lacework, rug-making, hand-painted delph and china ware. The Government would have to act as a 'kindly father'.[123] John McCann (Fianna Fáil) argued that £200,000 would be a more appropriate sum and he urged that the State should support artists by buying their pictures: 'Give the artist a free and untramelled mind. Free him of all these petty worries of everyday existence'.[124]

The final contribution to the debate came from the leader of the opposition, Eamon de Valera. As if it set some sort of enlightened precedent, he began his speech by reminding the Dáil that he had been attending a commemoration of Dante, organised by the Minister of Fine Arts, when he had received news of the signing of the Treaty in London in December 1921. He did not mention that the Ministry of Fine Arts had been disbanded the following month.

De Valera argued that the State's contribution to the arts was most obvious in the quality of materials used in its buildings. He offered the opinion that modern concrete buildings could never compare in beauty to those built in stone and marble. As these were expensive materials, the State would have to 'be prepared to pay the extra amount for really good work...and not be satisfied with things that are shoddy'.[125]

In general, de Valera was supportive of Costello's action in bringing forward the Arts Bill. Whether this reflected a change of heart or not is difficult to estimate but he had certainly been reluctant to support such a proposal when it had been pressed by Paddy Little. In any event, de Valera told the Taoiseach that he was glad responsibility for the Arts Council would not rest with the Minister for Education who had enough to do already.

De Valera repeated his oft-stated argument about the primacy of spiritual values:

> My own view is that if we are to have any place in the world we will get it only through the intellectual and, for want of a better word, the spiritual line. It is in that realm we can hope to have some pre-eminence, and everything that is proposed here to make us more outstanding along that line should get support from the House.[126]

He advised that the Government should not be worried about those who attacked measures to support the arts as 'providing silk hats for the barefooted'. The State must be first-rate in its public buildings and must try to beautify them. In this regard, he supported Professor Bodkin's view that the Dáil was 'sitting in a place never designed for that purpose', and its presence caused unnecessary crowding in the National Museum and the National Library.[127]

Costello was pleased with the favourable attitude of the Dáil towards the Arts Bill. He asked Patrick Lynch of his Department to inform Bodkin of his success. Bodkin replied: 'I was delighted to hear what must have been a great personal triumph for the Taoiseach...it occurs to me that the Taoiseach might honour me by asking me to withdraw my refusal to accept the post of Director of the Arts Council'.[128] This volte-face gave Costello further enthusiasm to steer the Bill through the Oireachtas quickly.

The Committee Stage was taken in the Dáil on 1 May 1951 and the time for fine speeches had ended.[129] Fianna Fáil scheduled five amendments, all supportive of the Gaelic League's promotion of Irish titles instead of English ones. They stimulated an interesting debate. Thomas Derrig argued that the Arts Council should be known by its Irish title, An Chomhairle Ealaíon. The Constitution stated that Irish was the first language and large state bodies like

Córas Iompair Eireann and Bord na Móna had operated successfully with Irish titles. If the Electricity Supply Board had originally been given its Irish title, it would probably have gained the same currency as the English one.

The Taoiseach disagreed with Derrig and although he credited the Gaelic League with doing something for the Irish language, he said:

> In my view - and I say this with all sense of responsibility - these suggestions have quite the opposite effect. They have the effect - and I have had experience of it - of causing mockery in getting the right effect from the peculiar pronunciation of these words, and generally sneers on the language, thus causing very serious damage to the language.[130]

De Valera intervened to say that while the Taoiseach's views had a certain amount of substance, 'there is an opposite point of view, namely, that the introduction of the words does help familiarise people with the language'. He continued:

> It is patchwork - I am quite willing to admit that - but is not it better for us to begin a letter with "A Chara" and end it with "le meas" than to use the English forms? Of course, it would be very much better if we could have it the other way, if the substance of a letter were in Irish and the introductory and concluding phrases in English but, until we reach the stage in which the letter as a whole is written in Irish, why not introduce it in this way, as is done in the case of street names, or other short phrases?[131]

Despite the weaknesses in this argument, Costello agreed on a compromise. The new organisation would be known as 'An Chomhairle Ealaíon' and there would be no stated translation in English. The legislation would however refer to 'The Council' instead of 'An Comhairle'. This was a legal nicety but Costello was not prepared to agree to an amendment that the head of the Council should be known as 'An Stiúrthóir'. He insisted that the English translation, the Director, should be used: 'I can see the type of thing "An Stiúrthóir" will be called. I can see the derisive turns that will be given to it'.[132] In addition to his fear that the Irish title resembled the word 'whore', Costello pointed out that the title 'Director of a Gallery' was in use world-wide and Ireland should keep in line with this custom. De Valera agreed to withdraw the amendment but he noted: 'we ought to make it clear that out wishes would be that, where there is an alternative title available, the Irish one would be used'.[133] This did not happen in practice and so it was that the post of 'Director of An Chomhairle Ealaíon' was created.

Following the relative ease of its passage through the Dáil, Costello became more strident when introducing the Arts Bill in the Seanad on 2 May.[134] He described the Bill as 'a constructive effort to stop the rot and to remedy the failure that has existed for so long'. He hoped 'to sow the seeds from which some useful growth will emerge'. The arts had 'been starved and shamelessly neglected since the establishment of this State...the conclusion is inescapable that we have been utterly neglectful of our duties in those respects during the past 25 or 30 years'.[135]

Thirteen speakers contributed to the Seanad debate and they reflected much the same thinking as had emerged from the Dáil. John O'Farrell shared Seán Moylan's disdain for modern art: 'When I see pictures exhibited by a lot of modern artists I wish that we had not any modern art. They are not painting; they are not pictures. If anything at all, they are a puzzle'.[136] Nevertheless, O'Farrell considered that the Arts Bill was 'one of the most important Bills that has come before the House since the last election. I attach more importance to it for the future of Ireland and for the industrial future of Ireland, than any other Bill we have passed here'.[137]

Edward A. McGuire agreed that the arts had been shamefully neglected but he said: 'I think we must not be too despondent because 25 years is a very short period in the history of a nation'.[138] The neglect of the arts was obvious in that there were no paintings or sculptures decorating the Seanad chamber and this was true of most public buildings and offices. He argued that an interest in art was not a form of social snobbishness or a sign of effeminacy. Everybody was capable of an appreciation of art. The subject was not even on the school curriculum. The Arts Bill was a vital piece of legislation and it was nonsense 'to talk of the expenditure of £20,000 on art as being a waste of time when our citizens are spending millions on sports!'[139] Senator McGuire also raised a sensitive and important issue based on his experience as a member of the Board of Governors and Guardians of the National Gallery of Ireland:

> A tendency in the past, especially under the Party system - we have had it on both sides - seems to be that the appointments of governors of museums and galleries are influenced by Party politics. People are appointed more because of their political affiliations than anything else.[140]

Mrs Helena Concannon was glad that the Taoiseach had removed the ceiling of £20,000 because this amount reminded her of a line from Horace: 'The mountains laboured and produced a ridiculous mouse'.[141] She supported the appointment of Professor Bodkin as Director of the Arts Council because 'it

will retrieve for this country someone who would be very valuable'.[142] The Countess of Wicklow (Eleanor Butler) said that there was 'a very mistaken idea that culture is something that can be overlaid on top of ordinary education in the way you can spread butter on bread'.[143] She thought that the best definition of a cultural nation was one in which the citizens did their work well with a creative spirit acting for the glory and honour of God. De Valera would have nodded approvingly.

The debate ended with the Taoiseach in more optimistic form. The passing of the Arts Bill was, he said, 'the fulfilment of a personal ambition going back over many years'.[144] He elaborated:

> Perhaps I was a bit gloomy in some of my opening remarks about the position of art in Ireland and the neglect of our arts and crafts. I think that, on the whole, we have no reason for pessimism. I think the debate on this Bill in the Oireachtas gives us reasonably good grounds for hope in the future. We are not, in this Bill at all events, erecting a tombstone for Irish art. On the contrary, I think that we are doing something of really constructive national value.[145]

The Arts Bill, 1951, was enacted by President Seán T. O'Kelly on 8 May. The ambit declared it to be:

> An Act to stimulate public interest in, and to promote the knowledge, appreciation, and practice of, the Arts and, for these and other purposes, to establish an Arts Council, and to provide for other matters in connection with the matters aforesaid.[146]

It is obvious that the Government had taken the soft option in establishing an Arts Council without attempting to place it within an over-all defined arts policy. But it is also true that the measure was the most significant step since independence towards the development of an official arts policy. John McGartoll of the Department of Finance acknowledged Costello's achievement when he wrote:

> Our examination of the Bodkin Report was directed, I think, to forestalling any extensive expenditure and to ensuring that if any Arts Council were established it would be established on a reasonably inexpensive basis. We failed in our purpose and further observations on the Report or examination of it now would be an obvious waste of time.[147]

Attention was turned instead to the appointment of the first Arts Council - An Chomhairle Ealaíon.

# CHAPTER SIX

## LIMITED MEANS AND AMBITIOUS ENDS: 1951-6

*The task of the Arts Council is to direct public opinion towards an enthusiasm for what has hitherto been regarded as something 'dark and strange'.*

PATRICK LITTLE

In June 1951, a month after the enactment of the Arts Bill, the Inter-Party Government fell from office. It was replaced by a Fianna Fáil administration which had to cope with imminent economic crisis. The 1950s was a sad decade in Ireland. Ronan Fanning has remarked: 'Irish society remained staid and stagnant, conventional and conservative, poverty-ridden and inward-looking'.[1] It was a decade of mass emigration with over 400,000 people leaving the country. By 1961 the population was 2.8 million, five per cent less than at the foundation of the State.

Although there was little funding available, Fianna Fáil was anxious to appoint the members of the new Arts Council and also to resuscitate the cultural projects which had been cancelled by the Inter-Party Government. In July 1951, the Government revived the Cabinet Committee established in 1948 to make proposals on cultural matters. Those appointed to the Committee were the Minister for Finance (Seán MacEntee), the Minister for Education (Seán Moylan), and the Minister for Posts and Telegraphs (Erskine

Childers). Paddy Little was no longer a member of the Cabinet although he was still a Dáil deputy. He was 67 years of age and was delighted with the prospect of assuming the directorship of the Arts Council. De Valera was pleased to be able to reward Little's sustained interest in the arts.

What exactly were the arts for which the Arts Council would have responsibility? A definition was provided in Section 1 of the Arts Act, 1951: 'the expression "the arts" means painting, sculpture, architecture, music, the drama, literature, design in industry and the fine arts and applied arts generally'. This legal definition set the limits of the Arts Council's field of action. There was ample scope for interpreting the definition liberally but its ambit demonstrated a fundamental shift in what were perceived officially to be 'the arts'. In effect, the international fine arts had been recognised as worthy of public patronage along with the national arts of traditional Irish dancing, music, storytelling and poetry.

De Valera sent Little to Paris and London to gather ideas for future activities of the Arts Council. In Paris, an extensive itinerary was prepared for Little by the Irish Ambassador, Con Cremin.[2] Interviews were arranged with eminent people in French cultural life. The level of contacts established exaggerated the true nature of the Arts Council. It was presented as an imposing and well-endowed institution when it had not even been established formally. In London, Little met officials of the Arts Council of Great Britain and of the Royal Academy of Arts. In a follow-up letter to Sir Gerald Kelly, President of the Royal Academy, Little explained the policy he hoped to pursue:

> I am advising that any cultural institution should be as free as possible from political or Governmental control. At the same time, as there are no patrons for the Arts now in the old sense, a Government in a small country like Ireland is the only institution which can give really effective help in creating an interest in these matters and in helping judiciously artists and other people who are devoted to the various aspects of culture. The modern tendency seems to be to create as widely as possible an interest in these matters.[3]

Little may have considered that the Arts Council should be free from political control but his own nomination by de Valera implied otherwise. John A. Costello thought that Professor Bodkin was a more appropriate candidate and he decided to make representations to de Valera.[4] His letter, marked "Strictly Personal", began:

> I am writing to you with some reluctance, and only after very careful consideration, on a topic arising out of the Arts Act, 1951...My

reluctance in writing to you on the matter now is that I fully appreciate that the carrying out of the provisions of the Act is a matter for you and your colleagues. I did not press my colleagues to carry out those provisions before the change of Government because I felt it would not be proper to do so.

Costello proceeded to explain how he had intended to appoint Bodkin as Director of the Arts Council. The Arts Bill had been withdrawn and redrafted to satisfy Bodkin's wishes:

> These facts, I feel, impose upon me an obligation to inform you of them...I believe that Professor Bodkin would still be prepared to act. I believe also that he would do work that would greatly add to the prestige of the country in the matter of the improvement of the visual arts in Ireland.

De Valera telephoned Costello and informed him that the Government had set up a Cabinet Committee to examine the action necessary to implement the Arts Act.[5] He hoped to discuss the position generally with Costello when he returned from Zurich where he was going to have an eye operation. De Valera authorised Maurice Moynihan, Secretary to the Government, to convey the contents of Costello's letter to the Cabinet Committee. It is not known if de Valera met Costello as he had suggested. What is evident is that Costello's representations about Bodkin were ignored. Paddy Little had already prepared, at de Valera's request, a memorandum for the government on 'The Arts in Ireland'.[6] Its contents showed that Little had an open-minded and wide-angled view of the subject. He advocated the need for a co-ordinated policy which would offer:

> a nation-wide approach using all the means at our disposal and summoning up the full diversity of cultural activities in one big plan where each group will feel and be part of a great National effort...If we believe we are the authentic interpreters of Nationalism according to our traditions and especially that of Davis, then it would appear as an urgent duty that we should act quickly.

He continued: 'If the *first* principle is to create a nation-wide movement...the second must be to place the movement outside the political conflict'. Little suggested that the Arts Council: 'should be constituted of members of experience and of wide interests - with a real feeling for cultural interests - but with a mature sense of public opinion - a broad human approach to common sense'. It would be the Director's job to balance the development of the

various arts activities. Experts and specialists would be invited to join advisory panels but they had no place on the Council itself because: 'they may easily give one activity an unfair share of favour to the detriment of the others'.

Little sent an expanded version of the memorandum to the members of the Cabinet Committee on cultural matters, MacEntee, Moylan and Childers.[7] He offered the names of those whom he considered suitable for membership of the Arts Council.[8] He suggested that: 'as the Gaelic language and literature is such a large movement, involving strictly educational problems, it should not be officially attached as a panel to the Arts Council'. There could be advisory panels for the National Museum, Folklore (to plan an open-air folk museum), the National Gallery, Music, Drama, and Radio. Little envisaged that the Arts Council would act like a Ministry 'to co-ordinate, control and give driving force to all the institutions of art, archaeology and culture generally'. It would encourage 'cultural attractiveness' to help 'to soften the hardness in the Six Counties and ultimately absorb the best elements there into our common ideals and interests'. Little recommended that his former private secretary, Matt Doherty, should be appointed as Secretary of the Arts Council. Finally, he noted:

> The Bodkin problem might be solved by appointing him as a consultant on the judging of pictures, both in the Gallery, as to purchases and for judging pictures of younger artists for awards in association with the Hibernian Academy. He has a high reputation for this but not as a curator. It might be suggested that he be made a Professor of Modern Art in the University. This would get us out of a political difficulty.

Seán Moylan replied dismissively: 'As far as I am concerned there is no Bodkin problem'.[9] He considered that Fianna Fáil owed Bodkin nothing. As regards the Arts Council's role, Moylan disagreed with Little. He thought that the cultural institutions should not be controlled by the Arts Council but it should act in liaison with them.

Erskine Childers concurred with Little in thinking that the Arts Council should deal with broad issues. He gave as examples: the reform of the National Museum, the re-organisation of the National Gallery, the development of local museums, and the organisation of local arts festivals. He also listed those whom he favoured as members of the Arts Council.[10] The Arts Act allowed for the appointment of twelve Council members. The legislation gave the Taoiseach authority to nominate a Director and six ordinary members, and they in turn could co-opt five members. De Valera did not accept the lists of members proposed by Little and Childers. He intended to nominate the first

Council members himself. At a Government meeting on 30 November 1951, he suggested the appointment of P.J. Little as Director and the following as ordinary members: Alfred Chester Beatty, Monsignor Patrick Browne (Chairman of the Dublin Institute of Advanced Studies), John Maher (former Comptroller and Auditor General), R.J. Hayes (Director, National Library), Thomas McGreevy (Director, National Gallery) and the Earl of Rosse.[11] The Government approved the nominations and formal invitations were sent out immediately. Later the same day, the Taoiseach met a deputation from the Irish Theatre Council. The deputation asked that they should be represented on the Arts Council. Without revealing that a decision had already been taken, de Valera said: 'it was more likely that persons of general artistic interests rather than experts in some branch of the Arts would be selected'.[12] All the Taoiseach's nominees accepted the invitation to become members of the first Arts Council and they were appointed formally at the Government meeting on 4 December 1951. This is the official date of the establishment of 'An Chomhairle Ealaíon'.

In a letter which rather justified Fianna Fáil's suspicion of him, Bodkin wrote to Costello:

> I don't think I could have worked happily under "Dev" even if he had invited me to become Director of the Council; for I have never been able to bring myself to trust him, and I don't think he is remotely interested in the Arts or realises their importance to good government. I think it was very handsome of you to approach him on my behalf.[13]

Bodkin had been a student with Little at University College, Dublin. They were on friendly terms although, when writing to Costello, Bodkin tended to disparage Little's limited knowledge of the arts. This disagreeable personality trait did not endear Bodkin to many in Dublin. He was always an outsider because of his bristly character and dictatorial manner. Dr Liam O'Sullivan, the first Secretary of the Arts Council, described Bodkin as 'a difficult man':

> He would dominate any company he would be in. He'd pontificate about things he knew very little about. I suppose he was a bit of a snob. He always wanted the full shilling and he didn't do things for nothing. He had no feeling for politics. He didn't realise that it is the art of the possible. He wanted everything or nothing.[14]

Dr O Sullivan was offered the Secretaryship because it was thought, quite properly, that the job required someone with a knowledge of the arts. Dr O'Sullivan worked in the Art and Industrial Division of the National

Museum. John Maher, a collector of fine silver, advised de Valera that Dr O'Sullivan would be an ideal Secretary. He was appointed on 2 January 1952 and moved into an office which had been rented for the Arts Council at 45 St Stephen's Green. Throughout the 1950s, the Council staff was comprised of a Secretary and a short-hand typist.

On 10 January 1952, the Government-appointed Council members held a meeting to select co-opted members. Four nominees agreed to become members, Senator E.A. McGuire, Miss Muriel Gahan (proprietor of 'The Country Shop' and promoter of Irish crafts), Professors Seamus Delargy and Daniel Corkery. A fifth nominee, Con Curran (author and expert on Irish 18th century plasterwork) declined to become a member due to ill-health.[15] A number of important standing orders were agreed at the meeting: the normal practice would be to record decisions only in the minutes; and Council members' names would not be recorded in the making of such decisions unless by special request.[16]

The inaugural meeting of 'An Chomhairle Ealaíon' was held two weeks later on 25 January. The occasion was marked by grandiose speeches which were widely reported. De Valera told the new Council:

> The pressure of material forces upon our modern life has taken away from it, I fear, in many respects, the primacy once held by things of the spirit. Your task is to endeavour to restore that primacy - to give our people an abiding interest in the intellectual life and to stimulate them to aspire to win for our nation a worthy place in the realms of culture...I am very happy to be here with you to-day, a day which I hope will prove a red letter day in the cultural annals of our people.[17]

Costello echoed these sentiments:

> We live in an atmosphere of materialism...Lord Keynes fully realised that the arts are as important as economics to the social system and that starvation of the arts was bad economy. The amount so spent is infinitesimal compared to the great value received. In Ireland for many years we have suffered almost a complete neglect of art, literature, drama and the theatre. It has not been easy to convince people of the value of these things.[18]

He concluded with an important statement: 'There will be no nationality without art...It is the duty of every Irish Government to give every help to the arts and the application of art to industry'. It could be argued that Costello had reneged on this duty when he had cancelled Fianna Fáil's major cultural

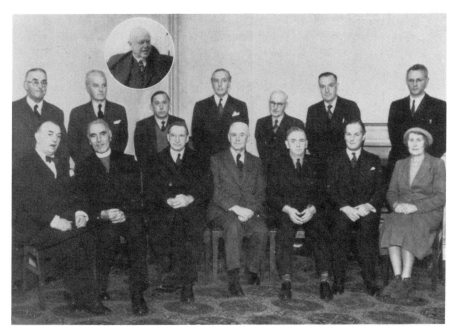

*The first meeting of An Chomhairle Ealaíon, 1951*

projects in 1948. But P.J. Little was willing to forgive any past lapses due to economic circumstances. He was optimistic:

> The situation is really not so bad. There have been encouraging signs not merely inside the various activities of Gaelic life, but in the cities, towns and villages; and especially within recent years, there has been a great increase in the interest in art, music, drama, archaeology and the patronage of the arts.[19]

The next procedural step in the formation of the Arts Council was the voting of a grant-in-aid to it by the Dáil. On 5 March, the Taoiseach moved a supplementary estimate of £1,100. Costello was correct in describing the amount spent on the arts as 'infinitesimal'. The debate should have passed without incident but James Dillon had planned an attack on Little's appointment as Director. Dillon suggested that de Valera had moved the estimate in Irish in order to conceal the amount of money involved 'hoping that nobody would understand him'.[20] He continued:

> I do not know if it is that the Taoiseach looks upon his erstwhile colleague as not only a politician by accident but a Minister by accident -

a disastrous accident at that - and seeks to ensure himself against the possibility of such a disaster recurring by choosing him for the position of chairman of the Arts Council'.[21]

De Valera was furious. In his opinion, Little was 'a man of culture' and 'somebody on whom we can rely'.[22] The Taoiseach rounded on Dillon:

> if there is one man who has brought rottenness into the political life of this country it is Deputy Dillon...I do not easily get into this, but when a colleague who is a cultured gentleman is made the subject of an attack by a person like Deputy Dillon it is time that one should show the disgust that one feels.[23]

Little was in fact an excellent first Director of the Art Council. He was amazingly energetic despite his age and full of enthusiasm. Following the example of the Arts Council of Great Britain, he launched Local Advisory Committees in regional centres. Committees were established in Cork, Waterford, Wexford, Limerick, Galway, Killarney, Tralee, Athlone, Sligo and Dublin.[24] Each committee was wholly voluntary and was known by the Irish title 'Gasra Ealaíon' (Arts Group). At the inaugural meeting of each of the Local Advisory Committees, Little delivered a speech which was invariably reported at length in provincial newspapers.[25]

In tandem with the Local Advisory Committees, five specialist panels were established to advise on particular matters. The membership was of high calibre and by 1953, 41 people had been appointed to the panels for Music (12), Drama (9), Architecture (7), Painting (7), Literature and Drama through Irish (6).[26] Neither the panels nor the local committees worked effectively. The basic problem was that they had no legal status and could not be given any funds. Dr O'Sullivan found that some members of the advisory panels were deliberately setting themselves up as if they were the Arts Council: 'There was no bad intention - they just got carried away with enthusiasm and assumed the power they didn't have'.[27] They were issuing statements on headed notepaper and instructing him to provide them with information. In 1953, the Comptroller and Auditor General raised queries regarding minor payments for the travelling expenses of Local Advisory Committee and specialist panel members. A decision was taken on 11 November 1954 to disband the panels. The Local Committees fizzled out gradually. The most enduring one, the Cork Advisory Group, was disbanded formally in May 1957.[28]

It was disappointing for Little that his attempts to organise local

committees failed. He believed in a policy of art for the people: 'The appeal should be as wide as possible for the benefit of the community as a whole'.[29] He considered that local involvement in artistic activities in rural areas was the key to development: 'Rural Ireland holds the heart of Ireland and it will not do to confine the Council's activities to the urban centres'.[30] The Arts Council's purpose was to provide seed money 'to stir the spirit of independent enterprise and to encourage people to take a pride in patronising artistic functions'.[31] It would support amateur and professional drama and music groups especially, because, in Little's opinion, these were the art forms in which most people were interested.

Some people were cynical about these sentiments coming from a politician. The poet and author, Patrick Kavanagh, wrote, tongue in cheek, that there had traditionally been 'Four Pillars of Wisdom' in Ireland - 'the Christian Brothers, Croke Park, Radio Iran and the Queen's Theatre'. 'Wearing the cultural smile which withers all life within range of its venom', politicians were now attempting to impart further wisdom:

> Government ministers, not being content to confine their confused discussions to economics and high finance, have recently been adding to their repertoire to gabble matters concerning Irish art and letters. Phrases like "Irish culture" and "Irish cultural relations" are beginning to compete with the worn-out and tired references to "our glorious martyrs". Men who in a well ordered society would be weeding a field of potatoes or cutting turf in a bog are now making loud pronouncements on art.[32]

There was a degree of truth in the contention that some politicians had questionable motives when using the theme of the arts for speech material. Little was an idealist whose motives were not in doubt. His tendency to philosophise gave him a reputation as a political lightweight. He seemed too sincere for hard-nosed politics. The public relations work involved in launching the Arts Council suited his temperament. He was rarely out of the news during his years as Director, opening exhibitions, promoting festivals, pleading for the restoration of historic buildings and lauding the work of amateur arts groups.[33] He was wildly ambitious and the Department of the Taoiseach felt it necessary to keep a close eye on the Arts Council's activities. Dr Nicholas Nolan, Assistant Secretary in the Department, telephoned Dr O'Sullivan at least once each week to receive a progress report.[34] He was concerned especially that the Council should be known by its legal title 'An Chomhairle Ealaíon'. This created a problem for Dr O'Sullivan who

complained: 'a great many people do not know where to look for our telephone number in the Directory'.[35] People looked for it under 'Arts Council' and found nothing. Dr Nolan gave permission for the additional entry to be made in the telephone book: 'Arts Council - see Comhairle Ealaíon'. This type of bureaucratic ingenuity was typical of the tight control maintained by the Taoiseach's Department. The Arts Council had been foisted on the Department whose officials, by their actions, indicated a distrust of the new institution.

By the end of 1952, the Arts Council had spent about £10,000 on grants and guarantees against loss to various arts groups. The emphasis had been on funding for drama and music groups in accordance with Little's policy. The Taoiseach and his Department were not impressed. In their opinion, the Arts Council's main task was the promotion of the visual arts and industrial design. It was decided to call representatives of the Council to a meeting with the Taoiseach on 15 January 1953. An agreed report was prepared in which de Valera outlined the policies he thought the Council should pursue.[36] The Council's representatives were P.J. Little, Dr R.J. Hayes, John Maher and Dr O'Sullivan. They were pleased that the Taoiseach was taking a personal interest in their work. From de Valera's point of view, the meeting provided an opportunity to use his influence although he 'stressed the fact that he had no desire to interfere with the discretion of the Council in the exercise of their functions'. His wishes were expressed politely: 'It would be a pity', he remarked, 'if the Council were to depart from the original intention with regard to their functions'. He thought that music was perhaps a matter for Radio Eireann and the Department of Education. Drama was, in his opinion, much less in need of encouragement than the visual arts and design in industry.

The Taoiseach advised the adoption of two important guidelines. He suggested 'that the Council should exercise special care in regard to any branch of art for which an existing State organisation was catering'. The second guideline in the agreed report read: 'The Taoiseach said that the restoration of the Irish language was not, in itself, a function of the Council, and money was being spent in other directions by the State for this purpose'. The Arts Council followed the Taoiseach's advice literally and refused all future applications for funding of arts activities by Irish language groups. While this was a somewhat reprehensible way of dispensing with the Irish language lobby, it was arguably the only solution. Dr O'Sullivan found the Gaelic League difficult to deal with:

I think that a lot of the Irish language people thought that the only art was the Irish language. They had no time for any of the other stuff at all. After I started to work in the office at St Stephen's Green, people would ring up talking vigorously in Irish and giving out that the language wasn't catered for by the Council and that a lot of the members of the Council - people like Rosse - were not in sympathy with the national ideals. I got great satisfaction out of answering these people because as soon as they'd start in Irish, I'd speak to them in Irish. The last thing they expected was to have somebody at the end of the phone able to answer their arguments in Irish.[37]

In its early years, the Arts Council had to justify its existence and give itself credibility. It was a difficult job with limited means and ambitious ends. In 1953/4, the Council received a grant-in-aid of £11,400. Administration costs accounted for ten per cent of the annual grant approximately. Much had to be done by providing information and recommendations to interested parties. The Arts Act, 1951, stated that the Council should advise the Government on arts related matters when requested to do so.[38] This limited the Council's role because Government Departments rarely asked for its advice. Little who knew the workings of Irish bureaucracy inside out, chose to interpret the Council's role broadly and offered recommendations without waiting to receive requests for them. For example, in August 1952, the Council submitted a memorandum to the Government proposing the subsidy of village halls in rural areas. Little was acting for his friend, Seán MacEntee, who had raised the idea in 1944. Once again the Government baulked at direct involvement in such funding. The Arts Council compromised by making grants available for the provision of stages suitable for the production of music and drama in village or parish halls.[39]

Representations by the Arts Council supporting the need for a tightening of the legislation on national monuments were successful. The Earl of Rosse campaigned for a system of preservation orders and the listing of important monuments. He was rewarded when legislation prepared by the Office of Public Works was enacted as the National Monuments (Amendment) Act, 1954.[40] More often than not, however, the Arts Council's advice was ignored. It had no power to implement recommendations or to insist that action be taken on them. The rigid compartmentalisation of responsibilities among Government Departments meant that the Council had to apply pressure without ministerial support. Ministers were reluctant to criticise their colleagues or to pirate the policy areas of other Departments. One instance will suffice to indicate the way the Council's recommendations were treated usually. The lack of government control on the export of works of art worried

the several leases in the Rotunda premises and for the reconstruction of those premises for the Council's purposes'.[55] The Council asked Raymond McGrath to draw up the revised plans.

Dr Nolan of the Taoiseach's Department, attentive as always, advised the Minister for Finance that the Council had no power to raise a loan under the Arts Act, 1951. But the legislation allowed the Government to confer further powers on the Council if desired.[56] An Additional Function Order was prepared and Dr Nolan promised the Council that it would be introduced when the Dáil reconvened in April 1953.[57] For a few weeks, Little believed that Dublin would finally have its oft-promised concert hall. It was not to be. After prolonged negotiation, Little informed the Taoiseach that the existing lessee was 'extremely unwilling to sell' for £75,000 and was demanding at least £105,000.[58] De Valera took the matter to the next government meeting at which it was decided to drop the proposal.[59] Little accepted the decision gracefully. He thanked the Taoiseach for giving the proposal 'sympathetic consideration' and reiterated the Council's view 'that the need for such a cultural centre still remains, and that such a centre would require a considerable sum of money'.[60]

A brief article in the *Irish Press* gave public notice that the planned purchase of the Rotunda buildings had been abandoned.[61] The public had already become disillusioned. In 1953 the Music Association of Ireland established a company, Concert and Assembly Hall Ltd., to campaign for a national concert hall. Little was reluctant to throw the Council's weight behind this new group until all his own ideas had failed. He had one more proposal up his sleeve. In January 1954, Sir Basil Goulding told Little that the Kildare Street Club might be willing to sell its premises for use as the headquarters of the Arts Council.[62] The Office of Public Works was asked to estimate the cost of refurbishing the premises as an exhibition centre.[63] They advised that a sum of £65,000 would be needed, £45,000 to purchase the premises, the remainder to refurbish it.[64]

Little was determined to see this proposal succeed. The timing was inauspicious because a general election was called for May 1954. Little decided to try to win a pre-election promise from the Government. He wrote 'a personal and unofficial letter' to de Valera and to all members of the Government.[65] In a series of passionate paragraphs, Little described the twenty years of frustration which he had endured while attempting to advance Irish arts policy. He also showed his disappointment that Government support for the Arts Council had been so weak:

The Arts Council was ushered in as an institution which would ultimately develop into a comprehensive body to administer the arts institutions and to cater for the arts all through the country. It undoubtedly has the germ of such, but frankly one feels frustrated by a sense that its proposals are set aside as something trivial and contemptible. I sometimes wonder if any one with real energy would be able to content himself with inertia...So far I have failed to convince the Government that there is a vital need for development in this direction...It is certain to come in the long run as a younger generation will not be content to see Ireland regarded as an inferior, an uncouth and bucolic island beyond an island.

He concluded with the plea:

It would be a pity if Fianna Fáil, having achieved a great work of a political and economic nature, should not achieve the same results in the cultural field. It is difficult to see how the language by itself can prevail without a big development of prestige and taste in the arts.

There is no record of a reply from de Valera but several ministers responded.[66] Frank Aiken said he would have a word with the Taoiseach at the first opportunity. Oscar Traynor was non-committal and said he would keep Little's views in mind. Dr James Ryan agreed with the proposal but thought it would have to wait until the election was over. Erskine Childers offered the astute advice that perhaps Little should be seeking the assurance from John A. Costello if, as appeared likely, Fianna Fáil was to lose the election.

The Second Inter-Party Government which assumed office in June 1954 had no time for the concert hall proposal. Having failed to convince his political allies, Little knew he could not persuade the new Government. He handed over the campaign for a concert hall and cultural centre to Concert and Assembly Hall Ltd. The Arts Council made a formal recommendation to Costello in March 1955 but ceased to take an active part in locating a suitable site for the cultural centre.[67] The following June, Dublin Corporation agreed to give a site at the junction of Nicholas Street and High Street to Concert and Assembly Hall Ltd., provided the Government funded the building costs.[68] Costello asked Concert and Assembly Hall Ltd. to submit an estimate of costs to the Department of Finance. They proposed that the Government should guarantee a loan of £450,000 if £50,000 could be raised by public subscription.[69]

In May 1956, as in 1943 when it had rejected the proposal for a new Abbey

Theatre, the Department of Finance made it clear that cultural projects were
luxury items which could not be supported:

> Public capital schemes already in progress affecting housing, agriculture,
> electricity, transport and other spheres of development entail as much
> expenditure in the years immediately ahead as can reasonably be
> expected to be met from available resources, including guaranteed loans.
> Indeed, every resource will have to be strained to find the necessary
> finance in a non-inflationary manner. In the circumstances, the Minister
> for Finance much regrets that no encouragement can be given at the
> present time to the expenditure of capital on projects which are not at
> least self-remunerative in the sense of yielding increased physical output
> and thus contributing to the redress of the financial situation.[70]

Throughout the 1950s, there was a prevailing gloom associated with what has
been described as 'withdrawal from expansion'.[71] It was only in the last years of
the decade that a reliance on foreign borrowing became acceptable.
Deflationary economic policies left no room for big cultural projects. The
National Gallery applied for an extension to its premises in 1951 but received
no commitment until 1962. The Abbey Theatre was destroyed by fire in 1951
and it was fifteen years before it was replaced by a new building. Ten years
after its foundation, the Arts Council's received an annual grant-in-aid of
£20,000.

Although Irish Governments failed to develop cultural institutions during
the 1950s, efforts were made to increase the country's tourism potential by
encouraging local arts festivals. The success of the post-war festival movement
convinced the Minister for Industry and Commerce, Seán Lemass, that a
national cultural festival tying together various local initiatives should 'become
a regular feature of our national life and a permanent asset to the tourist
industry'.[72] A festival to be known as 'An Tóstal' (the Pageant) was planned for
April 1953. The official English translation of 'An Tóstal' - Ireland at Home -
gave a hint of its origins. In 1951, proposals were made to Lemass by Pan-
American Airways 'for the holding of a 'National Week' centred around St
Patrick's Day each year, with the object of encouraging off-season tourist
traffic from America'. Although the scheme was 'based very largely on the
sentimental attachment of Irish Americans', Lemass viewed it 'as one likely to
produce results beneficial to this country in the shape of increased tourist
earnings'.[73] He was impressed with the way the big film success of 1952, John
Ford's *The Quiet Man*, had raised Ireland's tourism profile in America. Some
less commercial individuals were not so enamoured and feared Lemass would
sell the Irish soul for American dollars. Patrick Kavanagh called *The Quiet*

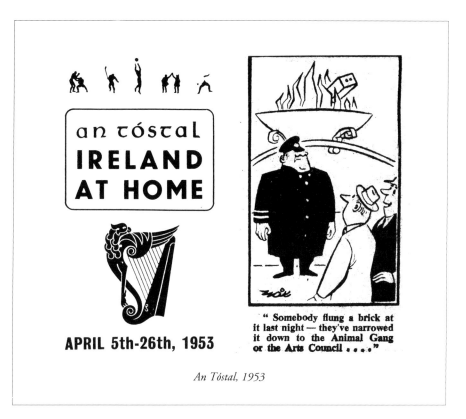

*An Tóstal, 1953*

*Man* 'a remarkable film, a mosaic of so many anachronisms...it is not stage-Irish, for there isn't enough Irish in it to make a stage'.[74] Lemass, to his credit, rejected the most Hollywood-like proposals put forward by Pan-American Airways. These included 'a special national park which might be called The Valley of the Fairies or The Home of the Leprechauns' and beauty competitions 'to locate a typical Irish colleen'.

Paddy Little considered that 'An Tóstal' would be 'regarded as a feverish political attempt to gain popularity'. He thought it was a poor substitute to place commercial above cultural criteria. He asked that his feelings on the matter be conveyed to the Taoiseach:

> It is a great pity from the National point of view, because with proper time and preparation the whole plan of cultural advance could have been established bringing the whole country and all our cultural institutions forward by fifty years, leaving really permanent assets in the shape of buildings and organisation of an enduring nature. Now it is hard to see how it can be anything but a flash in the pan.[75]

Little proposed that if Ireland was to be really attractive to tourists, investment should be made in a programme 'to achieve nationwide results' over three to five years which would provide: the refurbishment of the Rotunda buildings as a cultural and exhibition centre; the provision of a new Abbey Theatre; the adaptation of the Capitol Theatre for the staging of experimental plays; the siting of a concert hall in the Iveagh Gardens; extensions to the National Museum and Gallery; arts centres in Cork, Limerick, Waterford and Galway; an open-air folklore museum; and a series of public monuments commemorating scenes from Irish history. The provision of all these facilities within five years would have cost approximately two million pounds in 1952 prices. But the only response Little received was a reminder from the Department of Industry and Commerce that 'An Tóstal' was to be an inexpensive exercise aimed at 'achieving a rapid expansion of tourist traffic'.[76] The far-sightedness of Little's programme for cultural development was ignored.

Retired Major-General Hugo MacNeill was appointed as organiser of 'An Tóstal'. He visited New York to enlist the support of leading Irish-Americans.[77] The list of events arranged for 'An Tóstal' (5-26 April 1953) was tailored to suit the American market.[78] There was a special section called 'Irish-Ireland Features' which centred on the activities of the Gaelic League and the Gaelic Athletic Association. The highlight of the festivities was 'I.R.A. Day' on 24 April, the anniversary of the Easter Rising.

The Arts Council sponsored various exhibitions and concerts during 'An Tóstal' and supported the foundation of new arts organisations including the Amateur Drama Council of Ireland and the Institute of Sculptors of Ireland. But its most vocal involvement with 'An Tóstal' involved a public protest against the so-called Bowl of Light placed on O'Connell Bridge by Dublin Corporation. The British tabloid *Daily Mirror* described it as 'like something out of an ice-cream parlour - it stands 15 ft high in what appears to be a half-sunken submarine with fountains playing in it - and is the biggest joke of the festival'.[79] Further hilarity was derived from Major-General MacNeill's middle name which was Hyacinth. On the opening night of 'An Tóstal', a crowd gathered in O'Connell Street and after removing flowers from their decorative pots, began throwing them at the police. All in all, 'An Tóstal' attracted more criticism than tourists. The *Evening Herald,* in an editorial, claimed: 'It was obvious that the amount spent abroad on advertising and organisation was greater than the total receipts from foreign visitors'.[80] 'An Tóstal' was repeated annually until 1958 and, although not a commercial success, it encouraged many spin-off festivals which survived to become central elements in the

national calendar of artistic events.[81]

It is important to emphasise that the first Arts Council was on probation from a political point of view. The last thing politicians wanted was another pressure group which would embarrass the Government. For this reason the Council members were careful to avoid any public criticism of politicians. Although the Council's grant was paltry, the annual report never became emotive about the situation.[82] The Council decided that 'as a statutory body, it could not ethically raise agitation in the press on matters which were within the jurisdiction of a minister'.[83] While this gentlemanly attitude ensured that the Council was not disbanded, it also meant that it had a soft-edged media profile. The Arts Council of Great Britain, in contrast, pursued an aggressive policy of giving titles to its annual reports such as 'Art in the Red' (1956/7) and 'The Struggle for Survival' (1958/9). The annual reports of 'An Chomhairle Ealaíon' served as mere records of activities and policy statements were avoided.

The Arts Council knew that its independence was limited and it was careful to obey the wishes of the Taoiseach. Both John A. Costello and Eamon de Valera were especially interested in what the Council was doing to promote the improvement of design in industry. Nothing had been done at official level to develop industrial design since the disbandment in 1940 of the Committee on Design in Industry which had been appointed by Seán Lemass in 1937. Two Arts Council members - Edward A. Maguire and Muriel Gahan - were particularly interested in raising standards in industrial design, advertising and Irish crafts.[84] Paddy Little and the Council's Secretary, Dr O'Sullivan, were also committed on the subject.[85] The basic problem was that Irish manufacturers tended to view design and packaging as something 'extra' not as an inherent requirement of their products. As a result, industrial design was dull, unimaginative and timid in its use of form and colour.

The first 'Art in Industry' exhibition sponsored by the Arts Council was held during the Wexford Festival in October 1953. There were 314 exhibits by 27 different Irish, English and French companies.[86] The next year, the Council asked an English firm, Design Research Unit, which was establishing an office in Dublin, to organise an International Design Exhibition which would expose Irish industrialists to the latest design techniques. The exhibition was held at the Engineer's Hall, Dawson Street, Dublin, from 11 to 16 June 1954.[87] Design products of over 100 firms were displayed on 250 stands including examples from Canada, Denmark, Finland, Germany, Great Britain, Italy, Sweden, Switzerland and the United States. Special lectures were arranged featuring international design experts. The exhibition was shown in Cork in October 1954.[88]

In 1956, another two industrial design exhibitions were organised. A large exhibition of Italian industrial products was opened at St Anthony's Hall, Merchant's Quay, Dublin, in January, followed in March by an Irish Design Exhibition in the Mansion House, Dublin. This was the most important exhibition organised by the Arts Council since its foundation. Design Research Unit arranged the display which comprised 236 exhibits by 110 firms. The exhibition was toured to five centres - Waterford, Cork, Limerick, Galway and Sligo - and drew national attention to the importance of industrial design.[89]

Despite the reasonable success achieved by the Arts Council in promoting industrial design, John A. Costello was dissatisfied. He felt that Fianna Fáil and Paddy Little in particular, had hijacked the formative years of the Arts Council which he had brought into being. He was convinced that Bodkin should have been made Director and he intended to appoint him to the post when the first Council's term of office expired in 1956. Bodkin discredited Little's efforts in his correspondence with Costello: 'The Arts Council has certainly not given the lead to the Country which I think you looked for, and the work it has done has not been of a constructive kind'.[90] It is difficult to decide whether these remarks were rooted in disillusion or vindictiveness. Bodkin certainly shared the disillusion typical of the mid-1950s. In an article written under a pseudonym for the *Birmingham Post,* he wrote:

> So many hopes that were entertained thirty-three years ago when the Irish Free State was founded, have failed to come to fruition, that middle aged citizens tend to be disillusioned and apathetic; and young ones to be cynical. Partition persists. Emigration increases. The Irish language seems to be dying out...Dublin grows but at the expense of the countryside. The population of the State as a whole has declined.[91]

Costello decided to appoint Bodkin as a consultant to the Arts Council on an annual contract from 1 January 1955. The Council was not enthusiastic but consented to the Taoiseach's wishes.[92] At an introductory meeting, Costello assured the Council that Bodkin's 'unique knowledge and experience' would be useful. Bodkin said that he 'wished to help not to usurp the functions of the Director or Council'.[93] The Council knew well that it had been subjected to a coup.

Bodkin became a thorn in the Council's side by criticising it for 'not taking enough initiative and not having the standing in public life that it should have and being ineffective'.[94] He blamed the Council unfairly for not stopping the construction of the Bowl of Light; for not demanding the restoration of the

Royal Hospital, Kilmainham; and for failing to impress its views on Government Departments. The Council had indeed made representations about these matters but it was not prepared to blame politicians or civil servants publicly if its opinions were ignored. Dr O'Sullivan explained:

> Mere abuse in the press will not create proper prestige for the Arts Council. Constructive help and private representations are more effective than making people angry and getting their backs up - this leads to barren controversy and public "face-saving". Violent expressions of personal distaste only get a reputation for an irresponsible artistic temperament and carry no weight. Prestige depends on very deliberate and fully advised judgement. As to our prestige generally, we find that throughout the country and in most main towns we have been very highly respected and have met praise and gratitude. Our greatest difficulty is the lack of the right cultural values...there is a sullen and unexpressed hostility to cultural activities due to an ingrained suspicion that art and culture are anti-national and snobbish. Art activities in the past were exclusive of the people, and glorified the British. Hence the reserve on the part of the Arts Council.[95]

This eloquent statement about the pressures endured by the Council diplomatically did not refer to the increasing influence exerted by the Taoiseach. When Costello requested that the Council should make a grant to a particular individual, Little objected to the interference. The fact that the person involved was the impoverished poet, Patrick Kavanagh, whom Little knew, made it difficult to refuse. The Council decided to commission Kavanagh to produce 'a book on the nature of the poetic mind' but at the same meeting passed a significant standing order to determine future policy: 'The Director is to inform all individual applicants for financial assistance that the Council would not entertain such applications'.[96]

The Council was also irritated by the Department of the Taoiseach's refusal to allow an increase in Dr O'Sullivan's salary equivalent to the secretaryship of other state bodies (that is assistant principal grade 1 in the civil service). Dr O'Sullivan had neither pensionable status nor any possibility of promotion within the Arts Council. The Taoiseach rejected the claim and the Secretaryship remained an executive officer post.[97] An appeal for the appointment of an exhibitions officer to assist Dr O'Sullivan was dismissed as unnecessary.[98] These decisions confirmed the official determination to maintain the low status of the Arts Council. It was feared that added status might give weight to demands for increases in the Council's grant-in-aid.

On one issue, Costello, Bodkin and the Council were agreed - the need to

maintain the Irish claim to the Lane Pictures. The matter was highlighted by the sensation caused when one of the Lane Pictures was removed from the Tate Gallery, London, on 12 April 1955. The National Students' Council of Ireland claimed responsibility for the theft which was executed 'to publicise the British Government's consistent refusal to honour Ireland's moral right to the paintings'.[99] The Irish Government deplored the students' action and encouraged the return of the missing picture to the Tate Gallery. The students had no intention of keeping it and restored it to the Gallery via the Irish embassy in London. The publicity stunt worked however and Irish newspapers urged the Government to resolve the Lane Pictures affair. It was decided that the Arts Council should publish a popular edition of Bodkin's book, *Hugh Lane and his pictures*, which had been officially commissioned in 1932. A total of 5,000 copies of the book were published in June 1956. Copies were sent to every member of the British parliament at Westminster with a note from the Taoiseach which said: 'This book brings an old sad story up to date but does not finish it. I offer it to you in the confident hope that, when you have read it, you will want to do all you can to help the story to a happy ending'.[100]

An editorial in the *Evening Mail* asked the pertinent question:

> Has all the fuss about the Lane Pictures anything to do with art or art appreciation? The detached student of the controversy will unhesitatingly answer: No. Let us not imagine that love of modern art, or even of art in general, is the driving factor or even a factor at all...There is in fact no enthusiasm for art in any shape or form among our politicians or among the people as a whole.[101]

Pessimism about political attitudes to art was justified to a large extent but Costello's letter to British M.P.s had the desired effect. A number of them raised the matter in the House of Commons.[102] Hector Hughes, M.P., caused a storm when he described the British Government's refusal to return the paintings to Dublin as 'an act of unscrupulous dishonesty'.[103] It was decided that discussions on a compromise should take place between the authorities of the Tate Gallery and the National Gallery of Ireland. It took three years to work out a solution whereby the 39 paintings would be shared between London and Dublin. The credit for the settlement owed much to Bodkin's unflinching dedication to the achievement of Lane's wishes.[104]

In November 1956, Costello wrote to Bodkin and asked him would he agree to replace Little as Director of the Arts Council.[105] Echoing his response

of 1951, Bodkin declined the offer. 'The reason is simple', he explained, 'Paddy Little and his colleagues have quite obviously made the Arts Council a body which no-one takes seriously'. Bodkin continued with a long indictment of the Council under Little's direction:

> When you and I first thought of the Arts Council we did not envisage it as being mainly a conduit for subsidising minor and purely local activities...None of the major problems which I set out in the Report I wrote for you in 1949 have been successfully tackled by the Council. An old man like myself [Bodkin was 69], afflicted with various physical disabilities, could not hope in the short time at his disposal to put the necessary drive into a Council which has fallen into such a complacent and lethargic waste; though their Secretary, Dr O'Sullivan, seems to me to be still a most capable and energetic man who must suffer from the want of intelligent direction.

Whatever about Dr O'Sullivan, Bodkin concluded with the dramatic advice regarding the Council: 'Were I a dictator I should have no hesitation in sacking the lot'. He suggested:

> In view of the record of the Council, for the present I should be inclined to let the office of Director lapse for a while and not to reappoint its members until the air has cleared a little and the situation can be considered at leisure.[106]

Costello replied:

> It is a great disappointment to me that you will not consider giving your services to the Arts Council, but of course I must accept your decision. I have had so many frustrating disappointments that one more does not make any difference.[107]

The Taoiseach decided that if Bodkin was not prepared to assume the post of Director, he would have to find a replacement who was actively involved in the arts. His son, Declan, and his son-in-law, Alexis Fitzgerald, put forward Seán O Faoláin's name. Bodkin agreed with the proposal but the Catholic Archbishop of Dublin, Dr John Charles McQuaid, thought otherwise. O Faoláin had a reputation as a rebel, an anti-establishment figure who had often disagreed publicly with the Archbishop. Bodkin pleaded O Faoláin's case to Dr McQuaid:

> I knew he had gone off the rails from a religious point of view but I had been informed within the last year that he was safely back in the fold...If

he were appointed I believe that he would feel put upon his mettle to justify that trust and to make some worthwhile concern of the Arts Council which has failed so lamentably to be of use since its inception. If he is not appointed at this stage there is a danger that he might be tempted to run amok and do damage by spreading the belief that his appointment has been practically made but frustrated at the last minute by some extra-Governmental influence.[108]

The Taoiseach also wrote to the Archbishop:

> I considered the present nominee because of the feeling that artists and writers have got no support in Ireland from an Irish government. I think the present opportunity is a good one and while I cannot expect your Grace's blessing, I feel sure I will have your prayers.[109]

Dr McQuaid paid a visit to Government Buildings and spent over an hour with the Taoiseach and Professor Bodkin 'trying to prevent O Faoláin's nomination by persuading Bodkin to take the job'. Bodkin refused and the Archbishop told Costello: 'I can only hope the nominee will not let you down'.[110] Dr McQuaid explained to Bodkin:

> You will allow me to say how sorry I am that we cannot have a genuine expert, on whose direction and life experience we could very confidently rely. We shall stumble on, in the semi-gloom of minds that have never been disciplined from youth and that have not matured in the tranquility of assured knowledge. At best, you will advise, and I hope, strongly.[111]

Costello appointed O Faoláin as Director of the Arts Council on 21 December 1956, having chosen to ignore the Archbishop's foreboding which proved to be entirely unfounded.[112] It was anticipated that, compared to Little's gentlemanly style of directorship, O Faoláin's approach would be sharper and more unorthodox. The Council's apprenticeship was over and it was expected to formulate new policies quickly.

# CHAPTER SEVEN

## ALL CHANGED, CHANGED UTTERLY: 1956-66

*Perhaps it might be wiser for us to concentrate on things of the first rank in order to establish standards of excellence.*

<div align="right">SEAN O FAOLAIN</div>

On 22 December 1956, the *Irish Times* offered the following assessment of the first Arts Council's achievement:

> It would be very difficult to say just what the Arts Council has done - what positive contribution it has made to the cultivation of artistic taste in Ireland - during the first five years of its life...If it has not built theatres, or enriched civic museums and shown itself a beneficent patron - how could it, with the microscopic sum at its disposal? - it has done much in a quiet way to inculcate an acquaintance with the liberal arts, especially in the provinces, where it is most needed.[1]

There would be widespread regret, the editorial continued, at the retirement of Paddy Little who had 'shown himself a pleasant and discreet director, and a welcome speaker at dozens of public functions concerned with the Council and its activities'.

Seán O Faoláin wrote a letter to the *Irish Times* to say that it was not at all

*Seán O Faoláin*

difficult to say what the Arts Council had done.[2] If people looked through the Council's annual reports, they 'would be astonished by the amount of practical encouragement given to the arts in the past five years'. In O Faoláin's opinion, it was:

> an open question whether the Arts Council, far from not doing enough, may not have attempted too much with so small a budget. To bestow patronage on everybody actively concerned in painting, music, the drama (amateur and professional), sculpture, literature, design in industry, and the fine arts and applied arts generally, could absorb anything up to £1,000,000 per annum; and we have only £20,000...Perhaps it might be wiser for us to concentrate on things of the first rank, in order to establish standards of excellence. I mention it only because it is a question of future policy.

It was interesting that the new Director should raise such an important question in a newspaper before it had been discussed by the Council. With a few exceptions, the membership of the second Council was the same as its predecessor. O Faoláin's suggested policy ran counter to the established strategy of operating 'on a nation-wide basis by spending small sums in scattered parts of the country'.[3] He explained his views in a letter to Bodkin:

> Clearly the Council has dissipated a good deal of its energy on activities which, however laudable when taken in isolation...become questionable when considered as part of an over-all policy. If the policy has been that of a very long-term cumulative effect, intended to be achieved by more-or-less minor isolated and sporadic bursts of activity all over the country, I do not believe in it at all...My misgiving is that I virtually inherit the Council which for five years developed this policy. I should have asked the Taoiseach for a wholly new Council. As it is I shall have to be very tactful or else very ruthless. I shall try the first.

O Faoláin then made the remarkable admission:

> I am (odd thing for me to say in my present position) not at all sympathetic to the principle of State support for artists, except on the really grand scale, e.g. Czarist patronage of the ballet, or the establishment of the Comedie Francaise, or the foundation of Galleries, or Conservatoires of Music, or even Academies of Letters, or Science - in short only where the ordinary energies of commerce and enterprise and public spirit cannot apply.[4]

It was bizarre that the Director of the Arts Council was opposed to the existence of a state agency to assist the arts. O Faoláin was correct in

anticipating resistence to his views by Council members. The Earl of Rosse suggested:

> To a large extent I think that we should continue to be guided by local demand for our support, to encourage local initiative and enterprise subject of course to the essential provision that we are satisfied as to the standards in each case. For one thing it seems to me right in principle to foster individual efforts throughout the country, rather than to give directions from above; and for another we are bound by the smallness of our grant to keep our own expenditure to a minimum.[5]

Dependence on local demand was far too haphazard a policy for O Faoláin to accept. He wanted the Council to plan its future development and to cease being purely reactive. A compromise standing order was agreed at the Council meeting of 6 March 1957. It read: 'Future policy, while not failing to encourage local enterprise, would insist on high standards".[6]

O Faoláin directed the Council away from sponsorship of amateur dramatic activity. There were over 850 drama groups in Ireland[7] and he judged that the Council's grant was needed for other purposes. The Council advised the Amateur Drama Council of Ireland that, in future, it would advance amateur dramatic activity by sponsoring courses for producers rather than performances by local groups. O Faoláin felt that professional dramatic activity was capable of operating without the Arts Council's support. This was debatable. Although the Dublin Theatre Festival was launched successfully in 1957 without an Arts Council grant, brave ventures like the Pike Theatre, Dublin's best known little theatre of the 1950s, fought a hand-to-mouth existence before final extinction for want of a subsidy.

O Faoláin's priority was to provide Irish people with opportunities to see, read and hear the work of renowned artists, poets, writers and musicians. Concerts by the Vienna Philharmonic Orchestra, the London Symphony Orchestra, and Yehudi Menuhin, were sponsored by the Arts Council. In the winter of 1958/9, selected art experts and writers were invited to participate in a lecture series titled 'The Artist and his Milieu'. The lecturers - Rene Huyghe, Pierre Emmanuel, Felix de Nobel, John L. Sweeney, Angus Wilson and Gabriel Marcel - addressed audiences at the Royal Hibernian Hotel, Dublin, and the Imperial Hotel, Cork. The lecture series became something of a social event but its usefulness was questionable because some of the speakers had either poor English or none at all.[8] O Faoláin should not have expected Irish audiences to understand French. The exercise therefore created a sense of exclusivity, the opposite of that stimulated by Little's more indiscriminate policy.

In a further point of contrast, O Faoláin did not share Little's knowledge of civil service bureaucracy. O Faoláin was determined to challenge civil servants in order to win greater independence for the Arts Council. His first trial of strength against the Department of the Taoiseach concerned the appointment of a successor to Dr O'Sullivan who decided reluctantly in April 1957 to leave the Council to take up the higher paid post of Keeper of the Art and Industrial Division in the National Museum. Although the Council was statutorily empowered to select a new Secretary, Dr O'Sullivan explained to O Faoláin that de Valera, who had recently replaced Costello as Taoiseach, had his own views on the matter. Dr O'Sullivan wrote:

> At Dr Nolan's request I had an interview with him last evening in the Department of the Taoiseach about the position of Secretary. He said to me that the Taoiseach would be glad if the Council would consider favourably the appointment of Mr Leonard Joseph Harty, the present Director of the Government Information Bureau, as the next Secretary. His position has become redundant there.[9]

O Faoláin was indignant and made his feelings known to Dr Nolan. After three difficult weeks, the Taoiseach and his Department finally relented. Dr Nolan excused the Taoiseach's indiscretion by suggesting that it was thought that the Council 'in recruiting a Secretary, might be looking for a public relations officer'. The Director was 'now free to look around' for a suitable Secretary.[10] O Faoláin had someone in mind. He sent a telegram to Mervyn Wall, author and broadcaster, who was on holidays in Roundstone, County Galway: 'Would you be willing, if invited, to accept this post?'[11] Wall travelled back to Dublin for an interview with O Faoláin, John Maher and Dr Hayes. He was the only candidate invited to apply for the post and, predictably, the Council 'had no hesitation in recommending him'.[12] He took up his new position on 1 July 1957.

O Faoláin's Council followed up this little victory by rejecting representations from the Taoiseach, the Minister for Education and several other politicians, on behalf of a young musician who had applied for an Arts Council grant to help her to take up a place at the Royal College of Music, London. The Taoiseach felt that the case appeared to be 'worthy of further consideration by An Chomhairle Ealaíon'.[13] The Council decided to stand firm and reiterated its refusal to accept applications by individuals for grant aid. It was determined to quash political pressure in order to guarantee its independence. In any event, politicians had adequate opportunities to question the Council's policies. O Faoláin set out the position in a letter to the Minister for Finance, Dr James Ryan:

*Mervyn Wall*

There would appear to be three occasions during each year when Deputies are in a position to enquire in to the functioning of An Chomhairle Ealaíon; at the time of the Annual Vote; when the Annual Report is laid on the table of the Dáil; and when the Public Accounts Committee of the Dáil reports back to the Dáil.[14]

The latter occasion would arise only if the Comptroller and Auditor General, when presenting his annual report, raised queries about the Council's expenditure. It would then be open to the Public Accounts Committee to draw the attention of the Dáil to the issue. O Faoláin did not mention one further route of access to the Council for curious politicians. They could at any time table an oral or written parliamentary question about the Council's activities.

In the autumn of 1958, the Department of the Taoiseach asked the Arts Council to reduce the grant which had been awarded to the Wexford Festival because Bord Fáilte was also funding it. Having spurned political interference, O Faoláin decided it was time to challenge Dr Nolan. He wrote:

> It would help the Council in this matter if you would be so good as to explain to them in what manner their decision to grant the original sum to the Wexford Festival runs contrary to the Arts Act, 1951, as it may conceivably occur to some members of the Council that the Arts Council is entitled to spend the grant made to the Council "for such purposes connected with their functions as in their discretion they think fit".[15]

Dr Nolan was not to be easily outdone. He reminded O Faoláin that the Council's decision to fund the Wexford Festival 'was expressly qualified by the Council as being "subject to the approval of the Taoiseach"'.[16] O Faoláin refused to be made the victim of his own words. He replied to Nolan:

> The point at issue was not whether the Taoiseach's approval should be sought in the matter. The issue was the Taoiseach's power in the light of the Arts Act, 1951, to determine how much the Council should offer to the Wexford Festival.[17]

Dr Nolan was forced to agree that while it was for the Taoiseach to decide the amount of the Arts Council's annual grant-in-aid, the Council did not require the Taoiseach's approval to spend it.[18] He advised that in future the Council should seek the Taoiseach's approval only in relation to proposals involving the employment and conditions of Council staff which, under the Arts Act, required it. Having clarified the position, Dr Nolan sensibly relaxed the level

of supervision of the Council's activities and allowed it to get on with its business.

The Council realised that O Faoláin's hard-nosed style paid dividends and authorised him 'to pursue a policy of protesting privately or publicly against unsightly public buildings, erections, hoardings or street furniture'.[19] O Faoláin was concerned particularly about roadside advertising hoardings which were transforming Irish roads into American-style 'billboard alleys'. O Faoláin applied his campaign to three separate industries - petrol and oil, beer and spirits, and tobacco.[20] He began with the petrol and oil companies and asked that, for aesthetic, scenic and tourist reasons, they should refrain from erecting advertisements on roadside hoardings. Representatives of all the companies involved were invited to a meeting and, to O Faoláin's surprise, they agreed to his proposal. He was less successful with beer and spirits companies who argued that if they did not erect advertisements on the hoardings, their competitors would do so. The tobacco companies advised O Faoláin to secure the collective agreement of advertising agencies to withdraw the hoardings.

The campaign was welcomed enthusiastically by journalists who praised the Arts Council for its valuable lead on an important issue.[21] Advertising agencies were anything but happy. One of them, Messrs David Allen & Sons, Ltd., threatened to sue the Council on the grounds that the campaign was 'outside the functions of the Arts Council as prescribed in the Arts Act, 1951'.[22] O Faoláin sought legal advice which confirmed his view that the Council's action was in line with its statutory functions and was not directed at the business of Messrs Allen & Sons, Ltd., but at preserving 'the natural beauties of the countryside because of the salutary effect on public taste'.[23] The advertising agency decided not to pursue the matter.

Although the campaign gained useful publicity for the Arts Council, it did not work. The oil companies honoured their agreement until it became obvious that different advertisers had replaced them and no hoardings had been taken down.[24] The Department of Local Government began to plan new legislation which would include restrictions on hoardings at tourist sites.

There was a clear need for legislation to preserve buildings of architectural significance. The Council played its part in highlighting the issue by entering into a public controversy with the Office of Public Works in protest at the proposed demolition of Georgian houses at Nos 2 & 3 Kildare Place, Dublin. Despite the Council's objection, the O.P.W. demolished the buildings.[25] The Council at its meeting on 25 June 1957 approved a draft letter for issue to the press which criticised the O.P.W. strongly. Having considered the wisdom of entering into conflict with another exchequer financed agency, O Faoláin

asked the Council not to issue the letter.[26] The Council could not afford to be openly aggressive when it was pleading for more funds.

It would have been odd if Seán O Faoláin and Mervyn Wall had done nothing for the cause of writers, poets and publishers. The Council sponsored an International Book Design Exhibition held at the Technical Institute, Bolton Street, Dublin, in November 1957.[27] Financial support was given to periodicals of literary and cultural merit such as *Irish Writing*, *Studies*, and *The Dublin Magazine*. Mervyn Wall proposed that memorial tablets should be placed on buildings throughout the country to commemorate notable artists and writers who had resided in or been associated with them. The Council agreed in principle to the idea but it was later decided that it would be more appropriate for Bord Fáilte to implement it.[28] This was done successfully during the 1950s.

Mervyn Wall had full responsibility for managing the Arts Council office because his Director rarely visited it:

> Dr O Faoláin did not ordinarily attend at the Council's offices at all. He was in daily telephonic communication and arranged that he would visit the premises for a half-an-hour on two occasions each week This was his practice, and he did not use during his tenure of office either a room or even a desk.[29]

O Faoláin lectured in the United States for two months in the spring each year and tried to keep in touch with Council business by corresponding with Wall. In April 1958 this arrangement caused a serious problem because the annual accounts could not be passed without the Director's signature. O Faoláin apologised to Wall: 'I'm sorry about this...For me the Directorship has to be a part-time job, as I made clear to the former Taoiseach and it is in these 2 months that I mainly make the annual income of the O F's'.[30]

O Faoláin was never able to convince himself that the Arts Council's existence was sustainable with minimal funding. In November 1958, two years after his appointment as Director, he began to consider resigning from the post. He wrote to Bodkin:

> I have become gravely discouraged by the Arts Council's work. In sum I am obliged to pose to myself and to the Council the blunt question: Can the Arts Act be considered a fully workable Act within the intentions of the Legislature and at a constant level of achievement in accordance with the standards of the Council members, while being permanently endowed with a sum inadequate to implement its terms of reference? By my standards it cannot. The Council can only do (some) useful work

(a) by ignoring large parts of their terms of reference, and (b) by lowering their own personal standards.

This is going to be understood by NOBODY outside the Council and not by everybody in it...The result is inevitable. So if you hear of my wish to withdraw from an unequal battle do not be surprised.[31]

Bodkin sympathised with O Faoláin's predicament. He replied:

The great trouble is, of course, that nobody in Ireland, with the exception of John Costello, and very few others, is prepared to pay more than lip service to the cause of the Arts; a cultivated class in the full sense of the term, has ceased to exist in our country, and the present methods of education are not likely to encourage the growth of one to serve us in the near future. It was made clear to me years ago that the civil servants and the vested interests do not want to touch Art, fine or applied. Yet I would urge you strongly to try and hold on to the directorship of the Council. There is no-one but yourself who can fill the position with any credit or utility at the moment.[32]

O Faoláin decided that he no longer wanted the position. He let it be known that he intended to resign as Director with effect from 1 July 1959. He wished to take up the post of resident Fellow and Lecturer at Princeton University, New Jersey.[33] In the month of his resignation, the Arts Council moved from 45 St Stephens Green to more spacious premises at 70 Merrion Square, a fine Georgian residence which had been the home of the writer, Joseph Sheridan Le Fanu (1814-73).[34] An exhibition room was opened on 27 October 1959 with a display of modern and antique English silver.[35] The change of premises signalled the arrival of the Arts Council as an established institution. It now had a respectable address close to Government buildings and had secured considerable independence thanks to the courage of Seán O Faoláin.

Seán Lemass who became Taoiseach on 23 June 1959 appointed Mgr Pádraig de Brún (Patrick Browne) as Director of the Arts Council a week later.[36] Mgr de Brún had been a Council member from 1951 to 1956 but had been unable to attend many meetings due to his commitments as President of University College, Galway. He was retiring from U.C.G. at the age of 70 in October 1959 and it was agreed that he would assume the Council Directorship on 1 November. His appointment was greeted with cynicism in the Dáil by Oliver J. Flanagan, T.D., who accused the Taoiseach of political jobbery alleging that Mgr de Brún was appointed 'not because of his academic qualifications, but because he was a brother-in-law of the Minister for Health, Seán MacEntee'.[37] Lemass rejected the accusation and said that Mgr de Brún

*70 Merrion Square*

*Mgr Pádraig de Brún*

was a scholar with wide cultural attainments and important administrative experience. A former Professor of Mathematics at St Patrick's College, Maynooth, he had translated many classical works into Irish. As it happened, Mgr de Brún was not destined to be Director for long. He died on 5 June 1960 having organised one well-received event for the Arts Council.[38] This was an exhibition of etchings by the artist, Georges Rouault, shown in May 1960 at the Building Centre, Baggot Street, Dublin. The Council published a book of poems by Mgr de Brún to accompany illustrations of Rouault's etchings.

Mgr de Brún's successor as Director was also a Catholic priest.[39] Fr Donal O'Sullivan, S.J., was one of a number of enlightened Jesuits who tried to advance various facets of the arts in Irish society during the 1950s and 1960s. Others included Cyril Barrett, Roland Burke Savage and John C. Kelly. Fr O'Sullivan had been appointed to the Arts Council in 1956 and had quickly shown his expertise in the area of the visual arts. 'Todd' Andrews, a Council member for all of Fr O'Sullivan's years as Director (1960-73) wrote of him:

*Fr Donal O'Sullivan, S. J.*

His main interest, in fact his only interest, was in promoting modern painting by young Irish artists which was much to the advantage of those who fell into that category but not so good for those who favoured a more conservative style.[40]

A fellow Jesuit offered the following pen-sketch of Fr O'Sullivan:

He lived a huge vision. Some found him intimidating but most found him inspiring, masterful. A great European and a lover of the visual arts in particular. I could imagine him being an overly-strong, perhaps withdrawn presence among the artists. He was a contemplative, a man of wisdom, shy, often of poor health, but hiding it. Probably his high control concealed him, the real man. Thus some would find him stubborn, even dictatorial. He had a wit and a wisdom which would seem tough. His manner might be authoritarian but I can't imagine anyone finding him really tough or unkind.[41]

This description is useful as a guide to the type of leadership which Fr O'Sullivan brought to the Arts Council. He was well-meaning but high-handed and his Directorship was controversial from the day his appointment

*Seán Lemass*

was announced officially in Dáil Eireann by the Taoiseach. Lemass told the Dáil that both Mgr de Brún and Fr O'Sullivan were chosen for the post of Council Director because of their 'outstanding qualifications'. There was no question that the Director had to be a priest: 'When the next Director comes to be appointed, whoever has then the responsibility will be free to select the best qualified person available and need not consider himself bound, or committed in any way, by what has been done'.[42] James Dillon who, in 1952, had objected to Little's appointment, queried the propriety of appointing Catholic priests to oversee the State's arts agency. He commented wryly: 'We shall regard their succession...as a coincidence rather than as a design'.[43]

Lemass then informed the Dáil of his decision to transfer responsibility for industrial design from the Arts Council to the Export Advisory Board, An Córas Tráchtála. He declared that 'about the worst type of body to employ to interest businessmen in industrial design is one called an Arts Council...Few businessmen would accept that in any circumstances an Arts Council could teach them anything useful in relation to their business'.[44] Notwithstanding this criticism, Lemass said:

> The Arts Council could use a lot more money. They think that themselves. In cultural fields of that kind, there is almost no limit to the amount of money that could usefully be spent. I approached with considerable sympathy the idea of increasing the grant-in-aid of An Chomhairle Ealaíon, but decided to postpone taking a decision on the matter until I had the opportunity of looking fully into the whole question of the organisation of all our cultural bodies and their activities...proposals have been made from time to time for the establishment of some central co-ordinating authority to help these subordinate bodies to do better work. Whether that is a good idea or not I would not know, but I think I should examine these ideas and come to a decision about them before deciding to enlarge the scale of work of An Chomhairle Ealaíon or to provide additional funds for the work they are now doing.[45]

Lemass may have been interested in establishing a Ministry of Fine Arts or some umbrella institution for state funded arts activities. He had a personal vision of Irish society and the arts had a place in the future structure. But, like W.T. Cosgrave in the 1920s, Lemass's preoccupation with economic policy issues - the improvement of living standards, the creation of wealth and the development of industry - left little time for planning a cultural policy. Although he supported plans to rebuild the Abbey Theatre and to extend the National Gallery, the proposed co-ordination of the activities of cultural

bodies did not materialise. Instead, Lemass agreed to increase the Arts Council's budget for 1961/2 from £20,000 to £30,000. He expressed no further personal interest in the Council's policy and Fr O'Sullivan was allowed to direct its activities as he pleased.

The Arts Council accepted the unilateral decision to withdraw industrial design from its area of responsibility. Fr O'Sullivan chose to ignore Mervyn Wall's advice about the Taoiseach's decision. Wall commented correctly that the Taoiseach had no power to remove industrial design from the ambit of the Council's activities without amending the Arts Act.[46] The effect of Lemass's decision was to direct the Council to disregard one of its statutory functions. The Council complied with the Taoiseach's wishes by referring all future applications about industrial design to An Córas Tráchtála. It suited the Council to acquiesce quietly because its budgetary position was eased as a result. But Mervyn Wall was worried that the Council had shown itself to be too compliant. He advised that the Council's grant could easily be extinguished altogether and therefore it was necessary to find some alternative sources of income. He suggested that the Council should start opening trust funds.[47]

The first trust fund to be established was the William J.B. Macaulay Foundation in honour of President Seán T. O Ceallaigh. Macaulay, a former Irish Minister to the Holy See, wrote to the Arts Council in October 1958 enclosing a cheque for £20,000 to provide a foundation to award fellowships to creative workers in sculpture, painting, music, drama and literature, provided the recipients were under 30 years of age (or in exceptional circumstances under 35 years of age).[48] The fellowships could only be awarded to Irish-born persons and were designed to advance the pursuit of liberal education. The Council implemented Macaulay's wishes by awarding a fellowship of £1,000 in one of the arts specified on an annual rotating basis. When the state of the fund allowed it, the Council awarded a second fellowship of a lesser amount. The Macaulay Prize became widely respected and its recipients were accorded a singular publicity boost for their work.

The Denis Devlin Foundation was established in 1960 by the widow and friends of the poet. It was financed by moneys collected in Europe and the United States of America, augmented by a grant from the Arts Council which administered the fund. The Foundation awarded a triennial prize to an Irish citizen who had published what was judged to be the best book of poetry in the English language in the previous three years. Also in 1960, the Irish Institute of New York set up a fund to be administered by the Arts Council for the purpose of purchasing paintings or sculpture by Irish artists for

transmission to the Institute in New York.

Fr O'Sullivan promoted another method of trying to secure the Council's financial future. In the years 1959 to 1962, the Council did not spend all of its allocation from the State. By 1962 when the Taoiseach was finally persuaded to increase the Council's grant by £10,000, there was nearly that amount held in reserve in a bank account. This was an improper use of State funds and the Comptroller and Auditor General advised unofficially that if the Council did not remedy the situation quickly, he would inform the Minister for Finance.[49] It was unreasonable for the Council to campaign for more funds while it had failed deliberately to spend all of its annual grant-in-aid. Mervyn Wall advised: 'The Council's immediate need is to spend lavishly on the arts'.[50] The Council was jolted into action and within a few months, by accepting virtually all applications for grant assistance, had succeeded in spending most of its savings.

During the early 1960s, the Arts Council allowed itself to be used as a conduit for funds allocated by the Taoiseach. Seán O Faoláin's work in establishing the Council's independence was thereby compromised. The first occasion concerned the Gate Theatre which was in serious financial trouble in 1961 and was threatened with closure unless it received some urgent State or private funding.[51] Lemass decided that in future the Gate Theatre should receive a State grant of £5,000 per annum via the Arts Council. The Secretary of the Department of Finance, T.K. Whitaker, was instructed to inform Mervyn Wall that it was intended to increase the Arts Council's over-all grant-in-aid by £5,000 per annum provided this money was used to subsidise the Gate Theatre.[52] The worthiness of the decision to underwrite the Gate Theatre was not in doubt but the principle of not allowing politicians to nominate the recipients of the Council's funds had been breached.

The Taoiseach was also successful in securing an annual grant-in-aid for the Dublin Grand Opera Society. As with the Gate Theatre, it was proposed that the Council should give £5,000 to the D.G.O.S., if its grant-in-aid was increased by a similar amount. On this occasion, Mervyn Wall emphasised that the Arts Act gave the Council authority to spend its grant as it considered appropriate and the Council should therefore seek to safeguard its rights. The Taoiseach's Department replied:

> We are aware of the Council's rights and do not propose to direct the Council, but presumably an unofficial "gentleman's agreement" can be arrived at whereby the extra £5,000 would be made available to the Dublin Grand Opera Society.[53]

The Council accepted the deal and its grant-in-aid for 1963/4 was increased from £30,000 to £35,000. The following year, the Council was persuaded to continue the agreement when its grant was increased from £35,000 to £40,000.

Fr O'Sullivan had a priestly respect for politicians and bureaucrats. He accepted the Taoiseach's absolute right to determine the grant allocated to the Arts Council. He did not think it appropriate to adopt a begging bowl approach when seeking additional funds. He was cautious in his dealings with civil servants and believed that they would be sensible enough to appreciate the usefulness of supporting the arts. He had no time for tough tactics against politicians and preferred soft options if at all possible. He accepted Dr Nicholas Nolan's view that 'An Chomhairle Ealaíon exists by grace of Dáil Eireann, and it would be improper to bite the hand that feeds it'.[54]

It was Fr O'Sullivan's opinion that the Arts Council had been established with the primary purpose of advancing the visual arts. He asked Mervyn Wall to determine the percentage of Council funds which had been spent in the period from 1951 to 1960 on each of the arts for which the Council was responsible. Wall demonstrated that 53% of the Council's funding had been spent on music and drama. Painting and sculpture had received a mere 13%.[55] Wall recommended a five year plan with the target of 65% expenditure on the visual arts and 35% on the non-visual arts. As a first step, it was planned to spend 35% of funding on the visual arts in 1961/2. The realisation of this target called for some serious policy decisions.

It was Mervyn Wall who steered the Council towards a redefinition of its aims and policies. He provided comprehensive briefing for the Council based on Fr O'Sullivan's general instructions. Wall believed that the Council had to work towards a confined view of its statutory obligations.[56] During the 1950s the Council had been a patron of community arts and local cultural initiatives. Wall felt that the Council now needed to concentrate its efforts to a greater degree. On 15 November 1960 the Council met to discuss its future financial policy. This meeting confirmed the Council's move away from support for popular and traditional art forms. The new policy led the Council into a cul-de-sac because it was completely out of tune with the populist spirit of the 1960s.

The Council's basic standing order, formulated in 1957, that 'future policy, while not failing to encourage local enterprise, would insist on high standards' was revised to read: 'The Council's main function is to maintain and encourage high standards in the arts'. This more restrictive policy was elaborated in the Council's decision to refuse all future applications for funding of:

- brass, fife and drum, pipe or reed bands;
- amateur dramatic activity other than courses for producers, actors and playwrights, and by way of assistance towards lighting;
- the building or reconstruction of local halls used for general community purposes;
- feiseanna, Comhaltas Ceoltoiri Eireann functions, or general festivals in which traditional music, dancing or storytelling are extensively featured.[57]

It should be noted that the reason the Council decided to disqualify these categories of applications was because they were judged not to be 'fine or applied arts' under the Arts Act, 1951. Mervyn Wall carefully researched material to support the new policy. For example, he based the proposal to exclude folk dancing on a British Court of Appeal decision that:

> Folk dancing is not one of the fine arts...because such dancing is for the enjoyment of those practising it as opposed to a form of artistic expression giving aesthetic satisfaction to those perceiving it.[58]

Similar sophisticated legal judgments could not be found to justify the exclusion of brass bands, amateur dramatic activity and traditional Irish music. A liberal interpretation of the Arts Act would have allowed the inclusion of these art forms. The Council's decision to exclude them was therefore the result of a determined bias in favour of professional artistic activity in the English language which it judged to be of a high standard.

The Council's revised policy was based on a sincere appraisal of Irish needs and resources but it was not in line with international trends in arts policy. In France, André Malraux launched a brave and innovative cultural policy which established arts centres ('maisons de la culture') throughout the country. In Great Britain, a major report commissioned and published by the Gulbenkian Foundation in 1959, titled *Help for the Arts*, set out suggestions for future policy.[59] It was stated that access to the arts was a civil right. The arts could no longer be regarded as entertainment for the privileged in society. If An Chomhairle Ealaíon had read the signs correctly, a more strident and popular approach to the arts would have been adopted.

Mervyn Wall set out his personal views on 'The State and Culture' when participating in a debate organised by the Trinity College Historical Society:

> The State must of course legislate for Culture, but the State must not call the tune. The State must not interfere and direct the artist as to his work. We see the sad results of this under dictatorial forms of

government. But it is necessary that you should have State or at least local authority patronage and assistance of such arts as ballet, symphony concert music, and opera; for the practice of these arts is so costly that only public funds can really support them.[60]

This attitude would not have endeared Mervyn Wall to Paddy Little. But the Arts Council under Fr O'Sullivan was concerned with standards more than participation. The policy was coherent but it had the effect of establishing the Council as an arbiter of public taste, a fact which became obvious in the Council's activities to stimulate the visual arts. It should be noted that the membership of the Council remained virtually static throughout the 1960s.[61] It was controlled by Fr O'Sullivan with the support of Michael Scott, the gregarious and talented architect who had designed the Dublin Central Bus Station. Some Council members were unhappy with the situation. Terence de Vere White offered the following opinion: 'The Arts Council was run by Fr O'Sullivan and Michael Scott. I objected to the Director's one-man band style. O'Sullivan only consulted Scott and meetings were a farce. I resigned'.[62] Brian Boydell, who became a Council member in 1961, confided:

> I had the impression that everything was fixed beforehand by Fr O'Sullivan. Things ran on the nod without any hitches. Michael Scott was in collusion with Fr O'Sullivan and they decided things together. There was an awkward quality about having a priest as a Director. Firstly, at that time among Catholics there was a tremendous respect for priests and you never criticised them or disagreed with their opinion. Secondly, anyone like me reared in an Anglo-Irish Protestant background could never criticise a priest or it would invite a clamour of protest about being anti-Catholic and having no respect.[63]

Fr O'Sullivan's 'one-man band style' became apparent as a result of some controversial decisions made by him regarding planning applications. The Arts Council was often asked by local authorities for its opinion on whether or not planning applications by developers should be approved. This consultation process was formalised with the passing of the Local Government (Planning and Development) Act, 1963. The Arts Council had neither the funds nor the expertise to deal with its responsibilities as a prescribed body for the vetting of planning applications. The Council soon found itself embroiled in one public dispute after another.

The planning case which led the Arts Council into most difficulty involved the attempt by the Electricity Supply Board (E.S.B.) to demolish a number of Georgian buildings in Lower Fitzwilliam Street, Dublin, to make way for the

construction of new office buildings. The Arts Council's initial opinion was to approve the demolition of the Georgian buildings on condition that the E.S.B. organised an international architectural competition to design modern buildings which were in harmony with the surroundings.[64] Fr O'Sullivan was keen to promote modern architecture and Michael Scott was unwilling to sign any forms of objection because, in Mervyn Wall's words, 'being an architect, he did not think it right to take action which would prevent other architects obtaining a commission'.[65]

The E.S.B. publicised the Council's approval in an effort to avert mounting public unrest. The Council thus became identified in the public mind with those who were seeking to destroy Dublin's eighteenth century architecture. Although the Council retracted its approval of the demolition of the buildings in favour of a plan by Michael Scott to convert them into flats, its credibility had been undermined.[66] Ignoring these new plans, the E.S.B. organised an international architectural competition and, in November 1962, it was announced that the design by the Dublin architectural firm, Stephenson, Gibney and Associates, had been selected. For the next two years, a public controversy raged to prevent the demolition of what An Bord Fáilte described as 'the finest unbroken facade of its kind in Ireland - buildings of real national importance'.[67] But the E.S.B. was determined to build new offices and, in March 1965, work began on the demolition of the Georgian buildings.[68]

The proposal to build a huge Nítrigin Eireann Teoranta (N.E.T. - Irish Nitrogen Company) factory on the site of Shelton Abbey at Avoca, Co Wicklow, exposed the manner in which Fr O'Sullivan and Michael Scott were dominating the Arts Council. In February 1962, the Director of N.E.T., J.B. Hynes, wrote to Fr O'Sullivan inviting him to visit the site of the proposed factory to offer suggestions on how to avoid interfering with the local scenery.[69] On 14 April 1962, Fr O'Sullivan and Michael Scott visited the site at Avoca. They told the N.E.T. representatives that 'subject to minor modifications (the provision of an additional belt of trees and the curving of the approach road to the factory) the Arts Council approved the plan'.[70] The significant problem with this approval was that it was meaningless without formal confirmation by a meeting of the Arts Council. When the plan for the factory was published, there was an immediate outcry by those opposed to the alleged despoliation of the countryside.[71] In January 1963, the Minister for Industry and Commerce, Jack Lynch, defended the proposal to build the factory and said:

> Representatives of the Arts Council inspected the site in April 1962 and, having received full information as to the layout of the buildings etc.,

they intimated to representatives of Nítrigin Eireann Teoranta that they saw no objection from their point of view to the location of the industry as planned.[72]

At the Arts Council meeting of 26 February 1963, concern was expressed that the Director had seen fit to act in a dictatorial fashion. It was decided that the Council should write to N.E.T. and to the Minister for Industry and Commerce informing them that 'there had been a misunderstanding'. Fr O'Sullivan apologised to J.B. Hynes for giving him 'the impression that I was giving the fertiliser factory the Arts Council's blessing'.[73] Hynes replied that as far as N.E.T. was concerned, the Arts Council had given its approval.[74] Meanwhile Jack Lynch was furious that the public had been led to believe that he had duped Dáil Eireann into thinking that the Council had approved of the factory.[75] Both Fr O'Sullivan and Michael Scott were embarrassed by the affair but they managed to persuade the Council to let them off the hook by giving formal approval to the building of the N.E.T. factory.[76]

The Arts Council's image was tarnished by its involvement in the E.S.B. and N.E.T. controversies. It would be misleading, however, to assume that the partnership of Fr O'Sullivan and Michael Scott was always detrimental. They shared an enthusiasm for painting, sculpture and architecture. Together they did much to revolutionise attitudes to modern art in Ireland. They persuaded the Taoiseach to allow the Council to appoint an Exhibitions Officer.[77] They were determined to entice people to visit public art galleries. Travelling exhibitions were brought to Ireland and attracted large numbers of visitors. Among the most successful of these was the 'Art: U.S.A.: Now' exhibition held at the Municipal Gallery, Dublin, in 1964. The Council assisted Professor George Dawson of Trinity College, Dublin, in setting up the so-called College Gallery.[78] Reproductions of modern paintings, and some originals, were purchased, framed and offered on loan to students living in the College. Each term the students could change the pictures in their rooms. A scheme was established at the suggestion of C.S. Andrews, whereby the Council paid half the cost of paintings by Irish artists which would be exhibited in C.I.E. hotels or in C.I.E. premises normally frequented by the public.[79] The half-price scheme was quickly extended to local authorities, schools, public galleries and state sponsored bodies. The paintings were chosen by a sub-committee of the Council comprised of the Director, Michael Scott, R.R. Figgis and Sir Basil Goulding. Fr O'Sullivan prompted the organisation of various exhibitions to promote improved standards in sacred art and church architecture.[80] He encouraged the preparation of carefully researched catalogues to accompany Arts Council exhibitions. This stimulated the emergence of art history as an

academic subject in Irish universities. He fostered useful contact with the Arts Council of Northern Ireland, assisted the Disabled Artists Association and generally acted as a dynamic force for the visual arts.[81]

Fr O'Sullivan's most significant achievement was the formation of what became known as the Arts Council Collection. It began in 1961 and was comprised mainly of works of art by living Irish painters and sculptors. Fr O'Sullivan saw the need for such a collection because no public gallery in Ireland had a budget for purchasing works by living artists. He did not worry that the Arts Council had no space to exhibit the paintings and sculptures which he acquired. His preference was for abstract works of the international hard edge style which was considered to be avant garde in the 1960s. He purchased many works from the Hendricks Gallery on St Stephen's Green which became the venue for exciting exhibitions such as 'Kinetic Art', organised by Fr Cyril Barrett, S.J., in 1966.[82] The Arts Council Collection provided a lead to major commercial companies and financial institutions which began to form similar collections of contemporary Irish art.

Concerted efforts were made by the Arts Council to improve the position of artists in Irish society. The Council supported Mervyn Wall's suggestion that a fund should be established to enable compassionate grants to be made to distinguished writers and artists who needed financial assistance. Wall had been a member of a deputation to the Taoiseach in 1952 about the subject but de Valera had stated that although he was sympathetic, the scheme would be too difficult to administer. In 1962 Wall tried to muster support for the suggestion once again.[83] He was informed that additional powers would have to be conferred on the Arts Council to enable it to administer such a fund. The Arts Act, 1951 (Additional Function) Order, was finally approved by the Dáil and Seanad in December 1966. The fund established was called Ciste Cholmcille (The Colmcille Fund), at the suggestion of Justice Cearbhall O Dálaigh. The Government made no contribution to the fund and it proved difficult to attract private contributions but at least some deserving artists and writers were helped by its existence. Among those assisted were Kate O'Brien, W.R. Rodgers, Seamus Murphy and Padraic Colum.

The freedom of the artist was bolstered by the strong anti-censorship stance taken by the Arts Council. In no sense was Fr O'Sullivan prudish and his Council chose innovative young artists, musicians and writers, as winners of the Macaulay Prize, including Noel Sheridan, Seoirse Bodley, Brian Friel and John McGahern. The selection of McGahern was a brave decision based on the writer's first novel *The Barracks*. McGahern's second novel, *The Dark,* was banned by the Censorship Board in June 1965. When he went to resume his

position as a teacher in a Dublin primary school, following his year's leave of absence to take up the Macaulay Fellowship, he was informed that his services were no longer required. The 'McGahern case' became a cause celebre and was a significant factor in encouraging the Fianna Fáil Government to amend the censorship law.[84] In May 1967, the Minister for Justice, Brian Lenihan, sponsored the Censorship of Publications Act, which limited the period of prohibition orders to twelve years (although books so released could be banned again), and thereby allowed the immediate sale of over 5,000 previously banned books.[85] Cinema censorship had been liberalised in 1964 when the Films Appeals Board was appointed. The more tolerant climate owed much to the arrival in Ireland of a national television station.

Ulster Television began broadcasting on 31 October 1959 and the Irish television service, Telefís Eireann, opened on New Year's Eve, 1961. Television had a profound impact on Irish cultural development. It provided proof of the dominant influence of the English language and served as an agent of Anglo-Americanisation. It was also indicative of a growing openness to foreign cultures generally. The Arts Council was not invited to participate in the ceremonies organised to launch Telefís Eireann. The reason was simple. From the outset, the Arts Council had refused to give any support to the Government's efforts to launch a publically controlled television station on commercial lines (through advertising revenue).[86] The Council argued that commercial interests tend towards vulgarisation of public taste by attempting to appeal to mass-audiences. The high cost of making home-produced programmes meant that cheap imported programmes would be inflicted on Irish audiences. The £1.5 million required as an initial capital input to launch the service, could, in the Council's opinion, have been better spent on direct subsidy of artistic activities. The Council's Canute-like stance highlighted their pre-occupation with the ideal of raising public standards. But it also showed that they were out of touch with reality. The Council marched on to the high ground and the Government poured money into the new television service. By the mid 1960s about half of the 680,000 homes in the country had telvision sets.[87]

Charles McCarthy described the 1960s as the decade of upheaval: 'New attitudes were being painfully developed and new structures and institutions to reflect them'.[88] The beginning of co-ordinated economic planning, signalled by the publication of a Government White Paper, *Economic Development*, in November 1958, ushered in a period of unrivalled prosperity. The average annual rate of growth of gross national product in constant prices over the entire period from 1926 to 1968 was 1.8 per cent. But compared to this

average figure, the years from 1959 to 1968 were extraordinary. The average annual rate of growth of gross national product in these years was 3.75 per cent.[89] In a perceptive article titled 'Ireland: The End of an Era?', David Thornley described the country which was emerging:

> It seems certain that our island will become affected increasingly by the spread of European social and philosophical ideas, strongly tinged with Catholicism. It is reasonably certain that many of the issues of education and social welfare will slowly be transplanted from the fields of emotional controversy to that of economic efficiency and that a great deal more money will be spent on both. It does seem certain that the depopulation of the country will continue and perhaps accelerate, and that our social habits and our politics will take on a flavour that is ever more urban, and, as a consequence, even more cosmopolitan. And that this in turn will sound the death-knell of the attempt to preserve any kind of indigenous Gaelic folk culture in these islands.[90]

Pop culture descended on Ireland in November 1963 when The Beatles played a concert at the Adelphi Cinema in Dublin. Fans who failed to gain entry rioted in Abbey Street and O'Connell Street. A different sort of Playboy of the Western World had set Dublin life alight compared to the famous scenes of 1907.

Education became a priority for the Government because from 1961 the population began to increase and a consequent need for additional schools emerged. A new generation was growing up in a period of prosperity and the provision of recreational facilities became an urgent necessity. For the first time since independence, senior civil servants were encouraged to examine the administrative and financial implications of cultural development. The Institute of Public Administration, a Government sponsored body founded in 1957, introduced a lecture series in 1965 on aspects of State involvement in the arts. The publicity brochure for the lecture series advised that the arts could no longer be regarded as a side-issue. Ireland was still a long way from establishing a Minister for the Arts, as the British Labour Party Government did in 1965 when Jennie Lee took up the new post with vigour. But arts issues were appearing on the agenda for Government meetings with increasing regularity.

It would be wrong to assume that the Government had a structured plan for the development of an arts policy. There was an emphasis on projects as opposed to policy. Fianna Fáil had big plans, some of which came to fruition unlike previous plans prepared by them in the 1940s. Lemass and his Minister for Finance, Dr James Ryan, felt the provision made for cultural purposes was

'rather low'. As Dr Ryan put it: 'Whenever the axe of economy fell, it seemed to fall most heavily on provisions of this kind'.[91] Lemass advised that perhaps some 'grand gestures' could be made to remedy the situation.

The Taoiseach's own contribution to the new departure was his enthusiastic support for the Ardmore Film Studios which he opened officially on 12 May 1958.[92] The Government provided generous funding to launch the studios and in 1960 established the Irish Film Finance Corporation, a subsidiary of the Industrial Credit Company, to provide inducements to foreign film producers to make films in Ireland. The studios failed miserably. The Government did not pay attention to the content of films and concentrated on economic return. The studios met top international standards for equipment and facilities but what was produced in terms of films was generally second-rate. The Industrial Credit Company placed the studios in receivership in 1963.

Kilkenny Design Workshops, another commercial venture sponsored by the Government, was more successful than Ardmore Studios. Following the Taoiseach's decision in 1960 to transfer responsibility for industrial design from the Arts Council to An Córas Tráchtála, it was decided that a report was needed assessing the existing design standards in Ireland. Five Scandinavian industrial designers were commissioned to write the report. They visited Ireland for two weeks in April 1961 and gathered enough material to deliver a hard-hitting report, *Design in Ireland*, which was published in February 1962. The report gained notoriety for its verdict that 'the Irish school-child is visually and artistically among the most under-educated in Europe'.[93] Irish newspapers gave the report widespread coverage and editorials urged the need for industrialists to treat product design seriously.[94] The Taoiseach told the Dáil that the Scandinavian experts' report had by its 'controversial' character done more to prompt interest in industrial design than all the exhortations of Ministers or the Arts Council could have done.[95]

An Córas Tráchtála responded to the Scandinavian Report in April 1963 by establishing a private company, Kilkenny Design Workshops, to set new standards for design in Ireland. The coach-houses and stables of the Earls of Ormonde, situated opposite Kilkenny Castle, were restored by the architect, Niall Montgomery (a member of the Arts Council, 1956-9), and officially opened by the Minister for Industry, Patrick Hillery, in November 1965. Within a few years, Kilkenny Design Workshops, had established itself as an innovative and high quality company.[96]

The Government's concern to improve the standard of design in Ireland was also indicated by the appointment of a Council of Design in September 1963 to report on 'design activities and design policy for the twenty-six

counties of the Republic of Ireland'. This was a much more extensive examination than the Scandinavian Report. The Report of the Council of Design was presented to the Government in September 1965 (although it was not published until 1967). It concluded: 'In the recent past there has been less bad taste in Ireland than an absence of taste'.[97] The Council proposed the establishment of a new College of Art, Architecture and Design, a National Design Council, and a Design Centre.[98] It was argued that a radical modernisation of all existing cultural institutions was an urgent necessity.

The first of the cultural institutions to be modernised was the National Gallery of Ireland. A fine extension was designed by Frank Du Berry of the Office of Public Works and construction work was completed in May 1968 at a total cost of £420,000. The selection of James White as the new Director proved an enlightened choice by the Gallery's Board of Governors and Guardians. He had been an innovative Curator of the Dublin Municipal Gallery (1960-4) and his arrival at the National Gallery brought an open-door

*The National Gallery of Ireland, 1968*

policy which saw annual visitor numbers increase from 55,000 to 360,000 in eight years.[99] He was fortunate that his appointment in 1964 coincided with the expansion of the Gallery building and increased funds to purchase pictures due to the decision of George Bernard Shaw to insert in his Will, a provision that one third of the royalties from his writings would go to the National Gallery. During the 1960s, the success of *My Fair Lady*, based on Shaw's play *Pygmalion*, was consequently of great benefit to the Gallery. The enactment of some remedial legislation also helped. Up to 1963 the National Gallery was empowered to lend works of art to public exhibitions only. In that year, the National Gallery of Ireland Act gave Oireachtas approval to the Board of Governors and Guardians to lend works of art to any institution approved by them. The Dáil and Senate debates on the Bill gave political support to the policy of bringing art to the people by, for example, supporting exhibitions in rural areas.[100] James White was in total sympathy with this policy. He capitalised on the new developments and won acclaim as the archetypal Irish cultural administrator.

The longstanding plans for a new national library and a concert hall were pursued by the Government during the 1960s but without success. In 1961, a site near Morehampton Road, Dublin, was purchased for the National Library and designs were drawn up for an elaborate building at an estimated cost of £1,250,000.[101] The Department of Finance advised that 'the likelihood of capital being available...in the immediate future is remote'.[102] The project died a slow but predictable death. Financial difficulties also beset the concert hall saga which continued to simmer in the late 1950s until, in 1961, the Royal Dublin Society undertook an examination of the feasibility of assuming responsibility for the building and administration of a concert hall.[103] The proposal was suggested to the R.D.S. by Concert and Assembly Hall Ltd. but it was decided that it was not viable. In 1963 the Taoiseach, in line with the Government's series of grand gestures towards cultural projects, announced that the State would guarantee a grant of £100,000 to Concert and Assembly Hall Ltd. provided a site was made available by Dublin Corporation.[104] The Corporation proposed the site at Christchurch Place (Nicholas Street-High Street) which had been offered to Concert and Assembly Hall Ltd in June 1955 on condition that the Government provided the building costs. The site was being excavated by archaeologists and the Corporation advised that it would not be available immediately. But the main reason why the plan did not materialise in 1963 was because the Government's grant fell far short of the estimated £650,000 needed to build the concert hall.

The concert hall proposal received a new lease of life in January 1964 when the Arts Council took up the matter once again. The Government accepted

the Council's suggestion that President John F. Kennedy, who had visited Ireland a few months before his assassination in November 1963, should be commemorated by the construction of a concert hall and an exhibition hall. An All-Party Committee was formed to advise the Government on the project.[105] The site of the former Beggars Bush Military Barracks at Haddington Road, Dublin, was selected and Raymond McGrath, Principal Architect of the Office of Public Works, took charge of the scheme. The estimated cost of his imaginative design was £2.5 million and the project was to be completed by the autumn of 1968.[106] In January 1968 the Taoiseach made a controversial decision to postpone the project temporarily because the Government's budgetary position could not accommodate it.[107] An editorial in the *Irish Times* noted that the project had been postponed and not abandoned. The writer considered that the concert hall was now a test case of the Government's maturity:

> The argument that this hall must be one of the first projects to suffer in a credit squeeze because it is a concert hall is undoubtedly an admission that cultural life is a mere luxury and that our people do not regard it as a need. Slowly and with great effort we have transformed the image of Ireland abroad, and we have done it in spite of great difficulties. To falter in this would be a sad admission of deflated pretensions.[108]

For the next few years, news stories appeared intermittently confirming that the so-called Kennedy Concert Hall would finally be built.[109] The rumours were groundless and the project floundered like its predecessors.

In contrast, the Government had a major success with the opening of the reconstructed Abbey Theatre in 1966. There had been various pledges of Government support since the original theatre was destroyed by fire in 1951. On the occasion of the Abbey's Golden Jubilee performance on 27 December 1954, the second Inter-Party Government had announced its willingness to contribute funds for the rebuilding of the theatre.[110] When design details had been finalised, no funds could be found. Fianna Fáil, on resuming power in 1957, reset the plans in motion and the following year announced that the new theatre would be completed by 1960.[111] It took somewhat longer than anticipated to complete the project but when it was opened in 1966, Michael Scott's design won widespread acclaim. The Abbey theatre had all the latest fittings while retaining an intimate atmosphere. As in the original building, there was a smaller theatre, the Peacock, which was reserved for experimental plays and for works in Irish. The total cost to the State was £732,000 which represented a huge injection of funds allocated for a cultural purpose.[112] In 1966 the Arts Council's annual grant-in-aid was a mere £40,000. Again this

*The Abbey Theatre, 1966*

contrasts with the £300,000 contributed by the Government towards the construction of the new Cork Opera House in 1967. These figures illustrate clearly the emphasis on 'grand gestures' as against organised policy. Nevertheless, the expensive cultural facilities funded by the Government were sorely needed and their existence symbolised the emergence of general public interest in the arts in Ireland.

It is readily apparent that the growing involvement of the Government in the provision of better cultural facilities was occurring at a time when the Arts Council was taking a self-limiting view of its responsibilities. When the Government's initiatives were announced, the Council gave them enthusiastic support. But the Council was not asked for its advice before the Government launched its cultural initiatives. The Council found itself increasingly on the side-line when decisions were being taken. Politicians and civil servants were quietly taking control of arts issues which had previously been debated only at Arts Council meetings at 70 Merrion Square. It would be incorrect to state that the demise of the Arts Council was being planned. It was the Council which behaved as if it had a deathwish by failing to respond to the challenges facing it. As a result, for the first time in its history, the Council became the target of sustained public criticism.

# CHAPTER EIGHT

## PATRONAGE UNDER FIRE: 1967-73

*A group thus passes from the scene*
*Whose likes again shall not be seen*
*For casual heroic waste*
*Of public money on private taste*
*Complacence, arrogance, self-contentment,*
*Begrudgery and pure resentment,*
*We raise a cheer as it departs,*
*The Inquisition of the Arts.*

<div align="right">MICHAEL KANE</div>

On 11 April 1967, Charles J. Haughey delivered his first Budget speech as Minister for Finance and announced that he was increasing the Arts Council's grant-in-aid for 1967/8 from £40,000 to £60,000. In a paragraph on the subject of 'Culture and Leisure', he declared:

> In modern society, as income standards rise, there is a compelling social necessity to devote increasing attention to the problems of leisure. To ensure that an adequate variety of cultural and recreational facilities is available for their people, and, indeed, to raise general standards in this respect, is now accepted as an obligation by enlightened governments everywhere...The State is already providing assistance to music, the arts and theatre. I intend during the year to consider how these arrangements can be improved.[1]

This was the first of a number of positive signs for the arts which occurred in 1967. Another was the establishment of 'Project 67' which eventually became

*Charles J. Haughey*

the Project Arts Centre. It began in Autumn 1966 with a season of plays, poetry readings, concerts and films at the Gate Theatre and an exhibition of the works of four artists, John Behan, Charles Cullen, Michael Kane and John Kelly. The events were organised by Colm O Briain and Jim Fitzgerald. In March 1967 they opened the Project Gallery on the second floor of a building in Middle Abbey Street, Dublin. Its aim was new and refreshing - 'to provide a blanket cover for the arts, to allow ideas to interact freely between artists and their public who have become separated from art'.[2] Colm O Briain, a dynamic 23-years old Dubliner, advised the Arts Council that Ireland should have local and regional arts centres where various art workshops and studios would be gathered together in free association. The Project Gallery showed how the concept would work by organising lectures, poetry readings, musical events, dramatic productions and exhibitions of photography, painting and sculpture.

It was significant that the Project Gallery should have been opened officially by Donogh O'Malley, Minister for Education. In twenty months presiding over the affairs of the Department of Education, before his death in March 1968, O'Malley revolutionised the Irish educational system. He introduced free education for all at primary and secondary level, closed small rural schools and used free school transport to bring children to larger schools in urban areas. Intermediate and Leaving Certificate courses were brought into

*Donogh O'Malley*

151

the vocational school system. University College, Dublin, was given permission to begin building a new campus at Belfield. O'Malley's grand plan to merge the two universities in Dublin, University College and Trinity College, did not succeed but generated heated controversy.

O'Malley saw to it that art and music were given more attention and that civics was introduced as a subject in the school curriculum. In January 1968, he delivered what the *Irish Independent* described as 'a quite sensational speech' at a meeting in the Ursuline Convent, Waterford.[3] His talk entitled 'Thoughts on Art and Education' was remarkably candid:

> It is my conviction that every child should have some formal visual education, be it only a drawing class, and as far as in me lies, I intend to do a great deal about it. There is a latent talent in Ireland such as few other countries possess, but my neglect of the arts and my failure to provide adequately in our schools for music, drama, a knowledge of our national treasures and our wonderful ancient monuments - must be put right.[4]

Donogh O'Malley left his successors as Minister for Education in no doubt that the arts held an essential place in the education system. The Irish public too was beginning to discuss the subject of the arts, especially modern painting and sculpture. The main reason for this development was the success of an international art exhibition held at the Royal Dublin Society premises in Ballsbridge from 14 November 1967 to 9 January 1968.

The exhibition was called Rosc, an Irish word translated as 'the Poetry of Vision'. It was the brainchild of Michael Scott and had the enthusiastic support of Anne Crookshank, art historian; Cecil King, artist; Fr O'Sullivan; and Charles J. Haughey.[5] Three jurors of international stature, Jean Leymarie, William Sandberg and James Johnson Sweeney, were chosen to select three works by each of fifty artists from around the world. The works of art had to have been created within the previous four years. The jurors suggested that an exhibition of 150 objects of ancient Celtic art from the National Museum should be held simultaneously to act as a contrast to the modern exhibition and to 'demonstrate the universality of great art'.[6] The major sponsors were W.R. Grace and Company, An Chomhairle Ealaíon and An Bord Fáilte.

The exhibition attracted newspaper headlines quickly. The decision to exclude Irish artists was controversial and the choice of international artists was criticised as 'biased...based on the narrow Paris-London-New York art axis'.[7] The most vigorously contested aspect of Rosc '67 concerned the exhibition of ancient Celtic art. It was intended that this exhibition would be

*Michael Scott*

*Anne Crookshank*

on view beside the display of modern art at the R.D.S. But the removal of famous national monuments, such as the Turoe Stone in Co Galway, from their sites so that they could be viewed together at the exhibition in Dublin caused a furore among archaeologists and conservation groups. The R.D.S. authorities announced that they would not allow the display of national monuments on their premises. The National Museum then offered to host the exhibition but the division of the exhibition between two venues ruined the original concept.

The Rosc exhibition at the R.D.S. was opened officially by Charles Haughey who remarked: 'Most worthwhile things are born in controversy, often even in conflict. I believe that when the dust settles this endeavour will be seen clearly for what it is and the benefits it has achieved for art and for Ireland will stand proudly forth'.[8] Visitor numbers at Rosc were 50,000 at the R.D.S. and 29,000 at the National Museum.[9] The exhibitions drew public attention to works of modern art and to the treasures of the National Museum. Rosc captured the imagination and enthusiasm of journalists and art critics. It drew tourists to Ireland, prompted a stream of letters to the newspapers, was debated in the Dáil, and provided table talk for weeks.[10] The exhibition was so successful that it was agreed that it should be repeated every four years.

Rosc highlighted a number of developments in the arts in Ireland during the 1960s. It indicated the emergence of an art market based on international trends, the existence of a small but important group of private collectors of modern art, the conflict emerging between theories of art by the people (community arts) as against art for the people, and, not least, the emergence of art as a subject worthy of serious public speeches by an ambitious and capable Minister for Finance.

Charles Haughey visited the Arts Council's premises at 70 Merrion Square on 15 March 1968 to outline his plans for future State assistance to the arts.[11] Haughey managed to appear to be legally responsible for the Arts Council when in fact responsibility rested with the Taoiseach. Jack Lynch was preoccupied with other issues and allowed his Minister for Finance to assume a role as Fianna Fáil's patron of the arts. No Transfer of Functions Order was prepared giving legal authority to the change even though the Minister told the Arts Council that he intended to request the Taoiseach to give him formal responsibility for arts matters, including the Council's grant-in-aid. Haughey also declared that he intended to abolish the existing Council and to set up in its place three new Councils responsible for the Visual Arts, Drama and Literature, and Music. These new Councils would be independent of each other with separate staffs and premises. The Minister intended to grant

£100,000 to the Visual Arts Council and £50,000 each to the other two Councils. His Department considered £200,000 to be excessive. The Minister demurred and when the Budget was announced on 23 April 1968, the grant-in-aid allocated to the Arts Council for 1968/9 was £60,000 only. The sum of £100,000 was set aside to allow for the launch of the three new Councils. Haughey said that 'the legislation to establish the new bodies will be proceeded with as soon as possible'.[12]

The Arts Council accepted the involvement of the Minister for Finance in its affairs without the slightest protest. Mervyn Wall advised the Council that he and others felt that an enhanced superior body with three sub-Councils would be a better solution than three separate Councils.[13] Fr O'Sullivan was not prepared to make representations to the Taoiseach about the matter. He wished the Arts Council's demise to be dignified, ready for its resurrection as an expanded and better-funded tripartite institution. In the Council's Annual Report for 1967/8, Fr O'Sullivan's introductory essay read like an obituary:

> It is no easy task for a body to estimate its own success or failure in carrying out the duties allotted to it: and it is certainly all the more difficult in things artistic. But at least it can be said with safety that the artistic progress made in Ireland since 1951 - and in some fields it is marked - owes very much to the aid and activities of An Chomhairle Ealaíon.[14]

Few could argue with this assessment but Fr O'Sullivan's comments about the visual arts were less judicious. He wrote:

> The Council has consistently endeavoured to buy good Irish painting, irrespective of its origins. Unfortunately in the world of art, as in any of the professions in any country, the unpalatable truth is that there are those whose ambition runs far ahead of their talent: they are just bad at their job.[15]

The problem with this statement was that when purchasing works by contemporary Irish artists for the Arts Council collection, Fr O'Sullivan and his small sub-committee were using public funds to exercise their own taste. They neglected the emergence of figurative painting which was vigorous and expressionist in style and favoured the cool, smooth, abstract style which had been displayed at the Rosc exhibition. Michael Scott explained: 'The international mood of the time favoured abstract works. We bought the painters we thought were good and they were good'.[16] Those whom the sub-committee considered to be bad painters were cold-shouldered. Council

members did not attend their exhibitions and, only when accused of bias, made token purchases of their works. In some respects the Council's attitude was understandable. It was expected to know the difference between good and bad art. But it was also reasonable to expect the Council to attempt to represent the full range of painting styles in Ireland. Too often it appeared that 'bad' painters were those whose paintings Fr O'Sullivan disliked.

Two Dublin art critics, Bruce Arnold and Tony Butler, campaigned bitterly against the Arts Council's visual arts policy. They supported the Independent Artists group which exhibited at the Project Gallery. They argued that the Arts Council's duty was to purchase the works of talented young artists like Michael Kane, James McKenna and John Behan, instead of buying large numbers of works by established artists. Between 1960 and 1973, the Arts Council spent £92,300 on the purchase of works of art.[17] When Bruce Arnold asked the Council how much of this sum had been spent on the works of Anne Madden and her husband, Louis Le Brocquy, the answer proved embarrassing - 29 paintings by Le Brocquy at a cost of £9,200 and 12 paintings by Madden at a cost of £2,400.[18] It was generally agreed that the works of Le Brocquy and Madden were excellent but a disproportionate amount of the Council's funding was spent on them. It was alleged that the imbalance was due to Fr O'Sullivan's respect for and friendship with Louis Le Brocquy.

There was a wider issue - the apparent unwillingness of the Arts Council to view the arts as anything other than a pre-occupation of the middle class. Bruce Arnold wrote: 'Art in Dublin is a vicious, spiteful and rapacious business. It is concerned with reputation, with money, with quite formidable clashes of personality, with lies, with deceit, with bribery and corruption'.[19] The Arts Council ignored these accusations for some time but Tony Butler went too far when he wrote in a review of an exhibition by the Independent Artists at the Project Gallery:

> The Independents will suffer for their courage and their opening was notable for the fact that not one member of the Arts Council attended it...the purchases by the Council will be minute, if there are any, for our Establishment uses public money as an instrument of private resentment.[20]

The Arts Council asked its solicitors to seek a published apology from the *Evening Press* and, if there was any reluctance to comply, to institute proceedings in the High Court claiming substantial damages.[21] The Council members were enraged and felt that they had been libelled. They argued that

Butler's words could be taken to imply that that they had misused public money and that they had used it to further private interests.[22] The *Evening Press* published the required apology and 'wholly and unreservedly withdrew the words used'.[23]

Charles Acton offered a more useful criticism about the Arts Council when he pointed up the absence of policy:

> During nearly two decades of existence, our Arts Council does not seem to have worked out any policy...It has made possible a great number of events, large and small, which could not have taken place without its support, but nearly all of these have been of a hand-to-mouth, cheque-writing, nature without policy or permanency.[24]

Acton was particularly concerned about the continued use of guarantees-against-loss. He wrote: 'deficit grants without strings are invitations to stick in the mud'. Guarantees-against-loss conveyed the presumption that artistic activity was always loss-making and there was an incentive to recipients to use the whole of the guarantee up to the maximum loss. Acton explained: 'To know that the cheque from the Arts Council, whether for £20 or £800, depends upon one's not covering expenses is a disencouragement to effort and an encouragement to incurring losses'.

Throughout the 1960s, the membership of the Arts Council included one practising artist only, a composer, Brian Boydell. This fact made it easy for critics of the Council to claim that it was out of touch with the practical needs of artists.[25] The absence of any female member was also the subject of criticism.[26] The Council failed to respond to some important developments in the arts such as the growth of folk music and traditional Irish music. Seán O Riada died in 1971 having been the most creative force in the revival of traditional music.[27] At no stage had he received any assistance or recognition from the Arts Council. There was also well-founded criticism that the Council made no serious attempt to provide funding for artistic activities outside Dublin. Requests by the Department of the Taoiseach for details of Arts Council expenditure in twelve counties elicited disturbing information.[28] In 1961/2 the Council provided no funds in five of the counties. In 1965/6 seven of the counties received no funds. In the counties where artistic activities were assisted, the scale of funding was paltry.

It seemed as if the Arts Council could do nothing right. In October 1969, a controversy was sparked by an exhibition of 'Contemporary Irish Painting' which had been sponsored by the Council to tour a number of cities in Scandinavia. The choice of painters was criticised for excluding works by the

*Brian Boydell*

*Jack Lynch*

Independent Artists and representatives of the Royal Hibernian Academy.[29] But it was the tone of an essay in the exhibition catalogue which aroused widespread anger. The essay written by T.G. Rosenthal, an English art critic and Director of Thames and Hudson Publishers, described the 1916 to 1922 period in Irish history as 'a senseless war'.[30] In response to a parliamentary question, the Taoiseach, Jack Lynch, criticised the Arts Council for failing to edit out the provocative comment. He concluded curtly: 'I think it was unfortunate and that it should have been excised'.[31]

Mervyn Wall was in the unenviable position of having to defend the Arts Council although he was convinced that it had gone off the rails. In 1960 he had proposed that the Council should seek to define and limit its responsibilities, but he disagreed with the way Fr O'Sullivan used this tightening of responsibilities in order to devote himself almost exclusively to the visual arts. Mervyn Wall felt let down by the refusal of the Director and the Council members to talk to journalists. Fr O'Sullivan considered that following his review of the Arts Council's activities in the 1967/8 Annual Report, the Council had nothing further to add prior to the introduction of legislation to implement the Minister for Finance's plan for three independent Arts Councils. But this left Mervyn Wall as the sole spokesman for the Council at a time when it was under sustained attack. As Secretary, he had to argue the case for the Council's actions even when he disagreed strongly with them. As a competent, disciplined, cautious bureaucrat, he chose not to voice his objections. He explained:

> I did not speak very much at Council meetings. I prepared the agenda for 17 years and before each meeting I briefed the Director. Essentially he knew as much as I told him. At meetings I did not put my views forward because they were my employers and as such I respected them. I depended on them for my bread and butter and I had a wife and children to think of. In the event of any trouble I knew that the Taoiseach would not sack the Director, he would sack the Secretary.[32]

The knowledge that the Council faced imminent reorganisation meant that decisions requiring serious financial commitments had to be postponed. This was the main reason why a generous and imaginative offer by Sir Tyrone Guthrie to donate his house, Annaghmakerrig, Newbliss, Co Monaghan, to the Arts Council, was treated in a protracted and ungrateful manner. Guthrie, an internationally-renowned theatre director, envisaged that his ancestral home could be used as 'a hostel or hermitage in which artists seeking quiet in which to work, would receive free shelter and partial board for a limited

*Sir Tyrone Guthrie*

*Annaghmakerrig*

period'.[33] Guthrie intended that the Arts Council of Northern Ireland should be involved in the project but he was informed that because the house was situated in the Republic of Ireland, the Northern authorities might not be permitted legally to contribute any capital funding. There was a possibility, however, that the Arts Council of Northern Ireland could offer scholarships to Northern artists to allow them to spend time at Annaghmakerrig. Pending a definitive legal opinion, the two Arts Council's agreed to explore the proposal on a shared costs basis.

In April 1966, the Arts Council thanked Sir Tyrone Guthrie for his public-spirited offer and told him that the project had been granted approval in principle. It was decided that the Arts Council would meet half the cost of the fee of an architect appointed by the Arts Council of Northern Ireland to report on the feasibility and cost of the projected scheme.[34] The architect, Robert McKinstry, reported in October 1966 that each Council would have to contribute a capital sum of at least £10,850 to renovate and adapt the house. Current costs would depend on how many people were funded to stay at the house each year. Mervyn Wall advised: 'The venture would not appear to be a good one economically, and it would probably be cheaper to build a new house for the purpose, which would incidentally provide greater accommodation'.[35] The Arts Council decided that it had insufficient funds to underwrite the project. Sir Tyrone Guthrie was told politely that the Council was compelled to decline his offer. The theatre director's response was to improve the terms of his proposal. He agreed to pay for the entire capital costs of renovation if the Arts Council would pay the annual current costs. At this point, the Council began to procrastinate. It was December 1967 before a decision was made to give the revised terms approval in principle. A firm of accountants was nominated to determine the full annual cost to the Arts Council of maintaining Annaghmakerrig. By March 1968 when Charles Haughey announced his intention to restructure the Arts Council, no further contact had been made with Sir Tyrone Guthrie. He became impatient and wrote to Mervyn Wall to ask if any progress had been made. Mervyn Wall replied that he hoped and expected that the commitment to Annaghmakerrig would be adopted by the new Arts Councils when they were established.[36] Sir Tyrone Guthrie waited until April 1969 before writing again. He was in poor health and upset about the Arts Council's inaction:

> I have tentatively discussed the scheme with one or two public bodies in America who also expressed an interest, which was far more than merely polite, but cannot be expressed in practical terms until your Arts Council has reached a more definite decision. You will, therefore, understand that

it is somewhat frustrating to have heard nothing whatever from your side, since Mr Wall's last letter, written many months ago.[37]

Mervyn Wall sympathised with the frustrated benefactor and explained: 'The old Arts Council and I are still here, our abolition having been delayed by a car accident in which the Minister for Finance was involved and which rendered him inactive for four months'.[38] Sir Tyrone Guthrie decided to dispense with the accountant's report and, instead, to revise his will. He bequeathed Annaghmakerrig to the Minister for Finance on condition that the current costs of running it as a retreat for artists would be met by the Arts Council and the Arts Council of Northern Ireland. This would force the Irish Government to consider the proposal seriously following his death. He met Mervyn Wall in June 1969 and they discussed the whole matter.[39] Following Sir Tyrone Guthrie's death in May 1971, his bequest of Annaghmakerrig was widely acclaimed.[40] The Minister for Finance accepted the gift. It would have been politically damaging to have refused it because, in that eventuality, Sir Tyrone Guthrie had provided that it should fall to Queen's University, Belfast. Annaghmakerrig was not opened to receive visiting artists until 1981. The delay was due to legal difficulties relating to Sir Tyrone Guthrie's estate and to the need to devise a formula whereby the Arts Council of Northern Ireland could contribute to the current costs of maintaining the house as a centre for artists.

The saga of Annaghmakerrig was the most noteworthy example of the inertia of the Arts Council following the announcement that it was to be abolished. The Minister for Finance's car accident was only one reason why new legislation was not introduced. The main cause of the delay was explained to Mervyn Wall in a telephone conversation with Bob Whitty, Principal Officer in the Department of Finance with responsibility for cultural institutions. Mervyn Wall noted:

> He [Mr Whitty] said that the reason the Council had never heard anything about the new Bill was that the Minister had never decided whether or not to have three independent Councils or one supreme Council and three subordinate ones. The Dept. of Finance had recommended to him one Council, and the Minister had not given a decision. The matter still rests at that point. Perhaps, Mr Whitty said, Mr Haughey lost interest.[41]

The Department of Finance feared that three Arts Councils would create excessive demands for funding. The case for one Arts Council with three sub-

committees seemed more logical. Charles Haughey allowed the matter to rest and turned his attention to an innovative proposal that painters, sculptors, writers and composers, living and working in Ireland, would be free of income tax on all earnings derived from creative works judged to be of cultural merit.[42] The radical nature of the proposal attracted Haughey and he won the Government's acceptance to announce it in the Budget on 7 May 1969.[43] He declared in his speech on the Finance Bill, 1969:

> This is something completely new in this country and, indeed, as far as I am aware, anywhere in the world. We are entering a field in which there is no precedent of experience to guide us. It is a difficult undertaking because there are bound to be differences of opinion as to what constitutes a creative work and what has or has not cultural or artistic merit.[44]

Reaction to Haughey's announcement was mostly favourable although Maurice MacGonigal, President of the Royal Hibernian Academy, caused a row when he foresaw the concession being abused by 'the Art Nits of Dublin' and the 'Art Parasites of Europe'.[45] A number of artists including Louis Le Brocquy resigned from the Royal Hibernian Academy in protest at MacGonigal's outburst.

It was envisaged that the scheme would be implemented by the Revenue Commissioners in association with the Arts Council. The arrangements were devised in a rather unusual way. Mervyn Wall often met Seán Réamonn, Chairman of the Revenue Commissioners, at the Forty Foot bathing place in Sandycove, Dublin, where they were both regular swimmers.[46] Following a swim one day shortly after the scheme became law, the two men agreed that there was only way it could work effectively. If an artist was deemed eligible on one occasion, he or she would be exempted from income tax on all future works also. Seán Réamonn asked Mervyn Wall to submit a list of artists, writers and composers who would be suitable for inclusion in the scheme. While this approach was ham-fisted, it emphasised the difficulty the Revenue Commissioners had in deciding how to get the scheme off the ground quickly. Mervyn Wall drew up a list of 150 artists on the basis that if their work had been accepted for inclusion in the annual Oireachtas, Royal Hibernian Academy or Living Art exhibitions in the previous three years, they should be eligible. The 27 members of the Irish Academy of Letters were selected for inclusion as creative writers. Mervyn Wall's wife, the music critic Fanny Feehan, suggested the names of five composers.[47] The Revenue Commissioners accepted all of the names proposed without exception. Gradually as further

applicants claimed tax-free status, a set of operational principles was devised.[48] The Arts Council's role was to consider the creative merit of a work when requested to give its advice to the Revenue Commissioners regarding an application for tax-free status. Mervyn Wall decided that the Minister for Finance had intended that the measure be interpreted liberally. In consequence, the numbers of applications approved by the Revenue Commissoners, who always accepted the Arts Council's advice, increased rapidly. By November 1972, 466 applications had been assessed of which 338 were granted exemption from income tax.[49]

The introduction of tax free status for creative artists was without doubt the most important political gesture towards the arts in Ireland since independence. Charles Haughey deserved every credit for his enthusiastic support for the measure. But as the sculptor, John Behan, pointed out, it did not provide more work for artists:

> The younger Irish artists are not benefitting at all, particularly those in the visual arts. Any money they do earn goes straight back into their work. The tax-relief scheme is a nice gesture in that it has given the artist some recognition, but it will remain a gesture until there is some form of follow-up. What we need are more opportunities for the artist to use his talent.[50]

It was true that there was not much direct Government patronage through commissions. Nevertheless, Behan's own art of sculpture had been favoured with some support. This included commissions from the Office of Public Works for commemorative sculptures by Edward Delaney (the Thomas Davis Memorial, College Green, Dublin, and the Wolfe Tone Memorial, St Stephen's Green) and Oisín Kelly ('The Children of Lir', Garden of Remembrance, Parnell Square). The Office of Public Works also followed the Arts Council's lead and purchased contemporary Irish paintings for display in Government offices and embassies abroad. Charles Haughey used every available opportunity to exhort major business corporations and financial institutions to invest in works of art.[51] He endorsed Fr O'Sullivan's claims that 'the advertising returns from art patronage would be far more prestigious and far more durable eventually'.[52]

Throughout 1969, newspaper editorials offered comments on one announcement after another concerning the State and the arts. In August, the report of the Public Services Organisation Review Group (popularly called the 'Devlin Report' after the Chairman of the Review Group, Liam St John Devlin) included among its many proposals a recommendation that the

Department of the Gaeltacht should be replaced by a Department of National Culture.[53] The intention was that if responsibility for cultural affairs was centralised in one Department, it would be possible to plan a cultural policy. It was envisaged that the new Department would have three sections: one dealing with State-funded Irish language institutions; one with the National Library, National Museum, national archives, public libraries, national parks and monuments; and one with other grant-aided cultural institutions such as the Abbey Theatre, the Arts Council, the Royal Irish Academy, the National Gallery and Radio Telefís Eireann.

The Government ignored the Devlin Report's recommendation. At the same time, the Minister for Finance told a Fianna Fáil meeting in Dalkey that State planning for the arts was essential:

> We must all contribute to creating an increasingly satisfactory cultural and artistic environment...Enlightened and far seeing planning and action are needed now if we are to have in the future the sort of society which will not be just tolerable, where people lead lives of dull though perhaps prosperous monotony, but where there can be satisfaction, fulfilment and, dare one hope, joy and laughter.[54]

These sentiments were all very well but they sounded hollow when the Government was making no attempt to reorganise the Arts Council never mind plan a new cultural policy. Nonetheless, Charles Haughey had made it abundantly clear that he was concerned about the arts. In September 1969, he announced that the Government had decided to grant-aid the Gate Theatre Company to offset the cost of renovation of the theatre and annual running costs.[55] This was well-merited official acknowledgement of the Gate Theatre's place in Irish life and a special tribute to its founders, Hilton Edwards and Micheál MacLiammóir. Haughey's announcement following on from the introduction of tax free status for creative artists reinforced his position as the Irish politician who did most for the arts.

It is important to ask whether a fundamental shift had occurred in official thinking about State patronage of the arts. Would the Government treat cultural development the same way it had treated economic development by publishing a five-year plan with set targets? The answer was no. In fact, the question was never even considered by the Government. What had occurred was that a prominent Government Minister, Charles Haughey, was actively supporting the arts. This was a hopeful development but it led some observers to suspect that once-off measures, though useful in themselves, were being used in an attempt to win votes from an increasingly educated electorate.[56]

Bob Whitty was quite blunt in his assessment that the arts were governed to a large degree by opportunistic gestures.[57] This may be considered a cynical judgement but the lack of willingness to tackle serious reforming measures gives it some credence. It is equally true that it was a poor omen for the arts in Ireland when Charles Haughey resigned from the Government on 6 May 1970.

Haughey's post was taken by George Colley who said that he was too busy to consider his predecessor's proposals for the Arts Council.[58] In answer to a parliamentary question asking when he would introduce the necessary amending legislation, Colley replied: 'I have not yet had an opportunity to consider in detail this rather complex matter. I am not therefore able to say...what precisely the nature and extent of any changes will be'.[59] He showed himself to be under the illusion which Haughey had created that the Minister for Finance was responsible for the Arts Council. He affirmed when queried on the matter: 'It is one of my functions as Minister for Finance'.[60] This was manifestly untrue because the Arts Act, 1951, gave the Taoiseach responsibility for determining the amount of the Arts Council's annual grant-in-aid. In practice, the Taoiseach had nominated the members and dealt with all matters related to the Council's activities.

Although the Department of Finance appeared to share its Minister's opinion that he was responsible for the Arts Council, it did not push the question of reform. Bob Whitty offered a candid explanation:

> The Department of Finance did not care a fig about cultural bodies. While I'm not totally on the side of the angels, I favour support for the arts. But I, like everyone else in the Department, I should think, had little respect for the Arts Council. They established a coterie or clique around themselves. The Irish arts world was too in-grown and in-bred. They'd cut the nose off each other.[61]

It was left to art critics and artists to campaign for reform of the Arts Council and, as Whitty suggested, they did not pull their punches. Most of their criticism was directed at Fr O'Sullivan and calls were made for his resignation.[62] It was a surprise to his critics when Fr O'Sullivan announced at the press opening in October 1970 to launch an important exhibition of the work of the Russian-born sculptor, Alexander Archipenko:

> I believe that any man in my position has given of his best after 11 years in office...I believe the time has come to make way for a man or woman with fresh ideas. If they don't sack me this year, I shall certainly sack myself.[63]

But the Government did not remove Fr O'Sullivan when the Arts Council's term of office expired in December 1971. He was persuaded to remain as Director despite his protests that he was in poor health. He was re-appointed for two years only as were the six ordinary Council members. As if to confound the Council's critics, the same co-opted members were re-appointed. But the Department of the Taoiseach informed the Director and the Council members that their resignations might be required if the Council was re-organised before the expiry date had been reached.[64] Bruce Arnold commented on the decision to reappoint the Arts Council:

> It is fair to say that the present interregnum period, with the Arts Council waiting for its new Charter, is a difficult one for the men involved. But they make it no easier for those asking for help by the continued failure of the Council to communicate its wishes and intentions to the public.[65]

Those involved with the Project Gallery felt especially aggrieved that the Arts Council had not publicly supported their policies and activities. The Council had contributed limited funding but the Gallery was still forced to move to cheaper premises and to plead for more funds in order to survive. The Project Gallery received £3,000 in grant-aid between 1969 and 1973. By way of comparison, the Council spent £17,000 on the Rosc '71 exhibition which was held at the R.D.S. in Dublin from 23 October to 31 December 1971.[66] In the catalogue of a major exhibition of contemporary Irish painting held at the Municipal Gallery, Dublin, to coincide with Rosc '71, Fr O'Sullivan revealed that, in the decade 1959 to 1969, the Council had purchased nearly 800 works of contemporary Irish art.[67] This type of self-congratulation irked Colm O Briain, Chairman of the Project Gallery, who argued:

> The Council should stop buying works and instead plough the money into providing facilities for young artists. They should supply studio space for painters, sculptors and experimental theatre groups, and should sponsor the publication of art works not normally used as illustrations in present day publications.[68]

O Briain was representative of those who had become aware of the philosophy of cultural democracy. He explained:

> In a small country like ours the resources are limited...Every £1 the Arts Council spends should be justified in terms of what it produces...They should stop trying to put their money on the winning horse and promote art for all, not just for the ones who have made it.[69]

This sentiment was reminiscent of Paddy Little's opinion that art should be for the benefit of the community as a whole. It seemed that to appease its critics, the Arts Council would have to bring its policies full circle and re-emphasise participation as the main priority instead of the pursuit of artistic excellence.

The Independent Artists published a radical manifesto which accused the Dublin art world of 'symptoms of class bigotry, racial prejudice and pernicious art snobbery'.[70] They suggested that the Government could improve the situation by: launching a major programme like Roosevelt's Federal Art Project in the 1930s; appointing a full-time Director and executives for the Arts Council; building art centres throughout the country; subventing studios for artists; providing a grant system for individual artists; and instructing that 1% or 2% of the cost of public building contracts should be spent on art works.[71] No attempt was made by the Independent Artists to cost these measures but, despite its grandiose idealism, their document marked a new self-awareness among the artistic community.

Many of the younger artists participated in a campaign to reform the National College of Art. The atmosphere at the College was heavy with talk of student revolution. The students were angry about the poor conditions of employment of their teachers and the antiquated accommodation of the College's Kildare Street premises. They were incensed by the Department of Education's rejection of their claims. The Department regarded the protesting students as 'revolutionaries with Maoist tendencies' and locked them out of the College.[72] The Government intervened in the dispute and closed the College until a governing body could be appointed to oversee its affairs. In November 1971, Seanad Eireann began to debate the National College of Art and Design Bill. The aim of the Bill was simple - to remove the College of Art from the Department of Education's responsibility and place it under an independent Board. The provision of teacher and student representation on the proposed Board was the first time such a concept had been enshrined in Irish legislation.

During the debate on the Bill, Senator John Horgan compared the Department of Education to 'a rather rusty searchlight which can be trained on only one subject at a time, with much creaking and flaking of rust'.[73] He welcomed the extension of the title of the National College of Art to include Design. But it would be regrettable, he said, if the College moved from 'the rather old and inflexible tyranny of the direct control of the Department of Education' to 'the tyranny of the men who believe that all mankind's art and talents are ultimately of no use unless they are bent towards the making of money'.[74] Senator Mary Robinson argued that the real problem underlying the

College of Art's difficulties was the lack of an artistic system of education in Ireland. Instead, the country had an examination system. If the new College was to be a success, it would have to cast aside the academic approach and adopt 'a community approach'. Senator Robinson suggested that the Project Gallery provided a good example of how the community approach could work. But the Arts Council had failed to recognise this, she claimed, and was not giving adequate support to the Project Gallery.[75]

Senator James Dooge, in an enlightened speech, commented:

> In regard to artistic matters we are an unhealthy nation...I think more than any other country we tend to separate art and artists from the other sectors of our national life. We are guilty here of a heresy that has vitiated our attitude to art and left us in the condition in which we are. We, more than any other people perhaps, look on every artist as a special kind of man or woman, whereas we would be a much healthier community if we looked on every man and woman as potentially a special kind of artist. We tend to deny to the members of the community their full humanity because we tend to separate our art as something which belongs only to one group of people in the community.[76]

It is obvious that the Arts Council was guilty of the heresy identified by Senator Dooge. The Independent Artist, Michael Kane, called upon the Government to proceed towards a general overhaul of art education. But first the Arts Council had to be restructured. Kane wrote venomously:

> We have suffered long enough the bumbling and casual incompetence of academics and bureaucrats, the sacerdotty, the snotty, and the sacrosanct - I mean by the last three - I want to make this quite clear our Jesuitical/Unionist Arts Council, and its great Wailing Wall in Merrion Square.[77]

Kane's reference to Unionism was meant as a snide criticism of the Arts Council's increasing contact with the Arts Council of Northern Ireland. It also reflected comments about two members of the Arts Council who held British titles, the Earl of Rosse and Sir Basil Goulding. Colm O Briain complained: 'The Council represents a kind of social orientation which is not representative of the Irish people generally'.[78] Kane's reference to Mervyn Wall ('Wailing Wall'), was unfair but it indicated the public perception of the Arts Council as an organisation which was often forced to defend itself from criticism.

Mervyn Wall was in fact doing what he could to encourage members of the

Arts Council to respond to pleas for a change in its policies. He was also urging them to adopt a policy in anticipation of the proposed, although long-awaited, Arts Bill to reform the Arts Council. He wrote:

> In my opinion, the present Arts Act, 1951, is quite a good Act, and the new Bill should adhere generally to its provisions, but should have a superior Council and three Committees, to each of which the superior Council would allot their respective moneys based on an annual estimate of the needs of each.

In an implied criticism of the existing Council membership, Wall argued:

> Youth should be represented, and above all they should be active people expert in their respective spheres. The Direction must be in the hands of people who know the arts, who personally know the people active in the arts, and who know the towns and town life throughout the country. It should also be in the hands of persons with the knowledge and the will to plan.[79]

In 1972 the Arts Council showed some signs of realisation that change was required following Mervyn Wall's presentation of detailed statistics about the Council's expenditure in 1971/2.[80] He revealed that from a total grant-in-aid of £80,000, painting and sculpture had consumed £27,800 or 36% of expenditure. Music received £25,900 or 32% of expenditure. No funds were allocated to festivals, ballet or design. On the suggestion of Professor George Dawson, the Council agreed a five-point plan for future policy:

- the Council should think in terms of regions rather than of county towns and, to facilitate this, it should commission an initial survey of the present artistic position throughout the country;

- ideally a sum of money, possibly £100,000 should be made available every year for bursaries to both creative and interpretative artists, and sculpture should be encouraged by more frequent purchases by the Council of pieces of sculpture;

- a scheme of touring exhibitions should be developed in co-operation with the Arts Council of Northern Ireland;

- workshops for actors, producers, make-up artists etc. should be arranged for amateur dramatic societies throughout the country;

- a statement should be prepared on what could be done by the Council in the field of publishing.[81]

These proposals were admirable but they amounted to too little, too late. In March 1973, following a general election, a Coalition Government of Fine Gael and the Labour Party came to power. Within two weeks, the new Minister for Finance, Richie Ryan, announced in the Dáil that he intended to introduce a Bill to reorganise the Arts Council.[82] The Taoiseach, Liam Cosgrave, directed his Department to make the necessary arrangements and not the Department of Finance. The Arts Council was informed in a confidential letter that the Taoiseach intended to legislate for a Council comprised of a chairman and up to fifteen members.[83] The appointments would be made 'with regard to the person's attainments in or knowledge of the arts or his ability to give substantial practical assistance in the work of the Council'. The Taoiseach would 'ensure a fair balance of representation as between the different divisions of the arts'. The Chairman would be part-time and there would be an executive Director and a staff of full-time pensionable employees.

In May 1973 the Arts Council submitted its observations on the proposals to the Department of the Taoiseach.[84] The Council advised that the new body should have more appointees representative of the visual arts than for music and drama. The only direct exchequer support of the visual arts was through the Arts Council whereas music and drama received support via, for example, Radio Telefís Eireann and the Abbey Theatre. The Council also argued in favour of retaining limited co-option of members and suggested that the new Council should include a member of the Arts Council of Northern Ireland. It was recommended that the funding of the new Council should be comparable to the funding provided by the British Government for the Arts Councils of Scotland, Wales and Northern Ireland. The proposal to establish a staff pension scheme was endorsed but the Council considered that it should appoint the Director and other employees.

It was some months before the Arts Bill, 1973, was introduced in the Dáil. While the Arts Council was awaiting the legislation, it decided to approve the issue of a press release stating the prices paid for works of art purchased for the Council's collection and information on various grants approved and amounts paid.[85] This was the first such press release issued by the Arts Council in the twenty-two years of its existence. This fact emphasised the Council's failure to establish good relations with journalists and critics. It highlighted the need for a new Council which would react to developments in the arts and seek to provide innovative leadership.

The Second Stage Dáil debate on the Arts Bill, 1973, took place on 17 October 1973.[86] It was reminiscent of the debate on the Arts Bill, 1951, in that it was poorly attended. At one point, the debate was stopped because the number of deputies present had fallen below twenty, the quorum required for a Dáil sitting.[87] Eight speakers contributed to the debate (compared to nine in 1951) and the content of the speeches demonstrated that the speakers recognised the legitimacy of public funding of the arts. In 1951 it had been an effort to convince some politicians that public funding of the arts was justifiable. The pre-occupation then had been with the funding of efforts to promote the use of the Irish language. During the 1973 debate, the Irish language hardly received a mention.

The Taoiseach began the debate on the Arts Bill, 1973, by outlining its provisions.[88] They were largely the same as those already notified to the Arts Council. Cosgrave said that the new Council would have a part-time Chairman and up to sixteen other members who would be representative of all the arts and would be appointed by the Taoiseach. The Chairman would receive a small salary. The Council would appoint a full-time Director, on terms to be sanctioned by the Taoiseach's Department after consultation with the Department of Finance. The Bill included an important provision enabling local authorities to assist the development of the arts. Cosgrave said that this would help to promote the arts throughout the country. The Taoiseach envisaged that following the establishment of the new Council, it would take responsibility for the administration of State aid to arts institutions such as the Abbey and Gate Theatres. He considered that this would represent a more efficient and organised way of distributing State funds to the arts. Finally the Taoiseach thanked the existing Arts Council for having 'ensured that a solid foundation now exists on which to base further development'.

It was expected that Charles Haughey would make a significant contribution to the debate. Many had been impressed by a speech which he had delivered in July 1972 at Harvard University, on the theme of 'Art and the Majority', which was published in the *Irish Times*.[89] Haughey said that: 'In Ireland, as in most other European countries, our cultural institutions have grown up over the years in a haphazard manner, and not in accordance with any overall plan of design'. He called for 'a comprehensive policy for the arts in Ireland' and stated:

> I regard such a policy, with adequate financial provision, as an integral part of good government in a modern community. But there must be complete artistic freedom, and the Government's part must be confined to creating the conditions within which art can flourish - to foster and not to control.[90]

This important statement was reiterated by Haughey during the 1973 debate when he affirmed:

> The implementation of an enlightened comprehensive policy for the Arts with adequate financial provision enshrined in it is an essential part - I use the word essential deliberately - of modern progressive government...I do not think we can any more have a situation in which we have economic planning and cultural *laissez faire*.[91]

Haughey said that he now agreed that perhaps one central Arts Council would be preferable to three smaller Councils. But he disagreed with the proposal to leave responsibility for the Arts Council with the Taoiseach's Department and considered that it should be the responsibility of the Minister for Finance:

> I do not believe that the Taoiseach's Department is an appropriate home for a body of this sort...The Taoiseach has an over-all co-ordinating responsibility, very often a responsibility to hold a balance between different Departments with conflicting priorities. In that sort of situation it is not difficult to visualise a body like An Chomhairle Ealaíon, attached to the Taoiseach's Department, to some extent being neglected.[92]

Although Haughey welcomed the Bill because it directed attention towards artistic matters, he expressed disappointment with its serious limitations. He hoped that 'on some other occasion a much more far-reaching piece of legislation for the promotion of artistic and cultural endeavour will come before us'.[93] When the Committee Stage of the Arts Bill took place in the Dáil on 23 October, Haughey said sensibly: 'It seems to me that it would have been infinitely preferable to repeal the Arts Act of 1951 and re-enact one composite piece of legislation'.[94] The amending nature of the Arts Bill, 1973, made for confusing legislation.

The standard of the speeches made by the other speakers during the Dáil debates was disappointing. When the Bill moved to the Senate, the eight speakers there at least tried to change the Bill and did not accept that it should be passed without amendment. The Taoiseach set the tone for the Senate debate by emphasising the need for involvement in the arts by all citizens:

> There is a danger that many people may regard the arts as the preserve of a privileged coterie. We must actively promote and encourage a wider approach than this: a philosophy that art, in all its forms, is a means by which a fuller and more satisfying life may be achieved by the people at large.[95]

Cosgrave described the Arts Council as 'the vehicle of State patronage' of the arts. While he hoped for increased support for the arts from Irish companies by way of commissions, bursaries, endowments and fellowships, Cosgrave pledged that: 'For its part, the Government will ensure that when it comes to the annual division of resources at budget time the needs of the arts are given their due place'.[96]

The most interesting speech during the Senate debate was that of Mary Robinson. She found herself 'only being able to give a most qualified and watery welcome' to the Arts Bill. She asked pertinently that given the gap of twenty-two years since the Arts Act, 1951:

> Are we in a cyclical development, so that the next Arts Bill will be in 1995? If so, then I think that I cannot really welcome this Bill at all except in so far as it gives an opportunity in both Houses to talk about the Arts. We must talk about the arts not as something separate from ourselves but as an integral part of our lives.[97]

Senator Robinson criticised the new Bill for failing to face reality: 'What we have at the moment and what we have had in the previous Arts Council is a hierarchical structure which is not responsive and which is not accountable'.[98]

*Mary Robinson*

She said that it was unsatisfactory for the Taoiseach to appoint all seventeen members of the new Council. She considered that there should be legislative provision for the appointment of separate committees to deal with each of the arts. Finally she suggested that the scope of the Arts Act should be broadened to include film: 'In 1951 there may have been some doubt about films being an art form but there is no doubt about this in 1973'.[99] The Government had itself given support to this view when it acquired Ardmore Studios on 25 July 1973 at auction for £390,000. It will be recalled that the Government's first involvement with the Studios had led to receivership in 1963. The second attempt again proved to be disastrous leading ultimately to financial losses and severe embarrassment.[100]

Alexis Fitzgerald told the Senate that there was no activity of life 'more studded with snobs and cods' than 'the Arts' and the key to change was more widespread art education. He reminded his colleagues of Oliver St John Gogarty's definition of culture as 'the art of idling gracefully' and advised that: 'The Government ought to be concerned to teach the people of Ireland how to idle gracefully and not shamefully and disgracefully, which they will do if they are not taught otherwise'.[101] He supported Mary Robinson's view that film should be included as an art form under the Arts Bill, 1973. He did not offer the same latitude to the circus which Austin Deasy claimed was a popular form of entertainment which was also a legitimate art form.[102] Deasy's proposal was brave but no other Senator supported it.

When the Committee Stage of the Arts Bill was taken in the Senate on 11 December 1973, a concerted attempt was made to have amendments put down by Senator Robinson accepted by the Parliamentary Secretary to the Minister for Education, John Bruton, who had been given responsibility by the Government for steering the Bill through its final stages.[103] Senators Augustine Martin, Trevor West, Brian Lenihan and Eoin Ryan gave strong support to an amendment giving the Arts Council authority to establish sub-committees of experts to advise on the arts covered by the legislation. At first John Bruton was unprepared to accept the amendment but he was persuaded to put the matter to the Taoiseach for further consideration. He agreed also to consider the inclusion of film as an art form under the Bill. The amendments were accepted in principle by the Government, although their force was modified by rephrasing, but the Senate deserved credit for arguing the case for them. Bruton deserved credit too for the fair and open-minded manner in which he listened to the points raised by the Senate.

The Arts Act 1973, which became law on 24 December, left it open to the Arts Council to decide whether or not to appoint sub-committees. The legislation allowed for three committees, the first to advise on painting,

sculpture and architecture, the second to advise on music, and the third to advise on drama, literature and the cinema. This solution was a very diluted version of the plans envisaged by Charles Haughey in 1968 but at least it provided legislative support for a new formula. The Arts Act, 1973, like its predecessor of 1951, was not a hugely impressive piece of legislation, quite the contrary in fact. But small legislation was a good deal better than no legislation. Despite its shortcomings, the Arts Act, 1973, ushered in a period of vigour and expansion for the arts in Ireland. The notion of an arts policy was about to take a significant leap towards becoming a reality.

*The Arts Council, 1973*

# CHAPTER NINE

## EXPANSION AND DEVELOPMENT: 1973-82

*The implementation of an enlightened comprehensive policy for the Arts with adequate financial provision enshrined in it is an essential part of modern progressive government.*

CHARLES J. HAUGHEY

In 1973 Ireland joined the European Economic Community. This move provided proof that the country was committed to a non-isolationist future. It also indicated that economic links with Great Britain would be lessened by growing trade relations with Europe. By 1975 exports of manufactured goods to markets outside Great Britain represented 50% of Irish exports for the first time since independence. In 1979 Ireland joined the European Monetary System and broke the link with sterling. These changes were symbolic of the deep shifts which had occurred in Irish society during the 1960s. Ireland was developing fast into a relatively wealthy and self-confident country.

A growing audience for the arts was one of the spin-off effects of rapid industrial development. The opening up of Irish society through television, free education and greater travel opportunities stimulated a demand for the arts. The new Arts Council appointed in 1973 was charged with responding to a different environment to that encountered by any of its predecessors.

*Geoffrey Hand, Liam Cosgrave and Mervyn Wall*

There was now some political will to respond to public demands for greater State involvement in the arts.

The seventeen member Arts Council appointed by Liam Cosgrave on 31 December 1973 included only two former Council members, Brian Boydell and James White.[1] The new Council included professional artists and writers, a civil servant and a Belfast private gallery owner. Three of the members were women. Geoffrey Hand, a law professor at University College, Dublin, was nominated as Chairman.[2] Mervyn Wall retained the post of chief executive although his title had changed from Secretary to Director. The first decision by the Council was, sensibly, to ask Mervyn Wall to present a position paper on the activities of the previous five Arts Councils.

The position paper was considered at an important policy meeting on 1 March 1974.[3] Wall explained that the previous Councils had been guided by four main principles: the Council did not interfere with the functions of a Minister of State; two bodies whose main support is from Central Funds could not contribute to the same project; the Council left promotion of Irish artistic ventures abroad to the Cultural Relations Committee of the Department of Foreign Affairs; and the Council did not support applications

for funds by individuals. The total amount of grants-in-aid allocated by the State to the Arts Council in the period 1951 to 1973 was £798,081. The visual arts had received 42% of this sum, music 39%, drama 14% and literature 5%. Dublin absorbed 73% of all expenditure, Cork 9% and the other twenty-four counties 18%.

Given this stark background, the new Council established a strident attitude when adopting a general outline of future policy.[4] Five broad guidelines were set down:

-the members expressed their wish to take part in the educational process to a greater extent than hitherto;

-the Council intended to be more adventurous in encouraging creative artists by giving direct grant assistance to them;

-the Council would refuse consent to the earmarking of any part of the annual grant-in-aid;

-the Taoiseach would be informed that the Council would be reluctant to undertake any function over which they did not have some degree of control;

-the Taoiseach would be informed further that the Council considered that they should be consulted in their advisory capacity before decisions and commitments in relation to artistic matters were made by governmental authority.

It was decided that the Arts Council should encourage contact with the media. The Council agreed to issue a quarterly press release giving details of all grants approved and amounts paid. On 28 November 1974, the Arts Council held a press conference in the Shelbourne Hotel, Dublin, to indicate its openness to the press and to invite constructive dialogue.[5] During the next few years, Council members were often featured in newspaper interviews.[6] The presentation of the Arts Council's annual report was improved and it became the main published source of imformation about policies and activities.

The Taoiseach had promised during the Senate debate on the Arts Bill, 1973, that the grant-in-aid to the Arts Council would be increased. The Coalition Government did not renege on this promise. The Council's grant was increased from £85,000 in 1972/3 to £200,000 in 1975. Additional

*Colm O Briain*

funding meant more work for the Council and its staff. But Professor Hand was an experienced administrator and sub-committees of Council members were established quickly. These committees gave preparatory consideration to Council business and made recommendations to the full Council which was thereby allowed time to focus its attention on policy and planning. The Council declared that it intended to encourage 'a greater regional and local development of the arts'.[7]

In March 1975 Mervyn Wall retired from the Arts Council. The following month, a special ceremony was organised in his honour at which Council members and staff colleagues, past and present, paid tribute to his invaluable contribution to the arts in Ireland. Seán O Faoláin delivered the congratulatory speech. Mervyn Wall was happy to leave the Council to expand and develop under a new regime. He had served the Council with outstanding loyalty and his steady guidance had often been influential in steering it out of difficulties.

1975 was a decisive year for the Arts Council. After an elaborate application process organised by Professor Hand, Colm O Briain was selected to be the new full-time Director. O Briain had been a strong critic of Fr O'Sullivan's

policies and was regarded by many as a talented iconoclast. The Arts Council's decision to appoint him as Director was a brave and enlightened choice. It surprised many art critics. Brian Fallon had predicted:

> The new Director is not likely to be a controversial figure, or a dominating one...most likely he will be a career administrator or civil servant, operating by the rules and by the consensus of the members, and more concerned with seeing that the machinery runs smoothly and the Arts Council's funds are fairly and discreetly apportioned, than with 'educating' public taste.[8]

Fallon was proved wrong. Colm O Briain was controversial, dominant, and not a civil servant but a television producer and director. He interpreted rules and encouraged Council members to see things his way which they usually did. He was concerned that the Arts Council ran with its policies and proclaimed loudly how its funds were apportioned. Finally he was preoccupied with educating public taste. Brian Boydell attributed the Council's new vigour, commitment and enthusiasm after 1975 to O Briain:

> He was a natural human dynamo and used his socialist views to argue for arts for the masses, bringing art to all the people. Colm O Briain was the right man at the right time. He shook the Council out of its complacency and gave it a new image.[9]

In November 1975, the Department of the Taoiseach sanctioned the appointment of four new posts at the Arts Council. David Collins was appointed as Literature Officer, Dinah Molloy as Music Officer, Paula McCarthy as Visual Arts Officer and David McConnell as Administration Officer.[10] The new officers had to be committed to their tasks in order to keep up with the Director, Colm O Briain. As he explained to a journalist: 'When I got this job I had the choice of sitting back and waiting for things to happen - or of jumping in. So I jumped in...I'm pushing myself. But it's rough on the staff because I'm pushing them too'.[11]

O Briain was an arch-propagandist for the Arts Council. He was a naturally gifted communicator who cultivated a high media profile.[12] For example, on 21 September 1976 he gave a lunchtime lecture at the National Gallery. His subject was 'Performance Art' and instead of discussing it, he treated his startled audience to a performance. He placed two chairs with their backs to the audience. He sat on one of the chairs and used a television camera to show his face to the audience. He wore a motor cycle helmet and visor, a pair of flippers, shorts and a tee-shirt with the number 19 on it. The teddy bear he

*Patrick Rock*

was holding had the number 76 written on it. O Briain's point was simple. Performance art could have visual and dramatic impact but if it failed to become more than a mere happening, it was not art.[13]

Soon after O Briain's appointment as Director, Professor Hand resigned as Chairman to take up a post at the new European University Institute in Florence.[14] His replacement, Patrick Rock, was appointed by the Taoiseach on 2 July 1975. Rock was a Senior Management Consultant at the Irish Management Institute who admitted candidly 'to having no abiding dedication to any particular form of art'.[15] He was Chairman of the Fine Gael Constituency Council in Dunlaoghaire/Rathdown, which was Liam Cosgrave's constituency. The Taoiseach was convinced that Rock's management expertise would be useful to the Arts Council. The appointment was an excellent one. Rock was a shrewd and effective Chairman who, while he had great admiration for Colm O Briain and the Council staff, helped to keep their efforts compatible with the development of a disciplined organisation. He encouraged the use of better accounts presentation, planning and projections. He also introduced annual two-day meetings at which the Council and its staff discussed the development of new policies. In a strong public statement, he proclaimed a clear sense of purpose:

We have an obligation to our artists to ensure that proper facilities exist
for training, exhibition and performance; and we have an obligation to
the public, both children and adults, to ensure that they are provided
with a wider and deeper appreciation of the arts. Furthermore, we have
an obligation to both artists and public to see that adequate facilities
exist, especially at regional level, to enable all to participate meaningfully
in the arts.[16]

The Arts Council received a vital boost to its aims when on 19 December
1975, the Minister for Finance, Richie Ryan, announced that the Government
had decided to transfer responsibility for the funding of the Abbey Theatre,
the Gate Theatre, the Irish Theatre Company, the Irish Ballet Company and
the Dublin Theatre Festival, from the Department of Finance to the Arts
Council.[17] The decision was consistent with the Taoiseach's view that the Arts
Council was 'the vehicle of State patronage' of the arts. The effect on the scale
of the Council's funding was dramatic. The State grant-in-aid increased from
£200,000 in 1975 to £990,000 the following year. The Taoiseach further
distanced the Council from the Department of Finance when he decided that,
as from 1975, he would present the Council's estimate in Dáil Eireann and
not the Minister for Finance.[18]

The Department of Finance was delighted to rid itself of what were referred
to as the 'Big 5'. Bob Whitty called them his 'crown of thorns'.[19] The Irish
Ballet Company, based in Cork, had won the patronage of the former
Taoiseach, Jack Lynch. The Irish Theatre Company began its operations
touring plays throughout Ireland in February 1975. The Dublin Theatre
Festival waged a constant battle for survival and the Abbey and Gate Theatres
had financial and personality troubles. But the Government's decision to
transfer the 'Big 5' to the Arts Council represented important official
recognition of its role as the national body responsible for fostering all the arts.

There were other signs that official attitudes to the arts were improving. On
9 May 1974, the Government announced that the Great Hall of University
College, Dublin, at Earlsfort Terrace was to become a 900-seat concert hall.
The building was adapted magnificently by the Office of Public Works over
the next few years, thereby putting an end to a lengthy saga. In July 1975, an
extension to the Chester Beatty Library in Dublin, financed from public
funds, was opened officially by President Cearbhall O Dálaigh. There were
indications of a progressive attitude to the arts by local authorities also. Some
of them began to respond to the provision in the Arts Act, 1973, authorising
them to spend money on arts activities. Cork Corporation, Dundalk Urban
District Council and Sligo Corporation were among the first local authorities

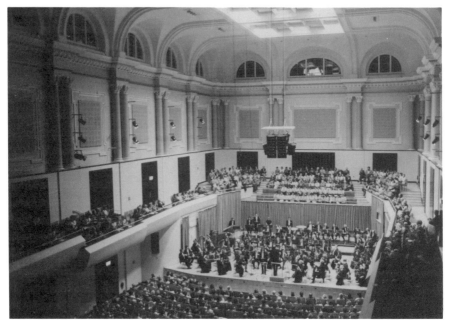

*The National Concert Hall*

to organise or subsidise arts activities. Monaghan became the first local authority to employ a full-time curator when a County Museum was opened there in April 1975. In the same year, the Department of Education sponsored the development of centres in Castlebar and Trim which aimed to show exhibitions of items from the collections of the national cultural institutions based in Dublin. A number of buildings such as Holy Cross Abbey, County Tipperary, and the Casino at Marino, Dublin, were restored by the Office of Public Works as Ireland's contribution to European Architectural Heritage Year (1975).

The development of the Arts Council's policies was helped considerably by the publication in January 1976 of the so-called 'Richards Report'. The report was titled *Provision for the Arts* and it sought to clarify how Irish arts organisations were organised and financed, and to make recommendations to help the Arts Council to structure its future programmes to achieve maximum effectiveness from its resources. The report was published jointly by the Arts Council and the Gulbenkian Foundation, a philanthropic organisation established after the death of the Armenian oil magnate, Calouste Gulbenkian.[20] It was Mervyn Wall who established contact with the

Gulbenkian Foundation when he visited its London office in 1962 and managed to persuade the officials there that although the Republic of Ireland was no longer a member of the Commonwealth, it should be included within the scope of the Foundation's activities. Between 1962 and 1973 the Foundation gave grants to Irish organisations totalling over £100,000.[21] In January 1973 the Gulbenkian Foundation proposed that it would pay four-fifths of the cost of a report on the arts in Ireland. After some negotiation, the Arts Council agreed to the proposal and accepted that the inquiry should be conducted by experts who were not already concerned with the Irish arts scene. It was decided that Sir James Richards (editor of *The Architectural Review* (1937-71) would be appointed as Chairman of a consultative committee of Irish arts experts.[22] Millicent Bowerman (former Deputy Director of the Greater London Arts Association) was appointed as Director responsible for co-ordinating the field work associated with the report.

The 'Richards Report' provided a vital independent assessment of the state of the arts in Ireland. It indicated that the situation had improved considerably since the publication of Professor Bodkin's report in 1949 but its list of recommendations showed that much remained to be done. The publication of the document received widespread newspaper coverage.[23] It was regarded as a valuable report although some critics found various recommendations either too harsh or too weak.[24] The 'Richards Report' was supportive of the Arts Council's role: 'The Arts Council should be regarded as the body responsible to the nation for the welfare of all the arts, and it should be in a position to take action accordingly'.[25] It was proposed that the Government should consider establishing a standing conference of government departments and state-sponsored bodies concerned with the arts. There could be general informal contact and also regular and formal meetings to discuss matters of mutual concern, to exchange information and to co-ordinate future action. It was suggested that the standing conference should be chaired by a Parliamentary Secretary (Junior Minister) to 'provide the arts with the spokesman they at present lack'.[26]

The Arts Council under the chairmanship of Patrick Rock and the directorship of Colm O Briain studied the 'Richard's Report' carefully and acted on its recommendations with a stream of innovative programmes. The Council developed two key policy aims and spelt them out in the annual report for 1976. The first line of that report said: 'Provision for the individual writer, artist and musician was identified as a major priority for the Council'.[27] A scheme of bursaries for creative writers which began in 1975 was extended quickly to include a programme of scholarships and awards in music and the

visual arts. In addition, the Arts Council continued to administer the Macaulay Fellowships and awards funded by the Music Association of Ireland. The Arts Council also launched a film script award in 1976 and plans were made to extend the bursary scheme to include theatre, dance and musical composition.

The second key policy aim was stated self-critically:

> Previous reports from the Council have given an indication of some bias in favour of arts activities in Dublin as opposed to the rest of the country. The Council has undertaken to correct this imbalance and to encourage regional development of the arts as a matter of urgency.[28]

The 'Richard's Report' recommended that the Arts Council should establish schemes in liaison with the existing regional development organisations throughout the country. The Council began the process in 1976 by supporting the establishment of the Mid-West Arts Association by the Regional Development Organisation for Limerick, Clare and North Tipperary. The following year, Paul Funge (founder of the Gorey Arts Centre), was appointed as Arts Officer for the Mid-West Region. The extensive touring by the Irish Theatre Company, the Irish Ballet Company, and the Irish National Opera, exposed audiences in the regions to high quality artistic performances. The Council's policy of touring exhibitions was continued and support was given to many local initiatives. New arts festivals, theatres, exhibitions and arts centres were launched every year, such as Kilkenny Arts Week (1974), Druid Theatre, Galway (1976), and the Limerick Exhibition of Visual Art (1977). The formation of national associations was a further sign of rapid development in the arts. These included the Association of Irish Composers (1977), the Federation of Irish Film Societies (1978), Poetry Ireland (1978), the Irish Museums Trust (1978), the Association of Independent Film Producers (1979), the National Association of Choirs (1980) and the Association of Artists in Ireland (1981).

The growth of artistic activity throughout the country created ever increasing demands for funding from the Arts Council. New Irish publishing companies like Poolbeg Press were assisted in their attempts to provide an outlet for Irish fiction, drama and poetry. In March 1976, the first issue of *Books Ireland,* a monthly periodical about Irish books was published. In 1977 the Irish Book Design Awards scheme was established. The Arts Council supported an exhibition of sculpture known as OASIS - Open-Air Show of Irish Sculpture - which was held at Merrion Square, Dublin, in 1975 and in 1977. The success of a European Film Fortnight at the International Cinema,

Earlsfort Terrace, in January 1976, led to the creation, later in the year, of the Irish Film Theatre as a subsidiary of the Arts Council. Traditional music and jazz were assisted by the Council for the first time in 1976. Encouragement was given to theatre companies like Team Educational Theatre which specialised in performing for schoolchildren. In November 1977, the Council launched an innovative scheme called 'Writers in Schools' with the aim of 'introducing living writers to young audiences' in second-level schools.[29] In 1978, the Council organised a touring exhibition of Irish photography and assisted the establishment of a Gallery of Photography in Dublin.

Demands for increased funding from the Arts Council by client organisations led inevitably to demands by the Council itself for increased funding from the Government. The Council adopted a vigorous approach. The Chairman, Patrick Rock, made a public statement declaring that, in Ireland, Government support for the Arts Council was equivalent to 50 pence per head of population, in contrast to 78 pence in Northern Ireland, 89 pence in England, 114 pence in Scotland and 141 pence in Wales.[30] Although the Government had increased the Council's grant by 22% to £1,565,000 in 1976, the Council decided to run the risk of seeming ungrateful for the significant increase in its funding by declaring that 'a proper level of funding has never been provided for arts activities' and 'inflation in the arts negated the value of most of the increased allocations'.[31] Patrick Rock said: 'The State as a patron of the arts reflects the general indifference of the people to the arts in general'.[32] The Council argued that the State had a duty to support the arts. There was, of course, a role for private funding of the arts. The Gulbenkian Foundation had agreed to fund a post of Arts Council Exhibition Officer for two years from January 1978. Martin Toonder, a Dutch author resident in Ireland since 1966, gave the Council £25,000 to establish a trust fund to finance an annual rotating award in literature, visual arts and music.[33] But the Council argued that private funding could not be asked to make up for under-financing by Government.

The Arts Council urged artists 'to use their undoubted creativity to communicate more effectively with the man in the street'. Innovation in presentation was the deciding factor, the Council argued, in 'the preparedness of individual citizens to put their hands in their pockets' and in persuading them to call on their politicians to finance the arts.[34] The Council identified 'a desperate need for new buildings to house the arts, particularly at local level'.[35] There was a limit to what local festivals and touring companies could achieve without adequate premises. Colm O Briain had personal experience of the Project Arts Centre and was anxious to see the spread of regional arts centres.

In 1977 the Arts Council grant-aided four arts centres (Project and Grapevine (Dublin), Gorey and Wexford) and five arts festivals (Dublin, Dunlaoghaire, Inishboffin, Kilkenny and Listowel). The Council began to lobby the Government for a capital allocation to finance the building of one arts centre in each of the twenty-six counties.

In developing a regional policy, the Arts Council benefitted from the experience of its counterpart organisations in Great Britain and Northern Ireland. The first formal meeting between the Chairman and the Director of An Chomhairle Ealaíon and the Chairman and the Secretary General of the Arts Council of Great Britain (Lord Gibson and Roy Shaw) took place in London on 28 July 1976. There had been many informal contacts over the years between the Councils, the two oldest such organisations in the world, but it was useful to have a formal discussion of policies and activities. In 1977 meetings were held between the so-called 'Celtic Quartet' of Arts Councils (An Chomhairle Ealaíon and the Arts Councils of Northern Ireland, Scotland and Wales). Close contact had been established in the 1960s between Mervyn Wall, Secretary of An Chomhairle Ealaíon and Ken Jamison, Director of the Arts Council of Northern Ireland. Arrangements were often made to show exhibitions in both Dublin and Belfast. In 1974 an exhibition of the work of the painter, Nano Reid, the first of a series of retrospective exhibitions of the works of Irish painters and sculptors was organised and financed jointly by the two Arts Councils. The catalogues to these exhibitions became recognised as important contributions to Irish art history.[36] In January 1978, the Arts Council of Northern Ireland invited An Chomhairle Ealaíon to a one-day joint meeting in Belfast to discuss future co-operation between the two Councils. The invitation was accepted enthusiastically and the meeting took place on 20 April 1978. One of the topics discussed was the final arrangement for the financing and structuring of the Tyrone Guthrie Centre at Annaghmakerrig, County Monaghan. Patrick Rock hailed the meeting as 'a historic milestone in the cultural development of Ireland as a whole' and Colm O Briain said 'as far as the arts are concerned, we're going to operate as if the Border didn't exist'.[37] On 13 October 1978, the second joint meeting of the two Arts Councils took place in Dublin.

The post-1973 Arts Council bore little resemblance to the mild mannered and cautious institution headed by Fr O'Sullivan. This was most obvious from the way in which the Council, spearheaded by Colm O Briain, used its position as a prescribed body under the Local Government (Planning and Development) Act, 1963, to campaign against the destruction of Dublin's architectural heritage. Colm O Briain was conscious of the damage done to the Arts Council's reputation by its stance in the 1960s on the Fitzwilliam

Street houses in Dublin and the N.E.T. factory at Arklow. He was determined to stimulate public opinion about the importance of Dublin's architectural heritage. The Arts Council lodged strong protests about the Central Bank building in Dame Street, Dublin, and about the plans by Dublin Corporation to build civic offices at the controversial Wood Quay site. In these cases the Council was one of a large number of objectors. But the Council took a leading role in resisting the efforts of Bord na Móna (the Irish Turf Board) to demolish Georgian buildings at 28-32 Upper Pembroke Street, Dublin, and to construct, in replacement, a new office block with a reproduction facade.

In November 1975, Dublin Corporation refused to grant Bord na Móna permission to demolish the buildings because they were listed as being of architectural importance. The Minister for Local Government, James Tully, decided to over-rule Dublin Corporation and to approve the demolition of the buildings. The Minister said that Bord na Móna had provided him with specialist evidence that the buildings were structurally unsafe. The Arts Council produced its own specialist evidence to show that it was both structurally and economically feasible to retain the buildings. The Council issued a letter to the national daily newspapers, signed by all the Council members and by Colm O Briain, sharply censuring the Minister for 'undermining the policy which has existed for the protection of Dublin's architectural heritage'.[38] On 9 January 1976, demolition workers began removing the roofs, doors and windows of the buildings. The Arts Council immediately sought a special sitting of the High Court and was granted an interim injunction restraining Bord na Móna from carrying out any further demolition works.[39] Bord na Móna based their case in the High Court on the premise that the Arts Council had no legal right to institute legal proceedings of any description.[40] The judgment of Mr Justice Hamilton stated that although the Arts Council was acting *bona fide* in what they conceived to be their obligations under the Arts Acts, an injunction against Bord na Móna was inappropriate.[41] Seventy architectural students of Bolton Street College of Technology and University College, Dublin, disagreed vehemently with the High Court decision and began an occupation of the buildings. A mass meeting was held in Pembroke Street on 24 January 1976 which was addressed by Colm O Briain. The students remained in occupation of the buildings for thirteen weeks[42] until Bord na Móna capitulated and agreed to sell the buildings to Allied Irish Investment Bank with an undertaking that they would be refurbished in their existing form.[43] The Arts Council, in a press statement, congratulated Bord na Móna 'for bringing a difficult problem to a successful conclusion, with far-reaching results'.[44]

The Arts Council's campaign against Bord na Móna was significant for a number of reasons. It firmly established the Council's independence because it proved that neither government ministers nor state-sponsored bodies were considered to be above public criticism. The Council increased its credibility among its client arts organisations by showing that it was committed to action not words. Finally, as Colm O Briain's personal popularity increased, the Arts Council won vital media attention. Journalists were sympathetic to O Briain and afforded him every opportunity to defend state funding of the arts. In September 1976, O Briain set the publicity machine in motion to counter a member of the European Parliament's attack on the tax free exemption scheme for artists resident in Ireland. Mr Willy Dondelinger from Luxembourg claimed that the scheme was 'immoral, unjust, demagogic and unfair to other EEC member states'. Colm O Briain defended the scheme:

> The legislation is concerned with creative Irish artists. It was brought in to stop the brain drain, to keep Irish people and talent at home. Just because American and other writers are coming to Ireland and also benefitting from it, is no reason to repeal the legislation. Does one do away with a good thing just because there are a few people abusing it?[45]

The controversy evaporated when the European Commission stated that it had no power to prevent the Irish Government from implementing the measure.

The term of the Sixth Arts Council came to an end in December 1978. Colm O Briain assessed its achievements and concluded:

> The Council was trying to do too much too quickly...The transfer to the Council in 1976 of the five national companies caused huge problems but also brought the Council face to face with some of the real issues facing the future of the arts in Ireland. There was an accelerated movement of the Arts Council to the centre of the stage.[46]

Patrick Rock made a final public statement that the arts were still not being taken seriously enough by politicians and civil servants. He credited the Government for increasing the level of arts funding but claimed that it was still inadequate. The Arts Council, he said, was being hampered by having aid to the arts channelled through other sources like An Bord Fáilte, the Tourist Board: 'we maintain that as the national body with a responsibility for all the arts, direct government support should be administered through the Arts Council'.[47]

There was some criticism of the Arts Council for seeking to control all state

arts funding. 'The Arts Council is becoming power-mad and dictator-like', wrote one critic[48] while another commented:

> The Council's excellent record of initiative was directed at proving the Council's worth whereas it should focus on developing a strong economic and political case for the arts...The ultimate irony that the outgoing Council faces is that all the brilliant achievements of the past few years have generated a momentum which they cannot service and an appetite which they cannot satisfy. The real and final test of its term of office will be the Oireachtas grant allocation to the new Council.[49]

The new Arts Council was nominated by Jack Lynch who had replaced Liam Cosgrave as Taoiseach when Fianna Fáil won a general election in July 1977. James White, the highly regarded Director of the National Gallery of Ireland, was appointed as Chairman of the Arts Council.[50] His five years as Chairman were marked by political resistance to some of the Council's policies. The basic problem was that the Council, having established its absolute independence under Patrick Rock, attempted to push the Government into further acknowledging the arts as a legitimate and essential part of public expenditure. This policy coincided with the rapid expansion of arts activity in Ireland and it became necessary for the Council to cease or reduce the funding of some arts organisations in order to live within its grant-in-aid from the Government. These arts organisations began to put political pressure on the Government to increase the Council's grant-in-aid. Relations with the Taoiseach became strained especially following the accession of Charles Haughey to the post in December 1979. Haughey was acknowledged to be a most impressive politician and he did not appreciate what appeared to him to be the Arts Council's concerted efforts to erode his credibility as a patron of the arts.

In its annual report for 1978, the Arts Council again stressed the need for the Government to provide funds for housing the arts.[51] Priorities for the new Council would be to secure capital funding, to demand a government policy on the arts in the education system, to develop community arts and to increase support for the individual artist. The Government responded to the appeal for capital funding in 1979 when a total of £273,000 was distributed to nine Irish theatres.[52] It was also decided that arts organisations, such as Comhaltas Ceoltóirí Eireann, which had previously been funded by An Bord Fáilte should in future be the responsibility of the Arts Council. The result of these two decisions, plus additional funding to compensate for inflation, was an increase in the Council's grant-in-aid from £1,565,000 in 1978 to £2,340,000 in 1979. The Arts Council staff was expanded to seventeen although Colm O

*James White*

Briain observed: 'every new post created and every grant-in-aid increase had to be fought for'.[53] Nevertheless the Department of the Taoiseach was being generous to the Arts Council and it is fair to say that it received little thanks from the Council. The Council's strategy of arguing that, despite any increases, the level of arts funding was too low, was bound to irritate the Taoiseach and his civil servants. It was only a matter of time before the Council entered into conflict with the Government.

The Arts Council's relationship with the Department of the Taoiseach was influenced to a considerable extent by Richard Stokes, a Principal Officer in the Department, who had been appointed to the Council in 1973. It was useful for the Council to have the advice of a civil servant who had direct contact with the Taoiseach. Stokes was supportive of the growth of State encouragement of the arts and this helped when the annual budget was being prepared. But at times it was awkward for Stokes to be associated with the Council, especially when it was pursuing policies which the Government found disagreeable.[54] Increased funding gave the Council self-confidence and a sense-of-purpose. Brian Boydell commented:

> The Council members had tremendous integrity and drive to see good things done. Michael Scott, who was reappointed to the Council in 1978, was very surprised at the new regime. At times it was quite clear that he thought things were still done on the 'nod' system where everything was fixed beforehand. Quite the opposite was true - things were thrashed out over the Council table in discussion which became quite heated and passionate.[55]

The Arts Council decided to set the agenda for the Government regarding the arts in Irish education by establishing a working party to examine and report on the matter.[56] Ciarán Benson was employed by the Arts Council to co-ordinate the project. In February 1979, *The Place of the Arts in Irish Education* was published. It provided 119 recommendations for improving the position of the arts within the Irish education system. These ranged from encouraging the Arts Council to build up a specialist educational arts service to proposing that the Minister for Education should establish a consultative committee to monitor progress made to develop the arts in education. The Arts Council fully endorsed the 'Benson Report' and called on the Department of Education to respond to it. The Department did so in a brief chapter on 'The Arts' in a *White Paper on Educational Development* published in December 1980. The Department felt that some evidence of the increasing popularity of the arts was found in the statistics that between 1970 and 1980 the numbers

taking art at Intermediate Certificate examinations rose from 11,700 to 18,600 and at Leaving Certificate from 1,750 to 6,200.[57] The White Paper made one proposal only, taken from the 'Benson Report', that a committee would 'be established to examine the extent to which artistic and creative activities are being catered for in second-level schools'.[58] As if to explain why so little action was planned, the Department offered the following explanation for the general low place of the arts in Irish education:

> Public demands on the school system are less urgent in art-related subjects. Indeed schools have daily experience of pressure for examination results in the traditional subject-areas and an education system must maintain a dynamic interaction with the society it serves.[59]

The Arts Council reacted strongly to this dependence on demand factors:

> The Department seems to be surprisingly reluctant to give sustained or serious consideration to the state of the arts in our education system...The White paper's emphasis on the lack of popular support for the arts in Irish schools can only be interpreted as an attempt to shirk the real issue. It is clearly the case that as the arts have never been adequately taught in our schools, they are hardly likely to command the wide attention of parents.[60]

There were some promising developments introduced by the Department of Education. The Department asked teacher training colleges to consider giving a points weighting to applicants who had good results in arts subjects. Courses for school teachers were organised to promote visual education. Colm O Briain congratulated the Department for agreeing to establish posts of Arts Education Organiser in three Vocational Education Committees - Kilkenny, Sligo and Westmeath. These posts were designed to complement the work being done by Regional Arts Officers. A number of regions, Galway/Mayo, Donegal, Cork/Kerry and the South East, had followed the example of the Mid-West region and had appointed Regional Arts Officers. For its part, the Arts Council launched two new schemes in 1980 along the lines of the successful 'Writers in Schools' programme. The first scheme, 'Prints in Schools', was comprised of four exhibitions of modern art prints and accompanying catalogues prepared by the Arts Council. It was open to schools to apply to borrow one of the exhibitions for up to three weeks at a time. The second scheme, 'Murals in Schools', later known as 'Paint on the Wall' allowed schools to select artists from lists provided by the Arts Council and to have them design a mural for a wall of the school. The idea was that the artist

would design the mural and the schoolchildren would help to paint it. The artist's fee and expenses were paid by the Arts Council. This imaginative scheme led to the creation of murals in several hundred schools throughout the country.

A spirit of participation also characterised the Arts Council's policy to stimulate community arts. The Council defined community arts as those which have the objective of 'community participation in the arts'.[61] Community arts could be seen as 'the process of creation in concert with one's audience as opposed to the traditional view that the work of art is an end in itself, divorced from the social context of its making'.[62] Groups like the Pintsize Puppet Theatre, Moving Theatre and Alternative Entertainments, encouraged participation by audiences in the creation of artistic entertainment. They were determined to bring art to the people as part of an educative and creative process. The Arts Council encouraged the breaking down of barriers to art by promoting its own schemes of art in public places. The Council joined with An Bord Fáilte and the National Tidy Towns Competition to launch a major sculpture commission scheme.[63] The winning town was given the finance to commission a work of environmental sculpture from an Irish artist, subject to the work being erected in a public place in the town.

The Arts Council's policy of seeking to give direct assistance to individual artists by way of commissions, bursary and scholarship schemes was strengthened in 1980 when the amount allocated to such activities was raised to £150,000, a 100% increase on the previous year. Provision was made for scholarships in arts education for second-level teachers of art and music. There was a constant stream of new arts awards which included the George Campbell Award for painting, the Mont Kavanagh Award for Environmental Art, and the Hamilton Harty bursary for music composition. The Arts Council was concerned, however, that the reality of life for artists in Ireland was such that grant schemes and awards were of minor assistance only. The Council decided to seek a detailed survey which would attempt to provide accurate information on the living and working conditions of artists in Ireland. The findings of the survey, conducted by Irish Marketing Surveys, were published in April 1980.[64] They were described by the Council as 'very worrying, though not unexpected'.

The survey distinguished between creative artists (for example, painters, sculptors and writers) and interpretative artists (for example, singers, dancers and actors). The major points to emerge from the survey were the following:

-75% of creative and 50% of interpretative artists had jobs (mainly part-time teaching) in addition to their artistic work;

-68% of creative and 64% of interpretative artists had made no provision for pensions;

-Income was unstable: 23% of creative artists had no earnings for a least one month each year;

-50% of the total moneys earned by creative artists went to the top earning 18% while 50% of interpretative artists earned less than 20% of earnings in their sector;

-75% of creative and 66% of interpretative artists favoured much more government involvement in the arts;

-60% of creative and 46% of interpretative artists considered that the Arts Council had been successful in its work. Most of these cited its grants to individuals and its general improvement in recent years as the reasons. But in apparent contradiction, the majority of artists were not satisfied with the Council's system of grants and bursaries because they were too competitive and under-financed.

The average artist was therefore someone who was not a full-time artist, had no pension entitlements, earned a small and irregular income from artistic activity, and favoured increased Government and Arts Council support for the individual artist. The majority of artists qualifying for income tax exemption under Section 2 of the Finance Act, 1969, earned less than £1,000 per year. The politician who had introduced that enlightened legislative measure, Charles Haughey, visited the Arts Council's premises at Merrion Square on 2 May 1980 to be presented formally with a copy of the survey report by James White. It was the first time Haughey had visited the Council's premises since 1968. He was impressed by the strength of the report's findings and began, in consultation with his Arts Adviser, Anthony Cronin, to consider what measures could be introduced to improve the situation for individual artists.

The first measure was suggested by the Arts Council. This was the extension of the fund known as Ciste Cholmcille which had been established in 1966. On 3 September 1980, the Taoiseach, Charles Haughey, signed an Additional Function Order under the Arts Act, 1951, allowing grants as well as annuities to be paid to individual artists or their dependants who were in

*Gary Hynes, founder and artistic director of*
*Druid Theatre, Galway*

independent theatre managers a combination of grants and guarantees against loss, royalty advances to playwrights and loans for production costs and purchases of equipment.

Cuts were made by the Arts Council in other areas besides drama. Funding was withdrawn from the Douglas Hyde Gallery (at Trinity College, Dublin), the Dublin Contemporary Dance group, and the Cork Film Festival. The effect of all these decisions was to cause a predictable public outcry. Unfortunately for the Arts Council, its actions were seen as aggressive and insensitive. The Taoiseach, Charles Haughey, was infuriated by the Council's approach to the shortage of funds. From a political angle, the Council was exercising undue pressure in attempting to force a crisis situation in order to win extra funding. The Taoiseach had a personal interest in the work of the Gate Theatre, the Dublin Theatre Festival and the Irish Theatre Company. The Council's harsh treatment of them was not calculated to win the Taoiseach's favour.

In Colm O Briain's opinion:

> The Irish Theatre Company saga was the breakpoint with the Taoiseach. The decision to abolish it represented a watershed in the Council's history. The Council was asserting its independence. It would not be a postman for the Taoiseach. It would decide policy and not just implement it.[77]

The Arts Council described the decision to withdraw its support for the Irish Theatre Company as 'an unpleasant necessity'.[78] But in March and April 1982, newspaper articles began to appear which suggested that the Taoiseach was seeking the removal of Colm O Briain as Director of the Arts Council. One article alleged:

> There is a general feeling among the artistic community that Colm O Briain and his officers decide who gets funded and to what extent; the Arts Council merely assent to what has already been decided. There is increasing resentment among artists that their work is not being judged by their peers.[79]

Another article alleged that the Taoiseach was coming under increasing pressure from the artistic community to reorganise the Arts Council and replace it 'with something more democratic and attuned to the times'.[80] Although these articles over-dramatised the situation, the Taoiseach's arts advisor, Anthony Cronin, did contact the Arts Council Chairman, James White, to convey the Taoiseach's wish that Colm O Briain should be asked to resign as Director.[81] James White refused and, instead, stated that the Arts Council had complete confidence in the Director.

The Arts Council decided to respond publicly to the suggestions that its officials were in control of policy and that it should be replaced by a Ministry of Arts and Culture.[82] The Council supported its staff fully and accepted responsibility for all policy decisions. The Council claimed that it was incorrect to suggest that the Director and the staff were out of control. The staff deserved public appreciation and not reprobation for their enthusiasm and commitment. James White, Máire de Paor and Brian Boydell made trenchant speeches in defence of the Arts Council. Máire de Paor argued:

> The only effective approach to State patronage of the arts is the one embodied in the principle of the Arts Council - an independent body which guarantees the freedom of the artist from political interference while managing State funds efficiently. The Arts Council concept has its problems and the Council can make mistakes but the suggestion seems

*Anthony Cronin*                    *Máire de Paor*

to be that the arts should be administered by civil servants from some new Ministry of Culture. This is a ridiculous concept. The arts are not like some drainage scheme which can be handled by a set of bureaucratic forms.[83]

Brian Boydell made an ill-advised statement at the opening of the Cork International Choral and Folk Dance Festival in which he said:

You all know what happened when patronage of the arts in Russia was in the hands of Stalin and his henchman Zhdanov - the greatest creative talents were dictated to by those who knew nothng of the arts but who knew a great deal about political aggrandisement, with results which shocked the artistic world.[84]

The comparison between Stalin and Zhdanov's policies in Russia and those of Haughey and Cronin in Ireland was colourful but unfair. Brian Boydell was justified in suggesting that personal rivalries and sensibilities had been aroused but exaggerated statements only served to inflame an already difficult situation.

On 4 May 1982, Anthony Cronin telephoned James White to say that both he and the Taoiseach 'were very disturbed at the concerted attack on the Taoiseach and the Government'.[85] He said that the Council members were challenging the Government and this was unacceptable. He then clarified the Taoiseach's position as confirmed by James White in a letter written the next day:

> I have been reflecting carefully on our telephone conversation of last evening and I would like to thank you for your assurance that the Taoiseach has confirmed that he has no intention of altering the autonomy of the Arts Council or of setting up a Ministry of the Arts. This is most consoling since the Council members feel a sense almost of siege, following the continual barrage of criticism it has received and then, after the change of Government the snide references in the Press that he intended to take various actions derogatory to the Council and staff. I am delighted to have your confirmation that this is unfounded. For my part I can confirm that the Council's staff will take no part in Press criticism of the Government.[86]

*Ted Nealon*

Anthony Cronin replied to say that there was no basis to 'unfounded journalistic reports' that the Government planned to 'take control' of the arts and he hoped that his telephone conversation with James White had 'cleared the air'.[87]

The confrontation between the Arts Council and the Taoiseach resulted in a re-affirmation of the Council's independence. It also led to a marked improvement in the Council's funding from £4,082,000 in 1982 to £4,954,000 in 1983, a 10.6% increase in real terms. It did not dissuade the Fine Gael-Labour Coalition Government which assumed office in December 1982 from appointing a Minister of State for Arts and Culture. The new Minister of State, Ted Nealon, assured the Arts Council that the statutory autonomy of the Council would not be infringed, that the promotion of all the arts as defined by the Arts Acts would remain the function of the Council, and that the Council would continue to be appointed by the Taoiseach.[88] These assurances were accepted by the Arts Council which, in a gesture of pragmatism and hope, welcomed the Minister of State's appointment as a signal of 'a commitment by the Government to the greater development of the artistic and cultural life of the nation'.[89]

The sixty years since the brief tenure of Count Plunkett as Minister of Fine Arts had been a period of growth and development in Ireland. Official policy towards the arts had finally emerged from general indifference and, at times, outright hostility, to an acceptance of the essential role of the arts as an important civilising influence in Irish society.

*The first annual general meeting of Aosdána, 14 April 1983*

# CHAPTER 10

## EPILOGUE

*We still have a long, long way to go before we can claim to have created anything like a fully sympathetic climate within which all of our artists may work. Much remains to be done and corrected.*

MAIRTIN McCULLOUGH

In his introduction to the *Arts Council Annual Report 1982*, James White wrote that the controversies caused by the 'stresses and strains' on the Council's budget during 1982 'were not understood and appreciated by either arts organisations or by the public at large'. The focus of attention had been on the aggrieved organisations and not on the overall issues facing the arts in Ireland. James White concluded:

> The Council recognises that it must accept responsibility itself for the fact that its role was so widely misunderstood and will, in future, seek to establish conditions which will lead to an informed debate on the merits and demerits of the Council's policies.[1]

The Council began the debate by commissioning Lansdowne Market Research to conduct a survey to gauge the extent of public participation in the arts in Ireland. The results of the survey were published in March 1983 under the title, *Audiences, Acquisitions and Amateurs*. Taken in conjunction with the

information available already about the living and working conditions of artists, the survey provided important statistical evidence about the state of the arts in Ireland.[2] It was encouraging that 60% of those surveyed claimed to have attended at least one arts event in the previous year. Among the 1,400 adults (over-16) surveyed, 37% had attended a film, 21% a traditional music concert, 20% a play, 17% a popular music concert, 9% a classical music concert, 8% an exhibition, and 5% a ballet. 37% of respondents had purchased some arts goods in the previous year and 23% of these had purchased records or tapes of traditional Irish music. Only 2% had purchased paintings or sculptures by living Irish artists. The middle class had the highest attendance rates at arts events and bought most of the arts goods sold. In terms of live arts events, only 20% of all respondents had attended one during the previous year. 76% of non-participants said that lack of information was the main reason for their lack of involvement.

The Arts Council was most concerned about the survey's striking revelation that rates of participation at arts events had been static in the ten year period from 1972 to 1981. This highlighted the failure of the Council's open policies of the 1970s to increase partipation rates at arts events. The need for greater efforts to promote the arts in the regions was obvious. Attendance at arts events varied from 73% of respondents in Dublin, to 50% in the rest of Leinster, Connaught and Ulster, to 60% in Munster. The Arts Council took some comfort from the fact that non-involvement increased with age from 8% for under-25s to 65% for over 65s. But certain 'life cycle' factors minimised any sense of complacency. Most of the young people had attended films or popular music performances, and participation in these events generally decreases with age.

*Audiences, Acquisitions and Amateurs* provided strong evidence that the Arts Council needed to consider the steps to be taken to increase audiences at arts events. The Council felt that the survey's conclusions suggested the need to establish a better information service about arts activities in Ireland, to provide arts venues especially outside Dublin, to promote arts education in the schools, and to encourage the Government to amend tax legislation to stimulate private and corporate sponsorship of the arts.

One critic argued that the Arts Council's failure to increase participation rates in arts activities implied that a complete re-direction of the Council's policies was required. The survey called into question 'the relationship between the Arts Council and real Irish culture':

> The Council pours millions of pounds into prestige institutions such as the Abbey, the Project Arts Centre and the Irish Ballet Company. More

money is spent on opera than on traditional music! Yet it is quite clear that this elitist cultural policy is, like it or not, remote from the cultural inclinations of most Irish people...Without doubt, state subsidies are totally biased in favour of the more passive traditions of the urban middle-class.[3]

Although the survey showed that traditional Irish music concerts or sessions were the most popular type of arts event, the Arts Council gave them only 2% of total expenditure. No support was allocated for the development of popular music. It was easy to make the case that the Council was ignoring the arts which had the highest participation rates. It was not so easy for the Council to shift its expenditure in new directions. The Council wished to address the imbalances but, at the same time, had to sustain employment in the main national arts institutions. There was also the political dimension of which the Council had only recently been made all too aware.

A major problem inhibiting the growth of an arts infrastructure in the regions was the lack of trained arts administrators. The Irish Museums Trust began to tackle the problem in 1982 by organising a training course in arts administration, in association with the Industrial Training Authority (AnCO). The aim of the training programme was 'to provide a solid base from which to build, create and develop the museum and arts organisations of the future'.[4] If the claims of arts organisations for state assistance were to be taken seriously by the taxpayer, they would have to demonstrate that they were managed properly by trained staff. The arts would have to be cost-effective and show adequate return on investment.

In the early 1980s, the Arts Council followed its counterparts in Europe by seeking to justify State aid to arts organisations on economic grounds. The Council's press statements were sprinkled with terms like 'the culture industries', 'arts goods' and 'private arts sponsorship'. An analysis of the Council's grant aid in 1982 showed that 195 organisations had received total grants of £3,383,970 from the Council and had generated a further £6,808,279 from other sources. Thus for every £1 of grant aid, a further £1.50 was generated from other sources. Alternatively, for every £1 in grant aid, £1.24 was generated in wages, salaries and fees.[5] In Great Britain, an exhaustive survey on *Public and Private Funding of the Arts* presented to the House of Commons by an all-Party Education, Science and Arts Select Committee, affirmed: 'While the funding of the arts needs no justification beyond itself, we are of the opinion that the economic importance of the arts is not generally appreciated by local and national government'.[6] The respected economist, Professor John Kenneth Galbraith, declared in a lecture delivered in January 1983:

There must be no doubt; in the modern affluent community the economic justification for education in, and encouragement of, the arts is not less than that for any other aspect of economic life. It serves equally the standard of living; it has equal relevance to growth in the Gross National Product.[7]

The increasing emphasis on the economic value of the arts had some negative effects. Professor Seamus Deane observed that in Ireland:

The last twenty years has created a climate in which art has itself become one of the commodities in which people deal. Reputations, first editions, paintings and sculpture, commissioned music, commissioned theatre are now all part of the cultural scene. Arts Council subsidies and tax-free artists, an increasing academic industry in the history and tradition of Irish art, have all combined to dispel the notion that exile is any longer a necessity. A climate of liberal opinion has created an undiscriminating respect for the artist and his products.[8]

Whether it was undiscriminating or not, respect for the artist was certainly prevalent. On 14 April 1983, Aosdána was formally inaugurated when the first annual general meeting of all the members took place in Dublin.[9] The inauguration was attended by the Taoiseach, Dr Garret Fitzgerald, and by two of his predecessors, Charles Haughey and Jack Lynch.

On 6 May 1983, three weeks after the inauguration of Aosdána, Colm O Briain resigned as Director of the Arts Council. James White issued a press statement to inform the public that the resignation had been 'reluctantly accepted':

Members of the Council expressed in the strongest possible terms their feelings of regret at the loss of a Director who has proved to be so dynamic and resourceful in the development of the Council's work over the eight years during which he has directed its activities.[10]

Colm O Briain's aim had been to change the emphasis of State assistance to the arts from organisations to individual artists. Aosdána was the final element in securing this change and, having seen it into existence, O Briain decided that he had made his contribution to the Arts Council.[11] He had succeeded, with the support of two committed Chairmen and Councils, in creating a challenging and independent institution which was committed to the development of the arts in Ireland.

The Arts Council decided that Colm O Briain's successor would have to give particular attention to the promotion of a regional policy and of a

*Adrian Munnelly*

programme for the arts in the education system. The Council reiterated its belief that 'unless proper recognition is given to art, music, drama and dance in primary and post-primary schools, the inclination to participate in the arts will be confined to a small sector of the adult population'.[12] The need for the extension of funding to the regions was proved by the revelation that in 1983, 57% of the Council's grant-in-aid was spent in Dublin.[13]

It was decided, following an interview process, that Adrian Munnelly, the Arts Council Education Officer since 1979, was the most suitable candidate for the Directorship. He was a native of Mayo, aged 36, a qualified vocational school teacher who had worked as Arts Education Officer at the Department of Education's Centre in Castlebar. This background in education and in arts administration, in and outside the Arts Council, gave Adrian Munnelly a distinct advantage as he attempted to build on the foundations laid by Colm O Briain.

The new Director was convinced that local authorities would have to assume a more prominent role in national arts funding. He told a conference held in Killarney on 'Arts in the Regions' that 'the level of funds available to the Arts Council was such that it was increasingly difficult for the Council to

meet its statutory obligations...morale was at a low ebb'.[14] Details of per capita expenditure by Arts Councils in Wales (£3.09), Scotland (£2.13) and Northern Ireland (£1.86) showed that the Republic had the lowest level (£1.39). The Council demanded boldly that it required a doubling of its grant-in-aid in order to cater adequately for the level of arts activity throughout the country.[15]

Adrian Munnelly identified two factors which were acting as barriers to increased participation in the arts in Ireland.[16] The first was a cultural barrier: 'People are unaware of the value of the arts mainly because of lack of contact with the arts during their most formative years in education'. In 1981, there were 850 post-primary schools in the Republic of Ireland. But there were only 230 art teachers and 146 music teachers. The second factor was a physical barrier: 'Outside of the major urban centres it is difficult for people to actually attend arts events due to lack of facilities locally'. The provision of more local arts centres was imperative.

The eighth Arts Council was appointed by the Taoiseach, Dr Garret Fitzgerald, on 13 January 1984. Strictly speaking, the Council should have been appointed before 31 December 1983 to comply with the Arts Act, 1951.

*Máirtín McCullough*

Máirtín McCullough, a prominent Dublin businessman with a long record of support for the arts in Ireland, was selected as Chairman. The membership represented a good cross-section of professional artists and arts administrators.[17] Their term of five years proved to be difficult and controversial.

Máirtín McCullough was convinced that, in future, there would have to be a three-fold approach to sources of funding for the arts: from the State (via the Arts Council), from local authorities (county councils and city corporations), and from private sector sponsorship.[18] The Arts Council would have to devote its efforts to increasing funding from all three sources. But the main focus of the campaign for increased funding would be directed at the Government. The Minister of State with responsibility for Arts and Culture, Ted Nealon, was barraged with requests for an increase in the Council's grant-in-aid. The Arts Council learned from its tussle with Charles Haughey in 1982 that it was important to have the support of the arts community. On this occasion, the arts community blamed the Government and not the Arts Council for the effects of restricted funding on arts organisations. The Irish Film Theatre was closed by the Arts Council in April 1984 and the annual Dublin Theatre Festival was cancelled. The Council's grant in 1984 was £5,193,000. This meant a 3.6% decrease in funding on the previous year. The Council decided to make a public stand on the issue of underfinancing of the arts.

On 14 September 1984, the Arts Council issued a hard-hitting press statement under the heading: 'There is a crisis in the funding of the arts in Ireland'.[19] The statement gathered together the key statistics underlying the crisis in arts funding:

-the arts in Ireland received 0.9% of government expenditure. This provided a much lower per capita expenditure on the arts than in England, Northern Ireland, Scotland or Wales;

-in 1984, the Arts Council received requests for assistance amounting to £7.5 million but it could only respond with £5 million;

-the accumulated debt of arts organisations in Ireland was £1.5 million;

-the arts provided full-time employment to 600 people;

-there was a tangible economic return from the arts. For every £1 in grant aid, another £1.30 was generated in other revenue.

The Arts Council said that the arts should be seen by the Government as further education and should be accorded priority treatment:

> The Council, in making this statement, is reflecting the very deep frustrations of the arts community, which, despite its huge contribution to community life, is too often regarded as being on the outside. *The Council demands that the arts be taken seriously by government.*

The Council engaged a public relations expert on a consultancy basis 'in connection with obtaining media support for the Council's campaign for significant additional funding'.[20] The campaign was carefully co-ordinated and successful in winning general acceptance that the arts required more support.

*The Royal Hibernian Academy Gallagher Gallery*

*The Royal Hospital, Kilmainham*

The Minister of State, Ted Nealon, was placed under intense pressure from the media to respond to the Council's demands. He pointed to a number of developments which proved the Government's commitment to the arts. The provisions of Section 32 of the Finance Act, 1984, offered tax benefits to corporations and individuals for sponsorship of the arts. The Fund of Suitors Act, 1984, which dispersed funds lying dormant in the courts for many years, provided a total of £900,000 in capital funding for various arts organisations (including Comhaltas Ceoltóirí Eireann £300,000, the Royal Irish Academy of Music £100,000, the Irish National Ballet £100,000 and the Royal Hibernian Academy £100,000). Rosc '84, Ireland's international art exhibition, was held in the Guinness Hop Store, Dublin, which had been renovated with some government assistance. In the 1984 Budget, theatre and other live performances were exempted from value added tax (V.A.T.). In the 1985 Budget, the rate of V.A.T. on cinema tickets was reduced from 23% to 10% The Government allocated £120,000 towards preparations for European Music Year, 1985. The Department of Labour, through its Social Employment

and Teamwork Schemes, provided considerable assistance for the employment of young people by arts organisation. Finally the Royal Hospital, Kilmainham, had been restored by the Office of Public Works and designated as a National Centre for Culture and the Arts.

The Arts Council acknowledged these government initiatives, but claimed that the position remained unchanged. The arts were under-financed. The Government spent £21 million on the restoration of the Royal Hospital, yet the cumulative total of government funding of the Arts Council since its foundation in 1951 was only £23 million. The Arts Council decided that the cover of its Annual Report for 1984 should be a collage of press cuttings about the underfunding of the arts. It was not long before the Council was informed that the Minister of State was 'extremely irate at the theme of the cover...and had accused the Council of deliberately and openly criticising the Government'.[21] The proposed cover was discussed at a meeting of the Government. It was suggested that the Arts Council should arrange an alternative cover 'and that the Chairman's introduction should confine itself to a review of the Council's stewardship and should not make political statements regarding the level of the Council's grant-in-aid'.[22] The Council decided that, in the circumstances, 'it would be most imprudent to ignore the views expressed'.[23] It was recognised that it would probably prove impossible to prevent the media from learning about the matter. This proved to be true because although all the copies of the report issued to Council members and staff were recalled, a photograph of the offending cover appeared in the *Irish Times*.

When the 1984 Annual Report was finally published, a photograph of an abstract painting was featured on its cover. Although the Arts Council had therefore succumbed to political pressure, Máirtín McCullough did not refrain from using harsh language in his introduction to the Report. He said that it had been a frustrating year: 'The problem was simply one of underfunding of the arts'. It had been stated many times during the year, but it was necessary for the Council to repeat 'an already tiresome appeal':

> Public funding for years past has failed lamentably to keep pace with the dramatic growth in all the arts and this neglect by successive Governments of a vital, vibrant aspect of our daily lives can only be described as short-sighted.[24]

The Chairman continued by asserting that while the Arts Council would maintain its campaign for more funding, it would allocate what funds it had 'with critical discernment'. He warned that 'areas of past support where

*Garret Fitzgerald*

standards are declining, or are simply unacceptable, will be the first to feel the pinch'.[25]

One of the areas to be re-assessed under this policy was ballet. The Arts Council was worried that the level of subsidy per seat sold by the Irish National Ballet in particular was 'unacceptably high'. Peter Brinson of the Laban Centre for Movement and Dance in London was commissioned to report on the matter. His report, *The Dancer and the Dance* was published in May 1985. It offered a series of recommendations for the restructuring of dance in Ireland. These included a decrease in funding of the Irish National Ballet and an increase in support for new dance companies.

The Arts Council's arts officers, under Adrian Munnelly's directorship, began to propose new policies for each of the arts for which the Council was responsible. In 1985, policies were developed for traditional music, opera, arts in education and community arts. Important areas such as access to the arts for the disabled were explored and appropriate recommendations issued. As part of Ireland's contribution to European Music Year 1985, the Arts Council published a report on the provision of music education in Irish schools. The report, titled *Deaf Ears*, provided what the Arts Council described as 'detailed statistical evidence of the scandalous neglect of music in our schools'.[26] In 1985, only 2.9% of the total number of candidates sitting the Leaving Certificate took the music examination. This figure was particularly stark because many candidates studied for the examination outside school. The Curriculum and Examination Board established by the Minister for Education provided some hope for an improvement in the position of the arts in schools when it published a discussion paper *The Arts in Education,* in September 1985. The Arts Council endorsed the paper but complained that the Department of Education had ignored it.

The development of the Arts Council's regional policy was advanced also. The first phase of this policy had seen local arts activity stimulated by the appointment of regional arts officers. In September 1985, the second phase began with the appointment of the first County Arts Officer in County Clare. The Council argued that the arts were in an analogous position to the development of the public library system in the late nineteenth century. In the Council's opinion, it was a realistic aspiration that the arts would hold a similarly integrated position within the local authority structure by the end of the twentieth century. Much depended on the growth of community arts activity. In 1984, CAFE (Community Arts for Everyone) had been established, with Arts Council support, as a national umbrella organisation for community arts groups. This was followed in September 1985 by the

establishment of ACE (Arts Community Education) as a three-year community arts and arts in education project in association with the Gulbenkian Foundation. The aim of the ACE programme was 'to foster experience of art as part of everyday life at work, in school, or on the street'.[27] By 1985 there were 14 arts centres throughout the country. The Arts Council encouraged and funded this expansion. It was anticipated that the consequent demand for current funding to run the centres would create its own dynamic and force the Government to increase over-all state arts funding.

In September 1986, the Arts Council revealed another element of its regional policy - the prospect of cultural agreements with various local authorities and city corporations. The first city to agree to such an arrangement was Limerick.[28] A two-year development programme was drawn up between the Arts Council and Limerick Corporation and they agreed to fund arts projects and events jointly.

The general air of innovation and excitement was stimulated considerably by two announcements made by the Government. The first was the declaration by the Minister of State, Ted Nealon, that the Government intended to publish a white paper on cultural policy. For the first time since independence, an Irish Government intended to set down its objectives for the cultural development of the country. The Arts Council recognised the importance of the Government's decision. John Banville, a distinguished writer and Council member, was selected to draw up the Council's submission to the Government. John O'Mahony, Regional Arts Officer for Cork/Kerry, assisted with the work. Seventeen public meetings were held throughout the country to give people an opportunity to make their views known to the Arts Council. The Council's submission stressed the importance of protecting the individual artist; improving participation and access to the arts; providing new facilities and maintaining existing ones.[29]

The second Government announcement concerned the establishment of the National Lottery. It was intended that a proportion of the proceeds from the Lottery would be allocated to arts and cultural projects. When the Government White Paper, *Access and Opportunity*, was published in January 1987, it affirmed that the Government was committed 'to preventing any erosion in the position of the Arts Council'. The Government would look to the Council 'to continue to develop dynamic policies for the development of the arts. A target of doubling (in real terms) of the Council's funding, principally from the National Lottery allocation, by 1990 is therefore proposed'.[30] The White Paper echoed many of the Arts Council's concerns since it was restructured in 1973. The document's major themes - 'extending

*John Banville*

cultural opportunities, improving access to culture and increasing participation in cultural activity'[31] - and indeed its title, *Access and Opportunity*, represented an official acceptance of the Arts Council's policies. In June 1986, the Council reaffirmed its position by submitting a five-year development plan for the years 1987 to 1991 to the Department of the Taoiseach.

In 1987 the Arts Council altered its principal standing order which had remained unchanged since 1960. The original standing order devised by Seán O Faoláin's Council in 1957 had read: 'Future policy, while not failing to encourage local enterprise, would insist on high standards'. In 1960, this had been altered by Fr O'Sullivan's Council to read: 'The Council's main function is to maintain and encourage high standards in the arts'. In 1987, the position reverted to that formulated thirty years earlier: 'While recognising local enterprise and community activity, the Council's main function is to maintain and encourage high standards in the arts'. The Council's policies had, in a sense, come full circle. It was now recognised that the Arts Council's primary duty was to spend taxpayer's money on 'artistic excellence' but, at the same time, every effort had to be made to increase audiences and participation in artistic activities.

In November 1987, the Taoiseach, Charles Haughey, whose Fianna Fáil party had returned to power earlier in the year, announced that £8 million from the estimated £45 million profits from the National Lottery in 1987 would be spent on arts and culture projects.[33] One art critic considered that the announcement marked 'the launch of a cultural revolution'.[34] But other

*Colm O hEocha*

critics have cautioned that the reliance on discretionary spending on lottery tickets by the general public to support the activities of official agencies such as the Arts Council is an undesirable development. From a pessimistic viewpoint, it means that once again the arts are being regarded as a marginal area. The commitment to double the Arts Council's funding in real terms by 1990 has not been achieved.

During the last eighteen months of Máirtín McCullough's chairmanship, the Arts Council published a survey of European tax codes as they affect creative and interpretative artists[34] appointed Keith Donald as the first Arts Council Popular Music Officer (with the support of the Popular Music Industry Association); commissioned an important study, *The Performing Arts and the Public Purse: an Economic Analysis*[35]; and promoted arts sponsorship by private enterprises which led to the establishment of *Cothú*, the Business Council for Arts and Heritage.

In the autumn of 1988, Máirtín McCullough issued a number of press statements in which he suggested that an 'Arts Council Mark 2' was being established within the Taoiseach's Department. He was concerned about the way funds from the National Lottery were being allocated to arts projects by the Taoiseach's Department without any reference to the Arts Council. On 29 November 1988, the Taoiseach decided to dispel any doubts about future policy when he made an important statement to the Dáil. He said:

> It would be my intention from now on to allocate all moneys for the arts to the Arts Council and give them full jurisdiction over the distribution...I am increasingly of the view that we should establish a good Arts Council and entrust to them the task of holding the balance and deciding the priorities between the different sectors.[36]

This statement provided emphatic confirmation that Charles Haughey considered the Arts Council to be the primary agency for the disbursement of State funding for the arts. Although the late 1980s were marked by severe restrictions on the growth of public expenditure, the Taoiseach had signalled that the arts were an integral part of future government policy. On 22 December 1988, the Taoiseach appointed the ninth Arts Council. It took up office on 1 January 1989.[37] The Council and its Chairman, Dr Colm O hEocha, President of University College, Galway, face new and exciting challenges. But the basic task remains the same as that which faced the first Arts Council in 1951 - to stimulate public interest in, to promote the knowledge, appreciation, and practice of the arts in Ireland.

# CONCLUSION

It is obvious from this study that the arts are now accepted generally by Irish politicians and their electorate as having an essential place in government policy. There has been a progressive change in attitudes to the arts in Ireland in the seven decades since the achievement of national independence. But this study also provides evidence to indicate that there is no solid political commitment to the implementation of a comprehensive arts policy.

The Arts Council has specific policies for the various arts included in its remit. The Council is dependent, however, on adequate State finance to implement them. The wider aspect of cultural (including arts) policy has been the subject of a government White Paper, *Access and Opportunity*. This policy is being carried into effect in the un-coordinated, piecemeal manner which has been a basic feature of the behaviour of Irish Governments towards the arts.

The gradual emergence of the arts in Ireland has mirrored the growth of living standards. Public demand for the arts has increased rapidly since the 1960s when the country experienced accelerated economic development.

Increased disposable income, more leisure time (whether due to improved working conditions, or, conversely, unemployment) and growing urban sophistication, have assisted the emergence of the arts.

For the most part, the Irish public has dictated the pace of the development of arts policy. Leaders of Irish Governments have reflected popular attitudes to the arts. W.T. Cosgrave considered that there were such urgent tasks to complete that it would be wasteful to expend public money on what the Department of Finance called artistic luxuries. Eamon de Valera supported arts initiatives so long as they did not involve State expenditure. This disappointed Paddy Little who thought that some public funding was necessary to stimulate private arts initiatives throughout the country. During the late 1940s and early 1950s, Irish politicians and administrators came to accept the need for large-scale State borrowing for capital purposes. The need for a comprehensive State infrastructure was emphasised. This allowed greater freedom to John A. Costello in realising his desire to assist the liberalisation of Irish attitudes. He implemented Paddy Little's plans for an Arts Council which would offer government support to arts organisations. Seán Lemass launched a major programme of industrial development during the 1960s. He held that, in tandem with industrial development, the State should develop arts institutions which would offer tangible evidence of economic prosperity and of government concern for the arts. His policy of 'grand gestures' was valuable but it neglected the need to establish conditions which would offer direct support to Irish artists. Charles Haughey perceived this requirement and, in a series of enlightened 'grand gestures', has succeeded in enhancing the status of the artist in Irish life. Garret Fitzgerald helped to establish a firm basis for growth by creating a Ministry of State at the Department of the Taoiseach with responsibility for Arts and Culture and by publishing *Access and Opportunity.*

Despite this acknowledged emergence of the arts as an integral part of government policy, there is no clear commitment to a planned approach to the development of the arts in Ireland. Policy is fragmented and incoherent. But the situation is not pessimistic. Much has been achieved and yet much remains to be done. The arts in Ireland are in a state of rapid development. With public support, adequate funding and intelligent planning, they should have a bright future.

# NOTES

## CHAPTER 1

1   See for example: Harold Baldry, *The Case for the Arts* (London, 1981); Robert Hutchinson, *The Politics of the Arts Council* (London, 1982); John Pick, *Managing the Arts: the British Experience* (London, 1986); Roy Shaw, *The Arts and the People* (London, 1987); Eric Walter White, *The Arts Council of Great Britain* (London, 1975).

2   Where reference is made in this study to the 'Irish State' or 'Ireland', this shall be taken to mean the 26 counties of the Republic of Ireland.

3   For a useful discussion of this principle, see: *The Arm's Length Principle and the Arts: An International Perspective - Past, Present and Future* (Canada Council, Ottawa, 1985).

4   Some examples include: Bryan Appleyard, *The Culture Club: Crisis in the Arts* (London, 1984); Robert Hewison: *The Heritage Industry: Britain in a climate of decline* (London, 1987); Owen Kelly, *Community Art and the State: Storming the Citadels* (London, 1984); Geoff Mulgan & Ken Worpole, *Saturday Night or Sunday Morning: Who or What is doing most to shape British culture in the 1980s?* (London, 1986).

5   Roy Shaw, *The Arts and the People,* p. 17.

6   See: John Kenneth Galbraith, *Economics and the Arts* (London, 1983) for some useful general observations on this subject. For the Irish situation see: John W. O'Hagan and Christopher T. Duffy, *The Performing Arts and the Public Purse: an Economic Analysis* (Dublin, 1987).

7   John Maynard Keynes, 'Art and the State', *The Listener,* 26 Aug. 1936,pp 371-4.

## CHAPTER 2

1   S.P.O., D.E. 2/389. See Labhrás Breathnach, *An Pluincéadach* (Dublin, 1971), Chap. X1.

2   S.P.O., D.E. 2/411.

3   *Dáil Debates,* Vol. 125, 24 Apr. 1951, col. 1337.

4   S.P.O., D.E. 2/411, Breathnach to O hEigeartaigh, 17 Jan. 1922.

5   *Ibid.,* O hEigeartaigh to Breathnach, 18 Jan. 1922.

6   *Thomas Davis: Selections from his Prose and Poetry,* with an intro. by T.W. Rolleston (Dublin, 1889).

7   See Alan Denson, *Thomas Bodkin: A Bio-Bibliographical Survey* (Kendal, 1967) and newspaper obituaries about Bodkin, *Irish Times, Irish Independent* and *Irish Press,* 25 Apr. 1961.

8   T.C.D., MS 6965/1, Corcoran to Bodkin, 12 Oct. 1921.

9   T.C.D., MS 6965/2.

10   T.C.D., MS 6965/10, Memorandum titled 'The Functions of a Ministry of Fine Arts'.

11   T.C.D., MS 7003/1, Michael Hayes to Bodkin, 8 Feb. 1922.

12   Thomas Bodkin, *Report on the Arts in Ireland* (Dublin, 1949), p. 8.

13   T.C.D., MS 7003/1a, 16 May 1923.

14   Ministers and Secretaries Act, 1924, fourth part of the Schedule.

15   Department of Finance, F 599/17, memorandum dated 27 Apr. 1923.

16   *Dáil Debates,* Vol. 5, 2 Nov. 1923, col. 666.

17   See *A Tribute to Sir Hugh Lane* (Cork, 1961) and *The City's Art - the original municipal collection* (Exhibition Catalogue, Dublin 1984). For the background to the Lane controversy, see Thomas Bodkin, *Hugh Lane and his Pictures* (Dublin, 1956).

18    Lady Augusta Gregory, *Sir Hugh Lane: His Life and Legacy* (London, 1921).

19    See Lieut. Colonel James M. Doyle, 'Music in the Army' in Aloys Fleischmann (Ed.), *Music in Ireland* (Cork, 1952), pp 65-70.

20    James Meenan, *George O'Brien: a biographical memoir* (Dublin, 1980), p. 114.

21    León O Broin, *Just Like Yesterday: an Autobiography* (Dublin, 1986), p. 94.

22    Meenan, *George O'Brien,* p. 115.

23    See Richard Pine, *All for Hecuba* (Exhibition Catalogue, Dublin, 1978).

24    Micheál MacLiammóir, *All for Hecuba: a Theatrical Biography* (Revised Edt., Dublin, 1961), p. 31.

25    See Michael Adams, *Censorship: The Irish Experience* (Dublin, 1968) and Kieran Woodman, *Media Control in Ireland 1923-1983* (Galway, 1985).

26    Fr P.J. Gannon, S.J., 'Literature and Censorship', *The Irish Monthly,* Vol. LXV, No. 769, July 1937 p. 439.

27    Seán O Faoláin, 'The Dangers of Censorship', *Ireland To-Day,* Vol. 1, No. 6, Nov. 1936, pp. 57-63.

28    'Some Questions about the Thirties', Mervyn Wall in conversation with Michael Smith (Ed.), *The Lace Curtain 4,* Summer 1971, pp 77-86.

29    Brian O Cuiv, *Irish Dialects and Irish-Speaking Districts* (Dublin, 1951), pp 31-2. For an excellent study of the failure of Irish language policy, see Seán de Fréine, *The Great Silence* (Dublin & Cork, 1978).

30    *Censuses of Population of Ireland 1946 to 1951. General Report* (Dublin, 1958), p. 200. The figure of 589,000 relates to the 1946 census and it was admitted that the subjective element in language assessment made it 'far less susceptible to exact measurement'.

31    See León O Broin, *Just Like Yesterday,* pp 94-5.

32    'The Cost of *An Gúm*', *Irish Independent,* 24 Jan. 1966 (a translation of an article '*Costas an Ghúim*' which appeared in *Comhar,* Nov. 1965).

33    See Paddy Clarke, *Dublin Calling: 2RN and the birth of Irish Radio* (Dublin, 1986) and Robert J. Savage, 'The Origins of Irish Radio' (Unpublished M.A. thesis, U.C.D., 1982). The call sign, Radio 2RN, was designated by London from the phonetic version of the last words of 'Come Back to Eireann'. In 1932 the station's name was changed to Radio Eireann.

34    Clarke, *ibid.,* p. 44.

35    Séumas O Braonain, 'Music in the Broadcasting Service', in Fleischmann (Ed.), *Music in Ireland,* p. 198. See also Louis McRedmond (Ed.), *Written on the Wind: Personal Memories of Irish Radio 1922-1976* (Dublin, 1976).

36    See essay by Thomas Ryan in *Seán Keating and the E.S.B.* (Dublin, 1985), p. 33.

37    See Kenneth McConkey, 'Paintings of the Irish Renascence', *Irish Arts Review,* Vol. 3, No. 3 Autumn 1986, pp 19-21.

38    S.P.O., S 3458.

39    *Ibid.,* memorandum dated 30 Sept. 1926.

40    S.P.O., CAB 2/291, item 10, 4 Oct. 1926.

41    S.P.O., CAB 2/329, item 6, 5 Apr. 1927. The French experts were M. Antoine Druot, General Inspector of Technical Education, Paris; M. Adrien Bruneau, Inspector of Professional Art teaching of the City of Paris; and M. Yvanhoe Rambosson, Honorary Curator of the Museums of the City of Paris.

42    S.P.O., S 5392, Joseph O'Neill to Secretary of the Executive Council, 24 Mar. 1927.

43    *Ibid.,* 31 Mar. 1927. The four Irish members appointed on 19 May 1927 were Charles McNeill (Expert on Archaeology), Thomas Bodkin (Art and Industry), Dermod O'Brien, P.R.H.A. (representing the Board of Visitors of the National Museum) and Dr P.A. Murphy (Natural Science) who was replaced on 6 Oct. 1927 by James M. Adams.

44    T.C.D., MS 6965/30, 'The Report of the French Delegation on the reforms that are necessary in Artistic and Technical Education in the Free State, and especially in the Dublin Metropolitan School of Art', 8 June 1927.

45    See John Turpin, 'The Ghost of South Kensington: the Beginnings of Irish State Qualifications in Art, 1900-1936', *Oideas,* No. 30, 1987, pp 48-57.

46    T.C.D., MS 6965/36.

47    S.P.O., S 3458, Keating to Thomas Derrig, Minister for Education, 2 May 1932.

48    *Ibid.*, Keating to Kathleen O'Connell, Secretary to Mr de Valera, 21 Jan. 1936.

49    Bodkin, *Report on the Arts,* pp 11-14.

50    S.P.O., S 5392, Professor Nils Lithberg, *Report on the National Museum,* 20 Oct. 1927.

51    *Ibid.*, 'Report of the Irish Members of the Committee of Enquiry on the National Museum', 7 Dec. 1927.

52    *Ibid.*, Thomas Bodkin, 'Explanatory Note of Reservations on the Main Report', 13 Dec. 1927.

53    *Ibid.*, Memorandum circulated at the Government meeting on 4 June 1928 and approved at the meeting held on 3 July 1928.

54    D/Finance, S 2/28/29.

55    *Dáil Debates,* questions by Deputies Seoirse de Bhulbh, Vol. 30, 10 June 1929; Bryan Cooper, Vol. 32, 30 Oct. 1929; Earnán Altún, Vol. 29, 15 May 1929 and Vol. 32, 13 Nov. 1929.

56    *Ibid.*, question by Earnán Altún, 13 Nov. 1929.

57    *Census of Population 1926,* Vol. X, General Report (Dublin, 1934), p. 64.

58    T.C.D., MS 7003/2, Cosgrave to Bodkin, 31 Aug. 1927, thanking him for a subscription to the funds of Cumann na nGaedheal. MS 7003/63 is a receipt dated 1 June 1937 of a subscription by Bodkin to the funds of Fine Gael.

59    T.C.D., letters of Bodkin to McGilligan (MS 6965/41), to Hogan (MS 6965/38) and to Blythe (MS 6965/40).

60    S.P.O., S 6222A, McGilligan to Cosgrave, 28 Aug. 1929.

61    *Ibid.*, undated and unsigned 13 page memorandum.

62    *Irish Times* and *Irish Independent,* 19 Dec. 1929.

63    T.C.D., MS 6965/42, Bodkin to John Marcus O'Sullivan, 19 Dec. 1929.

64    S.P.O., S 6222A, Bodkin to Cosgrave, 20 Feb. 1930, 'Supplementary notes on the Memorandum on the Control and Regulation of the various Institutions, Corporations, Academies and Learned Societies connected with the Study and Cultivation of the Arts in Saorstát Eireann'.

65    *Ibid.*, Cosgrave to Bodkin, 21 Feb. 1930.

66    T.C.D., MS 7003/31, Bodkin to Cosgrave, 9 Mar. 1931.

67    T.C.D., MS 7003/36, Michael McDunphy, Department of the President, to Bodkin, 12 Sept. 1932.

68    S.P.O., S 6222A, Sir Robert Woods to Cosgrave, 22 Oct. 1931.

69    *Ibid.*, Department of Finance memorandum prepared by H.P. Boland.

70    *Ibid.*, note of meeting, 4 Dec. 1931.

71    *Dáil Debates,* Vol. 107, 24 June 1947, col. 118.

72    *Saorstát Eireann Official Handbook* (Dublin, 1932), p. 16.

73    *Ibid.*, p. 243.

74    *Ibid.*, p. 244.

75    *Ibid.*

76    T.C.D., MS 7003/318-62B.

CHAPTER 3

1    Edward Mac Lysaght, *Changing Times* (Gerrards Cross, Buckinghamshire, 1978), p. 167.

2    Gordon Henderson, 'An Interview with Mervyn Wall', *The Journal of Irish Literature*, Vol. XI, Nos. 1 & 2, Jan.-May 1982, p. 72.

3    Maurice Moynihan, *Speeches and Statements of Eamon de Valera 1917-73* (Dublin, 1980), pp 154-5.

4    *Ibid.*, p. 205.

5    Interview with Dr George Furlong, 29 May 1984.

6    Moynihan, *Speeches and Statements by Eamon de Valera*, pp 220-3.

7    *Dáil Debates*, Vol. 125, 24 Apr. 1951, cols 1337-8.

8    Quoted in Gabriel Fallon, 'Celluloid Menace', *The Capuchin Annual*, Vol. 10, 1938, p. 249.

9    See *Catholic Emancipation Centenary Celebrations: A Pictorial Record* (Dublin, 1929). Ireland's first sound film was a record of the Catholic Emancipation Centenary Celebrations. It was premiered at the Capitol Cinema, Dublin, on 1 July 1929.

10  See *Eucharistic Congress, Dublin 1932: Pictorial Record* (Dublin, 1932) and Maurice Hartigan, 'The Eucharistic Congress, 1932' (Unpublished M.A. thesis, U.C.D., 1982).

11  Very Rev E.J. Cullen, 'On the Purpose of Art' (Dublin, 1936), p. 24.

12  See James White and Michael Wynne, *Irish Stained Glass* (Dublin, 1963) and Michael Wynne, 'Stained Glass in Ireland, principally Irish, 1760-1963' (Unpublished Ph.D. thesis, T.C.D., 1976).

13  There were 44 published volumes of *The Capuchin Annual*, the last in 1977. The author is grateful to Dr Maurice Moynihan (interview 24 Jan. 1987) and to Benedict Kiely (interview 17 Mar. 1987) for information about Fr Senan. See Benedict Kiely, 'The Corpulent Capuchin of Capel Street', *The Education Times*, Supplement to *The Irish Times*, 26 Dec. 1974.

14  Examples include the tributes to Seán O'Sullivan (1937), Carl Hardebeck (1943), Jack B. Yeats (1945), Vincent O'Brien (1945-6), John McCormack (1946-7), F.J. McCormick (1948), Margaret Burke Sheridan (1959), Dermot Troy (1964), Thomas McGreevy (1968), Richard King (1975) and Séamus Murphy (1976).

15  C.E. 382, Will of Thomas Haverty.

16  'Cinema Statistics in Saorstát Eireann', a paper read by Thekla Beere to the Statistical and Social Inquiry Society of Ireland on 21 May 1936. Statistics quoted in Fallon, 'Celluloid Menace', *The Capuchin Annual*, 1938, p. 249.

17  James Montgomery, 'The Menace of Hollywood', *Studies,* Vol. XXI, No. 124, December 1942, p. 420.

18  See Kevin Rockett, Luke Gibbons & John Hill, *Cinema and Ireland* (Beckenham, Kent, 1987). Part One, 'History, Politics and Irish Cinema', by Kevin Rockett, is particularly useful (pp 1-144).

19  See Liam O'Leary, 'The Shop around the Corner' and 'Potemkin and Afterwards', *Irish Times,* 17 & 18 Nov. 1987.

20  See Brian P. Kennedy, '*Ireland To-Day:* a brave Irish periodical', *Linen Hall Review,* Vol. 5, No. 4 Winter 1988, pp 18-19.

21  James Devane, 'Nationality and Culture', *Ireland To-Day,* Dec. 1936, p. 14.

22  Liam O Laoghaire, 'Irish Cinema and the Cinemas', *Ireland To-Day,* Jan. 1937, p. 75.

23  Bodkin, *Hugh Lane and his Pictures*, pp 62-8.

24  S.P.O., S 2236A, Memorandum for Government Meeting of 12 Dec. 1933, 'Proposals for the erection of new Government Buildings'.

25  Those appointed to the committee were: the Minister for Local Government and Public Health, Seán T. O'Kelly; the Minister for Finance, Seán MacEntee; the Minister for Defence, Frank Aiken; and the Parliamentary Secretary to the Minister for Finance, Hugo Flinn.

26  S.P.O., CAB 7/107, item 4, 26 Jan. 1934.

27  In 1944 de Valera tried to revive the scheme and, on his instructions, a draft press release announcing the plans was considered by the Government (S.P.O., S 2236A, 8 Dec. 1944). On the advice of the Minister for Finance, Seán T. O'Kelly, it was decided not to issue the press release and the plan was postponed until after the emergency (as the second world war was described officially). The plan was not revived again but it became a source of public controversy in 1953 when General Seán MacEoin told the Dáil about it in order to embarrass Fianna Fáil. He had learned the details while he was Minister for Justice (1948-51) in the first Inter-Party Government and it was questionable whether or not he should have revealed them. At first the Government denied that the scheme had ever existed but later a full and open statement was made by Donnchadh O Briain, Parliamentary Secretary to the Taoiseach. (*Dáil Debates,* Vol. 139, 10 June (cols 921-3), 11 June (cols 1232-44) and 16 June 1953 (cols 1245-50). See also *Sunday Independent,* 9 May 1954, 'Government planned to demolish city area').

28  T.C.D., MS 7003/58, 20 Dec. 1935.

29  León O Broin, 'The Mantle of Culture', in McRedmond (Ed.), *Written on the Wind,* p. 7.

30  Little contributed poems to *The Capuchin Annual* under the pseudonym 'M.J. Labern' (e.g. *The Capuchin Annual*, 1945-6, p. 228). MacEntee had a book titled *Poems* published in 1918.

31  D/Finance, S 101/13/36, 3 Jan. 1936.

32  *Ibid.*, 10 Jan. 1936.

33  *Ibid.*, Memorandum for Government, 'A Concert Hall for Dublin', 1 Sept. 1936.

34 *Ibid.*, handwritten note, 23 Sept. 1936.

35 *Ibid.*, 28 Sept. 1936.

36 *Ibid.*, 8 Oct. 1936.

37 *Ibid.*, Maurice Moynihan to Private Secretary, Department of Posts and Telegraphs, 13 Oct. 1936.

38 The committee members were: H.P. Boland and T.S.C. Dagg (Department of Finance), Dr T.J. Kiernan and R.J. Cremins (Department of Posts and Telegraphs), L. Murray and Ursula Murphy (Department of Education).

39 D/Finance, S 101/13/36, 'Symphony Orchestra and Concert Hall in Dublin: Report of Inter-Departmental Committee', 27 Feb. 1937.

40 *Ibid.*, Tomás O Deirg to Secretary, D/Finance, 6 Apr. 1937.

41 *Ibid.*, P.S. O'Hegarty to Secretary, D/Finance, 10 May 1937.

42 *Ibid.*

43 *Ibid.*, Memorandum submitted by D/Finance (signed J.A. Scannell & S.P.O Muireadaigh) to D/President, 21 May 1937.

44 León O Broin, *Just Like Yesterday*, p. 171.

45 D/Finance, S 101/13/36, Seán O Muimhneacháin to MacEntee, 26 May 1937.

46 *Ibid.*, P.S. O Muireadaigh, D/President, to Private Secretary, D/Finance, 26 May 1937, enclosing a memorandum submitted to the President at his meeting on 14 May 1937 with the Hon. C.A. Maguire (President of the High Court), Dermod O'Brien, George Furlong, C.P. Curran, Alice B. Griffith, Hubert Briscoe and H.P. Boland.

47 *Ibid.*, Seán O Muimhneacháin to W.F. Nally, 15 July 1937.

48 The members of the first Committee (22 Oct. 1937 to 31 Mar. 1939) were P. McCarthy (Chairman), Mrs J. Ryan, G. Atkinson, R.H. Byrne, R.C. Ferguson, G. Furlong, S.C. Hughes, S. Keating, E.A. McGuire, E.T. Mahony, D. O'Brien, F.H. O'Donnell, C. O Lochlainn and F.H. Boland (Secretary). In January 1939, F.H. Boland became a committee member and J.J. Lennon was appointed Secretary. J.J. O'Leary replaced C. O Lochlainn on the second Committee (23 May 1939 to 31 Mar. 1940).

49 C.E. 57, 'Reports of the Advisory Committee on Design in Industry'.

50 Micheál MacLiammóir, *All for Hecuba*, chap. 15.

51 Terence Brown, *Ireland: A Social and Cultural History 1922-79* (London, first edt. 1981), pp 225-6.

CHAPTER 4

1 See John S. Harris, *Government Patronage of the Arts in Great Britain* (Chicago, 1970), chapters 2 & 3.

2 MacLysaght, *Changing Times*, pp 167-70.

3 Moynihan, *Speeches and Statements by Eamon de Valera*, pp 436-49.

4 D/Finance, S 101/13/36, 13 Nov. 1940.

5 *Ibid.*, 18 Nov. 1940.

6 Interview with Professor Aloys Fleischmann, 23 Oct. 1987.

7 O Braoin, 'Music in the Primary Schools', in Fleischmann (Ed.), *Music in Ireland*, p. 38.

8 *Report of the Department of Education 1937-1938*, p. 160. Comparative figures for 1983 offer little comfort. In that year, 0.73% of boys and 3.68% of girls took the Leaving Certificate examination in music. As in 1938 there was only one music inspector for the entire country. See Donald Herron, *Deaf Ears* (Dublin, 1985), p. VII.

9 D/Finance, S 109/1/46, observations of the D/Finance on the 'Acquisition of Premises in Dublin for Public Performances and for a State Opera House', 15 Aug. 1942. Little's memorandum was dated 6 Aug. 1942.

10 *Ibid.*, undated.

11 C.E. 26, memorandum titled 'Proposed Establishment of National Theatre', 16 Apr. 1943.

12 *Ibid.*, minutes of the Cabinet Committee, 1944.

13 *Ibid.*, memorandum titled 'Erection of Village Halls', 14 July 1944.

14 *Ibid.*, Government decision, 25 July 1944.

15 *Seanad Debates*, Vol. 27, 18 Nov. 1942. See Adams, *Censorship: the Irish Experience*, pp 84-95, for an excellent summary of the 1942 debate.

16 *Dáil Debates,* Vol. 90, 13 May 1943, col. 105.

17 Donal McCartney, 'Education and Language, 1938-51', in K.B. Nowlan & T.D. Williams (Eds.), *Ireland in the War Years and After 1939-51* (Dublin, 1969), pp 83-4.

18 Kenneth Reddin, 'A Man Called Pearse', *Studies*, Vol. 34, 1945, pp 250-1.

19 *Report of the Department of Education 1937-1938*, p. 160.

20 Hilary Pyle, *Irish Art 1900-50*, ROSC exhibition catalogue (Cork, 1975), p. 16.

21 *Ibid.*, quoted from *A Fretful Midge* (London, 1957), pp 110-11.

22 Marianne Hartigan, 'The Irish Exhibition of Living Art', *Irish Arts Review*, Vol. 4, No. 4, Winter 1987, pp 58-9. See also: Brian Kennedy, 'Irish Art and Modernism', unpublished Ph. D. thesis, T.C.D., 1986.

23 *Report of the Department of Education 1937-1938,* pp 98-9.

24 In 1947/8 there were 253,000 visitors to the National Museum. *Report of the Department of Education 1947-1948* (Dublin, 1950), p. 54.

25 B.G. MacCarthy, 'The Cinema as a Social Factor', *Studies*, Vol. 33, 1944, p. 49.

26 *Ibid.*, p. 52.

27 Seán O Faoláin's introduction to 'A Tour of Films' by Lucy Glazebrook, *The Bell*, Vol. 10, No. 1 April 1945, p. 42.

28 Rockett, Gibbons & Hill, *Cinema and Ireland*, pp 95-7.

29 *Ibid.*

30 *Ibid.*, Department of Finance memorandum dated 30 Nov. 1946.

31 *Irish Independent*, 13 May 1946.

32 S.P.O., S 13773A, Little to de Valera, 27 Nov. 1945.

33 Letter dated 3 Aug. 1944. In private possession of Ms Catríona MacLeod to whom the author is grateful for making available the papers of Paddy Little (hereafter denoted as the 'Little Papers').

34 *Ibid.*

35 León O Broin, *Just Like Yesterday*, p. 173, and for background information, author's interview with O Broin, 15 Nov. 1985.

36 Little Papers, manuscript notes of conversation with de Valera, Jan. 1945.

37 John Maynard Keynes, 'The Arts Council: Its Policy and Hopes', *The Listener,* 12 July 1945, p. 31.

38 S.P.O., S 13773A, Little to de Valera, 27 Nov. 1945.

39 Little Papers, 27 Nov. 1945.

40 *Ibid.*

41 *Ibid.*, 29 Nov. 1945.

42 S.P.O., S 13773A, 16 Jan. 1946.

43 D/Finance, S 109/1/46, P. O Cinnéide, D/Taoiseach, to Private Secretary, D/Local Government and Public Health, 10 Jan. 1946.

44 S.P.O. S 13773A, note by Dr N.S. Nolan, Assistant Secretary, D/Taoiseach, 5 Feb. 1946.

45 *Ibid.*

46 D/Finance, S 109/1/46, MacEntee to Aiken, 19 Feb. 1946.

47 *Ibid.*, 20 Feb. 1946.

48 *Ibid.*, P. O Cinnéide, D/Taoiseach, to Private Secretary, D/Posts and Telegraphs, 23 Feb. 1946.

49 Little Papers, memorandum dated 1 Mar. 1946.

50 D/Finance, S 109/1/46, report dated 27 May 1946, considered by the Government on 4 June 1946.

51 *Ibid.*, paragraph 12.

52 *Ibid.*, paragraph 13.

53 *Ibid.*

54 *Ibid.*, report dated 30 May 1946.

55 *Ibid.*, memorandum titled 'National Arts Centre' and dated 17 June 1946.

56 *Ibid.*, note dated 30 May 1946.

57 *Irish Independent*, 23 May 1947, 'State Concert Hall to be erected'.

58  D/Finance, S 109/1/46, 24 May 1947.

59  *Ibid.*, Seán O'Grady to Lord Longford, 13 June 1947.

60  *Ibid.*, the meetings took place on 17 & 23 June 1947.

61  *Ibid.*, notes of meeting on 23 June 1947.

62  *Ibid.*, George Fagan, Commissioner, Office of Public Works, to J.E. Hanna, 23 Apr. 1948.

63  S.P.O., S 13773A, 17 Feb. 1947.

64  *Ibid.*, 9 Apr. 1947.

65  *Ibid.*, memorandum titled 'Cultural Publicity Abroad: Proposed Establishment of Advisory Committee', dated 2 June 1947.

66  *Ibid.*

67  S.P.O., G.C. 4/264, item 1, 6 June 1947.

68  *The Bell*, Vol. XIV, No. 4, July 1947. The verse was ascribed to 'Eusebius Cassidy'.

69  *Irish Press,* 25 June 1947.

70  *Dáil Debates*, Vol. 107, 24 June 1947, col. 41.

71  D/Finance, S 2/28/29, government decision, 20 Aug. 1946.

72  *Ibid.*, Second Interim Report of the Inter-Departmental Committee, 14 June 1947.

73  *Ibid.*, memorandum for government titled 'Proposed new Site for National Library', dated 20 June 1947.

74  *Ibid.*, T.J. Morris, Office of Public Works, to W. Sandys, 1 Aug. 1947.

75  *Ibid.*, Sandys to Morris, 1 Sept. 1947.

76  *Ibid.*, 23 Oct. 1947.

77  *Ibid.*, the Fitzwilliam representatives were Mr Justice Cahir Davitt, Mr J. Miley and Mr W. Sandys.

78  *Ibid.*, notes by D/Taoiseach, 14 Jan. 1948.

79  Little Papers, revised memorandum 'Proposed Council of Culture', January 1948.

## CHAPTER 5

1  *Ireland's Economy.* Radio Eireann talks on Ireland's part in the Marshall Plan (Dublin, 1949), p. 2.

2  *Ireland is Building* (Dublin, 1949). This was an interesting brochure compiled by the Department of Health in consultation with the Departments of Local Government and Social Welfare.

3  U.C.D. A., McGilligan Papers, P35 C/48, 23 Jan. 1949.

4  Patrick Lynch, 'The Irish Economy Since the War, 1946-51', in K.B. Nowlan & T. Desmond Williams (Eds.), *Ireland in the War Years and After 1939-51* (Dublin, 1969), p. 188.

5  Kieran A. Kennedy & Brendan R. Dowling, *Economic Growth in Ireland: The Experience Since 1947* (Dublin & New York, 1975), p. 212.

6  Lynch, *op. cit.*, p. 187.

7  *Ibid.*, p. 188.

8  Kieran A. Kennedy & Richard Bruton, *The Irish Economy* (Brussels, European Commission Study, March 1975), p. 129.

9  *Dáil Debates,* Vol. 123, 30 Nov. 1950, cols 1573-4 and 14 Dec. 1950, col. 2281.

10  Interview with Liam O'Leary, 14 Apr. 1984

11  The population numbered 2,960,000 in 1951, an increase of 5,486 or 0.2% on the 1946 figure. *Censuses of Population of Ireland 1946 to 1951. General Report* (Dublin, 1958), p. 16.

12  *Ibid.*, 51,000 males and 69,000 females emigrated 1946-51. The annual rate compared with 19,000 in the inter-censal period 1936-46.

13  *Irish Statistical Survey 1955* (Dublin, 1956), p. 32.

14  *Censuses 1946 and 1951*, p. 193.

15  *Ibid.*, pp 195-7.

16  *Ibid.*, p. 176.

17  T.J. Barrington, 'Whatever happened to Irish Government?', in Frank Litton (Ed.), *Unequal Achievement: The Irish Experience 1957-1982* (Dublin, 1982), p. 94.

18  Seán O Faoláin, 'Autoantiamericanism', *The Bell*, Vol. XVI, No. 6, Mar. 1951, p. 22.

19    John Ryan, 'The Young Writer', *The Bell*, Vol. XVII, No. 7, Oct. 1951, p. 22.

20    *Ibid., Remembering How We Stood* (Dublin, 1975), p. xiii.

21    Harold Pinter, *Mac* (Ipswich, 1968), p. 16.

22    Edward Sheehy, 'Recent Irish Painting: The Irish Exhibition of Living Art, 1950', *Envoy*, Vol. 3, No 10, Sept. 1950, pp 45-6.

23    See Rudi Holzapfel, 'A Survey of Irish Literary Periodicals from 1900 to the Present Day' (Unpublished M. Litt. thesis, T.C.D., 1964)

24    See Brian P. Kennedy, 'Seventy-five years of *Studies*', *Studies*, Vol. 75, No. 300, Winter 1986, pp 361-73.

25    *Irish Times*, 22 June 1950.

26    Fergus Murphy, *Publish or Perish* (Cork, 1951).

27    David Marcus, 'Seán O Riordáin: Modern Gaelic Poet', *Irish Writing*, No. 32, Autumn 1955, p. 44.

28    See Roibeárd O Faracháin, 'Some Early Days in Irish Radio', in Louis McRedmond (Ed.), *Written on the Wind*, pp 29-50.

29    Among the painters emerging at this time were Louis Le Brocquy, Patrick Scott and Colin Midleton; sculptors included Oisín Kelly and F.E. McWilliam.

30    See Niall Montgomery, 'Dublin's Central Bus Station', *Ireland of the Welcomes*, Vol. 5, No. 4, Nov.-Dec. 1956, pp 12-14; and Frank MacDonald, 'The Making of Busárus', *Irish Times*, 29 May 1984.

31    Cecil Ffrench Salkeld, 'The Cultural Texture of the Country', *The Bell*, Vol. XVI, No. 2, Nov. 1950 p. 23.

32    Brian Boydell, 'The Future of Music in Ireland', *The Bell*, Vol. XVI, No. 4, Jan. 1951, p. 21.

33    See Patrick Delany, 'A Concert Hall for Dublin', *The Bell*, Vol. XVII, No. 10, Jan. 1952, and replies to this article by Edgar M.Deale, James Chapman, Walter Beckett and Aloys Fleischmann in *The Bell*, Vol. XVII, No. 11, Feb. 1952, pp 16-23.

34    See Eric W. White, *The Arts Council of Great Britain*, chap. 12.

35    Compton MacKenzie, 'The Wexford Opera Festival Arts', *Ireland of the Welcomes*, Vol. 5, No. 3 Sept.- Oct. 1954, pp 6-7.

36    The others were Des Ffrench, James Liddy, Eugene McCarthy and Séamus O'Dwyer. Interview with Dr T.J. Walsh, 25 Mar. 1987.

37    See Eric Crozier, 'The Origin of Aldeburgh', in *Aldeburgh Anthology* (London, 1972).

38    *Irish Independent*, 10 Nov. 1951.

39    *Sunday Times*, 28 Oct. 1951.

40    *Boston Globe*, 13 Nov. 1951.

41    Eamonn O Gallchobhair, 'The Cultural Value of Festival and Feis', in Fleischmann, *Music in Ireland*, pp 211-2.

42    *Ibid.*, p. 212.

43    In the 25 year period, 1952-77, Ceol Chumann na nOg promoted more than 300 concerts for over 170,000 school children.

44    Interview with Joan Denise Moriarty, 24 Oct. 1987.

45    D/Finance, S 2/28/29, government decision, 16 Apr. 1948. Also D/Finance, S 102/4/47, J.E. Hanna to Chairman, Office of Public Works, 22 June 1948. In 1947 the D/Finance authorised the purchase of a house, 'Ardmore', and 16 acres of land at Stillorgan for £24,675, as a site for a new broadcasting studio. Following the government decision of 16 Apr. 1948, the studio was not built. The house and site were exchanged in 1955 for a 23 acre site at Montrose owned by University College, Dublin.

46    T.C.D., MS 7003/103a-183, correspondence between Bodkin and Costello. The first letter is dated 17 May 1926.

47    S.P.O., S 14922, 16 Aug. 1948.

48    T.C.D., MS 7003/122, 20 Aug. 1948.

49    S.P.O., S 9988, 30 Sept. 1948.

50    *Estimates for the Public Service 1948-49* (Dublin, 1948), p. 9.

51    S.P.O., S 14559A, Bodkin to Costello, 21 Dec. 1948.

52    *Ibid.*, 5 Mar. 1949.

53    *Ibid.*, 11 July 1949.

54    *Dáil Debates*, Vol. 117, 20 July 1949, cols 1370-1.

55    *Ibid.*, col. 1372.

56    S.P.O., S 14559A, 3 Oct. 1949.

57    Thomas Bodkin, *Report on the Arts in Ireland* (Dublin, 1951), p. 12.

58    *Ibid.*, pp 13-15.

59    *Ibid.*, pp 18-22.

60    *Ibid.*, p. 35.

61    *Ibid.*, p. 40.

62    *Ibid.*, pp 54-5.

63    *Ibid.*, p. 58.

64    *Ibid.*, pp 58-9.

65    *Ibid.*, p. 59.

66    *Ibid.*

67    T.C.D., MS 7003/156, 11 Nov. 1949.

68    S.P.O., S 14559A, Costello to Bodkin, 11 Nov. 1949. It was decided, for example, to delete the sentence criticising the National Museum for displaying 'the insightly umbrella presented by the boys of St Enda's to Patrick Pearse on his birthday, the necktie worn by Willie Pearse, and a couple of delf cups from which they drank tea at school'.

69    Bodkin, *Report,* p. 51.

70    *Ibid.*, p. 52.

71    *Ibid.*, p. 58.

72    S.P.O., S 14559A, Bodkin to the Earl of Rosse, 28 Nov. 1949. Bodkin was flattering Costello with intent because he sent the Taoiseach a copy of his letter!

73    *Dáil Debates*, Vol. 125, 24 Apr. 1951, cols 1292-3.

74    Bruce Arnold, 'Politics and the Arts in Ireland - the Dáil Debates', in Frank Litton (Ed)., *Unequal Achievement,* pp 281-97.

75    *Dáil Debates,* Vol. 125, 24 Apr. 1951, col. 1344.

76    S.P.O., S 14559A, 23 June 1950.

77    *Irish Times*, 5 Aug. 1950.

78    D/Finance, F 200/47/49; comments were submitted by the Minister for Agriculture (13 Feb. 1950), the D/Industry and Commerce (J.C.B. McCarthy, 22 Mar. 1950) and the D/Education (M. Breathnach to Secretary, D/Taoiseach, 6 Apr. 1950, attaching reports by Dr P. O'Connor, Dr J Raftery, Dr M. Quane and L. Gogan (about the National Museum), by Dr J. Burke (on art in the schools system), by M. Burke (regarding the National College of Art) and by Dr G. Furlong (about the National Gallery).

79    S.P.O., S 14559A, memorandum submitted by M/Agriculture, 13 Feb. 1950. Dillon's nominees for membership of the Arts Council were: Fr Senan (Editor, *The Capuchin Annual*), Miss Kitty McCormick, E.A. McGuire, John Burke, Thomas McGreevy, Con Curran, E. Richards-Orpen, P.J. Little T.D., Myles Dillon and Dr R.A. Stewart Macalister.

80    *Ibid.*, 3 Mar. 1950.

81    S.P.O., S 14922A, 22 Aug. 1950.

82    S.P.O., S 14559A, Bodkin to Arthur Cox, 26 May 1950.

83    *Ibid.*, 9 Aug. 1950.

84    S.P.O., S 14856A, 22 Aug. 1950.

85    S.P.O., S 14922A, 6 Sept. 1950. The speech was based on a draft by Thomas McGreevy, Director of the National Gallery, which had been amended by Dr Nicholas George Nolan, Assistant Secretary, D/Taoiseach. See *Irish Press,* 7 Sept. 1950.

86    Arnold, 'Politics and the Arts in Ireland', p. 285.

87    For a study of this subject, see Brian P. Kennedy, *Alfred Chester Beatty and Ireland 1950-68: A Study in Cultural Politics* (Dublin, 1988).

88    S.P.O., S 14922A, 24 Oct. 1950.

89      *Ibid.*, 14 Nov. 1950.

90      C.S. Andrews, *Man of No Property* (Cork, 1982), pp 119-20.

91      See Ronan Fanning, *The Irish Department of Finance 1922-58* (Dublin, 1978), chaps. 10 & 11, pp
        405-519.

92      *Dáil Debates,* Vol. 110, 9 Mar. 1948, col. 253.

93      Fanning, *op. cit.*, p. 466.

94      S.P.O., S 14922A, the final draft of the memorandum was prepared by McElligott.

95      *Ibid.*, memorandum titled 'Proposed Establishment of an Arts Council'.

96      D/Finance, F 200/42/50.

97      S.P.O., S 14922A.

98      T.C.D., MS 7003/175, 30 Nov. 1950.

99      *Irish Press,* 7 Dec. 1950.

100     *The Leader,* 'The State, The Arts and Public Expenditure', 16 Dec. 1950.

101     S.P.O., G.C. 5/230, item 3, 19 Dec. 1950.

102     S.P.O., S 15073A, 21 Dec. 1950.

103     *Ibid.*, 28 Dec. 1950.

104     T.C.D., MS 7003/184, 1 Jan. 1951.

105     T.C.D., MS 7003/185, 1 Jan. 1951.

106     *Irish Times,* 9 & 11 Jan. 1951; *Irish Press*, 12 Jan. 1951.

107     S.P.O., S 14922A, 29 Jan. 1951.

108     T.C.D., MS 7003/190, 16 Feb. 1951.

109     S.P.O., S 14922A, 21 Feb. 1951.

110     *Irish Press,* 27 Apr. 1951, 'Arts Bill causes anxiety: Gaelic League Proposal', and *Sunday Press*, 15 Apr.
        1951, 'Fine Arts Bill is now in danger: Taoiseach warns Gaelic League'.

111     S.P.O., S 14922B, minutes of meeting.

112     *Dáil Debates,* Vol. 125, 24 Apr. 1951, cols 1283-1349.

113     *Ibid.*, col. 1316.

114     *Ibid.*, col. 1286.

115     *Ibid.*, col. 1285.

116     *Ibid.*, col. 1290.

117     *Ibid.*, col. 1292.

118     *Ibid.*, col. 1300.

119     *Ibid.*, col. 1316.

120     *Ibid.*; it should not be thought that Moylan was a cultural ignoramus. In fact he was widely read and
        keenly interested in the arts. See Liam C. Skinner, *Politicians by Accident* (Dublin, 1946), pp 260-
        74, and León O Broin, *Just Like Yesterday,* pp 130-1.

121     *Ibid.*, col. 1318.

122     *Ibid.*, col. 1327.

123     *Ibid.*, col. 1333.

124     *Ibid.*, col. 1336.

125     *Ibid.*, col. 1339.

126     *Ibid.*, col. 1341.

127     *Ibid.*, col. 1342.

128     T.C.D., MS 7003/199a, Bodkin to Patrick Lynch, 25 Apr. 1951.

129     *Dáil Debates,* Vol. 125, 1 May 1951, cols 1717-37.

130     *Ibid.*, col. 1723.

131     *Ibid.*, col. 1723-4.

132     *Ibid.*, cols 1731-2.

133     *Ibid.*, col. 1732.

134     *Seanad Debates,* Vol. 39, 2 May 1951, cols 1033-87.

135     *Ibid.*, cols 1036-7.

136     *Ibid.*, col. 1044.

137     *Ibid.*, cols 1047-8.

138    *Ibid.*, col. 1051.
139    *Ibid.*, col. 1056.
140    *Ibid.*, col. 1058.
141    *Ibid.*, col. 1064.
142    *Ibid.*, col. 1065.
143    *Ibid.*, col. 1069.
144    *Ibid.*, col. 1074.
145    *Ibid.*, col. 1075.
146    *Acts of the Oireachtas, 1951*, pp 71-81.
147    D/Finance, F 200/47/49, McGartoll to Miss M. Breathnach, 30 May 1951.

CHAPTER 6

1      Ronan Fanning, *Independent Ireland,* p. 199.
2      C.E. 6, note by P.J. Little, 'Visit to Paris, 24 Sept. to 5 Oct. 1951'.
3      C.E. 8, 22 Oct. 1951.
4      S.P.O., S 15073A, 20 Oct. 1951. Costello advised Bodkin to lobby for the position: 'Perhaps if opportunity again offers your friend the A.B. [Archbishop] might put in another word' (T.C.D., MS 7003/211, 24 Oct. 1951). Bodkin had a friendly relationship with John Charles McQuaid, Catholic Archbishop of Dublin (T.C.D., MS 7003/ 654-73).
5      *Ibid.,* note by Maurice Moynihan, 25 Oct. 1951.
6      *Ibid.*, 22 Oct. 1951.
7      C.E. 1, 'Memorandum on Suggested Cultural Institute', 22 Oct. 1951.
8      *Ibid.*, Little's nominees were: Fr Hubert Quinn, O.F.M. (Chairman, Irish Manuscripts Commission), Dick Hayes, Fr O Floinn (Maynooth and *An Réalt*), An Seabhac, J.J. Robinson (Architect), John Maher (former Comptroller and Auditor General), Professor Liam O Briain (U.C.G.), E.A. McGuire and Daniel Corkery (U.C.C.).
9      C.E. 1, Moylan to Little, 17 Nov. 1951.
10     C.E. 1, Childers to Little, 27 Nov. 1951. Childers' nominees were: Michael Scott (Architect), Lord Longford, Seán O Riordáin (National Museum), R.R. Figgis, John Maher, W. Watt and Dr T.J. Walsh.
11     S.P.O. S 15073A, note by Maurice Moynihan, 30 Nov. 1951.
12     C.E. 25, minutes of meeting by Dr Seamus McHugo, D/Taoiseach, 1 Dec. 1951.
13     T.C.D., MS 7003/214, 31 Dec. 1951.
14     Interview with Dr O'Sullivan, 31 January 1987.
15     C.E. 9, Con Curran to P.J. Little, 31 Jan. 1951.
16     C.E. 4, minutes of Council meeting, 10 Jan. 1952.
17     *Irish Press,* 26 Jan. 1952.
18     *Ibid.*
19     *Ibid.*
20     *Dáil Debates*, Vol. 129, 5 Mar. 1952, col. 1498.
21     *Ibid.*, col. 1501.
22     *Ibid.*, cols 1507-8.
23     *Ibid.*, col. 1513.
24     Unsuccessful efforts were made to establish Local Advisory Committees in Dungarvan, Clonmel, Navan, Monaghan, Cashel, Tullamore and Kilkenny.
25     Examples include: 'Aim of Council of Fine Arts', *The Connaught Sentinel*, 5 Aug. 1952; 'Co-Ordination of Cultural Activity in Wexford', *The Echo,* 7 Feb. 1953; 'Discussions on Cultural Activities', *The Post* (Kilkenny), 30 Mar. 1955.
26     C.E. 52 (Architecture), C.E. 59 (Music), C.E. 62 (Drama). The Drama panel gives an idea of the quality of membership: Hilton Edwards, Lord Longford, Lennox Robinson, Ria Mooney, Gabriel Fallon, Professor Liam O Briain, Dermot Doolan, Denis O'Dea and J.I. Fanning.

27    Interview with Dr O'Sullivan, 31 Jan. 1987.

28    C.E. 58, Dr O'Sullivan to Secretary, Cork Advisory Group, 15 May 1957.

29    *The Echo* (Wexford), 7 Feb. 1953.

30    *Ibid.*

31    *Irish Times,* 'Art treasures in Limerick Exhibition', 27 May 1952.

32    *Kavanagh's Weekly,* 'Four Pillars of Wisdom', 19 Apr. 1952,

33    Examples include: *Cork Examiner,* 'The Intentions of the Arts Council', 10 Mar. 1952; *Irish Press,*
      'Save Historic Sites call: Arts Council chief opens drama week' (Scariff, County Clare), 24 Mar.
      1952; *Irish Independent,* 'Architect's told of Council's progress', 4 Dec. 1952; *Irish Times,* 'Public
      Bodies urged to foster art', 13 Mar. 1953; *Irish Catholic,* 'Art and Education', 19 Mar. 1953.

34    Interview with Dr O'Sullivan, 31 January 1987.

35    C.E. 3, Dr O'Sullivan to Secretary, Department of Posts and Telegraphs, 5 Aug. 1953.

36    C.E. 19, 'Agreed memorandum of meeting between the Taoiseach and representatives of the Arts
      Council'. 15 Jan. 1953.

37    Interview with Dr O'Sullivan, 31 Jan. 1987.

38    Arts Act, 1951, Section 3 (2).

39    C.E. 275, Council decision, 2 Mar. 1954. The grants were channelled through Foras Eireann which
      was founded in 1949 as an umbrella group of voluntary organisations. Foras Eireann arranged
      conferences on themes like adult education, rural depopulation, and the need for local museums.
      It was responsible for the Mrs George Bernard Shaw bequest. She died in 1943 leaving £94,000
      for cultural and educational purposes in Ireland (see *Irish Times,* 4 Dec. 1959, 'Foras Eireann: aid
      for rural Ireland'). In 1950 her husband, the writer and dramatist, left a third of his estate to the
      National Gallery of Ireland.

40    *Dáil Debates,* Vol. 147, 3 Nov. 1954, cols 309-32.

41    C.E. 526, P.J. Little to the Minister for Finance, 25 Sept. 1956.

42    *Irish Press,* 14 Apr. 1954.

43    *Ibid.*

44    C.E. 9, Manager, Shelbourne Hotel to Liam O'Sullivan, 16 Sept. 1952.

45    C.E. 9, e.g. Liam O'Sullivan to each Council member, 26 Mar. 1954.

46    Interview with Muriel Gahan, 23 Mar. 1987. See Muriel Gahan, 'This is how they happened', in
      Sheila Carton (Ed.), *Our Book:* Irish Country-women's Association Golden Jubilee 1910-1960
      (Dublin, 1960), pp 54-8.

47    See Donal J. Giltenan, 'P.E.N. comes', *Ireland of the Welcomes,* Vol. 2, No. 1, May-June 1953, pp
      22-5.

48    *Irish Press,* 21 July 1953, 'Art Congress Opened'. See James White, 'Art Critics' Congress', *Ireland of
      the Welcomes,* Vol. 2, No. 2, July-Aug. 1953, pp 17 & 26.

49    D/Finance, S 109/1/46, memorandum for government, 'Provision of Concert Hall', 7 Aug. 1951.

50    C.E. 27, Little to Seán MacEntee, 21 Feb. 1952.

51    *Ibid.,* memorandum titled 'Rotunda Buildings', 28 Aug. 1952.

52    *Ibid.,* Lemass to Little, 10 Sept. 1952.

53    *Ibid.,* E.A. McGuire to Secretary, D/Taoiseach, 15 Sept. 1952.

54    *Ibid.,* Little to MacEntee, 6 Oct. 1952.

55    D/Taoiseach, S 7918B, Moynihan to Little, 5 Dec. 1952.

56    Arts Act, 1951, Section 3 (4) (a).

57    D/Taoiseach, S 15424, Dr Nolan to Dr O'Sullivan, 31 Mar. 1953. The Order was titled 'Arts Act,
      1951, Additional Function Order, 1953'.

58    C.E. 27, 23 Apr. 1953.

59    D/Taoiseach, S 7918B, Moynihan to Little, 29 Apr. 1953.

60    C.E. 27, 1 May 1953.

61    *Irish Press,* 5 May 1953, 'Arts Council gives up Rotunda plan'.

62    C.F. 257, Goulding to Little, 4 Jan. 1954.

63    D/Finance, S 2/21/51, Dr O'Sullivan to O.P.W., 7 Jan. 1954.

64    C.E. 257, Dr O'Sullivan to Dr Nolan, 27 Feb. 1954.

65    *Ibid.*, 12 Apr. 1954.

66    *Ibid.*, four replies dated 15 Apr. 1954.

67    C.E. 31, Little to Costello, 16 Mar. 1955.

68    The Corporation made the offer in May 1953 but withdrew it soon after. In June 1955 they relented. See *Irish Independent*, 8 June 1955, 'Project taking Shape: Site Allotted for Concert Hall'.

69    *Irish Independent*, 10 Apr. 1956, 'Statement on Concert Hall Project' and *Irish Times*, 11 Apr. 1956, 'Only Capital in Europe without Concert Hall'.

70    D/Finance, S 109/1/46, O.J. Redmond, Secretary, D/Finance, to Secretary, D/Taoiseach, 14 May 1956.

71    Kennedy & Dowling, *Economic Growth in Ireland*, chap. 14, pp 214-30.

72    *Ireland of the Welcomes*, Vol. 1, No. 4, Nov.-Dec. 1952, p. 2.

73    S.P.O., S 15297A, John Leydon, Secretary, D/Industry and Commerce, to Maurice Moynihan, 29 Apr. 1952.

74    *Kavanagh's Weekly*, 14 June 1952.

75    C.E. 73, memorandum for government on 'The Proposed National Festival', written by Paddy Little and approved by the Arts Council, 25 Mar. 1952.

76    *Ibid.*, Moynihan to Little, 30 Apr. 1952.

77    *Irish Press*, 30 Oct. 1952.

78    *Ireland of the Welcomes*, Vol. 1, No. 6, Mar.-Apr. 1953, pp 14-15.

79    *Daily Mirror*, 9 Apr. 1953, 'General Hyacinth's "at home" runs riot'. Dublin Corporation replaced the Bowl of Light with an even more controversial structure which became known variously as 'The Thing', 'The Yoke', and 'The Tomb of the Unknown Tourist (or Gurrier)'. The Arts Council, the Royal Hibernian Academy and the Royal Institute of Architects in Ireland campaigned for its removal which took place eventually in 1961. See *Irish Press*, 19 Nov. 1953, 'Cascade Controversy may begin where Bowl of Light Tussle ends', and *Evening Press*, 7 Feb. 1961, '"The Thing" on the Bridge'.

80    *Evening Herald*, 28 Apr. 1953, 'Tóstal - Some Suggestions'.

81    For example, Cork launched an International Choral Festival during 'An Tóstal 1954' and an International Film Festival two years later. It should be noted that 'An Tóstal ' was retained as an annual festival in Drumshanbo, County Leitrim.

82    The Council's Annual Report for 1955/6 stated: 'The limitation as to finance is keenly felt and it is suggested that a larger expenditure of public money on cultural development constitutes an investment that will bring in a rich return, enhancing the national estate, attracting visitors and thus improving the valuable tourist traffic' (p. 8). This bland reasoning failed to impress the Government which, in 1956/7, cut the Council's grant by nearly £2,000.

83    C.E. 384, Council meeting with Dr Thomas Bodkin, 11 July 1955.

84    See *Irish Press*, 19 May 1952, 'Higher Artistic Quality of Goods' (speech by E.A. McGuire) and Muriel Gahan, 'Ireland's Country Crafts', *Ireland of the Welcomes*, Vol. 5, No. 3, Sept.-Oct. 1956 pp 12-15.

85    See *Irish Times*, 29 Sept. 1955, 'Importance of Art in Industry - P.J. Little' and C.E. 9, Liam O'Sullivan to Earl of Rosse, 7 Mar. 1953.

86    *Irish Independent*, 26 Oct. 1953, 'Development of Art in Industry Urged'.

87    *Irish Times*, 12 June 1954, 'Minister stresses task facing many Industrialists'.

88    *Irish Independent*, 23 Oct. 1954, 'Design Exhibition in Cork'.

89    *Irish Press*, 24 Mar. 1956; *Waterford News*, 20 Apr. 1956; *Cork Examiner*, 16 May 1956; *Limerick Leader*, 30 May 1956; and *Sligo Champion*, 14 July 1956.

90    T.C.D., MS 7003/227a, 21 Aug. 1954.

91    *Birmingham Post*, 24 Jan. 1955, 'Dublin revisited: The Mood of Disillusion' by 'A Dubliner'.

92    C.E. 365, Little to Daniel Corkery, 29 Nov. 1954. Little noted that the Council had agreed to Bodkin's appointment 'after very considerable discussion and certain misgivings were frankly expressed'.

93    C.E. 384, minutes of meeting on 6 Jan. 1955 attended by the Taoiseach, Thomas Bodkin, P.J. Little, E.A. McGuire and Dr O'Sullivan.

94 *Ibid.*, minutes of meeting on 16 Feb. 1956 attended by Thomas Bodkin, P.J. Little, Thomas McGreevy and Dr O'Sullivan.

95 *Ibid.*, memorandum in response to Bodkin's queries, undated.

96 C.E. 16, Council meeting, 14 June 1955. Kavanagh was paid £200 for the work which he called 'The Forbidden Plough'. The Council tried unsuccessfully to find an Irish publisher willing to undertake publication of the work without further Council subsidy. In 1959 the Council, at Kavanagh's request, returned the manuscript and surrendered the copyright to him.

97 C.E. 4, John A. Costello to P.J. Little, 11 Oct. 1956.

98 C.E. 19, report by Dr O'Sullivan, 1 Sept. 1956. Maurice Curtin, an official of the Department of External Affairs, had, in his spare time, helped Dr O'Sullivan to mount several exhibitions. It was hoped that he could be seconded to the Arts Council but the Taoiseach's Department refused to sanction the arrangement.

99 *Irish Independent,* 13 Apr. 1955. The two students who removed the painting were named later as William Fogarty and Paul Hogan.

100 C.E. 370, stencilled letter signed by Costello, June 1956.

101 *Evening Mail,* 6 June 1956, 'Art and Ourselves'.

102 *Irish Times,* 11 July 1956, 'Six M.P.s seek return of Lane Pictures'.

103 *Irish Press,* 3 July 1956, 'Lane Bequest causes clash in Commons'.

104 *Irish Press,* 9 Sept. 1959, 'British Gallery spokesman says settlement near'. See also *Irish Independent,* 20 Jan. 1961, 'The End of a Controversy'.

105 T.C.D., MS 7003/271, Costello to Bodkin, 16 Nov. 1956.

106 T.C.D., MS 7003/271a, Bodkin to Costello, 28 Nov. 1956.

107 T.C.D., MS 7003/272a, 3 Dec. 1956.

108 T.C.D., MS 7003/273a, 20 Dec. 1956.

109 Private source.

110 *Ibid.*

111 T.C.D., MS 7006/665, 24 Dec. 1956.

112 The membership of the second Arts Council was as follows. On 21 December 1956, Costello appointed to ordinary membership of the Council: Sir A. Chester Beatty, Dr Thomas McGreevy, John Maher, Niall Montgomery, Fr Donal O'Sullivan, S.J., and the Earl of Rosse. In January 1957, Muriel Gahan, Sir Basil Goulding, Dr R.J. Hayes and Dr G.A. Hayes-McCoy, were co-opted to the Council. Niall Montgomery resigned in January 1959 and was replaced by Soirle MacCana. In the same month, Michael Scott became a co-opted Council member. Seán O Faoláin resigned on 30 June 1959 and was replaced as Director by Mgr Pádraig de Brún on 1 November 1959. Mgr de Brún died on 5 June 1960. Fr O'Sullivan was appointed as Director and Dr C.S. 'Todd' Andrews was appointed as an ordinary member on 5 July 1960.

CHAPTER 7

1 *Irish Times,* 22 Dec. 1956, editorial headed 'The Arts Council'.

2 *Ibid.*, 29 Dec. 1956.

3 C.E. 384, memorandum on Council policy by Fr O' Sullivan in response to queries by Professor Bodkin, undated.

4 C.E. 553, 29 Dec. 1956.

5 C.E. 574, Earl of Rosse to Seán O Faoláin, 4 Mar. 1957.

6 C.E. 574, minutes of meeting, 6 Mar. 1957.

7 See Micheál O hAodha, 'Ireland's Amateur Drama', *Ireland of the Welcomes,* Vol. 6, No. 3, Sept.-Oct. 1957, pp 12-14.

8 *Irish Independent,* 20 Feb. 1959.

9 C.E. 560, 22 May 1957.

10 C.E. 598, Dr Nolan to Dr O'Sullivan, 15 June 1957.

11 *Ibid.*, Seán O Faoláin to Mervyn Wall, telegram, 15 June 1957.

12  *Ibid.*, Dr O'Sullivan to Dr Nolan, 28 June 1957. Wall (born 1908) was a prominent member of the literary scene in Dublin and was friendly with O Faoláin. He was educated at University College, Dublin, and worked for Radio Eireann. His novels which are satirical, humorous and poignant, include *The Unfortunate Fursey* (1946), *The Return of Fursey* (1948), *Leaves for the Burning* (1952) and *No Trophies Raise* (1956). See Thomas Kilroy, 'Mervyn Wall: The Demands of Satire', *Studies* Spring 1958; and Robert Hogan, *Mervyn Wall* (Lewisburg, 1972).

13  C.E. 587, Maurice Moynihan to Mervyn Wall, 19 July 1957.

14  C.E. 621, 18 Feb. 1958.

15  C.E. 14, O Faoláin to Secretary, D/Taoiseach, 13 Sept. 1958.

16  *Ibid.*, 16 Sept. 1958.

17  *Ibid.*, 20 Sept. 1958.

18  *Ibid.*, Dr Nolan to O Faoláin, 1 Oct. 1958.

19  C.E. 350, Council decision, 4 Jan. 1957.

20  C.E. 555, circular letter, 14 Mar. 1957.

21  See *Irish Press*, 27 Aug. 1957, 'Many rural advertising signs to go'; *Irish Times*, 27 Aug. 1957, 'Subtopia Limited'.

22  C.E. 555, Moran & Ryan., Solrs., to O Faoláin, 31 Aug. 1958.

23  *Ibid.*, O Faolain to Moran & Ryan, Solrs., 23 Sept. 1958.

24  *Irish Times*, 7 Oct. 1959, 'Advertising hoardings still deface countryside'.

25  *Ibid.*, 3 July 1957, 'No reprieve for Georgian houses'.

26  C.E. 578, Dr O'Sullivan to each Council member, 29 June 1957.

27  *Irish Press*, 8 Nov. 1957, '22 Nations show books in Dublin'.

28  C.E. 618, Council meeting, 12 Nov. 1957.

29  C.E. 747, Mervyn Wall to Mgr de Brún, 21 Oct. 1959.

30  C.E. 551, 29 Apr. 1958.

31  T.C.D., MS 6966/170, 17 Nov. 1958.

32  *Ibid.*, MS 6966/171, 22 Nov. 1958.

33  *Irish Press*, 2 July 1959, 'Seán O Faoláin for U.S. post'.

34  See Caroline Walsh, 'Joseph Sheridan Le Fanu and Dublin', *Irish Times*, 24 May 1977.

35  *Evening Press*, 28 Oct. 1959, 'New Home for the Arts'.

36  *Irish Times*, 7 July 1959, 'New Director appointed to Arts Council'.

37  *Ibid.*, 14 July 1959, 'Political Jobbery Alleged', and *Irish Independent*, 17 July 1959, 'New Director of Arts Council'.

38  See obituary articles, *Irish Independent, Irish Press* and *Irish Times*, 6 June 1960.

39  *Irish Times*, 6 July 1960, 'A New Director'.

40  C.S. Andrews, *Man of No Property*, p. 294.

41  Fr Michael Paul Gallagher, S.J., letter to the author, 8 May 1987.

42  *Dáil Debates*, Vol. 183, 19 July 1960, col. 1817.

43  *Ibid*, col. 1819.

44  *Ibid.*, col. 1825. See *Irish Press*, 20 July 1960, 'Taoiseach to move to improve industrial art'.

45  *Ibid.*, cols 1826-7.

46  C.E. 575, Mervyn Wall to Fr O'Sullivan, 13 Oct. 1960.

47  Interview with Mervyn Wall, 14 Feb. 1987.

48  C.E. 696, Macaulay to Secretary, Arts Council, 9 Oct. 1958. For obituary notices about Macaulay, see: *Irish Independent* and *Irish Times*, 9 Jan. 1964.

49  C.E. 15, 'Note for the Director' by Mervyn Wall, 5 June 1962.

50  *Ibid.*, Mervyn Wall to each Council member, 30 July 1962.

51  *Irish Independent*, 6 Mar. 1961, 'Gate Theatre to close this week'.

52  C.E. 91, Mervyn Wall's notes of telephone conversations with T.K. Whitaker and Brian Kissane, 24 May 1961.

53  C.E. 15, note by Mervyn Wall, 3 Dec. 1963.

54  C.E. 1005, 'Note for the Director' by Mervyn Wall, 15 May 1964.

55     C.E. 574, the total amount spent on all the arts by the Council from its foundation to 31 March 1960 was £128,239. The percentage of this amount spent on each category was as follows: painting 10.2%, sculpture 3.2%, architecture 2.6%, design 14.2%, fine and applied arts 2.6%, ballet 1.9%, music 22.6%, drama 30.6%, literature 1.8%, general festivals and exhibitions 4.8%, halls 5.5%.

56     Interview with Mervyn Wall, 6 Feb. 1988.

57     C.E. 574, 'Council's Future Financial Policy', 15 Nov. 1960.

58     C.E. 615, British Court of Appeal Decision, 21-27 July 1955. The Arts Council's exclusion of folk dancing did not pass unchallenged. The Gaelic League tried to mount a campaign in the media but it was unsuccessful. See *Irish Times,* 24 Sept. 1960, 'No Grant for Folk Dancing'.

59     *Help for the Arts,* London, The Gulbenkian Foundation, 1959.

60     C.E. 98, typescript of speech, 23 Nov. 1960.

61     The Director and ordinary members of the third Arts Council were appointed on 29 Nov. 1961. They were Fr O'Sullivan (Director), Dr C.S. Andrews, Sir Chester Beatty, Dr R.J. Hayes, Dr Thomas McGreevy, the Earl of Rosse and Michael Scott. The co-opted members appointed on 12 Dec. 1961 were Dr Brian Boydell, R.R. Figgis, Sir Basil Goulding, Conor A. Maguire and Terence de Vere White. Sir Chester Beatty resigned in 1962 and was replaced by John Hunt.

       The fourth Council appointed on 28 Nov. 1966 had one new member only, James Johnson Sweeney who replaced Dr R.J. Hayes. During this Council's term of office, Dr Thomas McGreevy died and was replaced by James White. Terence de Vere White resigned on 15 Mar. 1968 and was replaced by Professor George Dawson.

62     Terence de Vere White, letter to the author, 17 Mar. 1987. Michael Scott admitted in an interview with the author, 21 Mar. 1987: 'We ran the Council, Fr O'Sullivan and I'.

63     Interview with Brian Boydell, 18 Apr. 1987.

64     C.E. 866, minutes of Council meeting, 6 June 1961.

65     C.E. 1555, note by Mervyn Wall, 22 July 1974.

66     *Ibid.,* Mervyn Wall to J.C. Gargan, Secretary, E.S.B., 26 July 1961.

67     *Ibid.,* T.J. O'Driscoll, Director, An Bord Fáilte, to Fr O'Sullivan, 25 July 1961.

68     *Irish Times,* 4 Mar. 1965, 'Demolition work in Fitzwilliam Street begins'.

69     C.E. 901, J.B. Hynes to Fr O'Sullivan, 28 Feb. 1962.

70     *Ibid.,* handwritten note of the meeting by Fr O'Sullivan.

71     *Irish Times,* 5 May 1962, 'The Philistine's Day'.

72     *Dáil Debates,* Vol. 199, 23 Jan. 1963, col. 220.

73     C.E. 901, Fr O'Sullivan to J.B. Hynes, 5 Mar. 1963.

74     *Ibid.,* J.B Hynes to Fr O'Sullivan, undated.

75     *Ibid.,* Jack Lynch to Fr O'Sullivan, 8 Mar. 1963.

76     *Ibid.,* Council decision, 26 Mar. 1963.

77     C.E. 469, Dr Nicholas Nolan to Mervyn Wall, 23 Dec. 1960. Those appointed to the post of Exhibitions Officer during the 1960s were: Desmond Fennell (1961), Speer Ogle (1961-66), Martin Reynolds (1966-8), Liam O'Kelly (1968-9) and Oliver Dowling (1969-75).

78     See *The College Gallery,* 21st Anniversary Exhibition Catalogue, T.C.D., 3 June to 5 July 1980.

79     C.E. 926, C.S. Andrews to Mervyn Wall, 26 Mar. 1959.

80     For example 'Irish Sacred Art' held at the Council's Merrion Square premises in Feb. 1962, and 'Art in Worship Today' held at the Building Centre, Baggot Street, Dublin, in June 1967.

81     See *Irish Times,* 7 Jan. 1967 and *Irish Independent,* 12 Jan. 1967.

82     See Seán McCrum and Gordon Lambert (Eds), *Living with Art: David Hendricks* (Dublin, 1985).

83     Supportive editorials written by Terence de Vere White were published in the *Irish Times,* for example 'Living Monuments', 20 June 1962, and 'For Services Rendered', 10 Oct. 1962.

84     *Irish Press,* 4 Feb. 1966, 'Novelist Teacher Dismissed' and *Irish Times,* 7 Feb. 1966, 'Interview with John McGahern'.

85     The contributions to the Second Stage Dáil debate on the revised censorship of publications legislation provide a useful marker of the extent to which political attitudes had changed since the original legislation was introduced in 1926. See *Dáil Debates,* Vol. 228, 10 May 1967, cols 680-714.

86    C.E. 628, Council Resolution, 10 Dec. 1957: 'The Arts Council deplores the proposal to establish commercial television in Ireland and respectfully begs the Taoiseach to reconsider the matter'.

87    F.S.L. Lyons, *Ireland Since the Famine,* p. 692.

88    Charles McCarthy, *The Decade of Upheaval* (Dublin, 1973), p. 2.

89    Kieran A. Kennedy, *Productivity and Industrial Growth: The Irish Experience* (Oxford, 1971), p. 4.

90    David Thornley, 'Ireland: The End of an Era?', *Studies,* Spring 1964, pp 1-17.

91    D/Finance, S 2/6/58, Note by T.K. Whitaker, Secretary, D/Finance, following a meeting with Dr Ryan, 27 June 1960.

92    For a potted history of Ardmore Studios, see: Rockett, Gibbons & Hill, *Cinema in Ireland,* pp. 98-103.

93    *Design in Ireland* (Dublin, 1962), p. 49.

94    See *Irish Independent,* 3 Feb. 1962, 'Survey of Irish Design', and *Irish Press,* 3 Feb. 1962, editorial titled 'Industrial Design'.

95    *Dáil Debates,* Vol. 199, 31 Jan. 1963, col. 752.

96    See Nick Marchant and Jeremy Addis, *Kilkenny Design: twenty-one years of design in Ireland* (Kilkenny, 1984).

97    *Report of the Council of Design* (Dublin, 1967), p. 3.

98    *Ibid.,* pp 27-8. See *Irish Press,* 11 Feb. 1967, 'New College of Design and Art urged'.

99    N.G.I., unpublished annual reports, 1964-71. The annual attendance figure at the Gallery increased dramatically from 93,179 in 1967 to 324,573 in 1969 following the opening of the extension.

100   *Dáil Debates,* Vol. 199, 6 Feb. 1963, cols 1086-1104, and *Seanad Debates,* Vol. 56, 20 Feb. 1963, cols 319-40.

101   D/Finance, S 2/28/29, B. Fanning, Office of Public Works, to Secretary, D/Finance, 29 Aug. 1963.

102   *Ibid.,* S 2/32/46, note by M. Breathnach, 13 Dec. 1960.

103   *Irish Independent,* 28 Apr. 1961, 'R.D.S. may undertake building of a concert hall'.

104   *Irish Press,* 16 Jan. 1963, 'Government aid for concert hall'.

105   C.E. 31, minutes of meetings of the All-Party Committee. The Committee members were Dr James Ryan, Dr Patrick Hillery, Donogh O'Malley, Dr Noel Browne, Brendan Corish, Liam Cosgrave, Maurice Dockrell, Seán Dunne and Gerard Sweetman.

106   *Irish Press,* 10 Mar. 1963, 'Ambitious plans for J.F.K. Hall'.

107   *Sunday Independent,* 16 Jan. 1966, 'J.F.K. Concert Hall Shock'.

108   *Irish Times,* 18 Jan. 1966, 'In focus'.

109   For example, *Irish Independent,* 17 Sept. 1968, 'Kennedy Hall plans to be finished'.

110   D/Finance, F 78/1/58, Gerard Sweetman, Minister for Finance, to Ernest Blythe, Managing Director, Abbey Theatre. *Irish Times,* 28 Dec. 1954.

111   *Irish Times,* 22 Oct. 1958, 'New Abbey Theatre by end of 1960'.

112   D/Finance, F 78/1/58, J.W. Slemon, Secretary, Abbey Theatre, to Charles Haughey, Minister for Finance, 28 Oct. 1967.

CHAPTER 8

1    *Dáil Debates,* Vol. 227, 11 Apr. 1967, col. 1287.

2    C.E. 1148, Mervyn Wall's briefing for Arts Council meeting, 3 May 1967.

3    *Irish Independent,* editorial, 27 Jan. 1968.

4    *Irish Times,* 27 January 1968.

5    C.E. 1135, Michael Scott to Mervyn Wall, 'Proposal for an International Art Exhibition', 17 Feb. 1967.

6    *Ibid.*

7    Bruce Arnold, 'Shock for Irish Artists', *Sunday Independent,* 12 Nov.1967.

8    Martin Mansergh, *The Spirit of the Nation: the Speeches and Statements of Charles J. Haughey (1957-86)* (Cork and Dublin, 1986), pp 85-7.

9    C.E. 1135, 'Report on Rosc '67' by Michael Scott.

10 *Dáil Debates,* Vol. 231, 16 Nov. 1967, cols 382-9. Letters to the newspapers offered opinions ranging from 'Rosc is a practical joke in the worst taste' to 'Rosc is the best thing to happen to the country in years'.

11 C.E. 1116, Mervyn Wall to the Earl of Rosse, 21 Mar. 1968. See *Sunday Independent,* 17 Mar. 1968, 'Increased Arts Grants Forecast' and *Irish Times,* 18 Mar. 1968, 'Arts Cultivation - new scheme by Haughey'.

12 *Dáil Debates,* Vol. 234, 23 Apr. 1968, col. 65.

13 C.E. 15, note by Mervyn Wall, 21 Mar. 1968.

14 *Annual Report and Accounts of An Chomhairle Ealaíon for the period 1 April 1967 to 31 March 1968,* p. 1. See *Irish Press,* 31 Oct. 1968, 'Marked Progress in art since 1951'.

15 *Ibid.,* p. 2. See *Evening Press,* 30 Oct. 1968, 'Attack on mediocre Irish art'.

16 Interview with Michael Scott, 21 Mar. 1987.

17 C.E. 553, note by Mervyn Wall, 10 Apr. 1973.

18 *Ibid.*

19 Bruce Arnold, 'Battle Lines', *Contact,* No. 1, June 1968, p. 11.

20 Tony Butler, 'Solid Merits in Project Exhibition', *Evening Press,* 7 Aug. 1970.

21 C.E. 1116, Mervyn Wall to Arthur Cox & Co., 12 Aug. 1970.

22 *Ibid.,* note by Mervyn Wall, 18 Aug. 1970. C.S. Andrews and Conor Maguire were particularly incensed about the matter.

23 *Evening Press,* 21 Aug. 1970, 'The Arts Council'.

24 Charles Acton, 'The Arts and the Arts Council', *Eire-Ireland,* Vol. 111, No. 2, Summer 1968, p. 98.

25 John Boland, 'The Arts Council and its Critics', three part series, *Irish Times,* 17, 18 & 19 Mar. 1971.

26 For example, *Irish Press,* 30 Mar. 1968, a letter to the editor headed 'Women and the Arts Council', signed by 'A Feminist'.

27 See Gerard Victory, 'The World of O Riada', in Louis McRedmond (Ed.) *Written on the Wind,* pp 153-71, and Seán O Mordha, 'O Riada: the Man who Changed the Face of Irish Music', *Irish Times,* 20 Apr. 1987.

28 C.E. 553, Mervyn Wall to Secretary, D/Taoiseach, 9 Mar. 1966.
The following table illustrates the position clearly:

| County | 1961/2 | 1965/6 | County | 1961/2 | 1965/6 |
|---|---|---|---|---|---|
| | £ | £ | | £ | £ |
| Cavan | 75 | 85 | Longford | Nil | Nil |
| Clare | 85 | 400 | Mayo | 506 | 1117 |
| Donegal | 400 | Nil | Monaghan | Nil | Nil |
| Galway | 153 | 318 | Roscommon | 400 | Nil |
| Kerry | Nil | Nil | Sligo | 249 | 530 |
| Leitrim | Nil | Nil | West Cork | Nil | Nil |

29 Tony Butler, 'Arts Choice', *Evening Press,* 5 Sept. 1969.

30 T.G. Rosenthal, 'Jack B. Yeats 1871-1957', in *Modern Irish Painting* exhibition catalogue, p. 30. The exhibition included 56 paintings by 13 artists, 29 from the Arts Council's Collection and 27 borrowed from public and private collections in Ireland. It was shown in Goteborg, Norrkoping, Stockholm, Helsinki, Copenhagen, Bonn, Bielefeld, Saarbrucken, London, Leeds, Glasgow and Dublin.

31 *Dáil Debates,* Vol. 241, 29 Oct. 1969, cols 2011-2.

32 Interview with Mervyn Wall, 14 February 1987.

33 C.E. 1094, briefing note by Mervyn Wall for Council meeting, 27 Apr. 1966.

34 *Ibid.,* Council decision, 27 Apr. 1966.

35 *Ibid.,* briefing note by Mervyn Wall for Council meeting, 26 Oct. 1966.

36    *Ibid.*, Mervyn Wall to Sir Tyrone Guthrie, 28 Aug. 1968.

37    *Ibid.*, Sir Tyrone Guthrie to Mervyn Wall, 17 Apr. 1969.

38    *Ibid.*, Mervyn Wall to Sir Tyrone Guthrie, 16 May 1969.

39    *Ibid.*, Mervyn Wall to Messrs Kennedy Crowley & Co., 27 June 1969.

40    Sir Tyrone Guthrie died at Annaghmakerrig on 15 May 1971. The details of his will were announced on 1 July 1971. See *Irish Independent, Irish Press* and *Irish Times,* 2 July 1971.

41    C.E. 553, note by Mervyn Wall, 24 June 1970.

42    Des Hickey, 'Even I could be tax free says Haughey', *Sunday Independent,* 27 May 1973.

43    Mansergh, *The Spirit of the Nation,* pp 103-7.

44    *Dáil Debates,* Vol. 241, 15 July 1969, cols 509-10.

45    Anthony Butler, 'The Irish Art Scene', *Eire-Ireland,* Vol. IV, No. 3, Autumn 1969, p. 134.

46    Dr William O'Sullivan, the first Secretary of the Arts Council, was also a daily swimmer at the Forty Foot.

47    Interview with Mervyn Wall, 6 Feb. 1988.

48    C.E. 834, the principles were adopted at a special meeting of the Arts Council attended by Dr Seán Réamonn, 14 Nov. 1969. See Seán Réamonn, *History of the Revenue Commissioners* (Dublin, 1981), pp 175-9.

49    Marion MacDonald, 'The Haughey Scheme - Has it Helped?', *Irish Times,* 29 & 30 Nov. 1972.

50    *Ibid.*

51    *Irish Press,* editorial, 'Past, Present and Future', 28 Nov. 1969. The editorial was prompted by Charles Haughey's speech at the unveiling of a sculpture by Edward Delaney in the First National City Bank, Dublin.

52    John Armstrong, 'Art Patronage and Irish Industry', *Irish Times,* 8 Sept. 1971.

53    *Report of the Public Services Organisation Review Group 1966-1969* (Dublin, 1969), Chapter 27, 'Department of National Culture', pp 311-17.

54    *Irish Press, Irish Independent* and *Irish Times,* 21 Nov. 1969.

55    *Irish Times,* 11 Sept. 1969.

56    Bruce Arnold, 'Irish Culture in the '60s', *Nusight Magazine,* December 1969, pp. 61-4; John Horgan, 'Maecenas 1970?', *Irish Times,* 1 Jan. 1970; John Armstrong, 'Government promises of financial assistance not yet acted upon', *Irish Times Annual Review,* 31 Dec. 1971.

57    Interview with Bob Whitty, 11 Feb. 1987.

58    *Irish Times Annual Review,* 31 Dec. 1971.

59    *Dáil Debates,* Vol. 248, 9 July 1970, col. 862.

60    *Ibid.*, col. 863.

61    Interview with Bob Whitty, 11 Feb. 1987.

62    Bruce Arnold, 'Flaws in Arts Council', *Irish Independent,* 11 July 1970; Tony Butler, 'Irish Art: Darkness and Light', *Eire-Ireland,* Vol. V, No. 3, Autumn 1970, pp 110-17.

63    *Irish Press,* 28 Oct. 1970, 'Arts Council Chairman to resign'. See also Bruce Arnold, 'Exciting Exhibition', *Irish Independent,* 31 Oct. 1970, and Tony Butler, 'An Insult to Our Artists', *Evening Press,* 6 Nov. 1970.

64    The Director and Ordinary Members of the Fifth Council were appointed on 5 July 1971. They were: Fr O'Sullivan, Director, and C.S. Andrews, John Hunt, the Earl of Rosse, Michael Scott, James Johnson Sweeney, and James White. The co-opted members appointed on 5 Jan. 1972 were Brian Boydell, George Dawson, R.R. Figgis, Sir Basil Goulding and Conor Maguire (who died on 26 Sept. 1971).

65    Bruce Arnold, 'End of the Project Gallery', *Irish Independent,* 24 Jan. 1970.

66    Rosc '71 was a successful exhibition but did not attract quite the same numbers of visitors as the first Rosc in 1967. The visitor numbers at Rosc '71 were 20,310 adults and 18,796 school children. See Christopher Fitzsimon, 'Report on Rosc '71', 31 Oct. 1973, and Hilary Pyle, 'Rosc '71', *Ireland of the Welcomes,* Vol. 20, No. 1, May-June 1971, pp 19-29.

67    *The Irish Imagination 1959-1971* (Dublin, 1971), p. 7.

68    *Irish Press,* 30 Nov. 1971, 'Attack on Arts Council: Position not Healthy'.

69    Kerry McCarthy, 'Why the young Irish painters are bitter', *Irish Independent,* 2 Dec. 1971.

70    Bruce Arnold, 'Class Bigotry in Dublin Art', *Irish Independent,* 8 Aug. 1970.

71    Brian Fallon, 'Blueprint for a New-Style Arts Council', *Irish Times,* 11 Aug. 1970.

72    C.E. 1292, note by Mervyn Wall of telephone conversation with Mr Cuddihy, Principal Officer, Department of Education, 20 Apr. 1971. See Lelia Doolan, 'Art as Revolution', *Irish Press,* 25 Nov. 1970.

73    *Seanad Debates,* Vol. 71, 10 Nov. 1971, col. 1135.

74    *Ibid.,* col. 1141.

75    *Ibid.,* cols 1155-66.

76    *Ibid.,* 11 Nov. 1971, col. 1186.

77    Michael Kane, letter to the editor, *Irish Press,* 2 Apr. 1973.

78    *Irish Independent,* 30 Nov. 1971, 'Artist hits at Arts Council'.

79    C.E. 553, Mervyn Wall to C.S. Andrews, 10 Dec. 1970.

80    C.E. 1399, draft Annual Report and Accounts, 1971/2, 3 May 1972.

81    C.E. 1403, Professor George Dawson to Fr O'Sullivan, 13 June 1972.

82    *Irish Times,* 30 Mar. 1973, 'Bill to reorganise Arts Council'.

83    C.E. 553, D. O Súilleabháin, Secretary, D/Taoiseach, to Mervyn Wall, 16 Apr. 1973. Letter marked 'confidential'.

84    *Ibid.,* Mervyn Wall to Secretary, D/Taoiseach, 2 May 1973.

85    C.E. 1375, Council decision, 3 October 1973. The press release was issued on 8 Nov. 1973.

86    *Dáil Debates,* Vol. 268, 17 Oct. 1973, cols 33-83.

87    *Ibid.,* col. 75.

88    *Ibid.,* cols 33-5.

89    *Irish Times,* 13 & 14 July 1972. See also Mansergh, *The Spirit of the Nation,* pp 164-72.

90    Mansergh, *The Spirit of the Nation,* p. 165.

91    *Dáil Debates,* Vol. 268, 17 Oct. 1973, cols 62-3.

92    *Ibid.,* col. 66.

93    *Ibid.,* col. 71.

94    *Dáil Debates,* Vol. 268, 23 Oct. 1973, col. 337.

95    *Seanad Debates,* Vol. 76, 14 Nov. 1973, col. 15.

96    *Ibid.*

97    *Ibid.,* col. 22.

98    *Ibid.,* col. 24.

99    *Ibid.,* col. 33.

100   See Rockett, Gibbons & Hill, *Cinema and Ireland,* pp 102-3.

101   *Seanad Debates,* Vol. 76, 14 Nov. 1973, col. 35.

102   *Ibid.,* col. 47.

103   *Ibid.,* 11 Dec. 1973, cols 170-240, and 12 Dec. 1973, cols 297-324.

CHAPTER 9

1    The members of the sixth Arts Council were: Professor Geoffrey Hand (Chairman), Kathleen Barrington, John Behan, Brian Boydell, Tom Caldwell, George Collie, Máire de Paor, Andrew Devane, Seamus Heaney, John B. Keane, Seamus Murphy, Eilis Dillon, Brian Quinn, Richard Stokes, T.J. Walsh and James White. George Collie resigned in 1974 and was replaced by Patsy Lawlor. Professor Hand was replaced in 1975 by Patrick Rock. Seamus Murphy died on 2 Oct. 1975. John B. Keane resigned in 1975. The consequent vacancies were filled by J.B. Kearney and Hugh Maguire. See *Irish Times,* 31 Dec. 1973.

2    See Mavis Arnold, 'Geoffrey Hand - the quiet man of letters', *Irish Tatler and Sketch,* May 1975.

3    C.E. 553, 'Position Paper on the activities of the previous five Councils for the information of the sixth Council', 1 Mar. 1974.

4    C.E. 1403, 'Plan for future activities', 1 Mar. 1974.

5    *Evening Press,* 29 Nov. 1974, 'A New Guard at the Arts Council'.

6   See for example interviews with James White, *Irish Times,* 24 Jan. 1976; Hugh Maguire, *Irish Times,* 5 June 1976; Patsy Lawlor, *Irish Times,* 18 Sept. 1976; John Behan, *Irish Times,* 15 Jan. 1977; and Seamus Heaney, *Irish Press,* 24 Jan. 1979.

7   *The Arts Council Annual Report 1974,* p. 16.

8   Brian Fallon, 'More about the Arts Council', *Irish Times,* 30 & 31 Jan. 1974.

9   Interview with Brian Boydell, 18 Apr. 1987.

10  C.E. file A 58, press release, 19 Nov. 1975.

11  Des Hickey, 'Young Man with £1 million to spend', *Sunday Independent,* 18 Jan. 1976.

12  See for example: Fanny Feehan, 'New Man at the Arts Council', *Hibernia,* 4 Apr. 1975; Elgy Gillespie, 'Colm O Briain', *Irish Times,* 4 Feb. 1975; and Deirdre Younge, 'The Arts Council: Work in Progress', *Hibernia,* 18 Feb. 1977.

13  C.E. file A 51, and interview with Colm O Briain, 9 Jan. 1988.

14  *Irish Times,* 25 Mar. 1975, 'European University Chair for Irishman'.

15  Mary Anderson, 'Interview with Patrick Rock', *Evening Herald,* 4 July 1975.

16  *The Arts Council Annual Report for year ended 31 December 1975,* introduction by Patrick Rock, p. 5.

17  *Irish Times,* 19 Dec. 1975.

18  C.E. file A 1, Liam Cosgrave to Professor Hand, 5 Mar. 1975.

19  Interview with Bob Whitty, 11 Feb. 1987.

20  See Ralph Hewins, *Mr Five Per Cent: the Biography of Calouste Gulbenkian* (London, 1957).

21  The organisations which received grants from the Gulbenkian Foundation included the Wexford Festival, Trinity College Gallery, Irish Theatre Ballet, Cork University Press, Dolmen Press, and the New Irish Chamber Orchestra.

22  The members of the consultative committee were: Desmond Clarke, Gabriel Fallon, Christopher Fitzsimon, Dr Joseph Groocock, Cecil King, David Marcus, Seán O Mordha and Michael Scott.

23  *Evening Press,* 30 Jan. 1976, *Irish Times* and *Irish Press,* 31 Jan. 1976.

24  Charles Acton, *Irish Times,* 11 Feb. 1976; Mary MacGoris, *Irish Independent,* 18 & 20 Feb. 1976; and Fanny Feehan, *Hibernia,* 27 Feb. 1976.

25  J.M. Richards, *Provision for the Arts* (Dublin, 1976), p. 93.

26  *Ibid.,* p. 11.

27  *The Arts Council Annual Report 1976,* p. 7.

28  *Ibid.*

29  *Writers in Schools: 1979-80,* Dublin, 1979. The scheme was organised on a pilot basis at first for schools in the Mid-West region (Clare, Limerick and North Tipperary). From January 1979 the scheme was on offer to schools throughout Ireland under the sponsorship of An Chomhairle Ealaíon and the Arts Council of Northern Ireland.

30  C.E., file A 25/77, press release, 1 Nov. 1978.

31  *Arts Council Annual Report 1977,* p. 7.

32  *Irish Independent,* 24 Nov. 1977, 'Boost the arts like industry 20 years ago - Council'.

33  C.E. file A 19, press release, 1 Apr. 1977.

34  *Arts Council Annual Report 1977,* p. 5.

35  *Ibid.*

36  See catalogues of the following retrospective exhibitions (catalogue author's name in brackets): Nano Reid (Jeanne Sheehy), Colin Midleton (John Hewitt), Patrick Collins (Frances Ruane), John Luke (John Hewitt), Tony O'Malley (Brian Fallon), William Scott (Ronald Alley and T.P. Flanagan), Gerard Dillon (James White), Tom Carr (T.P. Flanagan).

37  *Irish Press,* 21 Apr. 1978, 'Arts Councils at Historic Milestone'. See also *Irish News,* 22 Apr. 1978 and *Irish Independent,* 25 Apr. 1978.

38  *Irish Times,* 9 Jan. 1976.

39  *Cork Examiner,* 10 Jan. 1976. See also Michael Brophy, 'One Man's fight for a Georgian heritage', *Irish Independent,* 16 Jan. 1976.

40  *Irish Press,* 17 Jan. 1976.

41  *Irish Times,* 21 Jan. 1976.

42  See Colm Rapple, 'A stench of peat in Pembroke Street', *Sunday Independent,* 15 Feb. 1976; *Sunday Press,* 7 Mar. 1976, 'Rebels with a cause'; *Munster Express,* 30 Apr. 1976, 'Significance of University students' action'.

43  *Irish Times,* 27 Apr. 1976.

44  *Cork Examiner,* 27 Apr. 1976.

45  *Evening Press,* 2 Sept. 1976, 'Irish artists' haven rapped'.

46  C.E., file A 12, 8 Sept. 1978.

47  C.E., file A 25/77, press release, 1 November 1978. *Irish Press,* 2 Nov. 1976, 'State support for arts inadequate'.

48  Sarah Hamilton, 'Arts Council danger signs', *Sunday Press,* 12 Nov. 1978.

49  John Stephenson, 'Radical change needed for Arts Council', *Hibernia,* 30 Nov. 1978.

50  The Seventh Arts Council was appointed on 22 Dec. 1978. Those appointed were: James White (Chairman), Kathleen Barrington, Brian Boydell, Máire de Paor, Andrew Devane, Bridget Doolan, J.B. Kearney, Hugh Maguire, Louis Marcus, Seán O Tuama, Donald Potter, Nora Relihan, Michael Scott, Richard Stokes, T.J. Walsh and James Warwick. Brendan Adams was appointed on 31 Jan. 1980. He died in Oct. 1981. The following members resigned: Hugh Maguire and Louis Marcus in Dec. 1981, Seán O Tuama in Jan. 1981, Bridget Doolan in Sept. 1982. Replacement appointments were made as follows: Robert Ballagh, Brian Friel, Proinsias MacAonghusa and Patrick Murphy were appointed in June 1982, and Arthur Gibney in Dec. 1982.

51  *Arts Council Annual Report 1978,* p. 8.

52  The recipient organisations were: the Abbey, Gaiety, Olympia and Focus Theatres and the Project Arts Centre, Dublin; Cork Opera House and the Irish Ballet Company, Cork; Druid Theatre, Galway; and Wexford Festival Opera.

53  Interview with Colm O Briain, 9 Jan. 1988. In 1978, David Kavanagh was appointed as Arts Council Administration Officer. In March 1979, Laurence Cassidy was appointed as Literature Officer. The following appointments were announced in May 1979: Arthur Lappin, Drama Officer; Marion Creely, Music Officer; Adrian Munnelly, Education Officer; Medb Ruane and Patrick Murphy, Visual Arts Officers. In 1980 Paddy Glackin was appointed to the post of Traditional Music Officer.

54  Interview with Richard Stokes, 4 Feb. 1987.

55  Interview with Brian Boydell, 18 Apr. 1987.

56  Ciarán Benson's post was funded by the Gulbenkian Foundation. The members of the working party were: Seán O Tuama (Chairman), Brian Boydell, John Coolahan, George Dawson, Bridget Doolan, Joe Dowling, Alice Hanratty, Seamus Heaney, Peter Killian, Pádraig MacDiarmada, Diarmaid O Donnabháin, Colm O Briain and Cathal O Neill.

57  *White Paper on Educational Development,* p. 64.

58  *Ibid.,* p. 65.

59  *Ibid.*

60  *Arts Council Annual Report 1980,* p. 43.

61  *Ibid,* p. 47.

62  Interview with Laurence Cassidy, 21 Aug. 1987.

63  C.E., file A 19, press release, 12 Feb. 1980.

64  *Living and Working Conditions of Artists* (Dublin, 1980).

65  Arts Act, 1951 (Additional Function) Order, 1980.

66  Interview with Colm O Briain, 9 Jan. 1988. See also *Soundpost,* July 1983, 'The Creative Collective'.

67  *Aosdána* (Arts Council, Dublin, 1987),

68  Interview with Colm O Briain, 9 Jan. 1988.

69  Bernard Levin, 'The nicest bandwagon you ever saw', *The Times,* 18 Mar. 1981. See also: *Irish Press,* 7 Mar. 1981, 'Out of the Garret'; *The Guardian,* 7 Mar. 1981, 'State wage for 150 artists'; *The Sunday Times,* 15 Mar. 1981; 'How Ireland puts its artists on the payroll'.

70  *Irish Times,* 6 Nov. 1982, 'Arts Council backs Aosdána'.

71    *Arts Council Annual Report 1980*, p. 7.

72    *A Sense of Ireland* (Dublin, 1980), p. 14.

73    Colm O Briain, 'Will it always be Catch 22 for the Arts?', *Irish Press*, 27 Jan. 1981.

74    *Arts Council Annual Report 1981*, pp 7-8.

75    *Ibid.*, p. 37.

76    For a consideration of the advantages and disadvantages of a Ministry of Culture, see: Augustin Girard, 'The Choice: Arts Council or Ministry of Culture?', in Elizabeth Sweeting (Ed.), *Patron or Paymaster? The Arts Council Dilemma* (Gulbenkian Foundation, London, 1982).

77    Interview with Colm O Briain, 9 Jan. 1988.

78    *Arts Council Annual Report 1982*, p. 16.

79    *In Dublin,* 31 Mar. 1982, 'Under the Bridge'.

80    *Sunday Press*, 18 Apr. 1982, 'Angry Artists'.

81    Interview with James White, 23 Feb. 1988.

82    See *Sunday Press*, 25 Apr. 1982, 'Who's behind it?'; *Irish Press,* 30 Apr. 1982, 'The Crisis facing the Arts'; *Evening Herald,* 8 May 1982, 'Arts Council members hit back'.

83    Emmanuel Kehoe, 'The Council strikes back', *Sunday Press,* 2 May 1982.

84    *Irish Times* and *Cork Examiner*, 29 Apr. 1982.

85    C.E., file A 12, aide memoire on discussion at Arts Council meeting, May 1982.

86    C.E., file A 18, James White to Anthony Cronin, 5 May 1982.

87    *Ibid.*, Anthony Cronin to James White, 5 May 1982.

88    *Arts Council Annual Report 1982*, p. 6.

89    *Ibid.*

## EPILOGUE

1    *Arts Council Annual Report 1982*, p. 5.

2    *Audiences, Acquisitions and Amateurs* (Dublin, March 1983), a commentary by Richard Sinnott and David Kavanagh.

3    Chris Sparks, 'Art for Whose Sake?', *The Phoenix,* 1 Apr. 1983.

4    Paula McCarthy-Panczenko, 'Irish Museums Trust Training Course in Arts Administration' (Irish Museums Trust, Dublin, 1982).

5    *Arts Council Annual Report 1983*, p. 46.

6    *Public and Private Funding of the Arts*, Vol. 1: Report (49-1), Eighth Report of the House of Commons Education, Science and Arts Committee (H.M.S.O., London, 1982).

7    John Kenneth Galbraith, 'Economics and the Arts' (Arts Council of Great Britain, London, 1983).

8    *A Sense of Ireland* (Dublin, 1980), p. 35.

9    *Irish Times*, 15 Apr. 1983.

10   C.E., file A 19, press statement, 6 May 1983. See: *Irish Press,* 7 May 1983, 'O Briain leaves Arts Council'; *Sunday Independent,* 8 May 1983, 'More money for arts plea by O Briain'; *Sunday Tribune,* 8 May 1983, 'It was his creation so who follows Colm'.

11   Interview with Colm O Briain, 9 Jan. 1988.

12   *Arts Council Annual Report 1983*, p. 6.

13   C.E., file A 19, speech by Máirtín McCullough, Druid Theatre, Galway, 5 Sept. 1984.

14   *Ibid.*, speech by Adrian Munnelly, 'Arts in the Regions' seminar, Killarney, 30 Sept. 1983.

15   Bairbre Power, 'Seeking 50% hike on £4.5m. for Arts', *Irish Independent,* 3 Nov. 1983.

16   C.E., file A 100, Adrian Munnelly to Senator Katherine Bulbulia, 25 May 1984.

17   The members of the Eighth Arts Council were: Máirtín McCullough (Chairman), John Banville, Vivienne Bogan, Breandán Breathnach, David Byers, Patrick Dawson, Máire de Paor, Bríd Dukes, Vincent Ferguson, Mairéad Furlong, Gary Hynes, Barry McGovern, Patrick Murphy, Eilis O'Connell, Seán O Mordha, Michael Smith and Michael Taylor. Breandán Breathnach died on 6 Nov. 1985. Tom Munnelly was appointed on 17 Feb. 1986. Eilis O'Connell resigned on 21 May 1986. Rosemarie Mulcahy was appointed in Aug. 1986.

18   C.E., file A 19, speech by Máirtín McCullough, Druid Theatre, Galway, 5 Sept. 1984.

19   *Ibid.*, press release, 14 Sept. 1984.

20   C.E., file A 18, minutes of Council meeting, 10 Oct. 1984.

21   C.E., file A 25/1984, minute 4 of Council meeting, 11 Dec. 1985.

22   *Ibid.*, minute 2 of Council meeting, 20 Dec. 1985.

23   *Ibid.*

24   *Arts Council Annual Report 1984*, p. 7.

25   *Ibid.*

26   *Arts Council Annual Report 1985*, p. 35. See Donald Herron, *Deaf Ears* (Arts Council, Dublin, 1985).

27   *Ibid.*, p. 34.

28   C.E., file A 12, press release, 11 September 1986.

29   *Ibid.*, minutes of Arts Council meeting, 15 Jan. 1986.

30   *Access and Opportunity: A White Paper on Cultural Policy* (Dublin, 1987), p. 21.

31   *Ibid.*, p. 13.

32   *Irish Times*, 20 Nov. 1987.

33   Ciarán Carty, *Sunday Tribune,* 22 Nov. 1987.

34   *Tax and the Artist* (Dublin, 1986).

35   John W. O'Hagan & Christopher T. Duffy, *The Performing Arts and the Public Purse: an Economic Analysis* (Dublin, 1987).

36   *Dáil Debates,* Vol. 384, 29 Nov. 1988, col. 1978.

37   The members of the ninth Arts Council are: Dr Colm O hEocha (Chairman), Dermot Bolger, Michael Colgan, Máire de Paor, Bríd Dukes, Arthur Gibney, Patrick Hall, Charles Hennessy, Ted Hickey, Richard Kearney, Proinsias Mac Aonghusa, Larry McCluskey, Paul McGuinness, Micheál O Siadhail, Donnie Potter, Eric Sweeney and Kathleen Watkins.

1951.]                    *Arts Act, 1951.*                    [*No.* **9.**]

---

*Number* 9 *of* 1951.

---

## ARTS ACT, 1951.

---

AN ACT TO STIMULATE PUBLIC INTEREST IN, AND TO PROMOTE THE KNOWLEDGE, APPRECIATION, AND PRACTICE OF, THE ARTS AND, FOR THESE AND OTHER PURPOSES, TO ESTABLISH AN ARTS COUNCIL, AND TO PROVIDE FOR OTHER MATTERS IN CONNECTION WITH THE MATTERS AFORESAID.

[*8th May*, 1951.]

BE IT ENACTED BY THE OIREACHTAS AS FOLLOWS :—

**1.**—In this Act—                                        Definitions.

the expression " the arts " means painting, sculpture, architecture, music, the drama, literature, design in industry and the fine arts and applied arts generally ;

the expression " the Council " means the body established by section 2 of this Act.

**2.**—(1) On the passing of this Act there shall by virtue of this subsection stand established a body to be called An Chomhairle Ealaíon to fulfil the functions assigned to them by or under this Act.                                    Establishment of An Chomhairle Ealaíon.

(2) The provisions of the Schedule to this Act shall have effect in relation to the Council.

**3.**—(1) The Council shall, by such means and in such manner as they think fit,—                                Functions of the Council.

(*a*) stimulate public interest in the arts,

    (*b*) promote the knowledge, appreciation and practice of the arts,

    (*c*) assist in improving the standards of the arts,

    (*d*) organise or assist in the organising of exhibitions (within or without the State) of works of art and artistic craftsmanship.

(2) The Council shall advise the Government or a member of the Government on any matter (being a matter on which knowledge and experience of the arts has a bearing) on which their advice is requested.

(3) The Council may co-operate with and assist any other persons concerned directly or indirectly with matters relating to the arts, and the assistance may include payments by the Council upon such terms and conditions as they think fit.

    (4) (*a*) The Government may from time to time by order confer or impose on the Council such additional functions as the Government think proper and specify in the order, and any order made under this paragraph may contain such incidental and supplementary provisions as the Government think necessary or expedient for giving full effect to the order.

       (*b*) The Government may by order revoke or amend any order made under this subsection (including this paragraph).

       (*c*) An order under this subsection shall not come into operation unless it is confirmed by resolution of each House of the Oireachtas, but shall, as from the date of the passing of the later of those resolutions, have statutory effect.

**4.**—The Council may accept gifts of money, land and other property for purposes connected with their functions, but shall not accept any gift if the conditions attached thereto are inconsistent with their functions. *Acceptance of gifts by the Council.*

**5.**—(1) There shall be paid to the Council annually out of moneys provided by the Oireachtas a grant of such amount as the Taoiseach shall determine. *State endowment of the Council*

(2) Any grant made to the Council under subsection (1) of this section shall, subject to paragraphs 3 and 8 of the Schedule to this Act, be expended by them for such purposes connected with their functions as in their discretion they think fit.

**6.**—(1) The Council shall keep accounts of their income and expenditure in such form as may be approved by the Minister for Finance.

*Accounts and audit.*

(2) The accounts of the Council shall be submitted annually by the Council to the Comptroller and Auditor General for audit at such time as the Minister for Finance may direct.

(3) An abstract of the accounts of the Council for each year, when audited, together with the report of the Comptroller and Auditor General on the accounts, shall be presented to the Government, and copies thereof shall be laid before each House of the Oireachtas.

**7.**—(1) The Council shall present to the Government annually a report of their proceedings during the previous year, and a copy thereof shall be laid before each House of the Oireachtas.

*Reports.*

(2) The Council shall furnish to the Government such information with regard to the exercise of their functions as the Government may from time to time require.

**8.**—This Act may be cited as the Arts Act, 1951.

*Short title.*

## SCHEDULE.

*Section 2(2).*

### PROVISIONS APPLICABLE TO THE COUNCIL.

1. The Council shall by the name assigned to them by section 2 of this Act be a body corporate with perpetual succession and an official seal (which shall be judicially noticed) and power to sue and be sued in that name and to acquire, hold and dispose of land and other property.

*Incorporation of the Council.*

2. The Council shall consist of the following members:—

*Membership.*

   (*a*) a member, who shall be called An Stiúrthóir, or (in the English language) the Director, appointed under paragraph 3 of this Schedule,

(*b*) six members (in this Schedule referred to as ordinary members) appointed under paragraph 4 of this Schedule, and

(*c*) such number of members (in this Schedule referred to as co-opted members) as may be co-opted under paragraph 5 of this Schedule.

3. (1) The Director shall be appointed by the President.     The Director.

(2) The remuneration, tenure of office and other conditions of service of the Director shall be such as the Government shall determine on the occasion of his appointment.

(3) The Government, with the consent of the Director for the time being, may from time to time alter all or any of the following, namely, the remuneration, tenure of office and other conditions of service for the time being applicable to him as the Director.

(4) The remuneration of the Director shall be paid by the Council out of their funds.

4. (1) The Government shall, in the year 1951 and in each fifth     Ordinary successive year thereafter, appoint six persons to be ordinary mem-     members. bers, and the term of office of every person so appointed shall commence on the day next following the date of his appointment.

(2) Every ordinary member appointed under subparagraph (1) of this paragraph shall, unless he sooner dies or resigns, hold office until the expiration of the day on which the Government next appoint, in pursuance of that subparagraph, six persons to be ordinary members.

(3) Whenever an ordinary member dies or resigns, the Government shall, as soon as conveniently may be, appoint a person to be an ordinary member, and the person so appointed shall, unless he sooner dies or resigns, hold office until the expiration of the day on which the Government next appoint, in pursuance of subparagraph (1) of this paragraph, six persons to be ordinary members.

(4) An ordinary member whose term of office expires by effluxion of time shall be eligible for re-appointment.

(5) No remuneration shall be payable to ordinary members.

5. (1) The co-opting body for the purposes of this paragraph and paragraph 6 of this Schedule shall consist of the following members :— <span style="float:right">Co-opted members.</span>

(a) the Director, who shall be the chairman thereof, and

(b) the ordinary members.

(2) (a) The co-opting body may from time to time at any of their meetings co-opt persons to be co-opted members, but shall so exercise this power that the number of co-opted members for the time being holding office is not more than five.

(b) Every question at a meeting of the co-opting body shall be determined by a majority of the votes of the members present and voting on it and, in the case of an equal division of votes, the Director shall have a second or casting vote.

(c) The quorum for a meeting of the co-opting body shall be three, of whom the Director shall be one.

(3) Every person who is co-opted as a co-opted member shall, unless he sooner dies or resigns, hold office until the date on which the term of office of the persons holding office as ordinary members at the time of his co-option expires, but shall on the expiration of that term be eligible for co-option for a further term.

(4) No remuneration shall be payable to co-opted members.

6. The Council may out of their funds, if they think fit, reimburse any member of the Council for any actual out-of-pocket expenses incurred by him as a member of the Council or of the co-opting body. <span style="float:right">Reimbursement of expenses.</span>

7. (1) At a meeting of the Council— <span style="float:right">Procedure of the Council.</span>

(a) the Director, if present, shall be the chairman of the meeting,

(b) if and so long as the Director is not present or if the office of Director is vacant, the members of the Council who are present shall choose one of their members to be the chairman of the meeting.

(2) Every question at a meeting of the Council shall be determined by a majority of the votes of the members present and voting on it and, in the case of an equal division of votes, the chairman of the meeting shall have a second or casting vote.

(3) The quorum for a meeting of the Council shall be five.

(4) The Council may act notwithstanding a vacancy in their membership.

(5) Subject to this paragraph, the Council shall by standing orders or otherwise regulate their procedure and business.

8. (1) The Council may appoint or engage such and (subject to the approval of the Taoiseach) so many officers and servants as they think fit. **Officers and servants of the Council.**

(2) Every officer and servant appointed or engaged by the Council shall be paid by the Council out of their funds such remuneration and shall hold his office or engagement by such tenure and on such conditions as they, with the approval of the Taoiseach, shall determine.

(3) Section 4 of the Civil Service Regulation Act, 1924 (No. 5 of 1924), shall not apply in relation to an appointment or engagement under this paragraph.

9. The Council shall provide and have a common seal and such seal shall be authenticated by the signature of the Director or some other member of the Council authorised by the Council to act in that behalf and by the signature of an officer of the Council authorised by them to act in that behalf. **Seal of the Council.**

[1973.]                    *Arts Act*, 1973.                    [*No* **33.**]

---

*Number* 33 *of* 1973

---

**ARTS ACT, 1973**

---

AN ACT TO AMEND AND EXTEND THE ARTS ACT, 1951.
[24*th December*, 1973]
BE IT ENACTED BY THE OIREACHTAS AS FOLLOWS:

**1.**—In this Act "the Principal Act" means the Arts Act, 1951.     Interpretation.

1951, No. 9.

**2.**—(1) The Council shall consist of a chairman (subsequently in     Membership
this Act referred to as the Chairman) and such number (not being     of Council.
more than sixteen) of other members as the Taoiseach shall from
time to time determine.

(2) In the selection of persons for appointment to membership of
the Council regard shall be had to—

   (*a*) the person's attainments or interest in or his knowledge of
        the arts, or his competence otherwise to assist the Council,

   (*b*) securing a balanced representation as between branches of
        the arts.

**3.**—(1) The Chairman shall be appointed by the Taoiseach.     Chairman.

(2) The Chairman shall be appointed for such term as shall be
determined by the Taoiseach on the occasion of his appointment and
shall be paid, out of moneys at the disposal of the Council, such
remuneration and allowances as the Taoiseach, after consultation
with the Minister for Finance, may determine.

(3) The Chairman may resign his office as chairman by letter
addressed to the Taoiseach and the resignation shall take effect on
being accepted by the Taoiseach.

(4) When the Chairman ceases during his term of office as chairman to be a member of the Council, he shall also then cease to be Chairman.

**4.**—(1) The term of office as a member of the Council of every person who on the appropriate day is such a member shall cease on the expiration of that day.

<div style="float:right">Cesser of terms of office of certain members of Council.</div>

(2) In this section " the appropriate day " means the day which next precedes the day on which the terms of office of the persons appointed in 1973 pursuant to paragraph 4 (1) (*a*) of the Schedule to the Principal Act (inserted therein by section 13 of this Act) are to commence.

**5.**—The Council shall from time to time appoint, on such terms and conditions as they shall determine and subject to the approval of the Taoiseach, a person to be the chief executive officer of the Council, and such person shall be known as and is, both in this Act and in the Schedule to the Principal Act (as amended by this Act), referred to as the Director.

<div style="float:right">Director.</div>

**6.**—(1) When a member of the Council is nominated either as a candidate for election to either House of the Oireachtas or as a member of Seanad Éireann, he shall thereupon cease to be a member of the Council.

<div style="float:right">Membership of either House of Oireachtas by member of Council.</div>

(2) A person who is for the time being entitled under the Standing Orders of either House of the Oireachtas to sit therein shall, while so entitled, be disqualified from becoming a member of the Council.

**7.**—A member of the Council shall be disqualified from holding and shall cease to hold office as such member if he is adjudged bankrupt or makes a composition or arrangement with creditors, or is sentenced by a court of competent jurisdiction to suffer imprisonment or penal servitude.

<div style="float:right">Disqualification of member of Council.</div>

**8.**—(1) The Council may perform any of their functions through or by the Director or any of their other officers or servants.

<div style="float:right">Performance of functions of Council by officers and servants, etc.<br>1956, No. 45.</div>

(2) The Civil Service Commissioners Act, 1956, and the Civil Service Regulation Acts, 1956 and 1958, shall not apply to an appointment as officer or servant of the Council.

**9.**—(1) Where the Director or any other officer or any servant in the employment of the Council. becomes a member of either House of the Oireachtas—

(*a*) he shall during the period (in this section referred to as the secondment period) commencing upon his becoming entitled under the Standing Orders of that House to sit therein and ending either when he ceases to be a member of that House, or, if it should sooner happen, upon his resignation or retirement from such employment or upon the termination of such employment by the Council, stand seconded from such employment,

(*b*) he shall not be paid by, or entitled to receive from, the Council any remuneration in respect of the secondment period.

(2) A person who is for the time being entitled under the Standing Orders of either House of the Oireachtas to sit therein shall, while so entitled, be disqualified from becoming the Director or any other officer or a servant of the Council.

*Membership of either House of Oireachtas by officer or servant of Council.*

**10.**—(1) As soon as may be after the passing of this Act the Council shall prepare and submit to the Taoiseach a contributory scheme or schemes for the granting of pensions, gratuities and other allowances on retirement to or in respect of their whole-time officers and servants (including the Director).

(2) Every such scheme shall fix the time and conditions of retirement for all persons to or in respect of whom pensions, gratuities or allowances on retirement are payable under the scheme, and different times and conditions may be fixed in respect of different classes of persons.

(3) The Council may at any time prepare and submit to the Taoiseach a scheme amending a scheme previously submitted and approved under this section.

(4) A scheme submitted to the Taoiseach under this section shall, if approved of by him after consultation with the Minister for Finance, be carried out by the Council in accordance with its terms.

(5) If any dispute arises as to the claim of any person to, or the amount of, any pension, gratuity or allowance payable in pursuance of a scheme under this section, such dispute shall be submitted to the Taoiseach who after consultation with the Minister for Finance shall determine it and whose decision shall be final.

*Superannuation of officers and servants of Council.*

(6) Every scheme submitted and approved of under this section shall be laid before each House of the Oireachtas as soon as may be after it is approved of and if either House, within the next twenty-one days on which that House has sat after the scheme is laid before it, passes a resolution annulling the scheme, the scheme shall be annulled accordingly, but without prejudice to the validity of anything previously done thereunder.

**11.**—(1) The Council may establish any or all of the following : Advisory Committees.

    (*a*) a committee to advise on painting, sculpture and architecture,

    (*b*) a committee to advise on music,

    (*c*) a committee to advise on the drama, literature and the cinema.

(2) A committee established pursuant to this section (in this section subsequently referred to as an advisory committee) shall advise the Council on any matter (being a matter on which knowledge and experience of a branch of the arts in relation to which the advisory committee is established has a bearing) on which their advice is requested.

(3) An advisory committee shall consist of a Chairman, who shall be a person who is for the time being a member of the Council, and eight ordinary members and, subject to subsection (7) of this section, the members of the advisory committee shall hold office for such term as shall be determined by the Council on the occasion of their appointment.

(4) In appointing members of an advisory committee the Council shall, so far as practicable, ensure that the committee is representative of the interest throughout the State in the branch or branches of the arts, as the case may be, in relation to which the committee is established.

(5) The Council may fill a casual vacancy occurring amongst the members of an advisory committee.

(6) Where a person who is chairman of an advisory committee ceases during his term of office as such chairman to be a member of the Council he shall also cease to be a member of the advisory committee.

(7) Each of the members of an advisory committee shall cease to hold office on the day which precedes the day on which the Taoiseach next makes appointments under paragraph 4 (1) (*a*) of the Schedule to the Principal Act.

(8) The Council may at any time—

(*a*) remove a member of an advisory committee from office,

(*b*) dissolve an advisory committee.

**12.**—(1) A local authority for the purposes of the Local Government Act, 1941, may assist with money or in kind or by the provision of services or facilities (including the services of staff) the Council, or any person organising an exhibition or other event the effect of which when held would, in the opinion of the authority, stimulate public interest in the arts, promote the knowledge, appreciation and practice of the arts, or assist in improving the standards of the arts.

<div style="float:right">Assistance by<br>local authority<br>to Council and<br>certain other<br>persons.<br>1941, No. 23.</div>

(2) Assisting under this section shall be a reserved function.

(3) In this section " reserved function " means—

(*a*) with respect to the council of a county or an elective body for the purposes of the County Management Acts, 1940 to 1972, a reserved function for the purposes of the County Management Acts, 1940 to 1972,

(*b*) with respect to the corporation of a county borough, a reserved function for the purposes of the Acts relating to the management of the county borough.

**13.**—(1) Section 1 of the Principal Act is hereby amended by the insertion of " the cinema," after " drama,".

<div style="float:right">Amendment of<br>Principal<br>Act.</div>

(2) Section 3 (1) of the Principal Act is hereby amended by the insertion of " within or without the State " after " as they think fit,".

(3) Section 5 (1) of the Principal Act is hereby amended by the insertion of " , after consultation with the Minister for Finance," after " the Taoiseach ".

(4) The Schedule to the Principal Act is hereby amended by—

(*a*) the substitution of the following subparagraphs for subparagraphs (1), (2) and (3) of paragraph 4:

" (1) (*a*) The Taoiseach shall, in the year 1973 and in each fifth successive year thereafter, appoint on a particular day not more than sixteen persons to be members of the Council, and the terms of office of the persons appointed hereunder on a particular day shall each simultaneously commence on such subsequent day as shall be fixed for that purpose by the Taoiseach and specified in each of the appointments.

*b*) In case the Taoiseach when making appointments pursuant to clause (*a*) of this subparagraph appoints to be members of the Council less than sixteen persons, he may within the appropriate period appoint persons to be members of the Council, provided that the appointments made pursuant to this clause shall not in any particular such period be greater in number than that by which sixteen exceeds the number of persons appointed pursuant to the said clause (*a*) last before the period commenced.

(2) Subject to the provisions of this Act and of the Arts Act, 1973, every member appointed under subparagraph (1) of this paragraph shall, unless he sooner dies or resigns, hold office until the beginning of the day on which the terms of office of the persons next appointed pursuant to clause (*a*) of that subparagraph are to commence.

(3) Where a casual vacancy occurs in the membership of the Council the Taoiseach shall, as soon as conveniently may be, appoint a person to fill the vacancy and a person appointed pursuant to this subparagraph to membership of the Council shall hold office for the remainder of his predecessor's term.";

(*b*) the substitution of " members other than the Chairman " for " ordinary members " in paragraph 4 (5);

(*c*) the insertion of the following new subparagraphs after subparagraph (5) of paragraph 4 :

" (6) A member of the Council may resign his office as such member by letter addressed to the Taoiseach and the resignation shall take effect on being accepted by the Taoiseach.

(7) The Taoiseach may remove a member of the Council from office.

(8) In this paragraph ' the appropriate period ' means the period beginning on the day fixed by the Taoiseach when making appointments under subparagraph (1) (*a*) of this paragraph as that on which the terms of office of the persons then appointed are to commence and ending on the day which precedes the day on which the Taoiseach next makes appointments under that subparagraph.";

(*d*) the substitution of the following paragraph for paragraph 6:

" Expenses

6. (1) A member of the Council, other than the Chairman, shall be paid out of the funds at the disposal of the Council, such allowances in respect of expenses as the Taoiseach, after consultation with the Minister for Finance, may determine.

(2) The Council may out of their funds, if they think fit, reimburse any member of an advisory committee established pursuant to section 11 of the Arts Act, 1973, for any out-of-pocket expenses incurred by him as a member of the Committee.";

(*e*) the insertion of " (in addition to the Director) " after " servants " in paragraph 8 (1);

(*f*) the substitution of " (including the Director) and every servant " for " and servant " and the insertion of " and allowances " and " given after consultation with the Minister for Finance " after "remuneration " and " the Taoiseach ", respectively, in paragraph 8 (2); and

(*g*) the substitution of " Chairman " for " Director " in each place where that word occurs in paragraphs 7 and 9.

**14.**—(1) In paragraph (*d*) of section 3 (1) of the Principal Act " (within or without the State) " is hereby repealed.

*Repeals.*

(2) The following provisions of the Schedule to the Principal Act are hereby repealed, namely, paragraphs 2, 3 and 5, subparagraph (3) of paragraph 8, and " ordinary " in subparagraph (4) of paragraph 4.

**15.**—(1) This Act may be cited as the Arts Act, 1973.

(2) The Principal Act and this Act may be cited together as the Arts Acts, 1951 and 1973, and shall be construed together as one Act.

*Short title. collective citation and construction*

| Financial Year | Grant-in-Aid | % Increase (Decrease in Grant-in-Aid on previous year, adjusted for inflation | Notes |
|---|---|---|---|
| | £ | | (i) In 1974 the Financial Year of the Arts Council was adjusted from an April to March basis to a January to December format. |
| 1951-3 (15 mths) | 11,642 | – | |
| | (= 9,314 for 12 months) | | (ii) In 1976, the Arts Council was given £742,000 to take on responsibility for the funding of five arts organisations previously funded by the Department of Finance. These were the Abbey and Peacock Theatre, the Irish Theatre Company, the Gate Theatre, the Dublin Theatre Festival and the Irish Ballet Company. The real % increase in the Arts Council's grant-in-aid for 1976 is shown in brackets. |
| 1953-4 | 11,400 | 19.4% | |
| 1954-5 | 19,150 | 67.6% | |
| 1955-6 | 18,889 | (-5.5%) | |
| 1956-7 | 17,000 | (-12.2%) | |
| 1957-8 | 20,000 | 12% | |
| 1958-9 | 20,000 | (-2.7%) | |
| 1959-60 | 20,000 | (-1.7%) | (iii) In 1979 an agreement was reached between the Arts Council and Bord Fáilte to transfer to the Council certain arts funding which had previously been the responsibility of Bord Fáilte. Funding to the value of £150,000 was transferred as a result. |
| 1960-61 | 20,000 | (-2.7%) | |
| 1961-2 | 30,000 | 47.4% | |
| 1962-3 | 30,000 | -3.6%) | |
| 1963-4 | 35,000 | 12.5% | |
| 1964-5 | 40,000 | 5.1% | |
| 1965-6 | 40,000 | (-3.2%) | |
| 1966-7 | 40,000 | (-3.9%) | (iv) In 1987, the Arts Council's grant-in-aid was reduced and, in compensation, substitute funding of £1,800,000 was allocated to the Council from the proceeds of the National Lottery Fund. |
| 1967-8 | 60,000 | 47.4% | |
| 1968-9 | 60,000 | (-5.4%) | |
| 1969-70 | 70,000 | 9.4% | |
| 1970-71 | 70,000 | (-10%) | |
| 1971-2 | 80,000 | (-3.4%) | |
| 1972-3 | 85,000 | (-2.2%) | (v) In 1988, as in the previous year, the Arts Council received substitute funding of £1,800,000. |
| 1973-4 | 100,000 | 5.4% | |
| (i) 1974 (9 mths) | 113,000 | | |
| | (= 150,667 for 12 months) | 36% | |
| 1975 | 200,000 | 13.7% | |
| (ii) 1976 | 990,000 | 376.1% (+24%) | |
| | (+ 248,000) | | |
| 1977 | 1,200,000 | 7.5% | |
| 1978 | 1,565,000 | 21.8% | |
| (iii) 1979 | 2,340,000 | 35.4% | |
| 1980 | 3,000,000 | 9.2% | |
| 1981 | 3,750,000 | 4.9% | |
| 1982 | 4,082,000 | (-8%) | |
| 1983 | 4,954,000 | 10.6% | |
| 1984 | 5,193,000 | (-3.6%) | |
| 1985 | 5,695,000 | 4.6% | |
| 1986 | 5,936,000 | 0.1% | |
| (iv) 1987 | 4,999,000 | 9.4% | |
| | (+ 1,800,000) | | |
| (v) 1988 | 4,799,000 | (-5.1%) | |
| | (+ 1,800,000) | | |

| Name | Appointed | Ceased Membership |
|---|---|---|
| Patrick J. Little (Director) | 1951 | 1956 |
| Alfred Chester Beatty | 1951 | 1962 |
| Mgr Padraig de Brun (Director) | 1951 | 1956 |
|  | 1959 | 1960 |
| John Maher | 1951 | 1961 |
| The Earl of Rosse | 1951 | 1973 |
| Thomas McGreevy | 1951 | 1967 |
| Muriel Gahan | 1952 | 1961 |
| Senator Edward A. Maguire | 1952 | 1956 |
| Professor Dónal O Corcora | 1952 | 1956 |
| Professor Seamus O Duilearga | 1952 | 1956 |
| Dr Seán O Faoláin (Director) | 1956 | 1959 (resigned) |
| Niall Montgomery | 1956 | 1959 (resigned) |
| Fr Donal O'Sullivan, S.J. (Director) | 1956 1960 | 1973 |
| Sir Basil Goulding, Bart. | 1957 | 1973 |
| Dr G.A. Hayes-McCoy | 1957 | 1961 |
| Soirle MacCana | 1959 | 1961 |
| Michael Scott | 1959 1978 | 1973 1983 |
| Dr C.S. Andrews | 1960 | 1973 |
| Conor A. Maguire | 1961 | 1971 |
| Terence de Vere White | 1961 | 1968 (resigned) |
| R.R. Figgis | 1961 | 1973 |
| Dr Brian Boydell | 1961 | 1983 |
| John Hunt | 1962 | 1973 |
| James Johnson Sweeney | 1967 | 1973 |
| Dr James White (Chairman) | 1967 1978 | 1983 |
| Professor George Dawson | 1968 | 1973 |
| Professor Geoffrey Hand (Chairman) | 1973 | 1975 |
| Kathleen Barrington | 1973 | 1983 |
| John Behan | 1973 | 1978 |
| Tom Caldwell | 1973 | 1978 |
| George Collie | 1973 | 1974 (resigned) |
| Máire de Paor | 1973 |  |
| Andrew Devane | 1973 | 1983 |
| Seamus Heaney | 1973 | 1978 |
| John B. Keane | 1973 | 1975 (resigned) |
| Dr Seamus Murphy | 1973 | 1975 |
| Eilis Dillon | 1973 | 1978 |
| Seán O Tuama | 1973 | 1981 (resigned) |
| Brian Quinn | 1973 | 1978 |
| Richard Stokes | 1973 | 1983 |
| Dr T.J. Walsh | 1973 | 1983 |
| Patsy Lawlor | 1974 | 1978 |
| Dr J.B. Kearney | 1975 | 1983 |
| Hugh Maguire | 1975 | 1981 (resigned) |
| Patrick J. Rock (Chairman) | 1975 | 1978 |
| Bridget Doolan | 1978 | 1982 (resigned) |
| Louis Marcus | 1978 | 1981 (resigned) |
| Donald Potter | 1978 1988 | 1983 |
| Nora Relihan | 1978 | 1983 |
| James Warwick | 1978 | 1983 (resigned) |
| Brendan Adams | 1978 | 1981 |
| Robert Ballagh | 1982 | 1983 |
| Brian Friel | 1982 | 1983 |
| Arthur Gibney | 1982 1988 | 1983 |
| Proinsias MacAonghusa | 1982 1988 | 1983 |
| Patrick J. Murphy | 1982 |  |
| Máirtín McCullough (Chairman) | 1984 | 1988 |
| Michael Smith | 1984 | 1988 |
| Vincent Ferguson | 1984 | 1988 |
| Seán O Mordha | 1984 | 1988 |
| Gary Hynes | 1984 | 1988 |
| Breandán Breathnach | 1984 | 1985 |
| John Banville | 1984 | 1988 |
| Michael Taylor | 1984 | 1988 |
| Mairéad Furlong | 1984 | 1988 |
| Bríd Dukes | 1984 1988 | 1988 |
| Patrick Dawson | 1984 | 1988 |
| Eilis O'Connell | 1984 | 1986 (resigned) |
| Barry McGovern | 1984 | 1988 |
| Vivienne Bogan | 1984 | 1988 |
| David Byers | 1984 | 1988 |
| Tom Munnelly | 1986 | 1988 |
| Professor Colm O hEocha (Chairman) | 1988 |  |
| Dermot Bolger | 1988 |  |
| Michael Colgan | 1988 |  |
| Patrick Hall | 1988 |  |
| Charles Hennessy | 1988 |  |
| Ted Hickey | 1988 |  |
| Dr Richard Kearney | 1988 |  |
| Larry McCluskey | 1988 |  |
| Paul McGuinness | 1988 |  |
| Mícheál O Siadhail | 1988 |  |
| Eric Sweeney | 1988 |  |
| Kathleen Watkins | 1988 |  |

| Name | Appointed | *Ceased Membership* |
|------|-----------|---------------------|
| **Secretaries/Directors** | | |
| Dr Liam O'Sullivan (Secretary) | 1951 | 1957 |
| Mervyn Wall (Secretary) | 1957 | 1975 |
| Colm O Briain (Director) | 1975 | 1983 |
| Adrian Munnelly (Director) | 1983 | |

**Synopsis**

1.  **NOTE ON SOURCES**

2.  **PRIMARY SOURCES:**

    (a)  Manuscript material.

    (b)  Printed material:

        i.    Newspapers and other periodicals

        ii.   Official publications

        iii.  Arts Council publications

        iv.   Exhibition catalogues

        v.    Annual reports.

    (c)  Interviews.

3.  **SECONDARY SOURCES**

    (a)  Biographical and reference works.

    (b)  Unpublished theses.

    (c)  Books.

    (d)  Articles and pamphlets.

## 1. NOTE ON SOURCES

A history of the development of official arts policy in independent Ireland must rely heavily on the availability of the relevant government files and of the files of the Arts Council. While there is extreme reluctance to release files on politically sensitive issues such as defence and security, the relative official indifference towards the arts makes for easy availability of source material. The attitude of the Arts Council towards the release of material is open and progressive, a historian's delight.

The files of the Arts Council were the single most important source of material in the preparation of this study. Dr Liam O'Sullivan, Mervyn Wall and David McConnell deserve credit for maintaining the Arts Council's excellent filing system over the years since its foundation in 1951. Consequently, the Arts Council's files provide a wealth of information about the history of each of the arts and of the development of arts policy. There are 1,600 files for the period from 1951 to 1975 and some 10,000 files for the period since 1975. All the pre-1975 files were examined systematically over a period of nine months. 300 of the post-1975 files from the general A (Administration) series were also examined. The vast majority of all the Arts Council's files refer to grant applications by individuals or groups. For this reason and for brevity's sake, the bibliography lists approximately 90 of the most valuable files only.

Government files were consulted at the State Paper Office. Individually, the files provided valuable information while, collectively, they demonstrated the development of arts policy. The files of the Department of Finance were especially instructive. The views of Finance officials were the most substantial obstacle to State expenditure on the arts in the early decades of independence. Since the 1950s, however, there has been a growing acceptance of State funding of the arts by the Department's senior officials.

The private correspondence of Thomas Bodkin (Trinity College, Dublin and the National Gallery of Ireland) and the papers of Patrick J. Little (Sandyford, Co Dublin) were essential because they included certain

documentation which was, at times, more indicative of what was really happening at political and official level than was apparent from government files. The papers of Thomas McGreevy (Trinity College, Dublin and the National Gallery of Ireland), Alfred Chester Beatty (Chester Beatty Library, Dublin, and the National Gallery of Ireland), Count Plunkett (National Library of Ireland), Patrick McGilligan and Cearbhall O Dálaigh (University College, Dublin) were useful for information on particular issues.

Newspapers are an essential resource for any near-contemporary research. They were consulted regularly as were the official reports of the parliamentary debates of the Irish Dáil and Seanad. The debates have a time-capsule effect which permits the close study of the development of political attitudes to the arts. Official publications, like parliamentary debates, offered bench-marks of the successes and failures of old policies and the hopes and aspirations for new policies. The publications of the Arts Council had a similar effect and were important particularly for the post-1975 period.

Irish periodicals are an under-utilised source of facts, observations and commentary. They were used extensively. Over 160 exhibition catalogues were consulted but only those directly relevant to the text have been cited in the bibliography. The Annual Reports of the Arts Council were important and oft-used sources of reference. The Annual Reports of the Arts Council of Northern Ireland, the Arts Council of Great Britain, the Cultural Relations Committee of the Department of External Affairs (Foreign Affairs), the Department of Education, the National Museum and the National Library of Ireland, were used for information and comparative purposes.

Recorded interviews and correspondence with influential figures in the Irish arts community provided the most satisfying aspect to the preparation of this study. Quotes from many of these interviews have been used in the text. Many other quotes, while potentially libellous and therefore unquotable, led to new and previously unexamined avenues of research. Historians, it is said, are natural sceptics, and interviews are an entertaining way to put this scepticism to the test. Interviews cannot be used in the same way as documentary material but they are, nevertheless, an important source of information.

The absence of significant published work on Irish arts policy was compensated for by consulting a broad range of secondary sources. Books and unpublished theses provided information about the background to the development of the arts in Ireland and of arts policy in other countries. Articles amd pamphlets were more important because they often gave short descriptions of arts activities and evaluations of developments in the arts.

## 2. PRIMARY SOURCES

### (a) MANUSCRIPT MATERIAL

**Arts Council, Merrion Square, Dublin**

| | |
|---|---|
| C.E. 1 | Chomhairle Ealaíon, Preliminary Memoranda |
| C.E. 2 | Director, appointment, conditions etc. |
| C.E. 3 | Furniture, office, equipment |
| C.E. 4 | Secretary, appointment, conditions etc. |
| C.E. 6 | France, art institutions |
| C.E. 8 | Royal Academy of Arts, London, correspondence |
| C.E. 9 | Council Members, correspondence, co-option |
| C.E. 14 | Wexford Festival |
| C.E. 15 | Funds |
| C.E. 16 | Procedure |
| C.E. 17 | Minutes, of Council meetings, copies |
| C.E. 18 | Agenda, of Council meetings, copies |
| C.E. 19 | Estimates, annual |
| C.E. 20 | P.J. Little, personal correspondence re. appointment etc. |
| C.E. 25 | Theatre, Memorandum from Irish Theatre Council |
| C.E. 26 | National Theatre |
| C.E. 27 | Rotunda |
| C.E. 31 | Concert Hall, Dublin |
| C.E. 33 | Taoiseach |
| C.E. 52 | Panels, formation, co-options |
| C.E. 57 | Industrial Design |
| C.E. 58 | Local Advisory Groups |
| C.E. 73 | Dublin Festival, 1953 |
| C.E. 91 | Longford Productions |
| C.E. 98 | Tralee Art Exhibition |
| C.E. 114 | Ravenna Mosaics Exhibition |
| C.E. 121 | Religious Art, exhibitions |
| C.E. 132 | '37' Theatre Club |
| C.E. 137 | Anew McMaster, application for aid |
| C.E. 205 | Pike Theatre Club |
| C.E. 257 | Kildare Street Club Premises |
| C.E. 275 | Foras Eireann, application |
| C.E. 350 | Buildings, standards and decoration of, plans |
| C.E. 365 | Consultant, appointment of Dr Bodkin |
| C.E. 370 | The Lane Pictures, Dr Bodkin's book, etc. |
| C.E. 382 | Haverty Trust Exhibition |
| C.E. 384 | Dr Thomas Bodkin, general |
| C.E. 391 | recommendation by Dr Thomas Bodkin's Report |
| C.E. 432 | Patrick Kavanagh, publication of works by |
| C.E. 458 | Capitol Theatre Purchase |
| C.E. 469 | Exhibition Officer |
| C.E. 526 | Comhaltas Ceoltóirí Eireann |
| C.E. 527 | Works of Art, export of |
| C.E. 550 | Council Members, appointment 1956, correspondence etc. |
| C.E. 551 | Director, appointment 1956 |
| C.E. 553 | Council Activities, general |
| C.E. 555 | Advertisement Hoardings |
| C.E. 560 | Miscellaneous Correspondence, 1957 |
| C.E. 574 | Policy, of Council |
| C.E. 575 | Agenda 1957-1961 |
| C.E. 578 | Kildare Place Demolitions |
| C.E. 587 | Miss Nuala Herbert, application |
| C.E. 598 | Secretary, appointment, conditions, 1957 |
| C.E. 615 | Gaelic League, Feis Mumhan |
| C.E. 618 | Memorial Tablets |
| C.E. 621 | Estimate 1958-9 & accounts generally |
| C.E. 628 | Commercial Television in Ireland, proposed service |
| C.E. 634 | 'The Artist & his Milieu', lecture series |
| C.E. 672 | Premises at 70 Merrion Square |
| C.E. 696 | Macaulay Foundation, William T.B. |
| C.E. 747 | Director, 1959 |
| C.E. 769 | Rouault Exhibition, 1960 |
| C.E. 834 | Income Tax Commission |
| C.E. 866 | E.S.B., Rebuilding in Lr Fitzwilliam Street |
| C.E. 901 | Nítrigin Eireann |
| C.E. 1005 | Annual Report and Accounts 1963/4 |
| C.E. 1094 | Annaghmakerrig |
| C.E. 1116 | Council Members 1966 |
| C.E. 1135 | Rosc |
| C.E. 1148 | Imprimatur Publications - Project '67 |
| C.E. 1292 | Student Union - National College of Art |
| C.E. 1375 | Council Members 1971 |
| C.E. 1399 | Annual Report and Accounts 1971/2 |
| C.E. 1403 | Plan for Council Activities |
| C.E. 1534 | In-Depth Study of the Arts in Ireland |
| C.E. 1555 | Planning Permission, correspondence |

| | |
|---|---|
| A 1 | Funds |
| A 12 | Council |
| A 17 | Standing Orders |
| A 18 | Policy |
| A 19 | Press Releases, general |
| A 25 | Annual Reports and Accounts |
| A 32 | Bord na Móna |
| A 51 | Director |
| A 58 | Additional Staff |
| A 100 | Miscellaneous |
| A 120 | Arts Councils of Ireland, Scotland, Wales, Joint Meetings |
| A 182 | White Paper on Cultural Policy 1987: Access and Opportunity |
| A 210 | Dept. of Arts and Culture |
| A 218 | Media Campaign '84 |
| A 247 | Association for Business Sponsorship of the Arts |

**Chester Beatty Library, Ballsbridge, Dublin**
Papers of Sir Alfred Chester Beatty

**Department of Finance, Merrion Street, Dublin**

| | |
|---|---|
| S 2/28/29 | Proposed extension to National Museum |
| S 101/13/36 | Inter-Departmental Committee on establishment of a Symphony Orchestra |
| S 2/32/46 | Proposed extension to National Library |
| S 109/1/46 | Provision of Concert Hall for Dublin |
| S 102/4/47 | Broadcasting Service: Erection of new Radio Headquarter Building |
| F 200/47/49 | Examination of *Report* by *Dr Bodkin* on Various Institutions and Activities with the Arts in Ireland |
| F 200/42/50 | The proposed establishment of the Arts Council - Arts Bill 1950 |
| S 2/21/51 | Provision of accommodation for Arts Council |
| S 2/6/58 | National Gallery Accommodation etc. |
| F 78/1/58 | Abbey Theatre Rebuilding: Fees, Estimates, Sanctions |
| F 78/2/61 | Abbey Theatre Rebuilding: Fees |
| S 200/2/63 | Memorandum for Government: President John F. Kennedy Concert Hall |

**Little Papers, Sandyford, Dublin**
Correspondence of Patrick J. Little
Memorandum for Government: Proposed Council of Culture, 1 Mar. 1946
Revised Memorandum for Government: Proposed Council of Culture, Jan. 1948.

**National Gallery of Ireland, Merrion Square, Dublin**
Correspondence of Sir Chester Beatty, Thomas Bodkin and Thomas McGreevy
Unpublished Annual Reports of the Board of Governors and Guardians of the National Gallery of Ireland

**National Library of Ireland**
Papers of George Noble, Count Plunkett

**State Paper Office, Dublin Castle.**

| | |
|---|---|
| D.E. 2/362 | Ministerial appointments to the Second Dáil Eireann: general file |
| D.E. 2/389 | George Noble Plunkett: Ministerial Appointment |
| D.E. 2/411 | Ministry of Fine Arts: general file (correspondence between Diarmuid O hEigeartaigh and Labhrás Breathnach 21 Sept. 1921 to 18 Jan. 1922) |
| S2236 A/B/C/C1 | Government Accomodation: Proposed New Buildings |
| S 3458 | Metropolitan School of Art: Reorganisation |
| S3655 A/B/C/C1 | National Gallery, Appointment of Governors and Guardians |
| S 5235 | Imperial Exhibition of Contemporary Art, 1927 etc. |
| S 5392 | National Museum, Committee of Inquiry, 1928 |
| S 6025 | Exhibition of Irish Art at Brussels, 1930 |
| S 6069 | International Congress on History of Art, Brussels, Sept. 1930 |
| S 6222 A | National Gallery: Proposed Reorganisation |
| S 9988 | The Lane Pictures |
| S 13773 | National Culture: 1. Proposed Permanent Council; 2. Proposed Cultural Minister |
| S 13814 A | Design in Industry |
| S 14559 | Condition of Art in Ireland: Professor Bodkin's Report |
| S 14922 A & B | An Chomhairle Ealaíon: Establishment |

| S 15073 A | An Chomhairle Ealaíon: Appointment of Director and Ordinary Members |
|---|---|
| S 15226 A/1 | An Chomhairle Ealaíon: Annual Reports and Accounts |
| S 15297 | An Tóstal: National Festival 1953 |
| S 15424 | Arts Act 1951 (Additional Function) re. Order 1953 for Acquisition of Rotunda Buildings |

| | Bodkin 1923-60 |
|---|---|
| 8147/1-15 | Arts Council. |

**University College, Dublin, Archives Department**
Papers of Patrick McGilligan and Cearbhall O Dálaigh

**Trinity College, Dublin**
Papers of Thomas Bodkin

| 6922 | Notes for Lectures and Speeches |
|---|---|
| 6964/1-234 | Advice on Art Matters (mainly Irish) |
| 6965/1-102 | Report on the Arts in Ireland |
| 6966 | Correspondence and documentation relating to the Arts Council, Ireland, 1950-61 |
| 6980 | Advice on Art matters 1935-61 |
| 6981 | Advice (Irish) on art matters 1935-61 |
| 7003/1-103 | Correspondence with W.T. Cosgrave |
| 7003/103a-317 | Correspondence with John A. Costello |
| 7003/318-362b | Correspondence with Eamon de Valera |
| 7003/362c-388a | Correspondence with Seán Lemass |
| 7003/396a-400 | Correspondence with Douglas Hyde |
| 7003/396a-400 | Correspondence with Seán T. O'Kelly |
| 7006/654-673 | Correspondence with Archbishop John Charles McQuaid |
| 7063-7078 | Cuttings Books 1921-67. |

Papers of Thomas McGreevy

| 8003/8/9/9a | Report on and draft of a speech on the cultural dilemma of Irishmen read to the Irish Society, Nov. 1934 |
|---|---|
| 8010-15 | Cuttings of articles by Thomas McGreevy |
| 8108/1-149 | Correspondence with Mgr Patrick Browne |
| 8117/1-5 | Correspondence with Ernie O'Malley |
| 8117/6-13 | Correspondence with George Reavey |
| 8117/14-27 | Correspondence with George Russell (A.E.) |
| 8118/138-41 | Correspondence with Seán O Faoláin |
| 8124/25-43 | Correspondence with Sarah Purser |
| 8132/40-52 | Correspondence with Thomas |

**(b) PRINTED MATERIAL**

i.   Newspapers and other periodicals

*Administration*

*Art Matters*

*Atlantis*

*The Bell*

*Broadsheet*

*The Capuchin Annual*

*Catholic Bulletin*

*Christus Rex*

*Contact*

*Cork Examiner*

*Counterpoint*

*The Crane Bag*

*Cultural Policy*

*Doctrine and Life*

*The Dublin Magazine*

*Dublin Opinion*

*Eire-Ireland*

*Envoy*

*Evening Herald*

*Evening Mail*

*Evening Press*

*Film Directions*

*The Financial Times*

*The Furrow*

*Hibernia*

*In-Dublin*

*Ireland of the Welcomes*

*Ireland To-Day*

*The Irish Arts Review*

*Irish Educational Studies*

*Irish Historical Studies*

*The Irish Independent*

*The Irish Monthly*

*The Irish Press*

*The Irish Rosary*

*The Irish Statesman*

*The Irish Times*

*The Irish University Review*

*Irish Writing*

*Kavanagh's Weekly*

*The Leader*

*Léargas*

*The Listener*

*Nonplus*

*Nusight Magazine*

*The Phoenix*

*Social Studies*

*Soundpost*

*Structure*

*Studies*

*The Sunday Independent*

*The Sunday Press*

*The Sunday Tribune*

*Theatre Ireland*

*The Times*

*Twentieth Century Studies*

*Writer's Digest*

## ii. Official Publications

*Acts of the Oireachtas.* Dublin, 1922-

*Access and Opportunity: A White Paper on Cultural Policy.* Dublin, 1987.

*Census of Population 1926: Vol. X, General Report.* Dublin, 1934.

*Census of Population 1936: Vol. IX. General Report.* Dublin, 1942.

*Census of Population 1946 and 1951: General Report.* Dublin, 1958.

*Dáil Eireann. Parliamentary Debates: Official Report.* Dublin, 1922-

*Design in Ireland: Report of the Scandinavian Design Group in Ireland.* Dublin, 1962.

*Economic Development.* Government White Paper. Dublin, 1958.

*Estimates for the Public Service.* Dublin, 1922-

*Issues and Structures in Education.* A Consultative Document. Curriculum and Examinations Board. Dublin, 1984.

*Public and Private Funding of the Arts.* Vols. 1 & 2. Eighth Report of the House of Commons Education, Science and Arts Committee. London, 1982.

*Report of the Committee concerned with the Outflow of Works of Art.* Dublin, 1985.

*Report of the Council of Design.* Dublin, 1965.

*Report of the Public Services Organisation Review Group.* Liam St John Devlin et al. Dublin, 1978.

*Report on the Arts in Ireland.* Thomas Bodkin. Dublin, 1949.

*Saorstát Eireann (Irish Free State): Official Handbook.* Bulmer Hobson (Ed.). Dublin, 1932.

*Seanad Eireann. Parliamentary Debates: Official Report.* Dublin, 1922-

*Statistical Abstract.* Dublin, 1922-

*The Arts in Education.* Discussion Paper. Curriculum and Examinations Board. Dublin, 1985.

*The Restoration of the Irish Language.* Government White Paper. Dublin, 1965.

*White Paper on Educational Development.* Dublin, 1981.

## iii. Arts Council Publications

*Aosdána.* Dublin, 1987.

*Audiences, Acquisitions and Amateurs,* Dublin, 1983.

*Deaf Ears.* A Report on the Provision of Music Education in Irish Schools. Donald Herron. Dublin, 1985.

*Find Your Music in Ireland.* Dinah Molloy. Dublin, 1979.

*Hugh Lane and his pictures.* Thomas Bodkin. Dublin, 1956.

*Living and Working Conditions of Artists.* A Summary of the main results of a survey of Irish artists. Dublin, 1980.

*Provision for the Arts.* Report of an Inquiry carried out during 1974-75 throughout the twenty-six counties of the Republic of Ireland. J.M. Richards. Dublin, 1976.

*Services in Literature.* Dublin, 1985.

*The Dancer and the Dance.* Developing Theatre Dance in Ireland. Peter Brinson. Dublin, 1985.

*The Performing Arts and the Public Purse: an Economic Analysis.* John W. O'Hagan & Christopher T. Duffy.

*The Place of the Arts in Irish Education.* Report of the Arts Council's Working Party on the Arts in Education. Ciarán Benson. Dublin, 1979.

*The Status of the Artist.* Dublin, 1980.

*Tax and the Artist.* Survey of European Tax Codes as they affect Creative and Interpretative Artists. Dublin, 1986.

*Writers in Schools.* Dublin, 1980.

## iv. Exhibition Catalogues

Barrett, Fr Cyril, S.J. *Irish Art 1943-73.* Rosc Exhibition, Cork, 1980.

Crookshank, Anne & King, Cecil. *Rosc '67.* Dublin, 1967.

Fallon, Brian. *Tony O'Malley.* Dublin, 1984.

*Irish Design Exhibition.* Dublin, 1956.

McConkey, Kenneth. *Irish Renascence.* Irish Art in a Century of Change. Pym's Gallery, London, 1986.

Murphy, Patrick T. *Out of the Shadows.* Contemporary Irish Photography. Gallery of Photography, Dublin, 1981.

O'Doherty, Brian. *The Irish Imagination 1959-1971.* Rosc Exhibition, Municipal Gallery of Modern Art, Dublin, 1971.

Oliver, Simon. *A Sense of Ireland.* Exhibition, London, 1980.

Pine, Richard. *All for Hecuba.* Municipal Gallery of Modern Art, Dublin, 1978.

Pyle, Hilary. *Irish Art 1900-1950.* Rosc Exhibition, Cork 1975-6.

Ruane, Frances. *The Delighted Eye.* Irish Painting and Sculpture of the Seventies. Touring Exhibition, 1980.

*Sean Keating and the E.S.B..* Touring Exhibition, 1981.

Sweeney, James Johnson. *Modern Irish Painting.* Touring Exhibition, 1971.

White, James. *The City's Art - the original municipal collection.* Hugh Lane Municipal Gallery of Modern Art, Dublin, 1984.

## v. Annual Reports

*Arts Council - An Chomhairle Ealaíon - Annual Report and Accounts.* 1951-

*Arts Council of Great Britain - Annual Report.* 1946-

*Arts Council of Northern Ireland - Annual Report.* 1965-

*Cultural Relations Committee of the Department of External Affairs (Foreign Affairs).* 1951-

*Department of Education - Annual Reports.* 1922-

*National Library of Ireland - Annual Report of the Board of Visitors.*1922-

*National Museum of Ireland - Annual Report of the Board of Visitors.* 1922-

## (c) INTERVIEWS

Boydell, Dr Brian. Dublin, 18 Apr. 1987.

Cassidy, Laurence. Dublin, 21 Aug. 1987.

Dowling, Seán. Dublin, 28 Mar. 1987.

Fleischmann, Professor Aloys. Cork, 23 Oct. 1987.

Furlong, Dr George. London, 29 May 1984.

Gahan, Muriel. Dublin, 23 Mar. 1987.

Hand, Professor Geoffrey. Dublin, 29 Feb. 1988.

Kiely, Benedict. Dublin, 17 Mar. 1987.

MacLeod, Catríona. Dublin, 13 Apr. & 31 Oct. 1987.

McConnell, David. Dublin, 11 Feb. 1987.

McCullough, Máirtín. Dublin, 2 Feb. 1987. & 10 Feb. 1988.

Moriarty, Joan Denise. Cork, 24 Oct. 1987.

Moynihan, Maurice. Dublin, 24 Jan. 1987.

O Briain, Colm. Dublin, 9 Jan. 1988.

O Broin, León. Dublin, 15 Nov. 1985.

O Faoláin, Seán. Dublin, 7 Feb. 1987.

O'Leary, Liam. Dublin, 1 Apr. & 9 July 1987.

O'Sullivan, Dr Liam. Dublin, 31 Jan. 1987.

Philipson, Serge. Dublin, 14 Feb. 1987.

Reynolds, Martin. Dublin, 17 Aug. 1987.

Rock, Patrick. Dublin, 29 Jan. 1988.

Scott, Michael. Dublin, 21 Mar. 1987.

Stokes, Richard. Dublin, 4 Feb. 1987.

Wall, Mervyn. Dublin, 14 Feb. 1987 & 6 Feb. 1988.

White, James. Dublin, 23 Feb. 1988.

Whitty, Bob. Dublin, 11 Feb. 1987.

## 3. SECONDARY SOURCES

### (a) BIOGRAPHICAL AND REFERENCE WORKS

Boylan, Henry. *A Dictionary of Irish Biography.* Dublin, 1978.

Browne, Vincent (Ed). *The Magill Book of Irish Politics.* Dublin, 1981.

Cairnduff, Maureen (Ed.). *Who's Who in Ireland.* Dunlaoghaire, 1984.

Deale, Edgar M. (Ed.). *A Catalogue of Contemporary Irish Composers.* 2nd Ed. Dublin, 1973.

Dudman, Jane (Ed.). *International Music Guide 1986.* London, 1985.

Fitz-Simon, Christopher. *The Arts in Ireland: A Chronology.* Dublin, 1982.

Flynn, William J. (Ed.). *Irish Parliamentary Handbook 1939.* Dublin, 1939.

Ford, P. & G. *Select List of Reports of Inquiries of the Irish Dáil and Senate 1922-1972.* Dublin, 1974.

Hickey, D.J. & Doherty, J.E. *A Dictionary of Irish History 1800-1980.* Dublin, 1980.

Hogan, Robert (Ed.). *The Macmillan Dictionary of Irish Literature.* London, 1985.

*International Dictionary of Arts 1985/86.* Frankfurt, 1984.

Knowles, Roderic. *Contemporary Irish Art.* Dublin, 1982.

Mansergh, Martin (Ed.). *The Spirit of the Nation.* The Speeches and Statements of Charles J. Haughey (1957-86). Dublin, 1986.

Marcan, Peter. *Arts Address Book.* High Wycombe, 1986.

Moulin, Raymond. *A Handbook for Plastic Artists.* Brussels, 1981.

Moynihan, Maurice (Ed.). *Speeches and Statements of Eamon de Valera 1917-73.* Dublin, 1980.

Myerscough, John. *Funding the Arts in Europe.* London, 1984.

*Facts about the Arts 2.* London, 1986.

O'Donnell, Jim (Ed.). *Ireland: The past twenty years: An Illustrated Chronology* (1967-1986). Dublin, 1986.

Wiesand, Andreas (Ed.). *Handbook of Cultural Affairs in Europe.* Baden-Baden, 1985.

White, James & Wynne, Michael. *Irish Stained Glass.* Dublin, 1963.

Williams, Raymond. *Keywords.* London, 1983.

### (b) UNPUBLISHED THESES

Dolan, Martin. *The Irish National Cinema and its Relationship to Irish Nationalism.* Doctor of Philosophy, University of Wisconsin - Madison, 1979.

Hartigan, Maurice. *The Eucharistic Congress.* Master of Arts, University College, Dublin, 1979.

Holzapfel, Rudi. *A Survey of Irish Literary Periodicals from 1900 to the Present Day.* Master of Litterature, Trinity College, Dublin, 1964.

Kennedy, Brian. *Irish Art and Modernism.* Doctor of Philosophy, Trinity College, Dublin, 1986.

McKee, Eamonn. *From Precepts to Praxis: Irish Governments and Economic Policy, 1939-1952.* Doctor of Philosophy, University College, Dublin, 1987.

Murphy, Brian. *J.J. O'Kelly ('Sceilg') and the Catholic Bulletin: Cultural Considerations - Gaelic, religious and national c. 1898-1926.* Doctor of Philosophy, University College, Dublin, 1986.

O'Callaghan, Margaret. *Language and Religion: the quest for identity in the Irish Free State.* Master of

Arts, University College, Dublin, 1981.

Savage, Robert J. *The Origins of Irish Radio.* Master of Arts, University College, Dublin, 1982.

Wynne, Michael. *Stained Glass in Ireland, principally Irish, 1760-1963.* Doctor of Philosophy, Trinity College, Dublin, 1976.

## (c) BOOKS

Abercrombie, Nigel. *Cultural Policy in the United Kingdom.* Paris, 1982.

Adams, Michael. *Censorship: the Irish Experience.* Dublin, 1968.

Akenson, Donald Harmon. *A Mirror to Kathleen's Face: Education in Independent Ireland.* London, 1975.

Andrews, C.S. *Dublin Made Me.* Cork, 1979.
*Man of No Property.* Cork, 1982.

Appleyard, Brian. *The Culture Club: Crisis in the Arts.* London, 1984.

Aspen Institute. *The Arts, Economics and Politics: Four National Perspectives.* New York, 1975.

Baldry, Harold. *The Case for the Arts.* London, 1981.

Blanchard, Jean. *The Church in Contemporary Ireland.* London, 1963.

Blanshard, Paul. *The Irish and Catholic Power.* London, 1954.

Bowen, Elizabeth. *The Shelbourne.* London, 1951.

Breathnach, Labhrás. An Pluincéadach. Dublin, 1971.

Brown, Terence. *Ireland - a Social and Cultural History 1922-85.* London, 1985.

Butler, Hubert. *Escape from the Anthill.* Mullingar, 1985.

Byrne, Gay. *To Whom it Concerns.* Dublin, 1972.

Campbell, Patrick. *My Life and Easy Times.* London, 1967.

Canada Council. *The Arm's Length Principle and the Arts: An International Perspective - Past, Present and Future.* Ottawa, 1985.

Carroll, Joseph T. *Ireland in the War Years 1939-45.* Newton Abbot, 1975.

Carton, Sheila (Ed.). *Our Book: Irish Countrywomen's Association Golden Jubilee 1910-1960.* Dublin, 1960.

Carty, Ciarán. *Robert Ballagh.* Dublin, 1986.

Clarke, Paddy. *Dublin Calling: 2RN and the birth of Irish Radio.* Dublin, 1986.

Cleeve, Brian. *W.B. Yeats and the Designing of Ireland's Coinage.* Dublin, 1972.

Cohan, Al. *The Irish Political Elite.* Dublin, 1972.

Coogan, Tim Pat. *The Irish: A Personal View.* London, 1975.
*Ireland and the Arts.* London, not dated.
*Disillusioned Decades 1966-1987.* Dublin, 1987.

Cronin, Anthony. *Dead as Doornails.* Dublin, 1976.

*An Irish Eye.* Dingle, 1985.

Davis, Thomas. *Literary and Historical Essays.* Dublin, 1862.

Denson, Alan. *Thomas Bodkin: a Bio-Bibliographical Survey.* Kendal, 1967.

Depaigne, Jacques. *Cultural Policies in Europe.* Strasbourg, 1978.

Donoghue, Denis. *The Arts Without Mystery.* London, 1983.

Eliot, T.S. *Notes Towards a Definition of Culture.* London, 1948.

Fanning, Ronan. *The Irish Department of Finance 1922-58.* Dublin, 1978.
*Independent Ireland.* Dublin, 1983.

Feld, A.L. & Davidson Shuster, J.M. *Patrons Despite Themselves: Taxpayers and Arts Policy.* New York 1983.

Fleischmann, Aloys (Ed.). *Music in Ireland: a Symposium.* Cork, 1952.

Fréine, Seán de. *The Great Silence.* Dublin & Cork, 1978.

Gorham, Maurice. *Forty Years of Irish Broadcasting.* Dublin, 1967.

Gregory, Lady Augusta. *Sir Hugh Lane: His Life and Legacy.* Gerrards Cross, Buckinghamshire, 1973.

Grist, Berna. *Twenty Years of Planning.* Dublin, 1983.

Groocock, Joseph. *A General Survey of Music in the Republic of Ireland.* Dublin, 1961.

Gulbenkian Foundation. *Help for the Arts.* London, 1959.

Harris, John S. *Government Patronage of the Arts in Great Britain.* Chicago and London, 1970.

Hewins, Ralph. *Mr Five Per Cent: The Biography of Calouste Gulbenkian.* London, 1957.

Hewison, Robert. *The Heritage Industry: Britain in a Climate of Decline.* London, 1987.

Hickey, Des & Smith, Gus. *A Paler Shade of Green.* London, 1972.

Hogan, Robert. *Mervyn Wall.* Lewisburg, 1972.

Hutchison, Robert. *The Politics of the Arts Council.* London, 1982.

Inglis, Brian. West Briton. London, 1962.

Kearney, Richard. *Transitions: Narratives in Modern Irish Culture.* Dublin, 1987.

Kelly, Anne. *Cultural Policy in Ireland.* Dublin, 1989.

Kelly, Owen. *Community Art and the State: Storming the Citadels.* London, 1984.

Kennedy, Brian P. *Alfred Chester Beatty and Ireland 1950-68: A Study in Cultural Politics.* Dublin, 1988.

Kennedy, Kieran A. *Productivity and Industrial Growth: The Irish Experience.* Oxford, 1971.
& Bruton, Richard. *The Irish Economy.* Brussels, 1975.
& Dowling, Brendan R. *Economic Growth in Ireland:*

*the Experience since 1947.*

Keogh, Dermot. *The Vatican, the Bishops and Irish Politics 1919-39.* Cambridge, 1986.

Litton, Frank (Ed.). *Unequal Achievement: The Irish Experience 1957-1982.* Dublin, 1982.

Lyons, F.S.L. *Ireland Since the Famine.* Paperback edt., London, 1973.
*Culture and Anarchy in Ireland 1890-1939.* Oxford, 1979.

McAvera, Brian. *Art, Politics and Ireland.* Dublin, 1989.

McCarthy, Charles. *The Decade of Upheaval.* Dublin, 1973.

Macken, Walter. *Rain on the Wind.* London, 1950.

McCrum, Seán & Lambert, Gordon (Eds.). *Living with Art: David Hendricks.* Dublin, 1985.

MacDonald, Frank. *The Destruction of Dublin.* Dublin, 1986.

McHugh, Roger (Ed.). *Jack B. Yeats: A Centenary Gathering.* Dublin, 1971.

MacLiammóir, Micheál. *Put Money in Thy Purse.* London, 1952.
*All for Hecuba: A Theatrical Biography.* Revised Edt., Dublin, 1961.

MacLysaght, Edward. *Changing Times: Ireland since 1898.* Gerrards Cross, Buckinghamshire, 1978.

MacManus, Francis. *The Years of the Great Test.* Dublin & Cork, 1967.

McRedmond, Louis (Ed.). *Written on the Wind.* Dublin, 1976.

Marchant, Nick & Addis, Jeremy. *Kilkenny Design: Twenty-one years of design in Ireland.* Kilkenny, 1984.

Meenan, James. *George O'Brien: a biographical memoir.* Dublin, 1980.

Mennell, Stephen. *Cultural Policy in Towns.* Strasbourg, 1976.

Minihan, Janet. *The Nationalisation of Culture: The Development of State Subsidies to the Arts in Great Britain.* London, 1977.

Moran, D.P. *The Philosophy of Irish Ireland.* Dublin, 1905.

Mulgan, Geoff & Worpole, Ken. *Saturday Night or Sunday Morning? Who or What is doing most to shape British culture in the 1980s.* London, 1986.

Murphy, John A. *Ireland in the Twentieth Century.* Dublin, 1975.

Murphy, Seamus. *Stone Mad.* Dublin, 1950.

Myerscough, John. *The Economic Importance of the Arts.* London, 1988.

Nilsson, Nils Gunnar. *Swedish Cultural Policy in the 20th Century.* Stockholm, 1980.

Nowlan, K.B. & Williams, T.D. *Ireland in the War Years and After.* Dublin, 1969.

O Broin, León. *Just Like Yesterday: an autobiography.* Dublin, 1986.

O Cuiv, Brian. *Irish Dialects and Irish Speaking Districts.* Dublin, 1951.

O Faoláin, Seán. *The Irish.* Middlesex, 1947.

O'Farrell, Padraic. *The Ernie O'Malley Story.* Dublin, 1983.

Pearson, Nicholas. *The State and the Visual Arts.* Milton Keynes, 1982.

Pick, John (Ed.). *The State and the Arts.* Eastbourne, 1980.
*Managing the Arts: the British Experience.* London, 1986.

Pinter, Harold. *Mac.* Ipswich, 1968.

Prendergast, Mark. *Irish Rock - Roots, Personalities, Directions.* Dublin, 1987.

Réamonn, Seán. *History of the Revenue Commissioners.* Dublin, 1981.

Rockett, Kevin & Gibbons, Luke & Hill, John. *Cinema and Ireland.* Beckinham, Kent, 1987.

Ronan, Rev. Myles V. *Catholic Emancipation Centenary Record.* Dublin, 1929.

Ryan, John. *Remembering How We Stood.* Dublin, 1975.

Schuster, J. Mark Davidson. *Supporting the Arts: an International Comparative Study.* Boston, 1985.

Share, Bernard. *The Emergency: Neutral Ireland 1939-45.* Dublin, 1980.

Sharpe, Henry. *Michael Kane: His Life and Art.* Dublin, 1983.

Shaw, Roy. *The Arts and the People.* London, 1987.

Sheehy, Jeanne. *The rediscovery of Ireland's past: the Celtic revival, 1830-1930.* London, 1980.

Simpson, James. *Towards Cultural Democracy.* Strasbourg, 1976.

Skinner, Liam C. *Politicians by Accident.* Dublin, 1946.

Snow, C.P. *The Two Cultures: and a Second Look.* Cambridge, 1959.

Stephens, Meic (Ed.). *The Arts in Wales 1950-75.* Cardiff, 1979.

Sweeting, Elizabeth (Ed.). *Patron or Paymaster? The Arts Council Dilemma.* London, 1982.

Swift, Carolyn. *Stage by Stage.* Dublin, 1985.

Tobin, Fergal. *The Best of Decades: Ireland in the 1960s.* Dublin, 1984.

Tracy, Honor. *The Straight and Narrow Path.* London 1956.

Unesco. *Declaration of the Principles of International Cultural Co-operation.* Paris, 1967.
*Cultural Policy: a Preliminary Study.* Paris, 1969.
*Place and Function of Art in Contemporary Life: Report of an International Symposium.* Paris 1971.

Ussher, Arland. *The Face and Mind of Ireland.* London, 1949.

Walker, Dorothy. *Louis le Brocquy.* Dublin, 1981.

Walker, Kathrine Sorley. *Ninette de Valois: Idealist Without Illusions.* London, 1987.

Wall, Mervyn. *Leaves for the Burning*. London, 1952.

Walsh, Rev. Paul (Ed.). *Saint Patrick:a Fifteenth Centenary Memorial Book*. Dublin, 1932.

White, Eric Walter. *The Arts Council of Great Britain*. London, 1975.

White, Terence de Vere. *A Fretful Midge*. London 1957.

Whyte, John. *Church and State in Modern Ireland 1923-1979*. Dublin, 1980.

Willatt, Hugh. *The Arts Council of Great Britain:* The First 25 Years. London, 1981.

Woodman, Kieron. *Media Control in Ireland 1923-1983*. Galway, 1985.

**(d) ARTICLES AND PAMPHLETS**

Acton, Charles. 'The Arts and the Arts Council'. *Eire-Ireland*, Vol. III, No. 2, Summer 1968.

Arnold, Bruce. 'Autumn Frolics'. *Eire-Ireland*, Vol. VI, No. 4, Winter, 1971.

'Politics and the Arts in Ireland - the Dail Debates', in Litton, Frank (Ed.) *Unequal Achievement: The Irish Experience 1957-1982*. Dublin, 1982.

Arts Council of Great Britain. *The Glory of the Garden: The Development of the Arts in England - A Strategy for a Decade*. London, 1984.

*Partnership: Making Arts Money Work Harder*. London, 1986.

Association of Artists in Ireland. *Crisis in the Arts*. Dublin, 1985.

Barrett, Fr Cyril, S.J. 'Irish Nationalism and Art 1800-1921'. *Studies*,Vol. LXIV, Winter 1975.

Barrington, T. J. 'Whatever Happened to Irish Government', in Litton, Frank (Ed.) *Unequal Achievement: The Irish Experience 1957-1982*. Dublin, 1982.

Beere, Thekla. 'Cinema Statistics in Saorstat Eireann'. *The Capuchin Annual*, 1938.

Bodkin, Thomas. 'Modern Irish Art', in Hobson, Bulmer (Ed.) *Saorstát Eireann: Official Handbook*. Dublin, 1932.

Bourke, Thomas. 'Nationalism and the Royal Irish Academy, 1916-1923'. *Studies*, Vol. LXXV Summer 1986.

Boydell, Brian. 'The Future of Music in Ireland'. *The Bell*, Vol. XVI, No. 4, January 1951.

'Half a Century of Music in Dublin'. *Dublin Historical Record*, Vol. XXXVII, No. 3/4, June-Sept. 1984.

Breen, Joe. 'Rock and Pop: the Most Active of all the Arts'. *Irish Times*, 8 July 1985.

Brown, Fr Stephen, S.J. *The Central Catholic Library*. Dublin, 1932.

*The Catholic Library comes of age 1922-43*. Dublin, 1943.

'Progress of the Republic of Ireland since 1921'. *The Irish Rosary*, Mar.-Apr. 1959.

Butler, Anthony. 'Irish Art: Darkness and Light'. *Eire-Ireland*, Vol. V, No. 3, Autumn 1970.

Butler, Hubert. '*Envoy* and Mr Kavanagh'. *The Bell*, Vol. XVII, No. 6, Sept. 1951.

Carty, Ciaran. 'The Arts Strike Out Alone'. *Sunday Tribune*, 20 Sept. 1987.

Connolly, Fr Peter R. 'The Basis of State Censorship'. *Christus Rex*, Vol. VIII, July 1959.

Corcoran, Fr Timothy, S.J. 'The Teaching of History'. *Studies*, Vol. XII, 1923.

'The Integral Teaching of History'. *Irish Monthly*, Jan. 1929.

Craig, Maurice. 'The Bodkin Report'. *The Bell*, Vol. XVII, No. 6, Sept. 1951.

Cronin, Anthony. 'The Cultural Relations Committee'. *The Bell*, Vol. XVII, No. 8, Nov. 1951.

Crozier, Eric. 'The Origin of Aldeburgh', in *Aldeburgh Anthology*. London, 1972.

Cullen, Rev. E.J. *On the Purpose of Art*. Dublin, 1936.

Cullen, Louis. 'The Cultural Basis of Modern Irish Nationalism', in Mitchison, Rosalind (Ed.) *The Roots of Nationalism: studies in Northern Europe*. Edinburgh, 1980.

Curran, C.P. 'Jack B. Yeats, R.H.A.'. *Studies*, Vol. XXX, 1941.

Darwin, Sir Robin. 'Art'. *Studies*, Vol. LVII, Winter 1968.

Dawson, George. 'The Douglas Hyde Gallery'. *Irish Arts Review*, Vol. 4, No. 4, Winter, 1987.

Delany, Patrick. 'A Concert Hall for Dublin'. *The Bell*, Vol. XVII, No. 10, Jan. 1952.

Devane, James. 'Is an Irish Culture Possible?'. *Ireland To-Day*, Sept. 1936.

'Nationality and Culture'. *Ireland To-Day*, Dec. 1936.

Dowling, John & Wall, Mervyn. 'The Abbey Theatre Attacked', *Ireland To-Day*, Jan. 1937.

Doyle, P.A. 'Seán O Faoláin and *The Bell*'. *Eire-Ireland*, Vol. 1, No. 3, Autumn 1966.

Fallon, Gabriel. 'Celluloid Menace'. *Capuchin Annual*, 1938.

Fennell, Desmond. 'The Irish Language Movement: its achievements and its failure'. *20th Century Studies*, Vol. 4, Nov. 1970.

'The Irish Cultural Prospect'. *Social Studies*, Vol. 1, Dec. 1972.

Fleischmann, Aloys. 'Ars Nova: Irish Music in the Shaping'. *Ireland To-Day*, July 1936.

Foley, Dermot. 'A Minstrel Boy with a Satchel of Books'. *Irish University Review,* Vol. 4, No. 2, Autumn, 1974.

Gahan, Muriel. 'Ireland's Country Crafts'. *Ireland of the Welcomes,* Vol. 5, No. 3, Sept.-Oct. 1956.

Galbraith, John Kenneth. 'The artist and the economist: why the twain must meet?'. *Times Higher Education Supplement,* 18 Feb. 1983. *Economics and the Arts.* London, 1983.

Gannon, Fr P.J., S.J. 'Literature and Censorship'. *Irish Monthly,* July 1937. 'Art, Morality and Censorship'. *Studies,* Vol. XXXI, 1942.

Giltenan, Donal J. 'P.E.N. comes'. *Ireland of the Welcomes,* Vol. 2, No. 1, May-June 1953.

Harmon, Maurice. 'The Era of Inhibitions: Irish Literature, 1920-1960'. *The Emory University Quarterly,* Vol. XXII, No. 1, Spring 1966.

Hartigan, Marianne. 'The Irish Exhibition of Living Art'. *Irish Arts Review,* Vol. 4, No. 4, Winter, 1987.

Henderson, Gordon. 'An Interview with Mervyn Wall'. *The Journal of Irish Literature,* Vol. XI, Nos. 1 & 2, Jan.-May 1982.

Keating, Seán. 'Painting in Ireland To-day'. *The Bell,* Vol. XVI, No. 3, Dec. 1950.

Kelly, Anne. 'A Cultural Policy for Ireland'. *Administration,* Vol. 32, No. 3, 1984. 'Government and the Arts in Ireland', in Cummings Jr, Milton C. & Katz, Richard S. *The Patron State: Government and the Arts in Europe, North America and Japan.* Oxford, 1987. 'The church, the state and Thomas Bodkin'. *Irish Times,* 25, 26& 28 Dec. 1987.

Kennedy, Brian P. 'Seventy-five years of *Studies'. Studies,* Vol. LXXV, Winter, 1986. 'Towards a National Cultural Policy'. *Seirbhís Phoiblí,* Vol. 9, No. 2, June, 1988. *'Ireland To-Day:* a brave Irish periodical'. *Linen Hall Review,* Vol. 5, No. 4, Winter, 1988.

Keynes, John Maynard. 'Art and the State'. *The Listener,* 16 Aug. 1936.

Kiely, Benedict. 'The Corpulent Capuchin of Capel Street'. *The Education Times* (Supplement to the *Irish Times*), 26 Dec. 1974. 'The Capuchins and the Chevalier'. *Irish Times,* 27 Jan. 1977.

Kilroy, Thomas. 'Mervyn Wall: the Demands of Satire'. *Studies,* Spring, 1958.

Lee, Joseph. 'Continuity and Change in Ireland, 1945-60', in Lee, J.J. (Ed.) *Ireland 1945-70.* Dublin, 1979.

Lynch, Patrick. 'The Irish Economy Since the War, 1946-51', in Nowlan, K.B. & Williams, T. Desmond *Ireland in the War Years and After 1939-51.* Dublin, 1969.

MacAvock, Desmond. 'A Year of Irish Art: 1975'. *Eire-Ireland,* Vol. XI, No. 1, Spring 1976.

MacCarthy, B.G. 'The Cinema as a Social Factor'. *Studies,* Vol. XXXIIi, 1944.

McCartney, Donal. 'Education and Language, 1938-51', in Nowlan, K.B. & Williams, T. Desmond *Ireland in the War Years and After 1939-51.* Dublin, 1969.

McConkey, Kenneth. 'Paintings of the Irish Renaissance'. *Irish Arts Review,* Vol. 3, No. 3, Autumn 1986.

MacDonald, Frank. 'The Making of Busárus'. *Irish Times,* 29 May 1984.

McGreevy, Thomas. 'Developments in the Arts'. *Studies,* Vol. XL, 1951. 'Fifty Years of Irish painting 1900-1950'. *The Capuchin Annual,* 1949.

McGuire, Edward A. 'Art and Industry'. *Ireland To-Day,* January, 1937.

Mackenzie, Sir Compton. 'The Wexford Opera Festival Arts'. *Ireland of the Welcomes,* Vol. 5, No 3, Sept.-Oct. 1954.

Mahon, Derek. 'Poetry in Northern Ireland'. *20th Century Studies,* Vol. 4, Nov. 1970.

Marcus, David. 'Seán O Riordáin: Modern Gaelic Poet'. *Irish Writing,* No. 32, Autumn, 1955.

Marcus, Louis. 'Facts and Fantasies of 20 years of Irish Film'. *Irish Times,* 29 July 1987.

Montague, John. 'The Young Writer'. *The Bell,* Vol XVII, No. 7, Oct. 1951.

Montgomery, James. 'The Menace of Hollywood'. *Studies,* Vol. XXI, Dec. 1942.

Montgomery, Niall. 'Dublin's Central Bus Station'. *Ireland of the Welcomes,* Vol. 5, No. 4, Nov.-Dec 1956.

Murphy, Brian. 'The Canon of Irish Cultural History: Some Questions'. *Studies,* Vol. LXXVII, Spring, 1988.

Murphy, Fergus. *Publish or Perish.* Cork, 1951.

Myerscough, John. 'Private Funding of the Arts'. *Cultural Policy,* No. 5-6/87.

Nissel, Muriel. 'Financing the Arts in Great Britain'. *Cultural Policy,* No. 1-2/85.

O Broin, León. 'The Mantle of Culture', in McRedmond, Louis (Ed.) *Written on the Wind.* Dublin, 1976.

O Buachalla, Séamus. 'Education as an issue in the First and Second Dáil'. *Administration,* Vol. 25,

No. 1, Spring, 1977.
'Educational Policy and the Role of the Irish Language from 1831 to 1981'. *European Journal of Education,* Vol. 19, No. 1, 1984.

O'Byrne, Robert. 'A Battle for the Ballet'. *Music Ireland,* July/Aug. 1987.

O'Callaghan, Margaret. 'Language, nationality and cultural identity in the Irish Free State, 1922-7: the *Irish Statesman* and the *Catholic Bulletin* reappraised'. *Irish Historical Studies,* Vol. XXIV No. 94, Nov. 1984.

O'Doherty, Brian. 'Irish Painting, 1953: Some Thoughts'. *Irish Monthly,* Mar. 1954.
'An Tóstal and the Visual Arts'. *Irish Monthly,* July 1954.

O'Donnell, Peadar. 'Suggestion for a Fighting Wake'. *The Bell,* June 1947.
*Monkeys in the Superstructure.* Galway, 1976.

O Faoláin, Seán. 'The Dangers of Censorship'. *Ireland To-Day,* Nov. 1936.
'Autoantiamericanism'. *The Bell,* Mar. 1951.

O hAodha, Micheál. 'Ireland's Amateur Drama Festivals'. *Ireland of the Welcomes,* Vol. 6, No. 3 Sept.-Oct. 1957.

O'Leary, Liam. 'The Shop around the Corner'. *Irish Times,* 17 Nov. 1986.
'Potemkin and Afterwards'. *Irish Times,* 18 Nov. 1986.

Pine, Richard. 'Cultural Democracy, cultural policy and cultural identity: a web of woven guesses'. *The Crane Bag,* Vol. 7, No. 2, 1983.
'The Suburban Shamrock: the embourgeoisement of Irish Culture'. *The Irish Review,* No. 2, 1987.

Pyle, Hilary. 'Rosc '71'. *Ireland of the Welcomes,* Vol 20, No. 1, May-June 1971.

Reddin, Kenneth. 'A Man Called Pearse'. *Studies,* Vol. XXXIV, 1945.

Rees-Mogg, Sir William. *The Political Economy of Art.* London, 1985.

Robinson, J.J. 'Church Art and the Life of Our People', in Ronan, Rev. Myles V. *Catholic Emancipation Centenary Record.* Dublin, 1929.

Rosenfeld, Ray. 'The Arts and Bombs'. *Eire-Ireland,* Vol. VIII, No. 2, Summer 1973.

Rushe, Desmond. 'Theatre: New Resources, New Responsibilities'. *Eire-Ireland,* Vol. XI, No. 1, Spring, 1976.

Ryan, John. 'The Young Writer'. *The Bell,* Vol. XVII No. 7, Oct. 1951.

Rynne, Etienne. *A Shrine of Celtic Art: the art of Sr M. Concepta Lynch O.P.* Dublin, not dated.

Salkeld, Cecil Ffrench. 'The Cultural Texture of a Country'. *The Bell,* Vol. XVI, No. 2, Nov. 1950.

Sheehy, Edward. 'Recent Irish Painting: the Irish Exhibition of Living Arts, 1950'. *Envoy,* Vol. 3, No. 10, Sept. 1950.

Sheridan, Peter. 'Theatre and Politics'. *The Crane Bag Book of Irish Literature.* Dublin, 1982.

Smith, Michael. 'Some Questions about the Thirties'. *The Lace Curtain,* Vol. 4, Summer 1971.

Stockley, W.P. 'Art and Literature in Ireland'. *The Capuchin Annual,* 1939.

Swift, Carolyn. 'Dance in Ireland'. *Ireland Today,* No. 996, Mar. 1983.

Thornley, David. 'Ireland: the end of an era?'. *Studies,* Spring, 1964.

Tierney, Michael. 'The Revival of the Irish Language'. *Studies,* Vol. XVI, 1927.

Titley, Alan. 'Language Report, 1982; One Hundred Years A-Going'. *Eire-Ireland,* Vol. XVII, No. 2, Summer 1982.

Turpin, John. 'Unbeautiful Ireland - History or Apathy?'. *The Crane Bag,* Vol. 6, No. 1, 1982.
'The Ghost of South Kensington: The Beginnings of Irish State Qualifications in Art, 1900-1936'. *Oideas,* No. 30, 1987.
'The National College of Art under Keating and MacGonigal'. *The G.P.A. Irish Arts Review Yearbook 1988.*

Tweedy, Colin. 'The Economics of Arts Sponsorship in the United Kingdom'. *Cultural Policy,* No. 1-2/86.

Walker, Robin. 'Architecture'. *Studies,* Vol. LVII Winter, 1968.

Wall, Mervyn. 'An Address'. *The Journal of Irish Literature,* Vol. XI, Jan.-May 1982.

White, James. 'The Fourth International Congress of Art Critics'. *Ireland of the Welcomes,* Vol. 2, No. 2, July-Aug. 1953.
'The Visual Arts in Ireland'. *Studies,* Vol. XLIV Spring 1955.

White, Terence de Vere. 'Social Life in Ireland 1927-1937', in MacManus, Francis *The Years of the Great Test.* Dublin & Cork, 1967.